The Visual Turn

Edited and with an Introduction by
Angela Dalle Vacche

The
Visual Turn

Classical Film Theory
and Art History

Rutgers
University
Press
*New Brunswick,
New Jersey and
London*

Library of Congress Cataloging-in-Publication Data

The visual turn : classical film theory and art history / edited and with an introduction by
Angela Dalle Vacche.
 p. cm. — (Rutgers depth of field series)
 Includes bibliographical references and index.
 ISBN 0-8135-3172-1 (alk. paper)—ISBN 0-8135-3173-X (pbk. : alk. paper)
 1. Art and motion pictures. I. Dalle Vacche, Angela, 1954– II. Series.

PN1995.25 .V57 2003
791.43'657—dc21 2002024830

British Cataloging-in-Publication data for this book is available from the British Library

This collection copyright © 2003 by Rutgers, The State University
For copyrights to individual pieces please see first page of each essay.

Manufactured in the United States of America

To Manuela Filiaci
Adrienne Mancia
Jill Poller

Contents

ICONOPHOBIA AND ICONOPHILIA

MODERNISMS AND SUBJECTIVITIES

THE EXPLODING IMAGE

THE THINKING IMAGE

Donald Crafton

Foreword

This collection provides an aerial view of a rich cultural terrain. Angela Dalle Vacche has selected diverse essays that demonstrate the usefulness of looking at cinema with the aesthetic systems provided by art history. In this foreword, writing as someone trained in a history of art department but being a film specialist, I would like to applaud her project. It might also be useful to add a few provocative observations.

Film History and Art History are popularly perceived to have in common subjects that were designed solely to produce pleasure. This is, of course, wrong. Some art is calculated explicitly *not* to produce pleasure. More important, and aside from the trivial question of content, the scholarly work of researching, understanding, and discoursing on the work under consideration can be, while intellectually satisfying, less than pleasurable. This is a big complaint from students: we thought studying film would be fun! Sometimes even economics, the "dismal science," must be brought in on a case. Still the notion persists that writing about film and art is less challenging than writing on, let's say, World War II. My response: if doing historical research is easy, it's not being done right, regardless of the subject. The essays collected here were all "difficult," especially when they were written and their authors were introducing ideas that were new to our understanding of film. Rereading them doesn't exhaust them; it only adds to the works' richness.

Whether writing about film, art, or anything else, one should avoid the historical fallacy, that is, the assumption that two events occurring at the same time or in succession are necessarily related to each other. To illustrate: it is tempting to observe that cinema's invention and formative periods coincided with the organization of art history as an academic enterprise. One might see Heinrich Wölfflin's innovative teaching technique of projecting lantern slides of art side by side as analogous to Marey and Muybridge's lectures: they also projected slides, made from their motion-study photographs. Wölfflin endeavored to trace the phases

of a motif as it developed through time; the photographers wished to display the elements of animal motion. Or one may imagine how Aloïs Riegl's notion of close-up vision and distant vision might have corresponded to his experience of watching the self-conscious tracking shots in early travel films, when objects loomed into and out of illusionistic depth. Or again, the early-twentieth-century fascination with metamorphosing forms, as in Bergson's aesthetics and Focillon's writing on stylistics, can be interpreted as cinematic constructs. Memory, combined with photography, effectively reverses the historical process, collapsing it into a condensed temporality in the way that early films retold Shakespeare plays and Victorian novels in ten minutes.

Like many temptations, this one, to equate the art-historical consciousness with the cinematic consciousness, should probably be resisted. Or at least indulged in moderately. A century of films has coerced us into thinking that the past is a movie, and a rather conventional one at that. One must forcibly resist representing historical relationships according to the principles of causal narration, temporal contingency, psychological agency, and basically telling a ripping good story. The connections I hypothesized above might have pertained, but more likely, they are *ex post facto* historical narrativizations (or, more accurately, cinematizations).

An early strategy in film history writing was its justification as an autonomous art—the "Seventh Art, " as Ricciotto Canudo famously wrote. None of the essays in this book resorts to the simple expedient of mapping a cinematic convention over an aesthetic formula. But examples of critics who latch onto a superficial resemblance between film and painting, sculpture, dance, or the other arts may be found elsewhere. At least one theorist in the 1960s, for instance, traced film back to its "origins" in the motions arrested in the Parthenon frieze and to the picture stories told on Trajan's Column and the Bayeux Tapestry. Film is not only an art, but also an ancient one! Sergei Eisenstein had only contempt for this approach: "To pass judgment on the pictorialism of the *shot* in cinema is naïve," he wrote. "It is for people with a reasonable knowledge of painting but absolutely no qualifications in cinema. This kind of judgment could include, for example, Kazimir Malevich's statements on cinema. Not even a film novice would now analyse a film shot as if it were an easel painting."[1] To her credit, Dalle Vacche presents a sophisticated, provocative toolbox for elucidating film through art. I admit, a little perversely, that including some of those older, superficial, even wacky comparisons between cinematic and putatively legitimate art would have pleased me. The palpable yearning of the "pictorialists" to show that movies are art would remind us that we have moved on to other questions.

The work assembled here is ample proof that the project of viewing film through the lens of art history has a history of its own. One might ask why it is that the field of film studies has only slowly meshed with art-historical practice, compared to the ways film studies has meshed with other disciplines for the past two decades. The answer is that the difference between film studies and art history is largely semantic and the result of academic contrivance. This anthology

shows that we should not too hastily dismiss art history as a conceptual tool. In recent years, film studies has grown closer to traditional art history in some ways, while the history of art has absorbed methods and issues from film. Let me explain, admittedly in gross oversimplification.

The "object" of study in art history was, for most of the past century, the alleged discrete work that could be analyzed for its formal properties. Discussions of the work would include observable stylistic changes over time, the role of the artist in its creation, the influence of other works and artists, its provenance (ownership), and its capital value. These discussions are heard today—perhaps more than ever—but increasingly they are heard outside academia. They have been pared off from art history and categorized as appreciation or connoisseurship, much as film studies has distanced itself from discussions of evaluation, authorship, and style by calling it criticism instead of theory. Meanwhile, art history has gradually absorbed the orientation and heterogeneous viewpoints that film utilized in the 1970s and 1980s, including Marxism, semiotics, Frankfurt School, Lacanian psychoanalysis, feminist theories of gendered representation, and vaguely defined cultural studies.

Film studies, and here my exaggerations are even more gross, has been moving away from its high theory preoccupations and proceeding in two directions. One is toward what has been called New Historicism, that is, focusing on external influences on a film's creation and consumption. Studies of studios, the effects of race segregation on exhibition, and the impact of government controls are examples. The other direction is toward a renewed interest in how films are constructed and perceived. I avoid the term *Formalist* here because it is inadequate to capture the complexity and diversity of this approach to film. Rather, I borrow David Bordwell's preferred term, *Stylistics*. While most of his writing reflects his knowledge of and interest in aesthetic issues, *On the History of Film Style* explicitly critiques analytic schemes derived from art history. He places himself in a research tradition that studies the development of forms, while at the same time condemning art historians who created a "Standard Version of stylistic history," the dogmatic story of cause and effect that went unchallenged for generations. "Film historians," Bordwell maintains, "looked to the sort of explanations invoked by art historians: national temperament, idiosyncrasies of artists, and impersonal principles of development lying latent within the medium." Bordwell hopes that scholars will learn from those misguided ones who painted history with too-broad brushes and that stylistics will replace "interpretive reading" as a method. "This is especially true as hermeneutic practices across the humanities have come to converge on the same interpretive schemas and heuristics. But if we take film studies to be more like art history or musicology, interpretive reading need not take precedence over a scrutiny of change and stability within stylistic practices."[2]

What Dalle Vacche's anthology demonstrates is that the disciplinary boundaries between film studies and art history are disappearing. Specialists in each pick and choose the methods and principles they want. This is possible only

if film studies and the discipline of art history are both, indeed, useful, but disposable, mythologies and not immutable fixtures. Early in my graduate student career, it became obvious that if art history were to be useful for the study of film—and I am still convinced that such is the case—then it would have to become a completely new regime of knowledge. This is gradually happening.

Film studies and contemporary art history are messy subjects. But that is what keeps them active and *relevant* intellectual endeavors. The writers who have the most interesting things to say about film and art—I'm thinking of Bazin, Benjamin, Eisenstein, Gombrich, and a few others—have moved adeptly among painting, literature, and science. It is likely that future contributions to a film-and-art history will also be accomplished by thinkers who make similar imaginative leaps with nary a thought about staying inside the academic pigeonholes we call disciplines and departments.

NOTES

1. Sergei Eisenstein, "The Fourth Dimension in Cinema," in *S.M. Eisenstein: Selected Works:* vol. I, *Writings, 1922–34*, ed. Richard Taylor (London: BFI Publishing, 1988), 191.
2. David Bordwell, *On the History of Film Style* (Cambridge, Mass.: Harvard University Press, 1997), 8–9.

Acknowledgments

I am most grateful to Charles and Mirella Affron, Robert Lyons, and Leslie Mitchner, who asked me to put together this anthology for the Depth of Field series. *The Visual Turn* is the very first anthology in English that revisits the canonical texts of classical film theory in the light of the founding works of the history of art at the beginning of the twentieth century—a period when the development of silent cinema coincided with the establishment of art history as an academic discipline in Vienna and Berlin. As soon as we observe that Vachel Lindsay's *The Art of Moving Pictures* was published in 1915, the same year as Heinrich Wölfflin's *Fundamental Principles of the History of Art*, we realize that my selection of writers and combination of essays was not only overdue, but it barely scratches the surface of a much broader territory of inquiry waiting to be explored and better understood in the very near future.

In *The Visual Turn*, my use of terms such as *iconophilia, iconophobia*, and *iconoclasm* is meant to suggest that great discursive transformations seem to be happening in visual studies. While the old semiotic terms based on Saussure and Peirce are still useful, their descriptive power is being rethought as a result of the advent of digital and analog images in new media, along with a whole new gallery of visual signs based on affect, perception, and action from Gilles Deleuze. The far-ranging implications of this discursive revolution are still unclear, yet I am confident that the emergence of new audiovisual technologies will only strengthen the study of cinema, without making it obsolete or reducing it to an archeological curiosity. If film studies until recently had to struggle to be taken seriously in conservative intellectual environments or academic institutions, now more than ever it has become clear that its place in the history of visual culture is absolutely pivotal.

My readers should know that I owe the title of this book, *The Visual Turn*, to a symposium on cinema and painting organized by Dudley Andrew at the University of Iowa in the early spring of 1997. I also want to thank Donald Crafton and Ara H. Merjian for agreeing to write original essays. Their excellent contributions have helped me to achieve the overall design of this interdisciplinary project.

In various ways, Jacques Aumont, George Baker, Raymond Bellour, Celeste Brusati, Thomas Elsaesser, Thomas Y. Levin, Molly Nesbit, Patrice Rollet, Stephen Z. Levine, and Christopher Wood have also been supportive of my attempt to bridge the gap between film studies and the history of art. Pietro Montani and Richard Allen, whose essays I have included in this anthology, have generously shared illustrations and bibliographical advice. I am also indebted to Dudley Andrew and Sally Shafto for bibliographical information about André Bazin. As far as the translations are concerned, I wish to acknowledge Ellen Sowchek, Renée Tannenbaum, and Cristina Degli Esposti-Reinert. My longtime copy-editor, Wendy Wipprecht, polished every single translation and every single original contribution, while Nadine Covert assisted with bibliographic and image research and manuscript preparation. At the Museum of Modern Art, Mary Corliss assisted me in choosing many illustrations. Finally, I wish to acknowledge my colleague Robert Kolker at the Georgia Institute of Technology. He provided me with a serene, supportive, and intellectually stimulating environment during the most delicate stages of this project.

The Emory University Summer Faculty Development Award and the Emory University Research Committee helped to cover the costs of clearing rights and permissions. I am most happy to dedicate this book to three friends—Manuela Filiaci, Adrienne Mancia, and Jill Poller—whose zest for life and companionship have helped me through many difficulties.

The Visual Turn

Angela Dalle Vacche

Introduction: Unexplored Connections in a New Territory

The Visual Turn is a dialogue between the history of art history in the early twentieth century and the history of classical film theory from the silent period to the aftermath of World War II. Its aim is to broaden the horizon of film studies, while making students of art history more comfortable when they approach the canonical texts of classical film theory.

Art history was founded as an academic discipline at the beginning of the twentieth century. Born in 1895 as a gadget for fairgrounds, pool halls, and cafés-concert, the cinema was to the much more established study of art in the universities of Vienna and Berlin what new media arts is to experienced film historians today. As an academic discipline, film studies began in the early 1970s. Since then, classical film theory and art theory have been asking a range of comparable questions. It is this group of shared themes that I have highlighted in order to chart the visual turn film studies can now perform toward the aesthetic methods of art history, after a fruitful alliance with literary theory.

Well aware of Christian Metz's definition of the cinematic sign as "the imaginary signifier"[1]—that is, an absent presence, specific to both the richest and the poorest of art forms—I thought this anthology should begin with attention to a widely known art-historical trope, the mapping of the senses. The latter was also a preoccupation for the founding fathers of the discipline, Aloïs Riegl and Heinrich Wölfflin. To map the senses is to establish a hierarchy in the system of perceptual faculties. Sight is at the top and taste at the bottom, while hearing, touch, and smell stand in between.

Throughout the centuries this hierarchy of the senses has been differently appropriated by innumerable aestheticians to justify higher and lower rankings within the system of the arts, another mapping or hierarchy of media subject to changes based on all kinds of ideological, cultural, and technological variables.

Besides being a point of departure, the mapping of the senses or the configuration of perception is also a zone of arrival for André Bazin, the last major film theorist of the classical period, before the 1960s age of poststructuralism and ideological criticism. By arguing that film is different from all previous art forms, Bazin underlines that its true medium is the flow of life itself, the world viewed,

whose motions and changes, intervals and durations, are preserved on the screen. Thus, for Bazin, cinema hardly needs the word *art*. Yet the mapping of the senses is still a trope deeply relevant to Bazinian film theory, and it will be the critic and filmmaker Eric Rohmer in his writings on film and the other arts who makes this art-historical legacy most apparent.

Besides the mapping of perception (fig. 1), the other themes of *The Visual Turn* are the relation between cultural identity and visual form; the iconographic and iconological methods; the tension between iconophobia and iconophilia in relation to the face in close-up; the construction of subjectivity within two competing modernist models, namely, Lessing's dictum of purity and self-referentiality in opposition to Nietzsche's and Wagner's celebration of the integrated, primitivist work of art, or the total, multimedia *Gesamtkunstwerk*; Lessing's division between spatial and temporal arts; the interweaving of cognitive and mimetic,

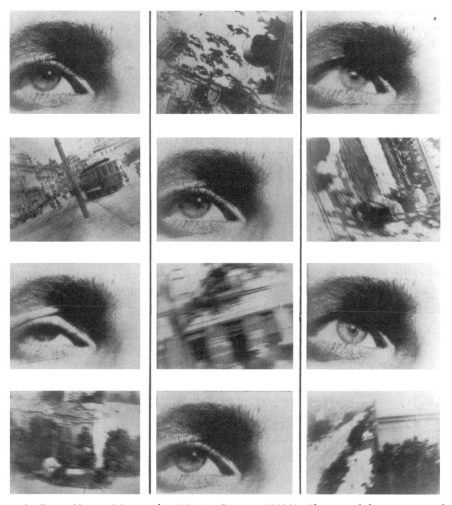

Figure 1. Dziga Vertov, Man with a Movie Camera *(1929). The eye of the camera and the mapping of perception. Museum of Modern Art, New York.*

psychological and aesthetic explanations in classical film theory to account for cinema's simultaneous relation to the world and to previous artistic traditions; and finally, the setting of Eisenstein's enthusiastic but also iconoclastic approach to the history of art against Bazin's writings on the frame and space in cinema and in painting. While, at first sight, these topics may seem unrelated, they all share the two interrelated models of the mapping of the senses and the system of the arts.

Some of the essays (or excerpts) I have included are already well known (Walter Benjamin's, Béla Balázs's); others have been translated into English for the first time from French (Patrice Rollet's, Jacques Aumont's) or Italian (Pietro Montani's). Because copyright restrictions prevented me from reprinting the entire third chapter on "Montage" from Gilles Deleuze's *Cinema*, vol. 1: *The Movement-Image* (1986), I chose to reprint only the parts devoted to D. W. Griffith and Sergei Eisenstein. My selection of the American and Soviet sections rather than Deleuze's overviews of German and French silent cinema reflects the fact that *The Visual Turn* is predicated on the well-known sequence of formative thinkers preceding the realist ones in Dudley Andrew's *The Major Film Theories* (1976).

The reader may wonder why I did not do more with Siegfried Kracauer's writings. The German critic developed his theory of mass culture as abstract ornament during his German years,[2] while he called for the redemption of physical reality in film after his arrival in the United States. Thus, Kracauer stands between the formative and the realist groups. Kracauer's intellectual itinerary, however, is so complex that the relation among the German Kracauer, the American Kracauer, and the history of art requires separate and extensive treatment in a different project. Despite this lacuna, my selection of writers seems to coalesce around three major ways of seeing: iconophilia, iconoclasm, and iconophobia—loving, transgressing, and fearing images. These three terms are meant to bridge the gap between the hermeneutics of suspicion so common in the ideological criticism of film studies during the 1970s and the 1980s and the hermeneutics of faith so dominant in the formalism of the history of art until the 1980s.

Well aware that the history of art history, including theory, from Aloïs Riegl, to Heinrich Wölfflin, to Erwin Panofsky, deals with the decorative arts, architecture, and sculpture, to name only a few media, my emphasis on painting in *The Visual Turn* is due to one reason: for the sake of internal coherence in regard to my choice of essays, I followed Patrice Rollet's reminder that art history is often reduced—at least in the popular doxa—to painting. Rollet underlines that the medium of oil painting has historically functioned as the paragon of high art. In recent years painting has been the medium through which models of vision have been best explained. More expensive than watercolor, oil painting participates in the canon of the old masters from the Renaissance. But it is not only a question of canon, register, or medium, it is also a problem of authorship or execution that Rollet is referring to. In this sense, painting is to film what sculpture is to architecture, since both painting and sculpture have traditionally been about manual skills, the single artist, subjectivity, and personal vision. It is

precisely all these dimensions based on uniqueness, individuality, originality, and value, which the invention of the cinema challenges because the technology of cinema changed the nature and organization of perception, the individual definition of authorship, and the meaning of key words such as *history, medium,* and *art.*

Aloïs Riegl and the Mapping of the Senses

Most readers in film studies and art history are already familiar with Walter Benjamin's (1892–1940) famous essay, "The Work of Art in the Age of Mechanical Reproduction" (1935–1936). Yet, in the English-speaking world of film studies, we still know little about Aloïs Riegl (1858–1905). The latter's volume, *Late Roman Art Industry* (1901), a study in applied, minor decorative arts, was translated for the first time from German into English in 1985 by Rolf Winckes and published by Bretschneider, in Rome, Italy. Unable to reprint several sections by Riegl in relation to his concepts of the *Kunstwollen,* haptic vision, and opticality, I explore these three areas through Benjamin's observations on the aura, acting, stardom, the close-up, and the comparison between architectural and cinematic perception. In the wake of Riegl's legacy, Benjamin's "The Work of Art in the Age of Mechanical Reproduction" can be seen as a brilliant but also quite free reapplication of his Viennese colleague's terminology to the mechanical era of photography and the mass civilization of the cinema.

Benjamin began to read Riegl around 1916, when he was studying the baroque style for his rejected doctoral thesis, *The Origin of German Tragic Drama.* Benjamin liked that Riegl, a curator in the Museum of Applied Arts in Vienna, handled art-historical periods by trying to figure out their organizing principles, or, at least, their basic representational formula. In his *Problems of Style: Foundations for a History of Ornament* (1893), Riegl introduced the notion of *Kunstwollen,* artistic volition or productive matrix; it was not to be confused with subjective will, since it described a transindividual will to art stored in artistic form itself. Riegl's early concept of *Kunstwollen* was useful to Benjamin, since the latter argued that modernity was characterized by the cinema as a mode of collective perception interwoven with a mode of social existence.

Later, during the years between *Problems of Style* and *Late Roman Art Industry,* Riegl's emphasis shifted from the production to the reception of art so that the perceptual configuration (haptic or optical) implied in the representational formula of the *Kunstwollen* became absolutely central. This new stage of Riegl's work was informed by two major categories that amounted to a dialectical axis of perception going from the haptic pole to the optical pole.

Riegl's terms—the *haptic* and the *optical*—can also be rephrased as the "near" or "close-up" view and the "distant" view, a whole conceptual infrastructure that he borrowed from Adolf von Hildebrand's *The Problem of Form in Paint-*

ing and Sculpture (1893). Whereas *optic* refers to a kind of art addressing primarily the viewer's eye, *haptic* stands for work that appeals to the sense of touch rather than to sight alone. Thus, it would be naïve to assume that these two terms describe how far or how near the viewer is. For Riegl, hapticality is a way of seeing that is analogous to tactility because it must process a number of discontinuous perceptual stimuli, which come through as tactile to the extent that they are self-contained and isolated. In the case of painting and sculpture, this haptic ideal involves minimizing any disruption of the plane of representation by suggestion of space and movement, since variability of view or conditions of illumination would undermine the belief in an objective, touchable, solid world out there which the haptic approach is meant to support (fig. 2). Furthermore, according to Riegl, links among the haptic view, tactility, and the discontinuous mode mean that a haptically inclined culture keeps itself separate from the object seen. This attitude is due to a feeling of awe toward the world's matter, which comes across as alien. Hapticality thus describes a viewer and a culture who prefer to process representations as if they were independent objects that exist out there, all by themselves, regardless of any producing or receiving agency.

For Riegl, Egyptian art is the first example of hapticality: a clear, inorganic style based on straight lines and a planimetric approach, a style that

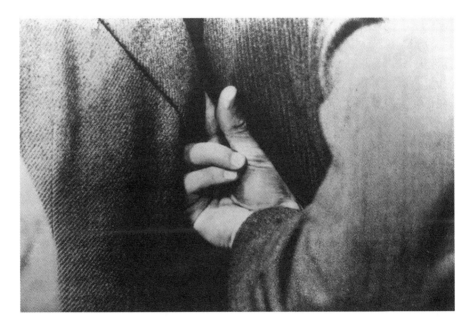

Figure 2. Robert Bresson, Pickpocket *(1959). A haptical image in film.* Museum of Modern Art, New York. "Bresson's visual space is fragmented and disconnected, but its parts have, step by step, a manual continuity. The hand, then, takes on a role in the image which goes infinitely beyond the sensory-motor demands of the action, which takes the place of the face itself for the purpose of affects, and which, in the area of perception, becomes the mode of construction of a space which is adequate to the decisions of the spirit."–Gilles Deleuze, *Cinema: The Time-Image,* p. 12.

eventually leads to modernist abstraction. On the other hand, throughout antiquity, there is a gradual increase in spatial suggestion and in the mobility and interaction of figures. Finally, in late antiquity, the limbs of figures and the folds of drapery are divided by such deeply cut shadows that their unity or orchestration becomes that of an overall optical plane projected from the viewer's eye onto the object.

In comparison to the near view or haptic approach, Riegl's distant or optical view is so much in control of the perceived object that it can fully display the power of the perceiving subject. The optical view is the so-called distant view, because it can easily take in a synoptic survey of objects in space. Due to its emphasis on subjectivity, what opticality handles well is an overall frame of mind, a general sensation, atmosphere, or mood, instead of separate elements. Riegl's dialectic of haptic and optical and the gradual ascendancy of the optical are best understood as a gradual increase in the sense of coherence, unity, and self-awareness of the beholding subject. Riegl's dialectical opposition of objective, haptic, near view and subjective, optical, distant view was taken up by Wilhelm Worringer in his *Abstraction and Empathy* (1908)[3] and, later, by Erwin Panofsky in relation to the development of Renaissance perspective.

As far as the cinema is concerned, in his *Techniques of the Observer* (1990) Jonathan Crary argues that the supremacy of the optical approach established through impressionism begins to accommodate a return to tactility in conjunction with the development of proto-cinematic machinery. Whereas Antonia Lant associates Méliès's cinema with hapticality, Steven Z. Levine demonstrates the optical connection between the films made by the Lumière Brothers and Monet's paintings.[4] In a very general sense, Riegl's dialectic of haptic and optical is relevant to André Bazin's statement that the filmic image is both an optical hallucination and a haptic fact, an insight he borrowed from surrealist photography.[5]

Riegl himself acknowledged that the optical, subjective way of seeing can reappear in different forms and in such totally separate contexts as late Roman art (mostly architecture and sculpture), Dutch art, and French impressionism (fig. 3). Riegl's opticality amounts to a sort of modernism driven by either sensualist, or realist, or empirical principles. There subjectivity plays a meaningful role, and images can be characterized by interconnections among particles of sheer light and color. It is also important to note here that opticality is characterized by a naturalistic, organic style based on the curvilinear approach and on three-dimensional realism, namely, an overall style that celebrates the achievement of individual goals. Thus, Greek art is the paradigm of proto-perspectival opticality, as far as antiquity is concerned. On the other hand, Jacques Aumont notes that "certain periods like the Gothic forge links between the two poles,"[6] namely, the Egyptian haptical abstraction and the Greek optical realism. Finally, for Benjamin, too, cinematic perception includes a mixture of haptic and optical situations, but it is also characterized by the brand-new elements of shock and distraction that go beyond Riegl's theory.

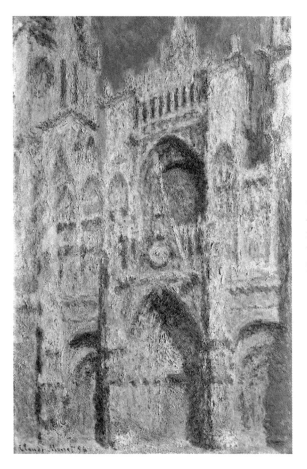

Figure 3. Claude Monet, Rouen Cathedral *(1894).*
An optical image in French impressionism. All rights
reserved, The Metropolitan Museum of Art, New York.
Theodore M. Davis Collection, Bequest of Theodore
Davis, 1915.

In addition to appropriating the *Kunstwollen*, Benjamin echoes Riegl's way of thinking in other respects. To begin with, Riegl's haptic and optical axes can be said to be replaced by Benjamin's dichotomy of cult value and exhibition value. In this particular case, Benjamin borrows his phrasing from Karl Marx and not from Riegl. In fact, Benjamin's cult value corresponds to Marx's use value, whereas exhibition value stands for exchange value. Cult value applies to objects in a society where ritual precedes the invention of art and the rise of the aura. By contrast, exhibition value replaces the aura with a sort of fake glow, and kitsch tends to dominate in a world where art has died, to be taken over by commerce, entertainment, and politics.[7]

Second, Benjamin's concept of the aura as distance may be stretched and understood in opposition to Riegl's hapticality as the near or close-up view. In fact, the aura, or halo, stands for the authenticity and authority of the artistic object, amounting to the "unique phenomenon of a distance, however close the object may be."[8] Distance, here, is a word used psychologically and metaphorically, for it does not mean far away in a literal, measurable sense. The trance-like loss of self typical of the age of ritual becomes the metaphorical distance or aura attributed to the work of art produced. The latter, in turn, requires a mental reception

different from the previous fusion of the subject with the object. More specifically, it calls for an individual "contemplative immersion," namely, a one-on-one relationship between viewer and artwork for the sake of sheer enjoyment. Yet this individualized approach becomes an elitist privilege, while the experiencing of art depends on the good taste of a few. To be sure, the invention of the cinema, a mass medium, takes culture back to the collective dimension at work in ritualistic practices preceding the invention of art. In this sense, the cinema predates and postdates the appearance of the work of art. Likewise, were we to follow Hans Belting's lead, art history may soon become the study of images in culture, before and after the age of art.[9] But the cinema is also a completely new kind of mass ritual in comparison to the religious practices adopted during the age of magicians and healers.

It would be tempting to associate the cinematic close-up with Riegl's hapticality, since the latter term is also known as the near or close-up view. For Benjamin, however, the close-up or "the optical unconscious" (or "the reverse unconscious of the visible," according to Rollet) is an example of opticality—namely, a viewing situation where the closer you get to the object, the more the latter dissolves into formlessness and hallucination. By making visible the overlooked, the close-up is also optical because it endows the humblest and lowest objects of daily life with an unprecedented aura—that is, with emotional elevation and perceptual emphasis.[10]

Benjamin's use of the term *optical* in relation to acting underlines the serialization of the self or the erosion of corporeal finitude brought about by mechanical reproduction. In film, the actor's body becomes a visual puzzle or a composite of tests, meaning takes. In the shift from stage to screen, acting no longer happens between the audience and the role. On the contrary, the fragmented and yet overlapping versions of the actor's body are mediated by the lens of the camera and presented to the audience.[11] Opticality here means self-alienation, hence distance, loss of unity, reassemblage for the sake of the camera's subjective but also mechanical gaze. Even when it is applied to the actor's face, the close-up fosters an effect of tactile disintegration; it does not involve hapticality, but it confirms its optical power or its allegiance to the distant view. The close-up makes the actor's face shift from icon to idol, while it imbues the performer with the pseudo-religious aura of cinematic stardom.

Benjamin's explanation of film's shock effect is the section where we encounter the most intriguing radicalization of Riegl's Egyptian hapticality. In the light of the modernist avant-garde, Benjamin writes:

> The work of art of the Dadaists became an instrument of ballistics. It hit the spectator like a bullet, it happened to him, thus acquiring a tactile quality. It promoted a demand for the film, the distracting element of which is also primarily tactile, being based on changes of place and focus which periodically assail the spectator. . . . The spectator's process of association in view of these images is indeed interrupted by their constant, sudden change. This constitutes the shock effect of the film.[12]

But, of course, the dialectical axes of haptic and optical is only a partial description of the complexity of cinematic perception. In contrast to the self-contained, flat, shadowless figurines of Egyptian hieroglyphs, which is what Riegl's hapticality is about, and in contrast to the haptic separation of subject and object, the masses in the movie theater experience their separation from the object in the form of distraction. Likewise, a moment later, they can also become the object of a Dada-like visual assault from the screen. Furthermore, without being necessarily aware of themselves as a collectivity, the masses at the cinema are a subject-in-process-held-in-fascination. On the other hand, the object itself, namely, the moving image, can become invading or shocking for a viewing subject who is, by definition, amorphous, discontinuous, and eclectic in its mode of apprehension. To account for the heterogeneity of the cinematic perceptual experience, Benjamin uses the term *apperception*, but he does not specify exactly how hapticality and opticality are involved.

Finally, Riegl's legacy can also be detected in one more area of this seminal essay: Benjamin's famous double comparison between the painter and the cameraman on the one hand, and the magician and the surgeon on the other. As Rollet explains, such a contrast illustrates the extreme changes in the mapping of the senses brought about by the advent of industrial modernity and mechanical reproduction. To put it another way, the magician and the surgeon can be said to stand for the age of ritual and the age of science. I have chosen to anthologize only this section of Benjamin's essay, because the complete text is already so well known. In fact, my purpose in *The Visual Turn* is more to use Benjamin in order to introduce at a basic level Riegl's terms in the light of the film experience rather than adding to the already huge scholarship on "The Work of Art in the Age of Mechanical Reproduction."

To begin with, in Benjamin's famous comparison, the magician is closer to the painter and the surgeon resembles the cameraman. Once again, it is as if Benjamin had further expanded the original meaning of the term *haptic*. Riegl's association of the near view with Egyptian art, a culture of collectivities, magicians, and rituals, is stretched out to new situations: the mysterious laying on of hands with chanting of spell-binding formulas, and the secret alchemies of color pigments and esoteric combinations of proportions known only to magicians and painters. On the other hand, it is the cold, scientific gaze of the surgeon/cameraman that we would expect to be analogous to the distant or optical view. But Benjamin surprises us again. In fact, Benjamin stresses the unprecedented mixture of closeness and anonymity, physical intimacy and psychological ignorance, between surgeon and patient, a one-on-one relationship enacted when the former's hands invade the latter's body. On the operating table, Riegl's close-up haptical view strangely meets with an alienating sense of optical distance, of intellectual mastery. And this is perhaps the point where classical film theory takes over and goes on to talk about the cinema through the surgeon/cameraman as a brand-new, intensely modern figure of faceless penetration, of temporary intimacy, of mass dialogue and private daydream, above and beyond any further debt to Riegl.

Finally, it is in the section on architecture that Benjamin achieves his most amazing, transformative overview of Riegl's mapping of the senses. The eye and the hand, the visual and the tactile, abandon their previous dialectic of near and far from Riegl, to reappear in a wholly new perceptual axis that Benjamin himself has custom-tailored for the age of mechanical reproduction: the shock and the distraction of the cinematic experience. While he compares architecture with film, Benjamin explains:

> Buildings are appropriated in a twofold manner: by use and by perception—or rather, by touch and sight. . . . On the tactile side there is no counterpart to contemplation on the optical side. Tactile appropriation is accomplished not so much by attention as by habit. As regards architecture, habit determines to a large extent even optical reception. . . . Reception in a state of distraction . . . finds in the film its true means of exercise. The film with its shock effect meets this mode of reception halfway.[13]

To sum it all up, in the wake of the analogy between the magician and the painter, the additional comparison between cinema and architecture bears witness to a radical redefinition of the meaning of tactility. The ritualistic laying-on of hands performed by the magician, the painter's alter ego, has become "tactile appropriation" that is accomplished more by mechanical habit than by personal choice. Needless to say, Riegl's haptic, near view was about the separation of subject and object, and tactility was an index of the object's self-containment. Where Riegl's and Benjamin's theories about perception might lead us today, in this age of digital media, remains to be seen. Muffled echoes of Riegl's hapticality and opticality can be also detected in Wölfflin's terms *linearly* and painterly (*malerisch*). Wölfflin's linearly approximates Riegl's hapticality, whereas painterly comes close to opticality. Furthermore, the linearly underlines the line of drawing, while the painterly emphasizes the richness of color. Painterly, at last, refers to a kind of art where shadows are allowed to travel across the plane of representation, in such a way to diminish the attention to the linearly boundaries of the outlined, drawn form. Since the writings of both Riegl and Wölfflin have been revisited by French philosopher Gilles Deleuze (1925–1995), who has also written about silent film, namely, the cinema of classical film theory, it seems appropriate to turn now to the encounter of art theory and film theory through Wölfflin and Deleuze.

Visual Form

Whereas Benjamin admired Riegl, he deeply disliked Riegl's Swiss contemporary Heinrich Wölfflin (1864–1945), with whom he also studied in Berlin. Unlike Riegl, who wrote about such disparate topics as the Mideastern arabesque and the professional group portrait in Holland, Wölfflin published only about the Renaissance and the baroque in Northern as well as Southern Europe. Like Riegl, who under-

played considerations of technique and purpose to explain changes in art from one culture to another, and across different historical periods, Wölfflin appropriated the notion of *Kunstwollen*, namely, an agency internal to form playing itself out according to different expressive orderings representative of a cultural sensibility. In *The Principles of Art History* (1915), Wölfflin expanded Riegl's contrast between haptic and optical into a set of five polarities which he then applied to the comparison between classic Italian Renaissance and baroque Northern art. Besides the linear (an adaptation of Riegl's haptic) and the painterly (an adaptation of Riegl's optic), the four other pairings were flatness and depth, closed and open, unity and multiplicity, clarity and complexity. I have chosen to anthologize a section on the linearly and the painterly from Wölfflin's *Principles* because I felt that these two categories, in comparison to the four other pairs, make more apparent for the reader the way in which Wölfflin borrows from Riegl's legacy, while he also transforms his language. Second, my anthological selection in favor of the linearly and the painterly is meant to encourage the reader to think of these terms in comparison to the oppositional pairing of *disegno* and *coloratura,* line drawing and color painting, since Riegl associates the optic with the color of impressionism, and since a certain degree of chromophobia informs Rudolf Arnheim's gestalt film theory and his rejection of American abstract expressionism, a whole stance to be later discussed in Ara Merjian's essay.

Wölfflin's five polarities are meant to describe culturally specific but also universally resonant differences in style: the contradiction could not be more apparent. To be more specific, for Wölfflin, Northern European art stressed the painterly, flat, open, multiple, and complex side of representation. By contrast, Italianate art privileged linearity, depth, and a closed, unified, clear style. But it is also true that when he spoke of the "Italianate" mode, Wölfflin did not necessarily and only mean "Italian" art. Instead, he meant any kind of art characterized by these particular features, which would refer to the classic Renaissance model originally developed in Italy but later taken over by artists all over Europe and beyond. Just as Riegl's *Kunstwollen* was transindividual, Wölfflin's visual form was transnational, but still based on national categories.

Riegl and Benjamin are comparable in that they were both interested in the marginal, neglected, and so-called decadent areas of the history of art, especially late Roman and the baroque. In the wake of his training with Jakob Burckhardt, the scholar who turned the art of the Italian Renaissance into "the" normative, canonical term of reference, Wölfflin's work gave powerful impetus to the development of an art history without names. This happened not because Wölfflin was eager to embrace an anti-canonical orientation the way Riegl and Benjamin did, but because, so self-assured he was of his system that even little-known, idiosyncratic artists would fit in, no matter what. Likewise, for Wölfflin, the artist's individual style was expandable to the whole world-image of a people. In a sense the blind spot of Wölfflin's system was where to stop the rule and begin the exceptions and vice versa.

In other words, Wölfflin's art history without names had more to do with a collective cultural mind-set than with the questioning of established names. Famous for having invented the standard format for the art history lecture which is still in use today (two slides of two different paintings at one time on the screen, in order to determine the images' general characteristics through comparison and contrast), Wölfflin was always working with a proto-filmic sequence of images, a comparative unit, a basic montage of two shots.

Throughout his career, Wölfflin did not hesitate to acknowledge that he was a formalist and a comparativist much more than a philologist or a historian. Furthermore, Wölfflin's pairings were not definitive, but they were always conscious that the perception of visual form is influenced by the way the comparison is carried out. For Wölfflin, perception was historical, but precisely because this was the case, how could he argue that individual examples proved a collective psychological orientation? Inadvertently he found himself caught in a hermeneutic circle where the part was confused with the whole and vice versa.

Interestingly enough, in his essay "The Magician and the Surgeon," Rollet points out that Benjamin rejected the "history of forms" that ties Riegl to Wölfflin in favor of "a history of tendencies," an approach more suited to accommodating discontinuities, labyrinthine webs, unexpected flash-forwards, inexplicable exceptions, or epiphanic anticipations of future cultural phenomena. The fact of the matter is that Wölfflin's five pairings or "principles" were originally meant as helpful tools or heuristic devices rather than static and absolute categories. It is also true that Wölfflin's Southern and Northern ways of seeing began as neutral, formalist categories, but they remained so only for a while and in a limited way.

As soon as we read Wölfflin's inaugural address to the Prussian Academy of Berlin in 1911, his language feeds nationalistic associations during the years preceding the outbreak of World War I. As the chair of the Department of the History of Art at the University of Berlin (c.1901–1912), Wölfflin became the defender of Northern art. By doing so, Wölfflin put himself in competition with his former student, Julius Maier-Graefe (1867–1935), who championed French postimpressionism and cubism. Wölfflin, in turn, supported the work of Arnold Böcklin and Caspar David Friedrich, honoring the latter during a major exhibition in Berlin in 1906.

It would seem, therefore, that Wölfflin, intentionally or not, turned Riegl's *Kunstwollen* into a national ethos or *weltanschauung*. Recent scholarship in French, however, makes much of the fact that Wölfflin was Swiss-born and somewhat displaced in Berlin, the city of his professional triumph.[14] In addition, little is known about the academic politics underpinning Wölfflin's rivalry with Meier-Graefe, not to mention the fact that the art worlds of Berlin and Vienna around 1900 were not only in competition with Paris, but were so rich and complex that their rivalry continues to remain somewhat elusive. Whatever the case may be, most art historians seem to agree that Wölfflin's analyses are stronger at the level of formal acuity and descriptive power than in terms of historical argument and cultural grounding.

Showing similar interest in paired comparisons and in the culturally specific nature of perception, Gilles Deleuze displays, in his chapter on "Montage" from *Cinema: The Movement-Image* (1986), a great awareness of the interplay of national film style and philosophically based traditions during the silent period, which is also the time of World War I and the postwar redrawing of the map of Europe that created new European nations. The link between Deleuze and Wölfflin, however, has been considered one of the most problematic aspects of Deleuze's contribution to the study of film, precisely because of the nationalistic associations that haunt Wölfflin's reputation to this day.

In defense of Deleuze's borrowing the emphasis on visual form from Wölfflin and recasting it in the light of nationally self-conscious filmmaking traditions, we can say that, during the silent period, French, Soviet, and German cinemas intentionally developed themselves as national-signature-styles. Their purpose was to compete with Hollywood's increasing expansion in the European market.

It remains surprising, however, that in his chapter on montage Deleuze does not include any discussion of Italian silent cinema, especially when we consider the pivotal role the Italian neorealist style plays in the shift from the movement-image to the time-image, from a cinema of action to one of duration. Deleuze's omission of the silent Italian film style remains all the more inexplicable when we remember that Wölfflin's two competing philosophies of representation were roughly based in Northern, Protestant Europe and in the Southern, Catholic Mediterranean area, with the Counter-Reformation in between.

In contrast to Deleuze's philosophical comparisons, Wölfflin's panorama of European art history amounts, to some extent, to a religious geography that includes hybrid, transnational, if not diasporic stylistic results both in France and Spain, and in Italy and the Netherlands. Finally, also somewhat surprising is the fact that, despite the ethnically heterogeneous composition of the newly born American film industry, Deleuze treats the classical Hollywood style as if it were a homogeneous national trademark. On the other hand, Deleuze's reduction of the American film style to Griffith's editing is an expedient choice to clarify the similarities and differences between the Hollywood and Soviet schools of montage.

Iconography and Iconology

Besides the mapping of perception and the study of visual form, iconography, or the study of imagery, is a third category that links the study of film with the discipline of art history. Basically, iconography considers the level of subject matter. The term comes from two Greek words—*eikōn*, meaning "image," and *graphē*, meaning "writing." Iconography is what the image "writes"—that is, the content it outlines. Whereas iconography deals primarily with sources, iconology is comparable to a program, in that it is more about the philosophical orientation,

the major intellectual themes or key ideas that inform the work and refer it to its cultural context.

An important group of scholars who developed the iconographic approach was associated with the Warburg Institute. As the name of the Institute suggests, the founder of the whole approach (and Erwin Panofsky's teacher as well) was Aby Warburg (1866–1929). Through this new method, Warburg wished to counter the limitations of both Riegl's and Wölfflin's formalisms. Founded in Hamburg, Germany, the Warburg moved to London before World War II to escape Nazi persecution. In the attempt to expand art history into a science of culture, Warburg was the first art historian who did not confine his investigations to official art literature, but opened himself up to extra-artistic areas such as astrology, magic, the accounts of festivals and pageants, and even business correspondence and contracts. In short, Warburg is responsible for having turned art history toward huge depositories of popular, marginal, and obscure imagery.

A towering figure with an amazing range of interests, Warburg never wrote about film, but Erwin Panofsky (1892–1968) did. According to Thomas Y. Levin, Panofsky turned to film somewhat by accident, to please the supporters of this young art form under consideration for acceptance in the Museum of Modern Art in New York. Aware that the cinema was one of the biggest warehouses of images in the history of culture, Panofsky's essay on the cinema is flatly iconographic, one of his weakest pieces of writing. Why bother, then, to include Panofsky in this anthology? And why have so few art historians written about the cinema? Perhaps because cinema is more significant in regard to the history of perception and art history has been more preoccupied with art-making. Furthermore, by reminding the reader that art history itself, as a discipline, is as old as the cinema has been a medium, I must acknowledge that the idea to include Panofsky in *The Visual Turn* comes simply from the fact that he is the only notable exception to the recent state of indifference between art historians and the cinema.

But there is also one more reason why Panofsky is featured in this anthology. As Levin points out at the end of his essay, by establishing a parallel between the history of spatial representation and the evolution of abstract thought, in "Perspective as Symbolic Form," Panofsky reconsidered Riegl's haptic and optical categories to the point of juxtaposing the relatively aggregate, haptic space of the Greeks, one still containing separate, individual objects, to the comparatively more systematic and continuous space of the Italian Renaissance prefiguring the modern, optical development. Panofsky's work on space is becoming more and more interesting for new media theorists. They have begun to deal with virtual space in contrast to space as an actual medium. Likewise, Levin argues, the study of space in film would benefit from turning to Panofsky's work on perspective even if in "Symbolic Form" he does not directly focus on film the way he did in "Style and Medium in the Motion Pictures." Whereas perspective and spectatorship have been huge topics in contemporary film theory from the 1970s to today, the temporal framework of "Style and Medium in the Motion Pictures" is much

more in line with the silent period, hence it falls naturally in the area of classical film theory.

In response to Panofsky's emphasis on cinematic types that are "modern equivalents of the medieval personifications of the Vices and the Virtues," Levin points out that Panofsky's attachment to the authority of the referent is an over-reaction to the abstract turn taken by postwar American art with Jackson Pollock (1912–1956), Barnett Newman (1905–1970), and Mark Rothko (1903–1970). In order to give full voice to his uneasiness about modernism and modern art, from the early 1930s to the mid-1940s Panofsky chose a model of immediate experience and transparent perception—a perceptual model based, of course, on his equivalence between iconicity and figuration on the one hand, and visual icons and cultural archetypes on the other. Thus, in the only film essay he ever wrote, Panofsky's advocacy for realism is influenced by the art historian's intellectual exchanges with the German émigré Siegfried Kracauer (1889–1966), the New York–based spokesman of realist film theory in the 1950s.

Iconophobia and Iconophilia

With Balázs and Benjamin, the face in close-up and the close-up as the face of objects become the pretext for the confrontation of iconophilic as well as iconophobic definitions of the cinema. By comparing "physiognomy" to "photogeneity," Jacques Aumont's essay takes us back to the increasing importance of the writings of Jean Epstein (1897–1953) on the face in close-up. On one hand, the face in close-up is an auratic icon of timeless, transcendent truth; on the other, it functions as a modernist vessel of time fleeting moment by moment.

Before Balázs 's positive recuperation of the term, physiognomy stood for the art of determining internal character based on the external expression of the face. Nineteenth-century criminal anthropology, the science of behavior before Freudian psychoanalysis, reinforced this belief that psychological character amounts to physical appearance. Along with criminal anthropology, the newly born disciplines of statistics and anthropometry, as well as the use of photography in nineteenth-century police archives, reasserted that the face stores innate psychological traits. At the same time, biological features were seen as transmitting themselves from one generation to the next, within a repetitive view of the historical process.

In his work on the face and the close-up, Balázs, a disciple of Georg Simmel and Henri Bergson, succeeds in reinscribing the terms *physiognomy* and *soul,* inherited respectively from the scientific positivist camp and the spiritual idealist one. With the advent of mechanical reproduction, the cinema is the new ritual of the masses. Thus the close-up can imbue the face with cult value and generate the phenomenon of the star. Likewise, Aumont remarks that the golden age of the

face in film belongs to the silent period and to the rise of stardom. Furthermore, Benjamin is deeply aware of the analogy between movie fandom and religious cult. Yet, in comparison to Balázs 's iconophilic itinerary from criminal to lyrical physiognomy, Benjamin's iconophobic trajectory goes from the loss of the aura to its haunting return through the close-up of the face as the ultimate icon of bourgeois individualism.

In his essay, Aumont summarizes the contrast between Eisenstein and Balázs through the opposition of "the primitive face"—a montage, a deliberate composite—and "the classical face"—immediate, organic, an anti-semiotic and anti-verbal iconophilic location, where "the visible originates in itself, it does not need to speak in order to exist or make its presence known. . . . It signals without being overladen with signs, it is based on the immediacy of appearance."[15]

Put another way, for Aumont, the "primitive" face is more theatrical, whereas the "classical" one is truly cinematic. To clarify how the distinction of primitive and classical face cuts across the competition between two media, theater and cinema, during the silent period, Aumont also writes:

> The face of the theater actor, a virtual support for innumerable masks, basically has no specific characteristics; the film actor expresses (*ausprägt*) one and only one mask, and thus his face must have salient and marked characteristics. The film actor . . . must possess everything in an innate fashion. . . . Moreover, makeup must not destroy this innate face; as for the director, his task is to have the actor play "within his limits," in a univocal (*eindeutig*) fashion.[16]

Even though he did not address the distinction between psyche and "physis," Balázs continued to search for a face that was all about the "visibility" of the soul shining through. He found this kind of nonverbal power of expression in Asta Nielsen's face. To conclude, Aumont's essay builds on Balázs 's iconophilic redefinition of physiognomy and, after widening the topic from the face to daily objects in general, he extends it to Jean Epstein's discussion of the close-up and to his use of the term *photogeneity*, which had been coined by Louis Delluc (1890–1924) in his *Cinéma et Compagnie* (1919). Most important, Aumont explains that for Epstein, photogeneity is the auratic, but also elusive halo of the filmic image because it exists only in movement, that is to say, "in time."

At the end of his essay, Aumont turns to Epstein's *The Fall of the House of Usher* (1928), a film about the failure of portraiture to achieve resemblance, to function iconically. On the one hand, Epstein's film argues that stillness and timelessness are the ambition of portraiture: on the other hand, it shows us Epstein's artist, Roderick Usher, attempting to paint a portrait of his wife and realizing that Madeleine's countenance is constantly changing. In good portraiture, unique, individual features are captured once and for all, but in such a way that they are neither too idiosyncratic nor too tied to the moment. The sitter's features must be recognizable in the portrait, and, most important, they must be compatible with

the viewer's own expectations about the sitter's individuality. It is the implied viewer's sense of self as a projection that also factors in and informs the painter's portrait of the sitter. On the other hand, the sitter's portrayed features hark back to the referent; that is, they achieve resemblance to the person originally sitting for the painter.

The ideal of portraiture is a tightrope walk between a resemblance that can be captured and an individuality that remains elusive. Yet this happy medium is not to be found in *The Fall of the House of Usher.* The film demonstrates, instead, that the very mutability of the human face, its movements, is what makes the face human. What is most significant about the face is that its surface is, by definition, always in motion. And yet, it is the face, and the face alone, in comparison to other parts of the body—the hands, for example—which has become not only the auratic icon of bourgeois individuality, but also the best analogue for the ever-shifting plasticity of the filmic image—the latter being an entity sharing a likeness with all the ephemeral, unreliable, transitory features of the faceless masses.

Modernisms and Subjectivities

In his manifesto "The Birth of a Seventh Art," Ricciotto Canudo (1877–1923) argued that the cinema absorbed the three spatial arts (architecture, sculpture, painting) concerned with coexistence in space and the three temporal arts (poetry, music, dance) dealing with succession in time. Canudo borrowed this division between spatial and temporal arts from Gotthold Lessing's *Laocoön: An Essay on the Limits of Painting and Poetry* (1766), a treatise on the differences between painting and poetry. In this work Lessing opposed the principle of *ut pictura poesis*—that is, the possibility of translating the verbal into the visual and vice versa—which had been originally formulated by the Latin poet Horace. By contrast, Lessing argued that the vocation of each medium was to explore its own specific properties, that only one medium at one time could best convey certain modalities of experience, and that it was best to avoid mixing the arts.

But Canudo could not accept Lessing's imperative of aesthetic separation, self-exploration, and medium specificity; toward the end of his manifesto, Canudo described the cinema as "plastic art in motion," thus turning the screen into a synthetic form of theater. Clearly, the Italian aesthetician had in mind an ideal of *Gesamtkunstwerk,* or total work of art, originally proposed by Nietzsche (1844–1900) to bridge the gap between high and low forms of creativity, and later applied by Richard Wagner (1813–1883) to appeal to a mass audience through the transformation of theater into collective ritual. By allowing the Wagnerian scheme to prevail, Canudo implied that the cinematic experience fosters an integration of all the perceptual faculties.

Wagner's modernist, empowering primitivism and Lessing's modernist, disjunctive specificity are only two models for the mapping of the senses. This endeavor, which had a long history before the twentieth century began, is devoted to the system of the arts: their rankings, properties, and affiliations. These two old models, however, are both deeply relevant to the disruptive appearance of the cinema, the new technology that drove a wedge into the system of the arts in the earliest days of the twentieth century.

In Lessing's footsteps, during the writing of *Film as Art* (1932), Rudolf Arnheim (1904–) privileged the visual, black-and-white, silent component of the cinema. He argued that it should not be mixed with sound or color. In this respect Arnheim aligned himself with a mapping of the senses based on visuality, one that placed sight at the top and touch at the bottom of its hierarchy. Furthermore, Arnheim felt that cinema could not become art, unless it abandoned as much as possible its humble photographic origins. For Arnheim, photography mingled too much with the world. It is as if he worried about color bleeding from real life into the frame of the moving pictures, releasing a sort of red ghost that would ruin the artifice of art.

For Arnheim, the photographic roots of cinema were also tainted with the mechanical, hence inhuman, reproduction of reality, and therefore too low and incompatible with rigorous aesthetic ideals. A photograph could be born quite by accident, without any intentional craft or intervention of the artist's hand. Such a possibility made Arnheim feel uneasy. For him, as a psychologist of art devoted to the study of perception, the purpose of creativity in film was to make the patterning power of art, the old-fashioned artist's hand, prevail over the technologically based randomness of the modern world. Thus, the more "cinematic" the filmic image looks, the better, as long as, Arnheim explains in his essay "Painting and Film" (1934), the artifice of art does not upset the realist illusion of film.

In his essay "Middlebrow Modernism: Rudolf Arnheim at the Crossroads of Film Theory and the Psychology of Art," Ara H. Merjian describes the Northern European origins of gestalt psychology, its links with postwar "general systems theory," and its final landing in American academia. The key themes of Arnheim's psychology of art are the power of vision to shape consciousness; the analogy between visual forms and percepts; the positing of universal patterns shared between perceptual and mental life; and the isomorphic relations possible between vision in art and vision in everyday life.

Merjian's essay makes clear that Arnheim's much more holistic (and therefore gestaltist) outlook assumes that there is a certain degree of order intrinsic to nature. Likewise, human perception strives toward equilibrium. In short, within the gestalt model, perception and cognition, intuition and intellect, belong to different but parallel tracks of the mind, and, as such, they are structurally comparable. Arnheim's balancing act between mental shaping and natural order becomes especially clear in regard to Picasso's *Guernica* (1937), whose analytical, figurative version of cubism is relevant to the cinema to the extent that it is comparable to

Eisenstein's montage. For Arnheim, both the painter and the filmmaker succeed in counterbalancing the fragmentations of montage—its chaotic potential—thanks to a compositional order achieved through their use of the frame as a boundary of containment.

Furthermore, by listing whatever Arnheim dislikes in the history of art, namely, surrealism, impressionism, abstract expressionism, and art *informel*, Merjian accounts for Arnheim's uneasiness about the unraveling of form into abstraction. Perhaps because he is writing about both contemporary art and the cinema, Arnheim is more tolerant about iconography than his contemporary, the American art critic Clement Greenberg (1909–1994).

Greenberg, interestingly enough, deeply disliked the quasi-figurative cubism of *Guernica*. To him, that painting looked too close to the politically engaged art of sociorealism, while the abstracting power of analytical cubism was not strong enough to blur the distinction between human figures and animals. Unlike Arnheim's, Greenberg's modernism ruled out iconographic content. The American art critic wanted painting to be so much and only about the medium that he vetoed figuration as subject matter in history painting altogether, in favor of extreme self-referentiality. Greenberg's prescriptive agenda dictated that painting should be about its two-dimensional surface, the sobering use of color as if it were a new form of line or *disegno*, and the frame-bound quality of the flat canvas.

By using Lessing to compare Arnheim's middlebrow modernism with Greenberg's radical imperative of aesthetic specificity, Merjian helps us to understand Arnheim's rejection of allegedly out-of-control painterly formlessness, the latter's refusal of a stable and fully knowable meaning. Thus, from a gestaltist point of view, the optical meandering elicited by Jean Dubuffet's, organicist canvases and the unraveling of the cinematic image into textures of rocks in Michelangelo Antonioni's *L'Avventura* (1960) are a problematic symptom of modernist alienation, an expression of "melancholy unshaped," a threatening manifestation of unconscious urges, a rejection of cognitive filtering and organic closure. To conclude, Merjian's essay provides an interdisciplinary genealogy oscillating between film theory and art theory. Within this dual family tree, so to speak, the cinematic trunk is Arnheim's "A New Laocoön: Artistic Composites and the Talking Film" (1938). And, pointing in the same direction, its two major and parallel branches in art theory belong to Clement Greenberg's "Towards a Newer Laocoön" (1940) and Michael Fried's "Art and Objecthood" (1967).

Eisenstein's Art History: The Exploding Image

Arnheim's film theory descends from Lessing's *Laokoön* and his modernist principle of separation of the senses paralleling the separation of media. By contrast,

Eisenstein's views on the cinema and on the history of art are in tune with Wagner's *Gesamtkunstwerk* and with the condition of synaesthesia, namely, the integration of media and the fusion of the senses. From an ideological point of view, it may seem odd that Eisenstein's film theory leans more toward Wagner's aesthetics than Lessing's, especially when we consider that *Laokoön* was the model for Bertolt Brecht's (1898–1956) theory of radical intellectual distanciation against bourgeois, empathetic identification. Thus, it is all the more worth noting that Eisenstein began to make *Ivan the Terrible* (1945–1946) just after he had staged Wagner's *Die Walküre* [The Valkyrie] (1940).

How can the filmmaker of the Bolshevik Revolution be compatible with the producer of Bayreuth, the grand master of German mythology on stage? While keeping in mind that the Wagnerian streak is only one aspect among many in Eisenstein's eclectic and somehow contradictory thought, it is also true that the *Gesamtkunstwerk* model allows for a primitivist return to origins and a consequent recharge of subjectivity before a leaping forward into the futurist realm of utopian Marxist society.

In order to construct on the screen the image of a rejuvenated subjectivity, Eisenstein exploited structural similarities across the heterogeneous components of the filmic medium. In regard to *Ivan the Terrible* (1945–1946), for instance, Eisenstein lists a series of possible levels—landscape, scenery, mise-en-scène, gesture, lighting, color—which are open to dialectical tensions, counterpoints, and all other kinds of "polyphonic" permutations, ranging from the graphic, to the acoustic, to the chromatic, to the choreographic, to the architectural. For Eisenstein, the cinema is not only the richest of art forms, but also the one with the most "pathos," or stored emotional energy, precisely because so many different media charge each other within cinema itself.

In the introduction to his translation of Eisenstein's *Nonindifferent Nature* (1987), Herbert Marshall explains that pathos is comparable to the engine of an organic structure bound to destroy itself from within in order to achieve reincarnation as its opposite. Eisenstein's pathos is loosely comparable to Riegl's *Kunstwollen,* a time bomb built into the structure. And indeed, Riegl does come up in *Nonindifferent Nature.* Diligently Marshall gives Riegl a single page reference in the index to his English translation. Furthermore, it is worth mentioning that, before shifting from the section on El Greco (1541–1614) to the following one on Giovanni Battista Piranesi (1720–1778), Eisenstein cleverly compares his dual model of pathos and ekstasis with Wölfflin's distinction between linearly and painterly.[17]

The point here is that the founding fathers of the history of art—Riegl and Wölfflin—were an inspiring term of reference for Benjamin and Eisenstein during the 1930s and 1940s. In his essay on El Greco's famous paintings, *The Purification of the Temple* (two versions: 1560–1565 and c. 1570) and *The Resurrection of Christ* (1605–1610), Eisenstein articulates his own film theory of pathos and ekstasis by

playing the roles of art historian and filmmaker at the same time. Whereas *The Purification of the Temple* is the site of pathos, *The Resurrection* is the location of ekstasis. In "The Uncrossable Threshold of Representation," Pietro Montani deals not only with Eisenstein's commentary on El Greco, but also with additional interfaces between film and the history of art, such as the filmmaker's analysis of Valentin Serov's *Portrait of Maria N. Ermolova* (1905), a famous actress. Eisenstein's discussion of Serov's portrait associates ekstasis with an "expulsion of meaning." By contrast, the filmmaker's handling of Vasily Surikov's large canvas, *La Bojara Morozova* (1887), is an example of ekstasis as expressive conversion from the visual to the acoustic. Eisenstein, Montani reminds us, manages to come up with an implosive model as well: a cartoon drawing by Saul Steinberg (1948–1995). This example is useful because it points to the comical flip side of the pathos/ekstasis model, which is revealed when it shifts from the metaphorical to the literal, and the effect becomes the content.

Eisenstein is an iconoclast who loves the images he fragments. This is why he turns to El Greco, even though the Spanish painter was neither an iconoclast nor a rebel. The filmmaker can recognize in the painter a fellow traveler, since both became famous—the first with montage, the second with light, color, and composition—for their ability to arouse the observer through intense emotionalism, dematerialization of form, and a strong sense of movement.

Eisenstein's opening and closing of the frame also seems to echo Arnheim's comparison between the pictorial use of the frame in a cinema of montage and the cinematic montage of separate elements in the semi-cubist pattern of *Guernica*. But whereas Arnheim's analogy between cinema and painting is more for the sake of an equilibrium between abstraction and figuration, in Eisenstein's revisitation of *The Purification of the Temple* the moment of ekstasis is one of temporary upheaval and a short-term loss of figuration. Cinematic framing means order for Arnheim, chaos for Eisenstein, but it does offer André Bazin an opportunity to meditate on the relation between cinema and painting as well as on the inscription of thought onto the moving image.

Bazin's Art History: The Thinking Image

Well aware of the importance of the arts for the development of the cinema, André Bazin (1918–58) dedicated an entire essay, "Painting and Cinema "(1950),[18] to the subject. For Bazin this kind of dialogue is primarily a conversation about space because the frame of painting is different from the frame of film. The frame of painting contains a special world that exists exclusively by itself and only for itself. Filmic space, by contrast, moves outward, centrifugally, by reaching far into the deepest and lowest recesses of daily life.

Still thinking about the space of painting and of film, Bazin says that film should not "fragment" painting as an object. This means that film should not use editing to penetrate the space of painting or to mobilize its inner world. It is surprising, however, that in "Painting and Cinema," it is not the wide-ranging, centrifugal, off-screen-oriented filmic image, but rather painting, with its all-inclusive, centripetal kind of framing, which is comparable to a landscape of the mind, a world of thought unto itself. Eager as he is to explore the film about art in general or a particular artist, Bazin sounds as if he were about to ask himself: what would happen if painting were to lose its centripetal frame—historically, its boundary against the world off-frame—and take on the centrifugal spatial properties of the cinema? Perhaps no director other than Eric Rohmer (1920–) can be said to have better carried out Bazin's invitation to make films that provide painting "with a new form of existence." In other words, painting brings to the cinematic screen a mental landscape that endows the filmic image with an edge of thoughtfulness. This thinking image will push Rohmer to compare the centripetal pictorial surface stored inside the filmic image to a plain object (the canvas). By contrast, painting as a hidden allusion, or an intertextual citation, for Rohmer, produces "a space of disorientation" (fig. 4). Rohmer's formulation is more a mental than a visual metaphor and therefore subordinates seeing-in-film to thinking-through-film.

Even when it does not suggest the off-screen space of film, but remains internal to the frame of painting as an object shown or a literal canvas, Rohmer's "space of disorientation" adds a vertigo of thought to the encounter between cinema and painting. It is as if the spatial continuity of the world, so crucial for Bazin, had not been so much violated by editing or by an intrusive camera movement, but rather enhanced and complicated with an invisible lining of aesthetic depth, and with the effect of raising the quotidian to the level of the abstract. In order to understand how Rohmer is, willingly or not, consciously or not, the intellectual heir of Bazin's writings on painting and cinema, I briefly turn to Alexandre Astruc's founding manifesto for the Nouvelle Vague.

Astruc's association of visual images with "tyranny" in his famous essay, "The Birth of a New Avant-Garde: La Caméra-Stylo" (1948–1949), refers back to an old debate that stretches from Gotthold Lessing to Matthew Arnold (1822–1888), who first mentioned Lessing in his own work around 1848. In *Laokoön* (1766), the German aesthetician argued that literature is an art of time, while painting should deal primarily with space. In his poem "Epilogue to Lessing's Laokoön" (1867), the British aesthetician Arnold stated that poetry thinks and the arts do not. Were we to consider jointly Lessing's and Arnold's views on the verbal and the visual arts, we would conclude that, as an art of time, literature is for the mind, while as an art of space, painting is for the senses. Lessing's and Arnold's hierarchy of the arts rests, in turn, on the idea that the senses, including sight, are below the mind. As a result, the temporal rhythm and the imaginary ear of liter-

Figure 4. Jean Cocteau, The Blood of a Poet *(1930).* Museum of Modern Art, New York.

ature come out on top. Most important, the imaginary ear or inner ear of litera-ture is comparable to an inward-bound perceptual faculty that appeals to the mind and encourages thought. Below literature is painting, an art which unfolds in space, that exists outwardly, for the eye alone (visuality) and for a vicarious sense of touch (tactility). For Lessing and Arnold, painting is an art form that is deaf and mute—a handicap that fascinated Denis Diderot (1713–1784), who in 1751 wrote *Letter on the Deaf and Dumb.*

As a result of the inward orientation of literature and the outward orien-tation of painting, the latter was considered to be stuck in the visual dimension, hence more sensual and intuitive, while the former acquired the reputation of being more philosophical and intellectual. In "Painting and Cinema," by focusing on the centripetal framing of painting and the centrifugal framing of film, and by associating painting with the mind and cinema with the world, Bazin turns the tables once and for all on this old argument.

Astruc had written as if he were defending the infant cinema against the superiority of literature, but Bazin does not need to make a claim based on an inferiority complex. Bazin's peaceful assumption that the cinema is an adult, finds full application in Eric Rohmer's *The Marquise of O* (1975) (fig. 5). This was Rohmer's first film based on a literary source, and hence a project almost destined

Figure 5. Eric Rohmer, The Marquise of O *(1975).* Museum of Modern Art, New York. "How vain a thing is painting" [which attracts our admiration for representations of objects that we do not admire in the original].–André Bazin, "The Ontology of the Photographic Image," *What is Cinema,* vol. 1, p. 10.

to confront cinema's inferiority complex toward literature. Sure enough, in *The Marquise of O*, it is to Bazin's centripetal framing of painting that Rohmer turns to make his images introspective, while crafting the words from the literary source as if they were visual objects with a centrifugal orientation meant to delight the senses. It is easy to see, here, how the cinema did not only break down the hierarchy of high art and popular culture, but it also defied Lessing's theory. In other words, Rohmer's use of painting to stimulate thought, and his deployment of words to produce a plastic feeling, reverses Lessing's separate association of literature with time, introspection, and hearing, and of painting with space, visuality, and tactility. But there is even more to Bazin's use of terms such as centripetal (inward-bound) and centrifugal (outward-bound) for his discussion of painting and film.

For Bazin, painting is a landscape of the mind, whose framing coincides with the viewer's boundaries of apprehension. By contrast, the filmic image is not merely frameless, it defies the markings the viewer may want to set, for the world continues to exist outside the borders of the screen. With the term "centrifugal," Bazin underlines that film is the only photographically-based art form which gains from the absence of man and the prevailing of the mechanical, the accidental, the improvisational through the agencies of children, animals, and non-professional

actors. Indeed the use of children, animals, and non-professional actors was cele-brated not only by Bazin, but also by both Balázs and Kracauer. On the contrary, the term "centripetal" suggests that painting-in-film obscures the photographic origins of the medium. It also reorients the filmic frame towards a kind of art-historical iconophilia and away from a certain cinephiliac longing for the face of the world, for the preservation of life instead of art-collecting. The true cinephile would like the cinema to be the one and only "museum without walls,"[19] of life living itself out on the screen during the projection. In *The Marquise of O*, how-ever, by filtering the use of painting through the actors' gestures, postures, and movements in space, Rohmer found a way to disclose the mental obverse of be-havior. This is why the director's choice of pictorial sources was meant to show "the period's conception of itself, its inner image, and thus reflect the issues of self-discovery, self-knowledge, and self-acceptance confronted by the characters."[20]

Rohmer uses his performers' gestures and postures—Diderot's deaf and mute elements, or, to put it another way, the corporeal and sensuous side of act-ing—as if they were the ideal interface for the equation between painting and in-teriority. This strategy should not come as a surprise, because it is perfectly consonant with the Bazinian tenet that cinema is an art of space, where the world stages itself from one mise-en-scène to another, reframing after reframing.

In comparison to other aspects of filmmaking, acting presupposes some degree of theatrical space even when no stage is involved. Put another way, for Rohmer, acting in film is where the world overlaps with the theater, where life confuses itself with the stage, to the point that it is hard to draw the line between thinking and behaving, speaking and feeling. Just as photography for Bazin can be simultaneously a document and a hallucination, a factual index of the world and a surrealist figment of the imagination, for Rohmer acting belongs at the border between appearance and being. Needless to say, painting, for Rohmer, slides itself beautifully between these two extremes of spectacle, exteri-ority on the one hand, and interiority—thought—on the other. In Rohmer's view, it is as if the filmic image were not made of flat celluloid but could achieve two sides, one utterly visual, the other completely invisible. It is this double-sidedness that accommodates the insertion of painting into a filmic frame that separates— or paradoxically, frames again—the pictorial composition from the loose ends of daily life.

Rohmer, thoroughly persuaded that painting is the inner side of film, argues that it belongs more to the moving pictures on the cinematic screen than to the figures and objects moving on the theatrical stage:

> The very nature of the screen—a completely filled rectangular space occupy-ing a relatively small portion of one's visual field—encourages a plasticity of gesture very different from what we are used to seeing on stage. For example, the arm movement common to an opera singer . . . is more easily justified in theatrical space, which is at once fixed and undefined, than inside a rectangle

whose edges are clearly indicated and that only provisionally circumscribes a variably wide portion of the surface where the action takes place.[21]

Rohmer's discussion here is not only about framing but also about space. He distinguishes between the space of the stage—motionless, yet plastic to the point of undergoing the most unpredictable and fantastic transformations—and the space of the screen—clearly indicated, but provisional, in the sense of inevitably photographic and indexical, hence tied to movement and the moment. Thus, for Bazin and Rohmer, the reason why painting is the introspective dimension of the filmic image is that, in film, thought is about making imaginary connections through the moving gaze of a mechanical eye; in theater, however, movement is about people and objects performing or experiencing a real change for a moment, while they seek an ideal fixity in the minds of those who are looking directly at them. In other words, the movements of a theatrical performance can never be repeated in exactly the same way; hence every moment of the performance is meant to imprint itself in the viewers' memories, before it disappears forever. The theater audience itself—its composition, its moods and reactions at that particular performance—is also a unique and one-time-only event, which can never be repeated in the very same way. But in film, the movement of the world is a repeatable flow, during which the viewers can see over and over again the very same images, yet reexperience them differently because the audience exists in a different moment in time, each time.

Besides illuminating the tension between an iconophilic and a cinephilic orientation, the terms centrifugal and centripetal beg for more research about Bazin's personal library in regard to early art theory, and especially in relation to Riegl's distinction between haptical and optical. Whether or not Bazin knew Riegl's work , the fact remains that the cinema in the days of Bazin makes the separation between haptical and optical obsolete. This is the case because with Bazin's centrifugal/centripetal metaphor, the tension is not any longer between the self-contained, alien world of hapticality and the subjective, empowering universe of opticality. Rather the tension between the object seen and the viewing subject, beginning with Bazin in the postwar period and ending recently with Deleuze's writings on the cinema, has recast itself as a problem of the mind, the brain, on one hand, and the screen, the world, on the other. But this gap between the brain and the screen is not only a gap between subject and object, rather it has also become a fertile analogy for new media specialists. The latter indulge in the possibility of an equivalence between brain and screen, cinema and thought, film and philosophy. At the same time, they are reassessing the role of the body in relation to emerging technologies and asking questions about the end of art; the return of the aesthetic, the mapping of the senses—all this in the digital era when the filmic image abandons its photographic origin for the sake of a logarythmus.

To conclude, both the viewing subject and the image viewed are important for Bazin, to the point that the mental aspect intertwines itself on an even

footing with the filmic image. For the sake of comparison with Bazin's take on painting and cinema, I decided to end this anthology with a thoughtful essay on illusionism by Richard Allen. There the discussion focuses on the tension between cognitive knowledge and visual recognition. I have placed this essay at the end of *The Visual Turn* to expose the reader to a dialogue among cognitive psychology, art-historical materials, and filmic examples.

In his essay Allen provides a fine-grained account of illusion. In the cinema, the latter can happen in two ways: as reproductive illusion, when it is derived from the photographic properties of the filmic image; or as projective illusion, when it is derived from the ways in which the projected moving image transforms the properties of the photographic image. Allen's approach is "cognitive," even though he does acknowledge the importance of the psychoanalytic theory of disavowal, namely, the centrality of the impression of reality and the suspension of disbelief in cinematic illusionism, whether it is reproductive or projective. Besides the flip-flopping way of seeing-as, Allen discusses what it means to be seeing-through and to be seeing-in. In order to give examples of seeing-as, seeing-through, and seeing-in, Allen references art as diverse as Barnett Newman's color-fields, Man Ray's photograms or cameraless photographs, John Salt's photo-realist paintings, Leroy De Barde's trompe l'oeils, and George Davison's photogravures (a combination of photographic technique and etching). Allen's essay also includes some esoteric examples from avant-garde film, primitive cinema, and performance art through photography. In short, the extreme heterogeneity of Allen's case studies functions as a reminder that the *history of art is in film,* but *film has been outside art history as an academic discipline,* while contemporary art and new media theory have been drawing ideas from both these pools of research.

NOTES

1. Christian Metz, *The Imaginary Signifier: Psychoanalysis and the Cinema* (Bloomington: Indiana University Press, 1982).

2. Siegfried Kracauer, *The Mass Ornament: Weimar Essays/Siegfried Kracauer,* translated, edited, and with an introduction by Thomas Y. Levin (Cambridge, Mass.: Harvard University Press, 1995); Gertrude Koch, *Siegfried Kracauer: An Introduction,* translated by Jeremy Gaines (Princeton: Princeton University Press, 2000); Rachel Moore, *Savage Theory: Cinema as Modern Magic* (Durham: Duke University Press, 2000).

3. Wilhelm Worringer is the author of *Abstraction and Empathy: A Contribution to the Psychology of Style* (1908). In 1907, Henri Bergson's *Creative Evolution* appeared in Germany. Udo Kultermann argues that the key debate at the time centered somewhat around these two books, Worringer's and Bergson's, and it concerned the shift from sensualism (realism) to abstraction (modernism). The implications of these two major books for early cinema warrant further research.

4. On the return of touch within ocular-centric, modern culture, see Jonathan Crary, *Techniques of the Observer: On Vision and Modernity in the Nineteenth Century* (Cambridge, Mass.: MIT Press, 1990); on Riegl's haptic and optic, see also Jonathan Crary, *Suspensions of Perception: Attention, Spectacle, and Modern Culture* (Cambridge, Mass.: MIT Press, 2001), 51–52; on French impressionism and opticality, see Steven Z. Levine, "Monet, Lumière, and Cinematic Time," *Journal of Aesthetics and Art Criticism* 36, no. 4 (Summer 1978): 441–447; crucial essays

about applying Riegl's categories and early cinema are Antonia Lant, "Haptical Cinema," *October* 74 (Fall 1995): 45–73; Noel Burch, "Building a Haptic Space," in *Life to Those Shadows* (Berkeley: University of California Press, 1990), 162–185.

5. André Bazin, "The Ontology of the Photographic Image," in *What Is Cinema?*, vol. 1, foreword by Jean Renoir; essays selected and translated by Hugh Gray (Berkeley: University of California Press, 1967), 16.

6. Jacques Aumont, *The Image* (London: BFI, 1997), 87.

7. Walter Benjamin, "The Work of Art in the Age of Mechanical Reproduction," in *Illuminations: Essays and Reflections*, edited and with an introduction by Hannah Arendt, translated by Harry Zohn (New York: Schocken, 1969), 224–225.

8. Ibid., 222.

9. Hans Belting, *Likeness and Presence: A History of the Image before the Era of Art* (Chicago: University of Chicago Press, 1994).

10. Benjamin, "The Work of Art," 237.

11. Ibid., 228–229.

12. Ibid., 237.

13. Ibid., 240.

14. Jacques Thuillier, Roland Recht, Joan Hart, and Martin Warnke, *Relire Wölfflin: Principes et théories de l'histoire de l'art* (Paris: Ecole Nationale Supérieure des Beaux-Arts, Musée du Louvre, 1995).

15. Jacques Aumont, "Le visage en gros plan," in *Du visage au cinéma* (Paris: Cahiers du Cinéma, 1992), 78: "Le visible va de soi, il n'a pas besoin de parler pour exister ni pour s'imposer . . . Il fait signe sans être tissé de signes, il se fonde sur l'immédiaté de l'apparaître."

16. Ibid., 80: "si le visage de l'acteur de théâtre, support virtuel de masques innombrables, n'a au fond pas de traits particuliers, l'acteur de cinéma exprime (*ausprägt*) un masque et un seul, et que donc son visage doit avoir des traits saillants, marqués. L'acteur de film . . . doit tout posséder de façon innée. . . . En outre, le maquillage ne doit pas détruire ce visage inné; quant au réalisateur, sa tâche est de faire jouer l'acteur 'à l'intérieur de ses limites,' de façon univoque (*eindeutig*)."

17. Sergei Eisenstein, *Nonindifferent Nature: Film and the Structure of Things*, translated by Herbert Marshall (New York: Cambridge University Press, 1987), 367 (Riegl), 122 (Wölfflin), 340 (Wölfflin).

18. The four volumes of *Qu'est-ce que le cinéma?* were published in Paris by Editions du Cerf in 1959, 1960, and 1961. Twenty-six essays out of these four volumes were translated into English by Hugh Gray in the two-volume *What Is Cinema?* (Berkeley, Los Angeles, London: University of California Press, 1967). Gray's translation of Bazin does not provide a detailed history concerning the geographical and historical contexts for the original publication of "The Ontology of the Photographic Image" (1945) and "Painting and Cinema." According to Hugh Gray's edition of *What Is Cinema?* vol. 1 published in 1967 by the University of California Press, the year and the source of this essay are unknown. Significantly, "The Ontology of the Photographic Image" was the only film essay included in *Confluences*, an art-historical journal printed in Lyon and edited by René Tavernier, the father of film director Bertrand Tavernier. Originally scheduled to appear in 1943, publication was delayed until 1945 due to the war. It amounted to a special issue devoted to new directions in the visual arts. Rohmer published "Cinema, art de l'espace" in *Revue du Cinéma*, no. 14 (June 1948); whereas "Vanité que la peinture" appeared in *Cahiers du Cinéma*, no. 3 (August 1951). The dating of Bazin's "Painting and Cinema" might fall between 1943 and 1951 and thus engage in a dialogue with the publication of Alexandre Astruc's "Naissance d'une nouvelle avant-garde: La caméra-stylo" for *Écran français*, no. 144 (30 March 1948). In this seminal essay, Astruc formally declared that the seventh art had come of age and had finally overcome the "tyranny of the visual," namely the prejudice that the cinematic image is supposed to be bound and limited to exteriority. By 1956, however, with an essay entitled "A Bergsonian Film: The Picasso Mystery," published in *Cahiers du Cinéma*, no. 60 (June), Bazin refines his views on the relation between cinema and painting, and on the tension between line and color in relation to animation and film. And just before that, Rohmer added his own voice to the ongoing dialogue about cinema and the other arts by writing a piece on "Le siècle des peintres" for *Cahiers du Cinéma*, no. 49 (August 1955).

19. André Maleauz, *A Museum without Walls* (London: Secker and Warburg, 1967).

20. Edith Borchardt, "Eric Rohmer's *Marquise of O* and the Theory of the German Novella," *Literature/Film Quarterly* 12, no. 2 (1984): 134, note 2.

21. Angela Dalle Vacche, *Cinema and Painting: How Art Is Used in Film* (Austin: University of Texas Press, 1996), 93, note 23. Rohmer's statement originally appeared in *La Revue du Cinéma* (1948); it was also reprinted in Eric Rohmer, *The Taste for Beauty,* translated by Carol Volk (Cambridge: Cambridge University Press, 1989), 21.

The Mapping
of Perception

Walter Benjamin

The Work of Art in the Age of Mechanical Reproduction (excerpt)

XI

The shooting of a film, especially of a sound film, affords a spectacle unimaginable anywhere at any time before this. It presents a process in which it is impossible to assign to a spectator a viewpoint which would exclude from the actual scene such extraneous accessories as camera equipment, lighting machinery, staff assistants, etc.—unless his eye were on a line parallel with the lens. This circumstance, more than any other, renders superficial and insignificant any possible similarity between a scene in the studio and one on the stage. In the theater one is well aware of the place from which the play cannot immediately be detected as illusionary. There is no such place for the movie scene that is being shot. Its illusionary nature is that of the second degree, the result of cutting. That is to say, in the studio the mechanical equipment has penetrated so deeply into reality that its pure aspect freed from the foreign substance of equipment is the result of a special procedure, namely, the shooting by the specially adjusted camera and the mounting of the shot together with other similar ones. The equipment-free aspect of reality here has become the height of artifice; the sight of immediate reality has become an orchid in the land of technology.

Even more revealing is the comparison of these circumstances, which differ so much from those of the theater, with the situation in painting. Here the question is: how does the cameraman compare with the painter? To answer this we take recourse to an analogy with a surgical operation. The surgeon represents the polar opposite of the magician. The magician heals a sick person by the laying on of hands; the surgeon cuts into the patient's body. The magician maintains the natural distance between the patient and himself; although he reduces it very slightly by the laying on of hands, he greatly increases it by virtue of his authority. The surgeon does exactly the reverse; he greatly diminishes the distance between himself and the patient by penetrating into the patient's body, and increases

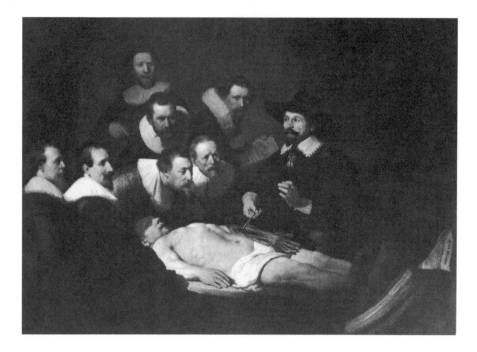

Figure 1. Rembrandt Harmensz van Rijn. The Anatomy Lesson of Dr. Nicolas Tulp *(1632).* Mauritshuis, The Hague, The Netherlands. © Giraudon/Art Resource, NY. "We have no idea at all what happens during the fraction of a second when a person steps out. [Photography] with its devices of slow motion and enlargement, reveals the secret. It is through photography that we first discover the existence of this optical unconscious, just as we discover the instinctual unconscious through psychoanalysis." –Walter Benjamin, *Small History of Photography* (1931).

it but little by the caution with which his hand moves among the organs. In short, in contrast to the magician—who is still hidden in the medical practitioner—the surgeon at the decisive moment abstains from facing the patient man to man; rather, it is through the operation that he penetrates into him (fig. 1).

Magician and surgeon compare to painter and cameraman. The painter maintains in his work a natural distance from reality, the cameraman penetrates deeply into its web. There is a tremendous difference between the pictures they obtain. That of the painter is a total one, that of the cameraman consists of multiple fragments which are assembled under a new law. Thus, for contemporary man the representation of reality by the film is incomparably more significant than that of the painter, since it offers, precisely because of the thoroughgoing permeation of reality with mechanical equipment, an aspect of reality which is free of all equipment. And that is what one is entitled to ask from a work of art.

Patrice Rollet

The Magician and the Surgeon: Film and Painting

Even more revealing is the comparison of these circumstances, which differ so much from those of the theater, with the situation in painting. Here the question is: how does the cameraman compare with the painter? To answer this we take recourse to an analogy with a surgical operation. The surgeon represents the polar opposite of the magician. The magician heals a sick person by the laying on of hands; the surgeon cuts into the patient's body. The magician maintains the natural distance between the patient and himself; although he reduces it very slightly by the laying on of hands, he greatly increases it by virtue of his authority. The surgeon does exactly the reverse; he greatly diminishes the distance between himself and the patient by penetrating into the patient's body, and increases it but little by the caution with which his hand moves among the organs. In short, in contrast to the magician—who is still hidden in the medical practitioner—the surgeon at the decisive moment abstains from facing the patient man to man; rather, it is through the operation that he penetrates into him.

Magician and surgeon compare to painter and cameraman. The painter maintains in his work a natural distance from reality, the cameraman penetrates deeply into its web. There is a tremendous difference between the pictures they obtain. That of the painter is a total one, that of the cameraman consists of mutliple fragments which are assembled under a new law. Thus, for contemporary man the representation of reality by the film is incomparably more significant than that of the painter, since it offers, precisely because of the thoroughgoing permeation of reality with mechanical equipment, an aspect of reality which is free of all equipment. And that is what one is entitled to ask from a work of art.

These lines by Walter Benjamin, from one of the best-known passages in his 1936 essay, "The Work of Art in the Age of Mechanical Reproduction," are excerpted from the definitive version.[1] They are also found, in almost the same words, in an early draft of the text,[2] as well as in the rather liberal French adaptation by Pierre Klossowski,[3] except for several comments on Charlie Chaplin and Mickey Mouse that were omitted from the final version and from the French adaptation. They

Translated by Ellen Sowchek. From *Cinéma et peinture: Approaches*. Edited by Raymond Bellour. Ecritures et arts contemporains. Paris: Presses Universitaires de France, 1990: 31–81. Translated and reprinted by permission of the author.

mark, within the essay, the first explicit instance of a comparison of the terms *painting* and *cinema*. In other words—and I am deliberately setting aside the text's more political prologue and epilogue—the beginning of the debate to which "The Work of Art" is too often reduced does not appear until the eleventh of the fifteen chapters that make up the essay.

Something, *apparently*, like a period of time, like a delay connected with a particular detour: the image of the labyrinth, the "homeland of he who hesitates,"[4] haunted the writer. He considered himself born, to use the title of the beautiful essay that Susan Sontag devoted to him, "under the sign of Saturn," the planet of irresolution, slowness, and melancholy. For Benjamin, "getting lost" was the result of an entire education, an art, and a virtue that he had cultivated beginning with his early childhood in Berlin. A text, if it is really a text, also designed a labyrinth for Benjamin. Note his remarks on the prosody of Baudelaire, "comparable," he tells us, "to the map of a large city in which one can travel discreetly in the shelter of housing blocks, carriage entrances, and courtyards."[5]

But I said *apparently* because, in the final analysis, it is not certain that this debate—whether it is viewed in the synchronic form of the *comparison* (of "painting with cinema"), of the *academic conjunction* ("painting and cinema" or "cinema and painting," depending on the seminar), of the *critical disjunction* ("painting or cinema"), or in the diachronic form of *genealogy* (as in "from painting to cinema")—is really the subject of "The Work of Art." It is as much the subject, strictly speaking, as the cinematic reproduction of painting (the film about art) or, to use Patrick de Haas's expression, "painting in cinema" (the art film or pure cinema). I wonder, on the contrary, whether "The Work of Art," in the wording of its theses as well as in the strategy of its text, is not one of the essays that has contributed the most toward making this type of argument outdated. After Benjamin, perhaps no comparison between painting and cinema is possible. Literally, they no longer or should no longer have a common setting or location. The actual arena of their confrontation—no matter how polemic—seems to have collapsed.

Why? Because comparing one to the other for Benjamin is, after all, the analysis of one (cinema) in terms inherited from the history and system of values of the other (painting). It is above all a misunderstanding of the effect on painting of the irruption *as such* of photography then of cinema. As Benjamin notes, "We dispensed subtleties in vain in order to determine whether photography was or was not an art, but we did not first ask ourselves whether this invention itself had not transformed the general nature of art. Cinema theorists seem to have succumbed to the same error."[6] It is worth noting here that, contrary to what is sometimes written, Benjamin, while correct in predicting a general transformation of the work of art, accompanied by a *decline* or a *collapse of its aura*, never speaks, to the best of my knowledge, either here or elsewhere, of an *end* or a *decline of art*, even the work of art.

In a response which was political at a time of rising fascism in Europe, he

calls for a "liquidation of the traditional element in the cultural heritage."[7] But for him, the "politicization of art" which must accompany the fascist aestheticization of politics would not, in any case, mean the "death of art." I believe that nothing remained stranger to him than this totally Hegelian theme in which, in order to move quickly, the disappearance of art always leads, in one single movement, to its fulfillment.

Moreover, what interests Benjamin in the appearance and especially in the generalization of reproduction techniques (whether printing, photography, or cinema) is their effect on traditional artistic forms. *Critical effect* is understood as *retrospective illumination* as well as an *endangering* of this a*esthetic of authenticity*[8] which defined, for him, the production and reception of the work of art. According to Benjamin, what will always be missing in a reproduction is the "here and now of the work of art—the unity of its presence with the place in which it is found."[9] In short, the reproduction will lose the authenticity value of the original, which also includes its unique and irreducible *being-there* along with its own *history*. This history, the *material* aspect of its changes (degradations, obliterations, recoveries), which only the physico-chemical analysis of the original makes legible, and the more *socialized* history of its path (in space and in time) or its circulation from one owner to another in a game of pass-the-slipper in which reconstitution can only be achieved based on its place of origin. Benjamin summarizes this as follows: "The unity of the work of art is identical to its integration in this ensemble of relationships that we call tradition."[10]

That also means, for those who would like to be quicker in playing them one against the other, that *authenticity* and *historicity* are partially connected. They are two sides of the same coin—heads or tails, your choice. There is no history of a work without first establishing its authenticity, as we have come to see, but there is no absolute authenticity without history. The concept and even the value of authenticity are completely historical, as is indicated in a short note from the second chapter: "At the time it was created, a Virgin from the Middle Ages was not yet 'authentic,' it became so during the centuries that followed, and particularly, perhaps, in the nineteenth century"[11]—which, Benjamin says, is the century of History.

This leads me to note the two modalities of this critical effect of reproductibility on the work of art. Initially there is *retrospective illumination,* based on a recurrent history defined as a "past loaded with 'at-present.'"[12] This is more a question of *tendencies* than of *forms*.

A rejection, in the first place, of a *history of forms*. Benjamin no more believed in the autonomy of art than in the closing or the impermeability of its sectors, as can be seen in his 1937 "Fuchs," in which he specifically takes Heinrich Wölfflin's "formalism" to task. There is no "cinematism" in his work either, even though it is possible to see Sergei Eisenstein's problem in the analysis Benjamin provides of *La Vague* (The Wave), the well-known 1869 painting by Gustave Courbet (fig. 1). This was for him the equivalent of "the discovery of a photogenic

Figure 1. Gustave Courbet, The Stormy Sea, *also called* The Wave *(1869).* Musée d'Orsay, Paris, France. © Réunion des Musées Nationaux/Art Resource, NY.

theme through painting. At that time, we still knew nothing of the close-up or the snapshot, and Courbet's painting opened the way to these processes by exploring a new world of forms and proportions that it would only be possible to capture on photographic plates at a much later date."[13] For Benjamin, Courbet's *La Vague* is already a photographic snapshot, just as Hokusai's *The Wave* (fig. 2) would already be cinema for Eisenstein.

Benjamin's work is an affirmation of a *history of tendencies.* In his "Discussion on Russian Cinema and Collectivist Art in General" (1927), he notes that

> political tendencies inhabit each work of art, each period of art; that's a common truth—since they are historical creations of consciousness. But, just as the deepest layers of rock only appear at breaking points, the deep formation of a "tendency" also appears only at breaking points in the history of art (and its works). Technological revolutions are the breaking points in the development of art in which, from time to time, the tendencies come to light. . . . With each new technological revolution, the very secretive elemental tendency in art becomes in and of itself a manifest element of it. This is what finally brings us to cinema.
>
> Among the breaking points of artistic formations, one of the most powerful is the cinema. A new area of consciousness was truly born with it.[14]

Thus, beyond the political conjunction and the Brechtian inflection that accompanies it in Benjamin's work, and except for seeing in "The Work of Art" a radical break with this 1927 text, the policy for becoming this "other form of praxis,"

Figure 2. Katsushika Hokusai, from The Thirty-Six Views of Fuji *(1823–29).* All rights reserved, The Metropolitan Museum of Art, New York. Henry L. Phillips Collection, Bequest of Henry L. Phillips, 1939.

on which henceforth the function of art would be based, has always inhabited the places of art and its religion. The cinema as it exists (reproduction, collective art, and mass movement), and even more so the cinema of Eisenstein and Vsevolod I. Pudovkin, does not introduce politics into art; it simply reveals that art has always been, in and of itself, political. It also dispenses with the veil of authenticity that the screen gives to this particular truth. For Benjamin, modernity is truly "the world dominated by its phantasmagoria."[15] There is a crisis of modernity: modernity is in crisis as much as it causes a crisis, because it is itself a crisis, which Benjamin summarizes with his famous *decline of the aura.* "In the age of mechanical reproduction, what is affected in the work of art is its aura."[16]

What is this aura? The answer is known, and as given, threadbare: "a singular web of space and time: a unique appearance of a background no matter how close it is."[17] It seems to come from within for Benjamin, in "The Work of Art." He repeats it almost word for word in the "Short History of Photography" (1931), using it in an almost incantatory manner, as if it were a magic spell, as if he wanted at all costs to avoid giving it meaning or having to define it. He finally mentions it in "On Some Motifs in Baudelaire" (1939), but in an entirely different context. While it is true that this definition alone crystallizes all of the natural and cultural values of authenticity and distancing, of unity and duration destroyed when mechanical reproduction substitutes artificiality and closeness, transience and repetition, aura nonetheless covers very different realities, depending on the text in which it appears.

When he introduced the theme of the aura in the "Short History of Photography," Benjamin, we know, did not find it in painting or in any other traditional art but, on the contrary, in photographs. And not in just any photographs, but in those of photography's first ten years—the most beautiful examples, according to him, of this art—the works of such photographers as David Octavius Hill, Julia Margaret Cameron, or Nadar. According to the "Short History," it is in the photographic portrait that *aura* makes its first appearance, while it will be the last for "The Work of Art." Moreover, this primitive aura frustrates the contrast of the natural and the cultural to which "The Work of Art" reverts. It is as much a matter of one as it is of the other. It was the aura of the client "who hides behind a bourgeois frock coat or cravat,"[18] but is viewed by a photographer still fascinated by the new rising classes. It was, above all, the meeting point for both the real and the photographic, in the image of light in the works of Hill who, during the interminable exposure time, worked his way "uneasily through the shadow."[19] In short, it is the perfect pairing of imperfect techniques with the self-confidence of the models; a precarious balance, rather miraculous, that the luminosity of the optics and the speed of the emulsions would soon destroy. This means the definitive loss of this primitive aura to which, according to Benjamin, there would be no need to return. To return would be to run the risk, after 1880, of artisans becoming "artists" and the photograph a piece of merchandise, of reintroducing as contraband, by means of the artifice of erasing and retouching, an *aura of substitution* that is all the more laughable since it no longer corresponds to anything, either in reality or in the technique being used. Continuing on this point, "The Work of Art" echoes the "Short History of Photography" by attacking, in turn, the "decadent charm" of this aura of substitution which is, for Benjamin, the cult of the star or the laborious construction of the star's "personality." In my opinion, he is less concerned with the traditional aura—which, after all, itself falls under the pressure of mechanical reproduction—than with this aura of substitution which denies the irremediable loss of the first.

A further comment on the artistic location and the historic moment of the decline of the aura in general, if this expression ever makes sense, every aura being, by definition, *singular* ("a unique web of space and time"): in other words, is there something like a simple dividing line between the aura and that which in the future may escape from it? And if there is, where and when would it occur? Benjamin's answer throughout "The Work of Art" is apparently clear. This line will occur between the traditional arts, of which the paragon is painting, and the arts of mechanical reproduction—or, to be more exact, inside the former under the effect of the latter, which does not originate naturally from itself. As Benjamin was aware, everything is much more complicated, in painting as in photography and in cinema.

The decline of the aura also affects photography—on at least three occasions, according to Benjamin in the "Short History of Photography": decline of its

primitive aura, as we have just seen, under the effect of the industrialization of photography; decline of the *pictorialist aura*, thanks to the work of Eugène Atget and surrealist photography; and finally the decline of the *promotional aura*—for which the formula, for Benjamin, would be the celebrated title by Albert Renger-Patzsch, *The World Is Beautiful.* This decline is due to the combined blows of photographic constructivism, the photomontage of John Heartfield, and the social "typing" of characters in the Soviet cinema. There is a photographic aura, and it does not cease to decline because it continues to rise from its ashes, in a never-ending logic of substitution. This makes authenticity a simple figure of artificiality, and the aura an increasingly grotesque grimace of itself.

As for painting, it did not wait for the period of mechanical reproduction to see its aura decline. It is not a matter solely of secularization, univocal and progressive, moving from the religious to the "exposable." There are periods of art in which the exposable violently supplants the religious, periods in which the aura abruptly reveals itself. This is certainly the case with Dada and the historical avant-garde, according to "The Work of Art," but it was also true of the baroque, with its foreshortening and its games of perspective:

> For a long time, mystery has been expressed by the image of the veil, ancient accomplice of the distant. The distant appears veiled. Unlike Renaissance painting, baroque painting is not fond of this veil. It lifts it in a rather ostentatious manner and, as is especially evident in its ceilings, it even places the distant heavens in a proximity that is intended to surprise and amaze. From this we can deduce that the degree of auratic saturation of human perception varies throughout history. (In the baroque, it may be said, the conflict between religious value and expositional value largely takes place in sacred art.) These variations must be clarified, but everything takes place as if the periods that favored allegorical expression had had an aura crisis.[20]

Although the allegory and the aura are antinomies, it should not be surprising that Benjamin uses the allegory to get a fix on the aura and, in so doing, to think about it. *Dissolve* ("a formal element, according to him, of the allegorical vision"):[21] let us leave the baroque allegory to return to our little modern allegory, that of the magician and the surgeon.

Let us first remember that it occurs following three chapters (8, 9, 10) that compare acting in the cinema with acting in the theater.

The first chapter, we know, emphasizes the consequences of "mediatization," the use of technical equipment to capture the actor's performance on film, as compared with the immediacy of the theater actor before his audience. The cinema actor plays to a machine, the camera, and not directly to an audience that he can see. Thus there is no longer an exchange, or reciprocity, no more face-to-face (this argument would be used again in the image of the relationship between the surgeon and his patient). The actor in cinema would thus be subject to a double

system of tests: the optical, using the equipment, and the critical, from a public transformed into experts. This is an attitude to which, says Benjamin, we "would not be able to subject religious values."[22]

The argument, obviously, is not convincing. On the one hand, the fact that the audience does not enter into any kind of physical relationship with the actor does not, for that reason, make it any more expert (the condition, while required, is not sufficient). On the other hand, we do not see why this non-relationship, this distance, this separation (in time as in space) between the actor and the audience should not produce an aura effect.

Moreover, it is precisely this disappearance of his aura, for the actor, that Benjamin uses as a theme in the following chapter: "For the first time—and this is the work of the cinema—man must act, with all of his living being, of course, while deprived of aura, as his aura depends on his here and his now. It does not suffer any reproduction."[23] Benjamin uses a logic similar to that described in the "Short History of Photography," which, on the subject of the urban landscapes—so-called voids—of Atget or of surrealist photography, speaks of the "salutary movement by means of which man and the surrounding world become strangers to each other."[24] To describe this privation of aura, here applied to the face, Benjamin refers to the memoirs of Luigi Pirandello's cameraman: "Film actors," wrote the latter, "feel as though they are in exile—in exile not only from the stage but from themselves as well."[25] A reflection that calls to mind the equally well-known comment by Jean Epstein: "Incredulous, deceived, scandalized, Mary Pickford cried when she saw herself on the screen for the first time. It seems only Mary Pickford did not know that she was Mary Pickford."[26] There is something, in both cases, akin to a reversed mirror, the very opposite of Jacques Lacan's "jubilatory assumption of specular image" by the child of man. To quote Benjamin: "in the future his image in the mirror distances itself from him, it becomes transportable. And where is it transported? To the audience."[27] Therefore, it is not necessary to examine this too deeply in order to see, in this story of the double, the shadow and the reflection that make themselves scarce, a certain feeling of "disturbing strangeness." This marks the final assault on the integrity of acting in film: the splitting up of shots and the non-respect for the chronology of the role that makes it so difficult for the film actor, unlike the actor in theater, to identify with his character. "Art," says Benjamin, "has left the domain of the 'beautiful appearance,' beyond which we so long believed it was destined to decline."[28]

This same idea of the end of art as "beautiful appearance"—or of what he had already called, in *Trauerspiel* (The Origin of German Tragic Drama), the "dissipation of the pretense of the totality"[29]—is once again found in the final comparison of cinema and theater, a comparison that leads directly to that of cinema and painting. Benjamin always sides with the production of the work, but now he is dealing with their respective scenographies, the stage in the theater and the studio in cinema. He is less struck, here too, by the way in which one may inherit from the other or their contemporary analogues ("superficial and unimportant,"

according to him) than by that which more radically separates them: the intrusion of the technical equipment into the reality of the studio space. That alone makes film illusion possible but does so only *from its point of view* (the camera's point of view, which, by omitting the "foreign body" of the crew and the technical from the picture, can by itself create an abstraction) and *following the shot* ("in the second degree," says Benjamin, once the film is edited). From the theater to the cinema, there is already a movement away from the *visible,* which would collapse from a certain completeness, a transparency or immediacy, and split into opacity and temporization.

If we dig deeper into this question of the visible, we see the origin of the parallel with *painting.* By means of the figures of the magician and the surgeon, Benjamin plays with the idea of and even the word *operation,* surgical or cinematographic, comparing the painter to the "operator." By "operator," he means the cameraman and, I believe, more specifically, the individual doing the framing (because, like him, the surgeon limits his field of operation). He is not referring to the filmmaker, properly speaking, but to the operator who serves as an index, the representation of the shooting crew and the idea of cinema. Why? Perhaps because the vision of the filmmaker is still too distant and general, almost panoptic in comparison with that of the cameraman, which is more partial and closer. In the same way, the doctor who has been able to maintain a "person-to-person" relationship with his patient occupies, for Benjamin, an intermediary position between the magician and the surgeon.

Thus, while the magician cures the patient by the laying-on of hands, the surgeon performs an operation on him. At least two consequences follow. On the one hand, the magician maintains a certain distance from his patient that he further emphasizes by his authority, while the surgeon suppresses it completely by intervening inside the body of the patient, using caution rather than authority. On the other hand, by proceeding "operatively," that is to say locally, in an ultimately inhuman relationship, the surgeon gives up the *face-to-face* that the magician maintains with his patient. Much like the daguerreotype—which, according to Benjamin, "forced one to look (for a lengthy period) at a camera, which receives the image of the man without returning his gaze"[30]—the surgeon abolishes, from the outset, what in the book on Baudelaire is attributed to the aura: the expectation of an always possible reversibility of gaze. "Once one is—or believes oneself—looked at, one lifts the eyes. Feeling the aura of a thing, is to give it the power to raise the eyes."[31]

If we take up his parallel, Benjamin thus contrasts the nearness of the operator with the distance of the painter and the division of the shot to the globality of the painting (is it necessary to add the "don't look at the camera" to the pictorial comparison?). As such, this would still be too simple. He is dealing here, of course, with something else. What perhaps interests Benjamin in the generalized division of the cinema, whether it be that of shots, sequences, or acting, is what already fascinated him in German baroque drama: the rejection, by the "ruin," the

"fragment," or the "allegorical division" of the "image of the organic whole."[32] The metaphor of the magician—or of magic—is neither accidental nor innocent. It occurs beginning with the fifth chapter of "The Work of Art." Ultimately, it is not even a metaphor; it is the origin of art or of painting, its fundamental religious value. "Artistic production begins with images that are useful to religion. It may be said that the actual presence of these images is of greater importance than the fact that they are seen. The elk that man drew on the walls of a cave, during the stone age, is a *magical instrument*."[33] He continues: "Originally the absolute dominance of the religious value had made a *magic instrument* of this work of art that would not, up to a certain point, be recognized as such later on."[34] But Benjamin does not attribute this magic value solely to religious art or to the traditional practices of painting and sculpture. He also finds it in photography, especially from the early years (the last entrenchment of the religious), which has its own force of conviction, and which simultaneously contains both the contingent and the premonitory. He writes:

> We discover the image of Dauthendey, the photographer, father of the poet, during the period of his engagement to the woman who, one day, shortly after the birth of his sixth child, he would find with her wrists slit in her Moscow bedroom. Here we see her next to him; he seems to hold her, but her look goes beyond him, without stopping, nostalgically fixed on fateful distances. It is sufficient to have meditated for a long time in front of such an image in order to recognize, here also, how the extremes affect each other. The most exact technique can give to its products a *magic value* that no painted image would be able to have for us.[35]

It has been understood, in all cases and regardless of the artistic medium adopted, that what Benjamin was, in fact, referring to by this term *magic* is the aura effect.

While baroque painting ostentatiously lifted the veil of the aura, cinema literally undid its spatio-temporal web. Using the close-up, which isolates and details, it broadens space; using slow motion, it reveals unknown movements. At this point in his argument,[36] Benjamin reuses almost word for word a fragment from his 1927 text on Russian cinema, in which he already spoke of "those offices, furnished rooms, cafés, city streets, stations, and factories [that] are ugly, incomprehensible, desperately sad [or that] seemed to be, up until the era of cinema. It was necessary to blow up this entire prison world with the dynamite of a tenth of a second, so that we could set out on long and adventurous journeys"[37] among its scattered ruins. But at the same time Benjamin radicalizes his position, he no longer speaks simply of the birth with cinema "of a new area of consciousness." He instead reveals *the reverse unconscious of the visible:*

> The nature that speaks to the camera is completely different from that which addresses the eyes. Different specifically because, for the space where man acts with consciousness, it substitutes a space in which his action is unconscious. . . . For the first time the camera opens up to us the experience of the

visual unconscious just as psychoanalysis delivers to us the experience of the driving unconscious.[38]

I am well aware to what extent Benjamin's words are hackneyed and the ideas beneath them common at the time. The same views can be found in the work of Laszló Moholy-Nagy or Jean Epstein, as well as in Fernand Léger or Germaine Dulac. I will give only two examples that I borrow from the book by Patrick de Haas, *Cinéma Intégral: De la peinture au cinéma dans les années vingt:* "Eighty percent of the elements and objects that help us to live," writes Léger on the subject of Abel Gance's *La Roue,* "are only *glimpsed* by us in daily life, while twenty percent are *seen.* From this I have deduced that cinematography created this revolution *of making us see that which was only glimpsed.*"[39] And here is Germaine Dulac, writing this time in "Visual and Antivisual Films": "Although cameras break down the movement and will explore the domain of the infinitely small in nature, it is in order to teach us visually about the dramas or the beauties that our eye, an ineffectual lens, does not perceive."[40] All share this same belief in the making-visible of the invisible and this same, somewhat naïve confidence in the scientific role of cinema. But the merit of Benjamin is that he had already given it a more rigorous formulation by relying on Freud's *Psychopathology of Everyday Life* and by inviting us, beginning in 1936, to think about the quasi-synchronous birth of cinema and psychoanalysis.

Having dealt with them elsewhere,[41] I will put aside the decisive questions of the exposable and the reception of works of painting or cinema. I thus pass quickly to that which separates the art lover from the film viewer, that expert who combines "the critical spirit" with "pleasurable behavior"; I also pass over the collective viewing of film and the effect of the "massification" of the film audience, compared with the contemplation—assumed to be solitary or in a small group— of a painting. I do not insist, although it might have merited a lengthy development, on the genealogy of new forms of art (cinema, for example), always using the "crossing of three progressive lines"—technical, artistic, and social—proposed in a long note in "The Work of Art."[42] Finally and above all, there remains the way in which the historical avant-garde (Dadaism, cubism, and futurism) cleared the way by introducing, in opposition to the aesthetic of contemplation handed down by traditional art, an aesthetic of collage, of provocation, and of shock. The cinema (for which "the traumatizing perception had taken on the value of a formal principle"),[43] according to Benjamin, was going to free this aesthetic from its "moral straitjacket," by banalizing and generalizing it through the intermittent unspooling of the film or breaks in the editing.

Is it possible to speak, in the works of Benjamin, of the "taking over," of the *Aufhebung* of painting by cinema? He does not use the term, even in "The Work of Art," although he is completely sensitive, in the preparatory notes, to the *dialectical structure of film,* to "discontinuous images dissolving in a continuous sequence"[44] in film as a *"dialectical image" of the dialectic.* This is how, in

a letter to Max Horkheimer dated 16 October 1935, Walter Benjamin positioned "The Work of Art" in comparison to the draft of *Parisian Passages:*

> This time it is a question of indicating where in the present the exact place is located to which my historical construction will relate to its point of escape. While the subject of the book is the destiny of nineteenth-century art, this destiny only has something to say to us because it is maintained in the tick-tock of a clock whose hour has not yet struck for the first time except to *our* ears. What I mean to say there is that it is for us that the fatal hour of art has struck, and I have situated the point in a series of brief reflections dealing with the following title: "The Work of Art in the Age of Mechanical Reproduction." These reflections attempt to give a true contemporary form to the problems of aesthetic theory: and they attempt to do so from inside, by avoiding any *non-mediatized* relationship with politics.[45]

The "fatal hour" has struck. Does this mean the death knell for art? Relief, then, will be provided. Without rest? Without there being anything to save (to use the problem of the *Rettung*)? Quite the contrary.

In "The Storyteller" (1936) and "Fuchs" (1937), Benjamin's final reflections, he would not follow this direction. The question of *rescue* would progressively supplant that of liquidation and would culminate, in the "Theses on the Philosophy of History" (1940), with the allegory of the *Angelus Novus* (which, it must be remembered, is a painting). But already in "The Work of Art," something in painting also resisted the unifying act performed by the techniques of reproduction—something *political* and, ultimately, paradoxical. And, as if by chance, it is once again the figure of the surgeon that makes its return in this painted scene:

> If things become "humanly more close" to the masses, this may mean that we are no longer taking into account their social function. Nothing guarantees that a contemporary portrait artist, when he shows a famous surgeon having his breakfast or at home with his family, understands more exactly his social function than a sixteenth-century painter who, like Rembrandt in *The Anatomy Lesson,* showed the public of his time doctors in the actual practice of their art.[46]

NOTES

1. Walter Benjamin, "The Work of Art in the Age of Mechanical Reproduction," in *Illuminations,* ed. Hannah Arendt and trans. Harry Zohn (New York: Schocken, 1968), 232–234.

2. "Das Kunstwerk im Zeitalter seiner technischen Reproduzierbarkeit" (Erste Fassung), in *Gesammelte Schriften* I 2:431–469. [Original German title of "The Work of Art" (draft), in *Works.*]

3. "L'oeuvre d'art à l'époque de sa reproduction mécanisée," in *Gesammelte Schriften.* I 2:709–739.

4. "Zentralpark," in *Charles Baudelaire, un poète lyrique à l'apogée du capitalisme,* trans. J. Lacoste (Paris: Payot, 1982), 225. [English edition: *Charles Baudelaire, A Lyric Poet in the Era of High Capitalism,* trans. Harry Zohn (London, 1973).]

5. "Le Paris du Second Empire," in *Charles Baudelaire,* 140.

6. "The Work of Art," 227.

7. Ibid., 221.

8. See Patrice Rollet, "Passage des Panoramas," in *Paris vu par le cinéma d'avant-garde 1923–1983* (Paris: Expérimental, 1985), 10–11.

9. "The Work of Art," 220.

10. Ibid., 223.

11. Ibid., 243, 2.

12. "Theses on the Philosophy of History," in *Illuminations*, 255 [?].

13. "Peinture et photographie. 2ᵉ Lettre de Paris, 1936," trans. M. B. De Launay, in *Cahiers du Musée National d'Art Moderne* (no. 1, 1979): 44.

14. Walter Benjamin, "Discussion on Russian Cinema and Collectivist Art in General" (response to O. A. H. Schmitz), trans. B. Eisenschitz, in *Cahiers du Cinéma* 226–227 (January–February 1971): 16.

15. *Das Passagen-Werk* (The Arcades Project), ed. Rolf Tiedemann (Frankfurt: Suhrkamp, 1983), 76–77. [English edition: *The Arcades Project*, trans. Howard Eiland and Kevin McLaughlin (Cambridge, Mass.: Belknap, 1999).]

16. "The Work of Art," 221.

17. "Petite histoire de la photographie" (Short History of Photography), in *Oeuvres II:* 27.

18. Ibid., 24.

19. Ibid., 24.

20. *Das Passagen-Werk*, 461–462, quoted by Rolf Tiedemann in *Etudes sur la philosophie de Walter Benjamin*, trans. R. Rochlitz (Actes Sud, 1987), 120.

21. Letter to Max Horkheimer dated 16 April 1938, in *Correspondance II, 1929–1940*, trans. G. Petitdemange (Paris: Aubier Montaigne, 1979), 241.

22. "The Work of Art," 229.

23. Ibid.

24. "Short History of Photography," 28.

25. Luigi Pirandello, *Si Gira* (Turning), quoted by Benjamin in "The Work of Art," 229.

26. Jean Epstein, *Ecrits I* (Paris: Seghers), 392.

27. "The Work of Art," 231.

28. Ibid., 230.

29. Walter Benjamin, *Origine du drame baroque allemand*, trans. S. Muller (Paris: Flammarion, 1985), 189. [English edition: *The Origin of German Tragic Drama*, trans. John Osborne (London, 1977).]

30. "Sur quelques thèmes baudelairiens," *Charles Baudelaire*, 199.

31. Ibid., 200.

32. *Origins of German Tragic Drama*, 188.

33. "The Work of Art," 224–225.

34. Ibid., 225.

35. "Short History of Photography," 18.

36. "The Work of Art," 236.

37. "Discussion on Russian Cinema," 16.

38. "The Work of Art," 236–237.

39. Fernand Léger, "Essai critique sur la valeur plastique du film d'Abel Gance, *La Roue*," *Comoedia* (Paris, 1922), as quoted by Patrick de Haas in *Cinéma intégral: De la peinture au cinéma dans les années vingt* (Paris: Transédition, 1985), 178.

40. Germaine Dulac, "Films visuels et anti-visuels," in *Le Rouge et le Noir* (Paris: July 1928), quoted by Patrick de Haas, *Cinéma intégral*, 179.

41. Rollet, "Passage des Panoramas," 12–13.

42. "The Work of Art," 249–250, 17.

43. "Sur quelques thèmes baudelairiens," *Charles Baudelaire*, 180.

44. *Gesammelte Schriften* I: 1040, as quoted by Pierre Missac in *Passage de Walter Benjamin* (Paris: Seuil, 1987), 107.

45. *Correspondance II*, 188.

46. "The Work of Art," 243, 4.

Visual Form

Heinrich Wölfflin

Linear and Painterly

If we wish to reduce the difference between the art of Dürer and the art of Rembrandt to its most general formulation, we say that Dürer is a draughtsman and Rembrandt a painter. In speaking thus, we are aware of having gone beyond a personal judgment and characterized a difference of epoch. Occidental painting, which was draughtsmanly in the sixteenth century, developed especially on the painterly side in the seventeenth. Even if there is only one Rembrandt, a decisive readjustment of the eye took place everywhere, and whoever has any interest in clearing up his relation to the world of visible forms must first get to grips with these radically different modes of vision. The painterly mode is the later, and cannot be conceived without the earlier, but it is not absolutely superior. The linear style developed values which the painterly style no longer possessed and no longer wanted to possess. They are two conceptions of the world, differently orientated in taste and in their interest in the world, and yet each capable of giving a perfect picture of visible things.

Although in the phenomenon of linear style, line signifies only part of the matter, and the outline cannot be detached from the form it encloses, we can still use the popular definition and say for once as a beginning—linear style sees in lines, painterly in masses. Linear vision, therefore, means that the sense and beauty of things is first sought in the outline—interior forms have their outline too—that the eye is led along the boundaries and induced to feel along the edges, while seeing in masses takes place where the attention withdraws from the edges, where the outline has become more or less indifferent to the eye as the path of vision, and the primary element of the impression is things seen as patches. It is here indifferent whether such patches speak as color or only as lights and darks.

The mere presence of light and shade, even if they play an important part, is still not the factor which decides as to the painterly character of the picture. Linear art, too, has to deal with bodies and space, and needs lights and shadows to obtain the impression of plasticity. But line as fixed boundary is assigned a superior or equal value to them. Leonardo is rightly regarded as the father of chiaroscuro, and his *Last Supper* in particular is the picture in which, for the first time in later art, light and shade are applied as a factor of composition on a large

From *Principles of Art History: The Problem of the Development of Style in Later Art.* Translated by M. D. Hottinger. New York: Dover Publications, Inc., 1950: 18–23. Reprinted by permission of the publisher.

scale, yet what would these lights and darks be without the royally sure guidance which is exercised by the line? Everything depends on how far a preponderating significance is assigned to or withdrawn from the edges, whether they *must* be read as lines or not. In the one case, the line means a track moving evenly round the form, to which the spectator can confidently entrust himself; in the other, the picture is dominated by lights and shadows, not exactly indeterminate, yet without stress on the boundaries. Only here and there does a bit of palpable outline emerge: it has ceased to exist as a uniformly sure guide through the sum of the form. Therefore, what makes the difference between Dürer and Rembrandt is not a less or more in the exploitation of light and shade, but the fact that in the one case the masses appear with stressed, in the other with unstressed edges.

As soon as the depreciation of line as boundary takes place, painterly possibilities set in. Then it is as if at all points everything was enlivened by a mysterious movement. While the strongly stressed outline fixes the presentment, it lies in the essence of a painterly representation to give it an indeterminate character: form begins to play; lights and shadows become an independent element, they seek and hold each other from height to height, from depth to depth; the whole takes on the semblance of a movement ceaselessly emanating, never ending. Whether the movement be leaping and vehement, or only a gentle quiver and flicker, it remains for the spectator inexhaustible.

We can thus further define the difference between the styles by saying that linear vision sharply distinguishes form from form, while the painterly eye on the other hand aims at that movement which passes over the sum of things. In the one case, uniformly clear lines which separate; in the other, unstressed boundaries which favor combination. Many elements go to produce the impression of a general movement . . . but the emancipation of the masses of light and shade till they pursue each other in independent interplay remains the basis of a painterly impression. And that means, too, that here not the separate form but the total picture is the thing that counts, for it is only in the whole that that mysterious interflow of form and light and color can take effect, and it is obvious that here the immaterial and incorporeal must mean as much as concrete objects.

When Dürer or Cranach places a nude as a light object on a dark ground, the elements remain radically distinct: background is background, figure is figure, and the Venus or Eve we see before us produces the effect of a white silhouette on a dark foil. Conversely, if a nude in Rembrandt stands out on a dark ground, the light of the body seems as it were to emanate from the darkness of the picture space: it is as if everything were of the same stuff. The distinctness of the object in this case is not necessarily impaired. While the form remains perfectly clear, that peculiar union between the modeling lights and darks can have acquired a life of its own, and without the exigencies of the object being in any way prejudiced, figure and space, corporeal and incorporeal, can unite in the impression of an independent tonal movement.

But certainly—to make a preliminary remark—it is of considerable advan-

tage to "painters" to liberate lights and darks from their function of mere form-definition. A painterly impression most easily comes about when the lighting no longer subserves the distinctness of the objects, but passes over them: that is to say, when the shadows no longer adhere to the forms, but, in the conflict between the distinctness of the object and the illumination, the eye more willingly surrenders to the play of tones and forms in the picture. A painterly illumination—say, in a church interior—is not the one which will make the columns and walls as distinct as possible, but, on the contrary, the one which will glide over the form and partially veil it. And in the same way, the silhouettes—if the notion can be used at all in this connection—will be apt to become inexpressive: a painterly silhouette never coincides with the form of the object. As soon as it speaks too clearly of the object, it isolates itself and checks the coalescence of the masses in the picture.

But with all that the decisive word is not yet said. We must go back to the fundamental difference between draughtsmanly and painterly representation as even antiquity understood it—the former represents things as they are, the latter as they seem to be. This definition sounds rather rough, and to philosophic ears, almost intolerable. For is not everything appearance? And what kind of a sense has it to speak of things as they are? In art, however, these notions have their permanent right of existence. There is a style which, essentially objective in outlook, aims at perceiving things and expressing them in their solid, tangible relations, and conversely, there is a style which, more subjective in attitude, bases the representation on the *picture,* in which the visual appearance of things looks real to the eye, and which has often retained so little resemblance to our conception of the real form of things.

Linear style is the style of distinctness plastically felt. The evenly firm and clear boundaries of solid objects give the spectator a feeling of security, as if he could move along them with his fingers, and all the modeling shadows follow the form so completely that the sense of touch is actually challenged. Representation and thing are, so to speak, identical. The painterly style, on the other hand, has more or less emancipated itself from things as they are. For it, there is no longer a continuous outline and the plastic surfaces are dissolved. Drawing and modeling no longer coincide in the geometric sense with the underlying plastic form, but give only the visual semblance of the thing.

Where nature shows a curve, we perhaps find here an angle, and instead of an evenly progressive increase and decrease of light, light and shade now appear fitfully, in ungradated masses. Only the *appearance* of reality is seized—something quite different from what linear art created with its plastically conditioned vision, and just for that reason, the signs which the painterly style uses can have no further direct relation to the real form. The pictorial form remains indeterminate, and must not settle into those lines and curves which correspond to the tangibility of real objects.

The tracing out of a figure with an evenly clear line has still an element of

physical grasping. The operation which the eye performs resembles the operation of the hand which feels along the body, and the modeling which repeats reality in the gradation of light also appeals to the sense of touch. A painterly representation, on the other hand, excludes this analogy. It has its roots only in the eye and appeals only to the eye, and just as the child ceases to take hold of things in order to "grasp" them, so mankind has ceased to test the picture for its tactile values. A more developed art has learned to surrender itself to mere appearance.

With that, the whole notion of the pictorial has shifted. The tactile picture has become the visual picture—the most decisive revolution which art history knows.

Now we need not, of course, immediately think of the ultimate formulations of modern impressionist painting if we wish to form an idea of the change from the linear to the painterly type. The picture of a busy street, say, as Monet painted it, in which nothing whatsoever coincides with the form which we think we know in life, a picture with this bewildering alienation of the sign from the thing is certainly not to be found in the age of Rembrandt, but the principle of impressionism is already there. Everybody knows the example of the turning wheel. In our impression of it, the spokes vanish, and in their place there appear indefinite concentric rings, and even the roundness of the felly has lost its pure geometric form. Now not only Velasquez, but even so discreet an artist as Nicolas Maes has painted this impression. Only when the wheel has been made indistinct does it begin to turn. A triumph of seeming over being.

And yet that is, after all, only an extreme case. The new representation includes the stationary as well as the moving. When a sphere at rest is no longer represented by a geometrically pure circular form, but with a broken line, and where the modeling of the surface of a cube has degenerated into separate blocks of light and dark, instead of proceeding uniformly by imperceptible gradations, we stand everywhere on impressionist ground.

And now if it is true that the painterly style does not body forth things in themselves, but represents the world as seen, that is to say, as it actually appears to the eye, that also implies that the various parts of a picture are seen as a unity from the same distance. That seems to be a matter of course, but it is not so at all. The distance required for distinct seeing is relative: different things demand different vicinities of the eye. In one and the same form-complex, totally different problems may be presented to the eye. For instance, we see the forms of a head quite distinctly, but the pattern of the lace collar beneath it requires closer approach, or at least, a special adjustment of the eye if its forms are to become distinct. The linear style, as representation of being, had no difficulty in making this concession to the distinctness of the object. It was quite natural that things, each in its particular form, should be rendered in such a way as to be perfectly distinct. The demand for unified visual perception is radically non-existent for this type of art in its purest developments. Holbein, in his portraits, pursues the design of

small goldsmith's work and embroidery into their smallest details. Frans Hals, on the other hand, occasionally painted a lace collar only as a white shimmer. He did not wish to give more than is perceived by the eye taking a general view of the whole. But, of course, the shimmer must look as if all the details were actually there, and the indistinctness were only the momentary effect of distance.

The measure of what can be seen as a unity has been taken very variously. Although we are accustomed to describe only the higher degrees as impressionism, we must always bear in mind that these do not signify something essentially new. It would be difficult to fix the point at which the merely "painterly" ceases and "impressionist" begins. Everything is transition. And in the same way, it is hardly possible either to establish any ultimate expression of impressionism which might be taken as its classic completion. That is much more possible on the opposite side. What Holbein gives is, as a matter of fact, an unsurpassable embodiment of the art of being, from which all elements of semblance have been eliminated. Curiously enough, there is no special term for this mode of representation.

A further point. Unified seeing, of course, involves a certain distance. But distance involves a progressive flattening of the appearance of the solid body. Where tactile sensations vanish, where only light and dark tones lying side by side are perceived, the way is paved for painterly presentment. Not that the impression of volumes and space is lacking; on the contrary, the illusion of solidity can be much stronger, but this illusion is obtained precisely by the fact that no more plasticity is introduced into the picture than the appearance of the whole really contains. That is what distinguishes an etching by Rembrandt from any of Dürer's engravings. In Dürer everywhere the endeavor to achieve tactile values, a mode of drawing which, as long as it is in any way possible, follows the form with its modeling lines; in Rembrandt, on the other hand, the tendency to withdraw the picture from the tactile zone and, in drawing, to drop everything which is based on immediate experiences of the organs of touch, so that there are cases in which a rounded form is drawn as a completely flat one with a layer of straight lines, although it does not look flat in the general impression of the whole. This style is not present from the beginning. Within Rembrandt's work, there is a distinct development. Thus the early *Diana Bathing* is still modeled throughout in a (relatively) plastic style with curved lines following the separate form: in the late female nudes, on the other hand, little is used but flat lines. In the first case, the figure stands out; in the later compositions, on the other hand, it is embedded in the totality of the space-creating tones. But what comes clearly to light in the pencil work of the drawing is, of course, also the foundation of the painted picture, although in the latter case it is perhaps more difficult for the layman to realize it.

In establishing such facts, however, which are peculiar to the art of representation on flat surfaces, we must not forget that we are aiming at a notion of the painterly which is binding beyond the special domain of painting and means as much for architecture as for the arts of the imitation of nature.

Gilles Deleuze

Montage–The American School and the Soviet School

Now, since the most ancient philosophy, there have been many different ways in which time can be conceived as a function of movement, in relation to movement, in various arrangements. We are likely to come across this variety again in the different 'schools' of montage. If we give to Griffith the distinction, not of having invented montage, but of having raised it to the level of a specific dimension, it seems that four main trends can be distinguished: the organic trend of the American school; the dialectic trend of the Soviet school; the quantitative trend of the prewar French school; and the intensive trend of the German expressionist school. In each case the directors may be very different; however, they have a community of themes, problems, and preoccupations: in short, an ideal community which is all that is needed, in the cinema as elsewhere, to found concepts of schools or trends. . . .

Griffith conceived of the composition of movement-images as an organization, an organism, a great organic unity. This was his discovery. The organism is, firstly, unity in diversity, that is, a set of differentiated parts; there are men and women, rich and poor, town and country, North and South, interiors and exteriors, etc. These parts are taken in binary relationships which constitute a *parallel alternate montage*, the image of one part succeeding another according to a rhythm. But the part and the set must also necessarily enter into a relationship, exchange their relative dimensions. *The insertion of the close-up* in this sense does not merely involve the enlargement of a detail, but produces a miniaturization of the set, a reduction of the scene (to the scale of a child, for example, like the baby who is present during the action of *The Massacre*). And, more generally, by showing the way in which the characters live the scene of which they form part, the close-up endows the objective set with a subjectivity which equals or even surpasses it (not just the close-ups of soldiers which alternate with the long shots of the battle, or the terrified close-ups of the young girl chased by a Negro in *Birth of a Nation*, but also the close-up of the young woman who identifies with the images of her thought in *Enoch Arden*).[1] Finally, the parts must necessarily act and react on each other in order to show how they simultaneously enter into

From *Cinema*, vol. 1: *The Movement-Image*. Translated by Hugh Tomlinson and Barbara Habberjam. Minneapolis: The University of Minnesota Press, 1986: 29–40. © 1986 by The Athlone Press. Reprinted by permission of The University of Minnesota Press and The Athlone Press.

Figure 1. Abel Gance meets D. W. Griffith in 1922, shortly after making La Roue. Anthology Film Archives. New York.

conflict and threaten the unity of the organic set, and how they overcome the conflict or restore the unity. From some parts actions arise which oppose good and bad, but from other parts convergent actions arise which come to the aid of the good: through all these actions the form of a duel develops and passes through different stages. Indeed, it is in the nature of the organic set that it should continually be threatened: the accusation raised against the Negroes in *Birth of a Nation* is that of wanting to shatter the newly won unity of the United States by using the South's defeat to their own advantage. . . . The convergent actions tend toward a single end, reaching the site of the duel to reverse its outcome, to save innocence or reconstitute the compromised unity—like the gallop of the horsemen who come to the rescue of the besieged, or the advance of the rescuer who recovers the girl on the thawing ice (*Orphans of the Storm*). It is the third aspect of montage, *concurrent* or *convergent montage*, which alternates the moments of two actions which will come back together again. And the more the actions converge, the closer the junction approaches, the more rapid the alternation becomes (accelerated montage). Admittedly, in Griffith, the junction does not always take place, and the innocent young girl is often condemned, almost sadistically, because she could only find her place and salvation in an 'inorganic' abnormal union: the Chinese opium-addict arrives too late in *Broken Blossoms*. This time it is a perverse acceleration which forestalls convergence.

These are the three forms of montage, or of the rhythmic alternation; the alternation of differentiated parts, that of relative dimensions, and that of convergent actions. A powerful organic representation produces the set and the parts in this way. The American cinema draws from its most solid form; from the general situation to the reestablished or transformed situation through the intermediary of a duel, of a convergence of actions. American montage is organic-active. It is wrong to criticize it as being subordinate to the narration; it is the reverse, for the narrativity flows from this conception of montage. In *Intolerance,* Griffith discovers that the organic representation can be immense, encompassing not merely families and a society, but different epochs and civilizations. The parts thrown together by parallel montage are the civilizations themselves. The relative dimensions which are interchanged range from the king's city to the capitalist's office. And the convergent actions are not just the duels proper to each civilization—the chariot-race in the Babylonian episode, the race between the car and the train in the modern episode—but the two races themselves converge through the centuries in an accelerated montage which superimposes Babylon and America. Never again will such an organic unity be achieved, by means of rhythm, from parts which are so different and actions which are so distant.

Whenever time has been considered in relation to movement, whenever it has been defined as the measure of movement, two aspects of time have been discovered, which are chronosigns: on the one hand, time as whole, as great circle or spiral, which draws together the set of movement in the universe; on the other, time as interval, which indicates the smallest unit of movement or action. Time as whole, the set of movement in the universe, is the bird which hovers, continually increasing its circle. But the numerical unit of movement is the beating of a wing, the continually diminishing interval between two movements or two actions. Time as interval is the accelerated variable present, and time as whole is the spiral open at both ends, the immensity of past and future. Infinitely dilated, the present would become the whole itself: infinitely contracted, the whole would happen in the interval. What originates from montage, or from the composition of movement-images is the Idea, that indirect image of time: the whole which winds up and unwinds the set of the parts in the famous wellspring of *Intolerance,* and the interval between actions which gets smaller and smaller in the accelerated montage of the races.

———

While he fully acknowledges his debt to Griffith. Eisenstein nevertheless makes two objections. Firstly, it might be said that the differentiated parts of the set are given of themselves, as independent phenomena. Just like bacon, with its alternation of lean meat and fat, there are rich and poor, good and bad, Whites and Blacks, etc. Thus when the representatives of these parts confront each other, it must be in the form of individual duels where narrowly personal motifs (for example, a love story, the melodramatic element) are hidden beneath collective

motivations. It is like parallel lines which pursue each other, and indeed meet at infinity, but only collide here below when a secant brings together a particular point on the one and a particular point on the other. Griffith is oblivious to the fact that rich and poor are not given as independent phenomena, but are dependent on a single general cause, which is social exploitation. . . . These objections which condemn Girffith's 'bourgeois' view do not merely relate to his way of telling a story or of understanding History. They relate directly to parallel (and also convergent) montage.[2] Eisenstein criticizes Griffith for having a thoroughly empirical conception of the organism, without a law of genesis or development— for having conceived of its unity in a completely extrinsic way as a unity of collection, the gathering together of juxtaposed parts, and not as a unity of production, a *cell* which produces its own parts by division, differentiation; for having interpreted opposition as an accident and not as the internal motive force by which the divided unity forms a new unity on another level. It will be noted that Eisenstein retains Griffith's idea of an organic composition or assemblage of movement-images: from the general situation [*situation d'ensemble*] to the transformed situation, through the development and transcendence of the oppositions. But it *is* true that Griffith did not see the dialectical nature of the organism and its composition. The organic is indeed a great spiral, but the spiral should be conceived of 'scientifically' and not empirically, in terms of a law of genesis, growth, and development. Eisenstein judged that he had mastered his method in *Battleship Potemkin*, and it is in his commentary on this film that he puts forward the new conception of the organic.[3]

The organic spiral finds its internal law in the golden section, which marks a caesural point and divides the set into two great parts which may be opposed, but which are unequal (this is the moment of sorrow where a transition is made from the ship to the town, and where the movement is reversed). But it is also each twist of the spiral, or segment, which divides up in its turn into two unequal opposing parts. And there are many kinds of opposition: quantitative (one-many, one man—many men, a single shot—a salvo, one ship—a fleet); qualitative (sea-land); intensive (dark-light); dynamic (movement upward and downward, from left to right, and vice versa). Moreover, if one starts off from the end of the spiral rather than its beginning, the golden section determines another caesura, the highest point of reversal instead of the lowest, which gives rise to other divisions and other oppositions. Thus the spiral progresses by growing through oppositions or contradictions. But what is expressed in this way is the movement of the One, which divides itself in two and recreates a new unity. Indeed, if the opposable parts are related to the origin O (or to the end), from the standpoint of genesis they enter into a proportion which is that of the golden section, according to which the smallest part must be to the largest what the largest is to the set:

$$\frac{OA}{OB} = \frac{OB}{OC} = \frac{OC}{OD} \ldots = m$$

The opposition serves the dialectical unity whose progression from the initial to the final situation it marks. It is in this sense that the set is reflected in each part and each part or twist of the spiral reproduces the set. And this applies not only to the sequence, but to each image which also contains its caesuras, its oppositions, its origin and its end. Each image not only has the unity of an element which may be juxtaposed to others, but the genetic unity of a 'cell', which may be divided into others. Eisenstein says that the movement-image is the cell of montage, and not simply an element of montage. In short, *montage of opposition* takes the place of parallel montage, under the dialectical law of the One which divides itself in order to form the new, higher unity.

We are only outlining the theoretical skeleton of Eisenstein's commentary, which closely follows the concrete images (the Odessa steps, for example). This dialectical composition may be seen in *Ivan the Terrible,* in particular with the two caesuras which correspond to Ivan's two moments of doubt—first, when he examines his conscience beside his wife's coffin, and then when he pleads with the monk. The first marks the end of the first twist of the spiral, the first stage of the struggle against the boyars; the other marks the beginning of the second stage and, between the two, the retreat from Moscow. Official Soviet criticism attacked Eisenstein for having conceived the second stage as a personal duel between Ivan and his aunt. Eisenstein does indeed reject the anachronistic view of an Ivan who united himself with the people. From start to finish, Ivan merely uses the people as a tool, as is appropriate to the historical conditions of the period. Nevertheless within these conditions he develops his opposition to the boyars, which does not become a personal duel in the manner of Griffith, but evolves from political compromise to physical and social extermination.

Eisenstein calls upon science, mathematics, and the natural sciences in his defense. This does not detract from art, since—like painting—the cinema must invent the spiral which suits the theme, and choose the caesura points well. We can already see from this standpoint of genesis and growth that Eisenstein's method essentially involves the determination of remarkable points or privileged instants. But they do not, as in Griffith, express an accidental element or the contingency of the individual. On the contrary, they belong fully to the regular construction of the organic spiral. This is even clearer if we consider a new dimension which Eisenstein presents, sometimes adding itself to those of the organic, sometimes perfecting them. The composition, the dialectical assemblage, involves not only the organic—that is, genesis and growth—but also the *pathetic* or the 'development'. The pathetic should not be confused with the organic. The point is that from one point to another on the spiral one can extend vectors which are like the strings of a bow, or the spans of the twist of a spiral. It is no longer a case of the formation and progression of the oppositions themselves, following the twists of the spiral, but of the transition from one opposite to the other, or rather into the other, along the spans: the leap into the opposite. There is not simply the opposition of earth and water, of the one and the many; there is the transition of the one

into the other, and the sudden upsurge of the other out of the one. There is not simply the organic unity of opposites, but the pathetic passage of the opposite into its contrary. There is not simply an organic link between two instants, but a pathetic jump, in which the second instant gains a new power, since the first has passed into it. From sadness to anger, from doubt to certainty, from resignation to revolt. . . . The pathetic, for its part, involves these two aspects: it is simultaneously the transition from one term to another, from one quality to another, and the sudden upsurge of the new quality which is born from the transition which has been accomplished. It is both 'compression' and 'explosion'.[4] *The General Line* divides its spiral into two opposed parts, 'the Old' and 'the New', and reproduces its division, redistributes its oppositions on one side and the other: this is the organic. But in the famous scene of the creamer, we witness the transition from one moment to the other, from suspicion and hope to triumph, from the empty tube to the first drop, a transition which accelerates as the new quality, the triumphant drop, approaches; this is the pathetic, the jump or qualitative leap. The organic was the bow, the collection of bows; but the pathetic is both the string and the arrow, the change in quality and the sudden upsurge of the new quality, its squaring, its raising to the power of two.

The pathetic therefore implies a change not merely in the content of the image, but also in the form. The image must, effectively, change its power, pass to a higher power. This is what Eisenstein calls 'absolute change of dimension,' in contrast to Griffith's merely relative changes. By absolute change, we must understand that the qualitative leap is as much formal as material. In Eisenstein, the insertion of the close-up marks just such a formal leap—an absolute change, that is, the 'squaring' of the image. In comparison with Griffith, this is a completely new function of the close-up.[5] And if it includes a subjectivity, it is the sense that consciousness is also a passage into a new dimension, a raising to the power of two (which can be achieved through 'a series of enlarging close-ups', but which may equally make use of other techniques). In any case, consciousness is the pathetic, the transition from Nature to man and the quality which is born from the transition which has been accomplished. It is at once the dawn of consciousness and consciousness attained, revolutionary consciousness attained, at least to a certain degree: which may be the very limited degree of *Ivan*, or the merely anticipatory degree of *Battleship Potemkin*, or the culminating degree of *October*. If the pathetic is development, it is because it is the development of consciousness itself: it is the leap of the organic which produces an external consciousness of society and its history, of the social organism from one moment to the next. And there are yet other leaps—in variable relationships with those of consciousness—all expressing new dimensions, formal and absolute changes, raisings to yet higher powers. It is the leap into color, like the red flag of *Battleship Potemkin*, or *Ivan*'s red banquet. With sound and the talkie, Eisenstein was to discover still further raisings of power.[6] But, to confine ourselves to silent films, the qualitative leap can attain formal or absolute changes which already constitute

powers to the 'nth degree'. The stream of milk in *The General Line* gives way to jets of water (passage to scintillation), then to a firework (passage to color) and finally to zigzags of figures (passage from the visible to the legible). From this standpoint, Eisenstein's difficult concept of 'montage of attractions'—which can certainly not be reduced to the bringing into play of comparisons or even of metaphors—becomes much more comprehensible.[7] In our view the 'attractions' consist sometimes in theatrical or circus representations (Ivan's red banquet), sometimes in plastic representations (the statues and sculptures in *Battleship Potemkin* and particularly in *October*) which intervene to prolong or replace the image. The jets of fire and water in *The General Line* are of the same type. Of course, attraction must firstly be understood in its spectacular sense. Then also in an associative sense: the association of images as a Newtonian law of attraction. But, furthermore, what Eisenstein calls 'attractional calculus' marks this dialectical yearning of the image to gain new dimensions, that is, to leap formally from one power into another. The jets of water and fire raise the drop of milk to a properly cosmic dimension. And it is consciousness which becomes cosmic at the same time as it becomes revolutionary—having reunited in a final leap of pathos the whole of the organic in itself—earth, air, fire, and water. We will see later how, in this way, montage of attractions constantly makes the organic and the pathetic communicate with one another.

Eisenstein substitutes a montage of opposition for Griffith's parallel montage, and a montage of qualitative leaps ('jumping montage') for convergent or concurrent montage. All kinds of new aspects of montage are brought together at this point—or rather flow from it—in a grand creation both of practical operations and theoretical concepts: a new conception of the close-up, a new conception of accelerated montage, vertical montage, montage of attractions, intellectual or consciousness montage. . . . We believe in the coherence of this organic-pathetic set. And this is indeed the key point of Eisenstein's revolution: he gives the dialectic a properly cinematographic meaning, he tears rhythm away from the purely empirical or aesthetic value which it had, for example, in Griffith, he reaches an essentially dialectical conception of the organism. Time remains an indirect image which is born from the organic composition of movement-images, *but the interval, as well as the whole* [tout] *takes on a new meaning.* The interval, the variable present, has become the qualitative leap which reaches the raised power of the instant. As for the whole as immensity, this is no longer a totality of reuniting which subsumes the independent parts on the sole condition that they exist for each other, and which can always be enlarged if one adds parts to the conditioned set [*ensemble*], or if one relates two independent sets to the idea of an identical end. It is a totality which has become concrete or existing, in which the parts are produced by each other in their set and the set is reproduced in the parts, so that this reciprocal causality refers back to the whole as cause of the set *and* of its parts, according to an internal finality. The spiral open at both ends is no longer a way of assembling an empirical reality from outside, but the way in which dialec-

tical reality constantly produces itself and grows. Things truly plunge *into* time and become immense because they occupy there an infinitely greater position than the parts have in the set or the set in itself. The set and the parts of *Battleship Potemkin*—forty-eight hours—or of *October*—ten days—occupy in time, that is, in the whole [*tout*], an immeasurably prolonged period. And, far from being added, or compared from the outside, the attractions *are* this very prolongation, or this internal existence in the whole. In Eisenstein the dialectical conception of the organism and of montage combines the ever-open spiral and the perpetually leaping instant.

 The dialectic, as is well-known, is defined by many laws. There is the law of the quantitative process and the qualitative leap: the passage from one quality to another and the sudden upsurge of the new quality. There is the law of the whole, of the set and of the parts. There is also the law of the One and the opposition, on which—it is said—the two other laws depend: the One which becomes two to attain a new unity. If we can speak of a Soviet school of montage, it is not because its directors are similar but because within the dialectical conception which they share they in fact differ, each having an affinity with one or other of the laws which his inspiration recreates. Pudovkin is clearly mainly interested in the progression of consciousness, in the qualitative leaps of a dawn of consciousness; it is from this viewpoint that *Mother, The End of St Petersburg*, and *Storm over Asia* form a great trilogy. Nature is there, in its splendor and theatricality— the Neva carrying along its ice-floes, the Mongolian plains—but as the linear thrust which subtends the moments of dawning consciousness; that of the mother, the peasant, or the Mongol. And Pudovkin's most profound art lies in disclosing the set of a situation through the consciousness which a character gains of it, and in prolonging it to the point where consciousness can expand and act (the mother watching over the father who wants to steal the weights of a clock, or, in *The End of St Petersburg*, the woman who sums up in a glance the elements of the situation; the policeman, the glass of tea on the table, the smoking candle, the boots of the arriving husband).[8] Dovzhenko is a dialectician in another way, obsessed with the triadic relation of the parts, the set, and the whole. If there was ever a director who knew how to make a set and the parts plunge into a whole which gives them a depth and extension disproportionate to their proper limits, it was Dovzhenko to a far greater extent than Eisenstein. This is the source of the fantasy and enchantment in Dovzhenko. Sometimes scenes can be static parts or disjointed fragments, like the images of poverty at the beginning of *Arsenal*—the prostrate woman, the immobile mother, the muzhik, the woman sowing, the gassed corpses (or, on the other hand, the joyous images of *Earth*—the couples who are immobile, seated, standing, or recumbent). Sometimes a dynamic and continuous set [*ensemble*] can form at a particular place, at a particular moment, for example, in the 'taiga' of *Aerograd*. Each time, we can be sure that a plunge into the whole will connect the images with a millenial past, like that of the Ukrainian mountain and the treasure of the Scythians in *Zvenigora*; and with a

planetary future where airplanes bring the builders of the new city from all points of the horizon. Amengual used to speak of 'the abstraction of montage' which, through the set or the fragments, gave the director the 'power to speak outside real time and space.'[9] But this outside is also the Earth, or the true interiority of time, that is, the whole which changes, and which by changing perspective, constantly gives real beings that infinite space which enables them to touch the most distant past and the depths of the future simultaneously, and to participate in the movement of its own 'revolution': for instance, the grandfather who dies peacefully at the start of *Earth*, or the one in *Zvenigora* who frequents the inside of time. What Dovzhenko gives to his peasants, and to *Shchors*, as 'legendary beings of a fabulous epoch' is what Proust describes as the giants' stature which men assume in time, which separates the parts as much as it prolongs the set.

In a certain respect, Eisenstein could consider himself leader of the school—in relation to Pudovkin and Dovzhenko—because he was imbued with the third law of the dialectic, the one which seemed to contain the other two: the One which becomes two and gives it a new unity, reuniting the organic whole and the pathetic interval. In fact, there were three ways of conceiving a dialectical montage, of which none was destined to please Stalinist criticism. But all three had in common the idea that materialism was primarily historical, and that Nature was only dialectical because always integrated into a human totality. Hence the name which Eisenstein gave to Nature: the 'non-indifferent'. Vertov's originality, on the contrary, is the radical affirmation of a dialectic of matter in itself. This is like a fourth law, breaking with the other three.[10] To be sure, what Vertov was showing was man present in Nature, his actions, his passions, his life. But, if he worked through documentaries and newsreels, if he violently challenged the filming of Nature and the construction of the action, this was for a profound reason. Whether there were machines, landscapes, buildings, or men was of little consequence: each—even the most charming peasant woman or the most touching child—was presented as a material system in perpetual interaction. They were catalysts, converters, transformers, which received and re-emitted movements, whose speed, direction, order, they changed, making matter evolve toward less 'probable' states, bringing about changes out of all proportion to their own dimensions. It is not that Vertov considered beings to be machines, but rather machines which had a 'heart' and which 'revolved, trembled, jolted about and threw out flashes of lightning,' as man could also do, using other movements and under other conditions, but always in interaction with each other. What Vertov discovered in contemporary life was the molecular child, the molecular woman, the material woman and child, as much as systems which are called mechanisms or machines. Most important were all the (communist) transitions from an order which is being undone to an order which is being constructed. But between two systems or two orders, between two movements, there is necessarily the variable interval. In Vertov the interval of movement is perception, the glance, the eye. But the eye is not the too-immobile human eye; it is the eye of the camera, that is, an eye in matter, a

perception such as it is in matter, as it extends from a point where an action begins to the limit of the reaction, as it fills the interval between the two, crossing the universe and beating in time to its intervals. The correlation between a non-human matter and a superhuman eye is the dialectic itself, because it is also the identity of a community of matter and a communism of man. And montage itself constantly adapts the transformations of movements in the material universe to the interval of movement in the eye of the camera: rhythm. Montage, it must be said, was already everywhere in the two preceding moments. It precedes the filming, in the choice of material, that is, the portions of matter which are to enter into interaction, sometimes very distant or far apart (life as it is). It enters into the filming, in the intervals occupied by the camera-eye (the cameraman who follows, runs, enters, exits: in short, life in the film). It comes after the filming, in the editing-room, where material and filming are evaluated against one another (the life of the film), and in the audience, who compare life in the film and life as it is. These are the three levels which are explicitly shown to co-exist in *Man with a Movie-Camera*, but which had already inspired all his previous work.

Dialectic was not just a word for Soviet filmmakers. It was both the practice and the theory of montage. But, while the three other great directors used the dialectic to transform the organic composition of movement-images, Vertov found in it the means of breaking with this composition. He criticized his rivals for being carried along in Griffith's wake, for imitating the American cinema, or for a bourgeois idealism. In his view, the dialectic should break with a Nature which was still too organic, and with a man still too readily pathetic. The result in his work was that the whole merges with the infinite set of matter, and the interval merges with an eye in matter, Camera. He would no longer be understood by official criticism. But he would have taken to its limit a debate within the dialectic which Eisenstein knew very well how to summarize when he was not content with polemic. Vertov opposes to the 'Nature-man', 'Nature-fist', 'Nature-punch' pair (organic-pathetic) a 'matter-eye' pair.[11]

NOTES

1. On the close-up and binary structure in Griffith, cf. Jacques Fieschi, "Griffith le précurseur," *Cinématographe*, no. 24, February 1977. On Griffith's close-up and the process of miniaturization and subjectivation, cf. Yann Lardeau, "King David," *Cahiers du cinéma*, no. 346, April 1983.

2. S. Eisenstein's brilliant analysis consists in showing that parallel montage, in its practice as well as its conception, relates to bourgeois society in its conception of itself and in its practice: *Film Form*, 1951, "Dickens, Griffith and the Film Today."

3. Eisenstein, *La non-indifférente Nature*, "L'Organique et le pathétique." This chapter, which revolves around *Battleship Potemkin*, analyzes the organic (genesis and growth) and tackles the pathetic which completes it. The following chapter, *"La centrifugeuse et le Graal,"* centered on *The General Line*, continues the analysis of the pathetic in its relation to the organic.

4. S. Eisenstein, *Mémoires*, I, 283–284.

5. Bonitzer analyzes this difference between Eisenstein and Griffith (absolute or relative change of dimension) in *Le Champ aveugle*, 30–32.

6. For instance, what Eisenstein calls 'vertical montage' in *the Film Sense*, 1968, trans. Jay Leyda, 67ff.

7. Eisenstein, in *La non-indifférente Nature*, already emphasizes the formal character of the qualitative (and not merely material) jump. This character is defined by the necessary presence of a 'raising of power' of the image; 'montage by attraction' necessarily intervenes here. The many commentaries to which a montage of attraction as presented by Eisenstein in *Au-delà des Étoiles* has given rise, seem interminable if the growing powers of the images are not taken into account. And, from this standpoint, the question whether Eisenstein renounced this technique does not arise: he would always need it in his concept of the qualitative leap.

8. Cf. Mitry, *L'Histoire du cinéma muet*, III, 306: "Then she looks: the glass, the boots, the policeman; then hurls herself upon the glass and throws it with her full strength at the window. The old man immediately drops down, sees the policeman and flees. By turns, a mere glass of tea, then an element of betrayal, a means of signalization and salvation, that object . . . successively reflects an attention, a state of mind, an intention."

9. Amengual, *Dovzhenko*, Dossiers du cinéma: "The poetic freedom which Dovzhenko had only recently demanded from the organization of disjointed fragments, is obtained in *Aerograd* by a cutting of extraordinary continuity."

10. The question of ascertaining whether there is only a human dialectic, or indeed whether one can speak of a dialectic of Nature in itself (or of matter), has always troubled Marxism. Jean-Paul Sartre raises it again in *The Critique of Dialectical Reason* (1976), in affirming the human character of any dialectic.

11. Eisenstein recognized that the Vertov method might be appropriate when man had attained his full 'development'. But, until that time, man needed the pathetic, and attractions. "It is not a cinema-eye that we need, but a cinema-fist. The Soviet cinema should split skulls," and not merely "bring together millions of eyes"; cf. *Au-delà des Étoiles*, 153.

Iconography
and Iconology

Erwin Panofsky

Style and Medium
in the Motion Pictures

Film art is the only art the development of which men now living have witnessed from the very beginnings; and this development is all the more interesting as it took place under conditions contrary to precedent. It was not an artistic urge that gave rise to the discovery and gradual perfection of a new technique; it was a technical invention that gave rise to the discovery and gradual perfection of a new art.

From this we understand two fundamental facts. First, that the primordial basis of the enjoyment of moving pictures was not an objective interest in a specific subject matter, much less an aesthetic interest in the formal presentation of subject matter, but the sheer delight in the fact that things seemed to move, no matter what things they were. Second, that films—first exhibited in "kinetoscopes," viz., cinematographic peep shows, but projectable to a screen since as early as 1894—are originally a product of genuine folk art (whereas, as a rule, folk art derives from what is known as "higher art"). At the very beginning of things we find the simple recording of movements: galloping horses, railroad trains, fire engines, sporting events, street scenes. And when it had come to the making of narrative films these were produced by photographers who were anything but "producers" or "directors," performed by people who were anything but actors, and enjoyed by people who would have been much offended had anyone called them "art lovers."

The casts of these archaic films were usually collected in a "café," where unemployed supers or ordinary citizens possessed of a suitable exterior were wont to assemble at a given hour. An enterprising photographer would walk in, hire four or five convenient characters, and make the picture while carefully instructing them what to do: "Now, you pretend to hit this lady over the head"; and (to the lady): "And you pretend to fall down in a heap." Productions like these were shown, together with those purely factual recordings of "movement for movement's sake," in a few small and dingy cinemas mostly frequented by the "lower classes" and a sprinkling of youngsters in quest of adventure (about 1905, I happen to remember, there was only one obscure and faintly disreputable *kino* in the whole city of Berlin,

Bulletin of the Department of Art and Archaeology, Princeton University, 1934. Reprinted in *Film Theory and Criticism: Introductory Readings.* Edited by Leo Braudy and Marshall Cohen. 5th edition. New York: Oxford University Press, 1999: 279–292. © Dr. Gerda S. Panofsky. Reprinted by permission.

bearing, for some unfathomable reason, the English name of "The Meeting Room"). Small wonder that the "better classes," when they slowly began to venture into these early picture theaters, did so, not by way of seeking normal and possibly serious entertainment, but with that characteristic sensation of self-conscious condescension with which we may plunge, in gay company, into the folkloristic depths of Coney Island or a European kermis; even a few years ago it was the regulation attitude of the socially or intellectually prominent that one could confess to enjoying such austerely educational films as *The Sex Life of the Starfish* or films with "beautiful scenery," but never to a serious liking for narratives.

Today there is no denying that narrative films are not only "art"—not often good art, to be sure, but this applies to other media as well—but also, besides architecture, cartooning, and "commercial design," the only visual art entirely alive. The "movies" have reestablished that dynamic contact between art production and art consumption which, for reasons too complex to be considered here, is sorely attenuated, if not entirely interrupted, in many other fields of artistic endeavor. Whether we like it or not, it is the movies that mold, more than any other single force, the opinions, the taste, the language, the dress, the behavior, and even the physical appearance of a public comprising more than 60 percent of the population of the earth. If all the serious lyrical poets, composers, painters, and sculptors were forced by law to stop their activities, a rather small fraction of the general public would become aware of the fact and a still smaller fraction would seriously regret it. If the same thing were to happen with the movies the social consequences would be catastrophic.

In the beginning, then, there were the straight recordings of movement no matter what moved, viz., the prehistoric ancestors of our "documentaries"; and, soon after, the early narratives, viz., the prehistoric ancestors of our "feature films." The craving for a narrative element could be satisfied only by borrowing from older arts, and one should expect that the natural thing would have been to borrow from the theater, a theater play being apparently the *genus proximum* to a narrative film in that it consists of a narrative enacted by persons that move. But in reality the imitation of stage performances was a comparatively late and thoroughly frustrated development. What happened at the start was a very different thing. Instead of imitating a theatrical performance already endowed with a certain amount of motion, the earliest films added movement to works of art originally stationary, so that the dazzling technical invention might achieve a triumph of its own without intruding upon the sphere of higher culture. The living language, which is always right, has endorsed this sensible choice when it still speaks of a "moving picture" or, simply, a "picture," instead of accepting the pretentious and fundamentally erroneous "screenplay."

The stationary works enlivened in the earliest movies were indeed pictures: bad nineteenth-century paintings and postcards (or waxworks à la Madame Tussaud's), supplemented by the comic strips—a most important root of cinematic art—and the subject matter of popular songs, pulp magazines, and dime novels;

and the films descending from this ancestry appealed directly and very intensely to a folk art mentality. They gratified—often simultaneously—first, a primitive sense of justice and decorum when virtue and industry were rewarded while vice and laziness were punished; second, plain sentimentality when "the thin trickle of a fictive love interest" took its course "through somewhat serpentine channels," or when Father, dear Father returned from the saloon to find his child dying of diphtheria; third, a primordial instinct for bloodshed and cruelty when Andreas Hofer faced the firing squad, or when (in a film of 1893–1894) the head of Mary Queen of Scots actually came off; fourth, a taste for mild pornography (I remember with great pleasure a French film of c. 1900 wherein a seemingly but not really well-rounded lady as well as a seemingly but not really slender one were shown changing into bathing suits—an honest, straightforward *porcheria* much less objectionable than the now extinct Betty Boop films and, I am sorry to say, some of the more recent Walt Disney productions); and, finally, that crude sense of humor, graphically described as "slapstick," which feeds upon the sadistic and the pornographic instinct, either singly or in combination.

Not until as late as c. 1905 was a film adaption of *Faust* ventured upon (cast still "unknown," characteristically enough), and not until 1911 did Sarah Bernhardt lend her prestige to an unbelievably funny film tragedy, *Queen Elizabeth of England*. These films represent the first conscious attempt at transplanting the movies from the folk art level to that of "real art"; but they also bear witness to the fact that this commendable goal could not be reached in so simple a manner. It was soon realized that the imitation of a theater performance with a set stage, fixed entries and exits, and distinctly literary ambitions is the one thing the film must avoid.

The legitimate paths of evolution were opened, not by running away from the folk art character of the primitive film but by developing it within the limits of its own possibilities. Those primordial archetypes of film productions on the folk art level—success or retribution, sentiment, sensation, pornography, and crude humor—could blossom forth into genuine history, tragedy and romance, crime and adventure, and comedy, as soon as it was realized that they could be transfigured—not by an artificial injection of literary values but by the exploitation of the unique and specific possibilities of the new medium. Significantly, the beginnings of this legitimate development antedate the attempts at endowing the film with higher values of a foreign order (the crucial period being the years from 1902 to c. 1905), and the decisive steps were taken by people who were laymen or outsiders from the viewpoint of the serious stage.

These unique and specific possibilities can be defined as *dynamization of space* and, accordingly, *spatialization of time*. This statement is self-evident to the point of triviality but it belongs to that kind of truths which, just because of their triviality, are easily forgotten or neglected.

In a theater, space is static, that is, the space represented on the stage, as well as the spatial relation of the beholder to the spectacle, is unalterably fixed. The spectator cannot leave his seat, and the setting of the stage cannot change, during one act (except for such incidentals as rising moons or gathering clouds and such illegitimate reborrowings from the film as turning wings or gliding backdrops). But, in return for this restriction, the theater has the advantage that time, the medium of emotion and thought conveyable by speech, is free and independent of anything that may happen in visible space. Hamlet may deliver his famous monologue lying on a couch in the middle distance, doing nothing and only dimly discernible to the spectator and listener, and yet by his mere words enthrall him with a feeling of intensest emotional action.

With the movies the situation is reversed. Here, too, the spectator occupies a fixed seat, but only physically, not as the subject of an aesthetic experience. Aesthetically, he is in permanent motion as his eye identifies itself with the lens of the camera, which permanently shifts in distance and direction. And as movable as the spectator is, as movable is, for the same reason, the space presented to him. Not only bodies move in space, but space itself does, approaching, receding, turning, dissolving, and recrystallizing as it appears through the controlled locomotion and focusing of the camera and through the cutting and editing of the various shots—not to mention such special effects as visions, transformations, disappearances, slow-motion and fast-motion shots, reversals, and trick films. This opens up a world of possibilities of which the stage can never dream. Quite apart from such photographic tricks as the participation of disembodied spirits in the action of the *Topper* series, or the more effective wonders wrought by Roland Young in *The Man Who Could Work Miracles,* there is, on the purely factual level, an untold wealth of themes as inaccessible to the "legitimate" stage as a fog or a snowstorm is to the sculptor; all sorts of violent elemental phenomena and, conversely, events too microscopic to be visible under normal conditions (such as the life-saving injection with the serum flown in at the very last moment, or the fatal bite of the yellow-fever mosquito); full-scale battle scenes; all kinds of operations, not only in the surgical sense but also in the sense of any actual construction, destruction, or experimentation, as in *Louis Pasteur* or *Madame Curie;* a really grand party, moving through many rooms of a mansion or a palace. Features like these, even the mere shifting of the scene from one place to another by means of a car perilously negotiating heavy traffic or a motorboat steered through a nocturnal harbor, will not only always retain their primitive cinematic appeal but also remain enormously effective as a means of stirring the emotions and creating suspense. In addition, the movies have the power, entirely denied to the theater, to convey psychological experiences by directly projecting their content to the screen, substituting, as it were, the eye of the beholder for the consciousness of the character (as when the imaginings and hallucinations of the drunkard in the otherwise overrated *Lost Weekend* appear as stark realities instead of being described by mere words). But any attempt to convey thoughts and feelings exclu-

sively, or even primarily, by speech leaves us with a feeling of embarrassment, boredom, or both.

What I mean by thoughts and feelings "conveyed exclusively, or even primarily, by speech" is simply this: contrary to naïve expectation, the invention of the soundtrack in 1928 has been unable to change the basic fact that a moving picture, even when it has learned to talk, remains a picture that moves and does not convert itself into a piece of writing that is enacted. Its substance remains a series of visual sequences held together by an uninterrupted flow of movement in space (except, of course, for such checks and pauses as have the same compositional value as a rest in music), and not a sustained study in human character and destiny transmitted by effective, let alone "beautiful," diction. I cannot remember a more misleading statement about the movies that Mr. Eric Russell Bentley's in the spring number of the *Kenyon Review*, 1945: "The potentialities of the talking screen differ from those of the silent screen in adding the dimension of dialogue—which could be poetry." I would suggest: "The potentialities of the talking screen differ from those of the silent screen in integrating visible movement with dialogue which, therefore, had better not be poetry."

All of us, if we are old enough to remember the period prior to 1928, recall the old-time pianist who, with his eyes glued on the screen, would accompany the events with music adapted to their mood and rhythm; and we also recall the weird and spectral feeling overtaking us when this pianist left his post for a few minutes and the film was allowed to run by itself, the darkness haunted by the monotonous rattle of the machinery. Even the silent film, then, was never mute. The visible spectacle always required, and received, an audible accompaniment which, from the very beginning, distinguished the film from simple pantomime and rather classed it—mutatis mutandis—with the ballet. The advent of the talkie meant not so much an "addition" as a transformation: the transformation of musical sound into articulate speech and, therefore, of quasi-pantomime into an entirely new species of spectacle which differs from the ballet, and agrees with the stage play, in that its acoustic component consists of intelligible words, but differs from the stage play and agrees with the ballet in that this acoustic component is not detachable from the visual. In a film, that which we hear remains, for good or worse, inextricably fused with that which we see; the sound, articulate or not, cannot express any more than is expressed, at the same time, by visible movement; and in a good film it does not even attempt to do so. To put it briefly, the play—or, as it is very properly called, the "script"—of a moving picture is subject to what might be termed the *principle of coexpressibility*.

Empirical proof of this principle is furnished by the fact that, wherever the dialogical or monological element gains temporary prominence, there appears, with the inevitability of a natural law, the "close-up." What does the close-up achieve? In showing us, in magnification, either the face of the speaker or the face of the listeners or both in alternation, the camera transforms the human physiognomy into a huge field of action where—given the qualification of the

performers—every subtle movement of the features, almost imperceptible from a natural distance, becomes an expressive event in visible space and thereby completely integrates itself with the expressive content of the spoken word; whereas, on the stage, the spoken word makes a stronger rather than a weaker impression if we are not permitted to count the hairs in Romeo's mustache.

This does not mean that the scenario is a negligible factor in the making of a moving picture. It only means that its artistic intention differs in kind from that of a stage play, and much more from that of a novel or a piece of poetry. As the success of a gothic jamb figure depends not only upon its quality as a piece of sculpture but also, or even more so, upon its integrability with the architecture of the portal, so does the success of a movie script—not unlike that of an opera libretto—depend, not only upon its quality as a piece of literature but also, or even more so, upon its integrability with the events on the screen.

As a result—another empirical proof of the coexpressibility principle—good movie scripts are unlikely to make good reading and have seldom been published in book form; whereas, conversely, good stage plays have to be severely altered, cut, and, on the other hand, enriched by interpolations to make good movie scripts. In Shaw's *Pygmalion*, for instance, the actual process of Eliza's phonetic education and, still more important, her final triumph at the grand party, are wisely omitted; we see—or, rather, hear—some samples of her gradual linguistic improvement and finally encounter her, upon her return from the reception, victorious and splendidly arrayed but deeply hurt for want of recognition and sympathy. In the film adaptation, precisely these two scenes are not only supplied but also strongly emphasized; we witness the fascinating activities in the laboratory with its array of spinning disks and mirrors, organ pipes and dancing flames, and we participate in the ambassadorial party, with many moments of impending catastrophe and a little counterintrigue thrown in for suspense. Unquestionably these two scenes, entirely absent from the play, and indeed unachievable upon the stage, were the highlights of the film; whereas the Shavian dialogue, however severely cut, turned out to fall a little flat in certain moments. And wherever, as in so many other films, a poetic emotion, a musical outburst, or a literary conceit (even, I am grieved to say, some of the wisecracks of Groucho Marx) entirely lose contact with visible movement, they strike the sensitive spectator as, literally, out of place. It is certainly terrible when a soft-boiled he-man, after the suicide of his mistress, casts a twelve-foot glance upon her photograph and says something less-than-coexpressible to the effect that he will never forget her. But when he recites, instead, a piece of poetry as sublimely more-than-coexpressible as Romeo's monologue at the bier of Juliet, it is still worse. Reinhardt's *Midsummer Night's Dream* is probably the most unfortunate major film ever produced; and Olivier's *Henry V* owes its comparative success, apart from the all but providential adaptability of this particular play, to so many tours de force that it will, God willing, remain an exception rather than set a pattern. It combines "judicious pruning" with the interpolation of pageantry, nonverbal comedy, and melodrama; it uses a

device perhaps best designated as "oblique close-up" (Mr. Olivier's beautiful face inwardly listening to but not pronouncing the great soliloquy); and, most notably, it shifts among three levels of archeological reality: a reconstruction of Elizabethan London, a reconstruction of the events of 1415 as laid down in Shakespeare's play, and the reconstruction of a performance of this play on Shakespeare's own stage. All this is perfectly legitimate; but, even so, the highest praise of the film will always come from those who, like the critic of the *New Yorker*, are not quite in sympathy with either the movies *au naturel* or Shakespeare *au naturel*.

––––––––––

As the writings of Conan Doyle potentially contain all modern mystery stories (except for the tough specimens of the Dashiell Hammett school), so do the films produced between 1900 and 1910 preestablish the subject matter and methods of the moving picture as we know it. This period produced the incunabula of the Western and the crime film (Edwin S. Porter's amazing *Great Train Robbery* of 1903) from which developed the modern gangster, adventure, and mystery pictures (the latter, if well done, is still one of the most honest and genuine forms of film entertainment, space being doubly charged with time as the beholder asks himself not only "What is going to happen?" but also "What has happened before?"). The same period saw the emergence of the fantastically imaginative film (Méliès) which was to lead to the expressionist and surrealist experiments (*The Cabinet of Dr. Caligari, Sang d'un Poète* [fig. 1], etc.), on the one hand, and to the more superficial and spectacular fairy tales à la Arabian Nights, on the other. Comedy, later to triumph in Charlie Chaplin, the still insufficiently appreciated Buster Keaton, the Marx Brothers, and the pre-Hollywood creations of René Clair, reached a respectable level in Max Linder and others. In historical and melodramatic films the foundations were laid for movie iconography and movie symbolism, and in the early work of D. W. Griffith we find, not only remarkable attempts at psychological analysis (*Edgar Allan Poe*) and social criticism (*A Corner in Wheat*) but also such basic technical innovations as the long shot, the flashback, and the close-up. And modest trick films and cartoons paved the way to Felix the Cat, Popeye the Sailor, and Felix's prodigious offspring, Mickey Mouse.

Within their self-imposed limitations the earlier Disney films, and certain sequences in the later ones,[1] represent, as it were, a chemically pure distillation of cinematic possibilities. They retain the most important folkloristic elements—sadism, pornography, the humor engendered by both, and moral justice—almost without dilution and often fuse these elements into a variation on the primitive and inexhaustible David-and-Goliath motif, the triumph of the seemingly weak over the seemingly strong; and their fantastic independence of the natural laws gives them the power to integrate space with time to such perfection that the spatial and temporal experiences of sight and hearing come to be almost interconvertible. A series of soap bubbles, successively punctured, emits a series of sounds exactly corresponding in pitch and volume to the size of the bubbles; the

Figure 1. Cesare (Conrad Veidt) and Jane (Lil Dagover). Robert Wiene, The Cabinet of Dr. Caligari *(1919).* Museum of Modern Art, New York.

three uvulae of Willie the Whale—small, large, and medium—vibrate in consonance with tenor, bass, and baritone notes; and the very concept of stationary existence is completely abolished. No object in creation, whether it be a house, a piano, a tree, or an alarm clock, lacks the faculties of organic, in fact anthropomorphic, movement, facial expression, and phonetic articulation. Incidentally, even in normal, "realistic" films the inanimate object, provided that it is dynamizable, can play the role of a leading character as do the ancient railroad engines in Buster Keaton's *General* and *Niagara Falls* (fig. 2). How the earlier Russian films exploited the possibility of heroizing all sorts of machinery lives in everybody's memory; and it is perhaps more than an accident that the two films which will go down in history as the great comical and the great serious masterpieces of the silent period bear the names and immortalize the personalities of two big ships: Keaton's *Navigator* (1924) and Eisenstein's *Potemkin* (1925).

The evolution from the jerky beginnings to this grand climax offers the fascinating spectacle of a new artistic medium gradually becoming conscious of its legitimate, that is, exclusive, possibilities and limitations—a spectacle not unlike the development of the mosaic, which started out with transposing illusionistic genre pictures into a more durable material and culminated in the hieratic supernaturalism of Ravenna; or the development of line engraving, which started out as a cheap and handy substitute for book illumination and culminated in the purely "graphic" style of Dürer.

Figure 2. Buster Keaton, The General *(1927).* Museum of Modern Art, New York.

Just so the silent movies developed a definite style of their own, adapted to the specific conditions of the medium. A hitherto unknown language was forced upon a public not yet capable of reading it, and the more proficient the public became the more refinement could develop in the language. For a Saxon peasant of around 800 it was not easy to understand the meaning of a picture showing a man as he pours water over the head of another man, and even later many people found it difficult to grasp the significance of two ladies standing behind the throne of an emperor. For the public of around 1910 it was no less difficult to understand the meaning of the speechless action in a moving picture, and the producers employed means of clarification similar to those we find in medieval art. One of these was printed titles or letters, striking equivalents of the medieval *tituli* and scrolls (at a still earlier date there even used to be explainers who would say, *viva voce,* "Now he thinks his wife is dead but she isn't" or "I don't wish to offend the ladies in the audience but I doubt that any of them would have done that much for her child"). Another, less obtrusive method of explanation was the introduction of a fixed iconography which from the outset informed the spectator about the basic facts and characters, much as the two ladies behind the emperor, when carrying a sword and a cross respectively, were uniquely determined as Fortitude and Faith. There arose, identifiable by standardized appearance, behavior, and

attributes, the well-remembered types of the Vamp and the Straight Girl (perhaps the most convincing modern equivalents of the medieval personifications of the Vices and Virtues), the Family Man, and the Villain, the latter marked by a black mustache and walking stick. Nocturnal scenes were printed on blue or green film. A checkered tablecloth meant, once for all, a "poor but honest" milieu; a happy marriage, soon to be endangered by the shadows from the past, was symbolized by the young wife's pouring the breakfast coffee for her husband; the first kiss was invariably announced by the lady's gently playing with her partner's necktie and was invariably accompanied by her kicking out with her left foot. The conduct of the characters was predetermined accordingly. The poor but honest laborer who, after leaving his little house with the checkered tablecloth, came upon an abandoned baby could not but take it to his home and bring it up as best he could; the Family Man could not but yield, however temporarily, to the temptations of the Vamp. As a result these early melodramas had a highly gratifying and soothing quality in that events took shape, without the complications of individual psychology, according to a pure Aristotelian logic so badly missed in real life.

Devices like these became gradually less necessary as the public grew accustomed to interpret the action by itself and were virtually abolished by the invention of the talking film. But even now there survive—quite legitimately, I think—the remnants of a "fixed attitude and attribute" principle and, more basic, a primitive or folkloristic concept of plot construction. Even today we take it for granted that the diphtheria of a baby tends to occur when the parents are out and, having occurred, solves all their matrimonial problems. Even today we demand of a decent mystery film that the butler, although he may be anything from an agent of the British Secret Service to the real father of the daughter of the house, must not turn out to be the murderer. Even today we love to see Pasteur, Zola, or Ehrlich win out against stupidity and wickedness, with their respective wives trusting and trusting all the time. Even today we much prefer a happy finale to a gloomy one and insist, at the very least, on the observance of the Aristotelian rule that the story have a beginning, a middle, and an ending—a rule the abrogation of which has done so much to estrange the general public from the more elevated spheres of modern writing. Primitive symbolism, too, survives in such amusing details as the last sequence of *Casablanca,* where the delightfully crooked and right-minded *préfet de police* casts an empty bottle of Vichy water into the wastepaper basket; and in such telling symbols of the supernatural as Sir Cedric Hardwicke's Death in the guise of a "gentleman in a dustcoat trying" (*On Borrowed Time*) or Claude Rains's Hermes Psychopompos in the striped trousers of an airline manager (*Here Comes Mister Jordan*).

The most conspicuous advances were made in directing, lighting, camera work, cutting, and acting proper. But while in most of these fields the evolution proceeded continuously—although, of course, not without detours, breakdowns, and archaic relapses—the development of acting suffered a sudden interruption by the

invention of the talking film; so that the style of acting in the silents can already be evaluated in retrospect, as a lost art not unlike the painting technique of Jan van Eyck or, to take up our previous simile, the burin technique of Dürer. It was soon realized that acting in a silent film neither meant a pantomimic exaggeration of stage acting (as was generally and erroneously assumed by professional stage actors who more and more frequently condescended to perform in the movies), nor could dispense with stylization altogether; a man photographed while walking down a gangway in ordinary, everyday-life fashion looked like anything but a man walking down a gangway when the result appeared on the screen. If the picture was to look both natural and meaningful the acting had to be done in a manner equally different from the style of the stage and the reality of ordinary life; speech had to be made dispensable by establishing an organic relation between the acting and the technical procedure of cinephotography—much as in Dürer's prints color had been made dispensable by establishing an organic relation between the design and the technical procedure of line engraving.

This was precisely what the great actors of the silent period accomplished, and it is a significant fact that the best of them did not come from the stage, whose crystallized tradition prevented Duse's only film, *Cenere,* from being more than a priceless record of Duse. They came instead from the circus or the variety, as was the case of Chaplin, Keaton, and Will Rogers; from nothing in particular, as was the case of Theda Bara, of her greater European parallel, the Danish actress Asta Nielsen, and of Garbo; or from everything under the sun, as was the case of Douglas Fairbanks. The style of these "old masters" was indeed comparable to the style of line engraving in that it was, and had to be, exaggerated in comparison with stage acting (just as the sharply incised and vigorously curved *tailles* of the burin are exaggerated in comparison with pencil strokes or brushwork), but richer, subtler, and infinitely more precise. The advent of the talkies, reducing if not abolishing this difference between screen acting and stage acting, thus confronted the actors and actresses of the silent screen with a serious problem. Buster Keaton yielded to temptation and fell. Chaplin first tried to stand his ground and to remain an exquisite archaist but finally gave in, with only moderate success (*The Greater Dictator*). Only the glorious Harpo has thus far successfully refused to utter a single articulate sound; and only Greta Garbo succeeded, in a measure, in transforming her style in principle. But even in her case one cannot help feeling that her first talking picture, *Anna Christie,* where she could ensconce herself, most of the time, in mute or monosyllabic sullenness, was better than her later performances; and in the second, talking version of *Anna Karenina,* the weakest moment is certainly when she delivers a big Ibsenian speech to her husband, and the strongest when she silently moves along the platform of the railroad station while her despair takes shape in the consonance of her movement (and expression) with the movement of the nocturnal space around her, filled with the real noises of the trains and the imaginary sound of the "little men with the iron hammers" that drives her, relentlessly and almost without her realizing it, under the wheels.

Small wonder that there is sometimes felt a kind of nostalgia for the silent

period and that devices have been worked out to combine the virtues of sound and speech with those of silent acting, such as the "oblique close-up" already mentioned in connection with *Henry V*; the dance behind glass doors in *Sous les Toits de Paris*; or, in the *Histoire d'un Tricheur*, Sacha Guitry's recital of the events of his youth while the events themselves are "silently" enacted on the screen. However, this nostalgic feeling is no argument against the talkies as such. Their evolution has shown that, in art, every gain entails a certain loss on the other side of the ledger; but that the gain remains a gain, provided that the basic nature of the medium is realized and respected. One can imagine that, when the cavemen of Altamira began to paint their buffaloes in natural colors instead of merely incising the contours, the more conservative cavemen foretold the end of paleolithic art. But paleolithic art went on, and so will the movies. New technical inventions always tend to dwarf the values already attained, especially in a medium that owes its very existence to technical experimentation. The earliest talkies were infinitely inferior to the then mature silents, and most of the present technicolor films are still inferior to the now mature talkies in black and white. But even if Aldous Huxley's nightmare should come true and the experiences of taste, smell, and touch should be added to those of sight and hearing, even then we may say with the Apostle, as we have said when first confronted with the sound track and the technicolor film, "We are troubled on every side, yet not distressed; we are perplexed, but not in despair."

From the law of time-charged space and space-bound time, there follows the fact that the screenplay, in contrast to the theater play, *has no aesthetic existence independent of its performance, and that its characters have no aesthetic existence outside the actors.*

The playwright writes in the fond hope that his work will be an imperishable jewel in the treasure house of civilization and will be presented in hundreds of performances that are but transient variations on a "work" that is constant. The script-writer, on the other hand, writes for one producer, one director and one cast. Their work achieves the same degree of permanence as does his; and should the same or a similar scenario ever be filmed by a different director and a different cast there will result an altogether different "play."

Othello or Nora are definite, substantial figures created by the playwright. They can be played well or badly, and they can be "interpreted" in one way or another; but they most definitely exist, no matter who plays them or even whether they are played at all. The character in a film, however, lives and dies with the actor. It is not the entity "Othello" interpreted by Robeson or the entity "Nora" interpreted by Duse; it is the entity "Greta Garbo" incarnate in a figure called Anna Christie or the entity "Robert Montgomery" incarnate in a murderer who, for all we know or care to know, may forever remain anonymous but will never cease to haunt our memories. Even when the names of the characters happen to be Henry VIII or Anna Karenina, the king who ruled England from 1509 to 1547 and the woman created by Tolstoy, they do not exist outside the being of Garbo

and Laughton. They are but empty and incorporeal outlines like the shadows in Homer's Hades, assuming the character of reality only when filled with the lifeblood of an actor. Conversely, if a movie role is badly played there remains literally nothing of it, no matter how interesting the character's psychology or how elaborate the words.

What applies to the actor applies, *mutatis mutandis*, to most of the other artists, or artisans, who contribute to the making of a film: the director, the sound man, the enormously important cameraman, even the make-up man. A stage production is rehearsed until everything is ready, and then it is repeatedly performed in three consecutive hours. At each performance everybody has to be on hand and does his work; and afterward he goes home and to bed. The work of the stage actor may thus be likened to that of a musician, and that of the stage director to that of a conductor. Like these, they have a certain repertoire which they have studied and present in a number of complete but transitory performances, be it *Hamlet* today and *Ghosts* tomorrow, or *Life with Father per saeculorum saeculorum.* The activities of the film actor and the film director, however, are comparable, respectively, to those of the plastic artist and the architect, rather than to those of the musician and the conductor. Stage work is continuous but transitory; film work is discontinuous but permanent. Individual sequences are done piecemeal and out of order according to the most efficient use of sets and personnel. Each bit is done over and over again until it stands; and when the whole has been cut and composed everyone is through with it forever. Needless to say that this very procedure cannot but emphasize the curious consubstantiality that exists between the person of the movie actor and his role. Coming into existence piece by piece, regardless of the natural sequence of events, the "character" can grow into a unified whole only if the actor manages to be, not merely to play, Henry VIII or Anna Karenina throughout the entire wearisome period of shooting. I have it on the best of authorities that Laughton was really difficult to live with in the particular six or eight weeks during which he was doing—or rather being—Captain Bligh.

It might be said that a film, called into being by a cooperative effort in which all contributions have the same degree of permanence, is the nearest modern equivalent of a medieval cathedral; the role of the producer corresponding, more or less, to that of the bishop or archbishop; that of the director to that of the architect in chief; that of the scenario writers to that of the scholastic advisers establishing the iconographical program; and that of the actors, cameramen, cutters, sound men, makeup men, and the diverse technicians to that of those whose work provided the physical entity of the finished product, from the sculptors, glass painters, bronze casters, carpenters, and skilled masons down to the quarry men and woodsmen. And if you speak to any one of these collaborators he will tell you, with perfect bona fides, that his is really the most important job—which is quite true to the extent that it is indispensable.

The comparison may seem sacrilegious, not only because there are, proportionally, fewer good films than there are good cathedrals, but also because

the movies are commercial. However, if commercial art be defined as all art not primarily produced in order to gratify the creative urge of its maker but primarily intended to meet the requirements of a patron or a buying public, it must be said that non-commercial art is the exception rather than the rule, and a fairly recent and not always felicitous exception at that. While it is true that commercial art is always in danger of ending up as a prostitute, it is equally true that non-commercial art is always in danger of ending up as an old maid. Non-commercial art has given us Seurat's *Grande Jatte* and Shakespeare's sonnets, but also much that is esoteric to the point of incommunicability. Conversely, commercial art has given us much that is vulgar or snobbish (two aspects of the same thing) to the point of loathsomeness, but also Dürer's prints and Shakespeare's plays. For we must not forget that Dürer's prints were partly made on commission and partly intended to be sold in the open market; and that Shakespeare's plays—in contrast to the earlier masques and intermezzi which were produced at court by aristocratic amateurs and could afford to be so incomprehensible that even those who described them in printed monographs occasionally failed to grasp their intended significance—were meant to appeal, and did appeal, not only to the select few but also to everyone who was prepared to pay a shilling for admission.

It is this requirement of communicability that makes commercial art more vital than non-commercial, and therefore potentially much more effective for better or for worse. The commercial producer can both educate and pervert the general public, and can allow the general public—or rather his idea of the general public—both to educate and to pervert himself. As is demonstrated by a number of excellent films that proved to be great box office successes, the public does not refuse to accept good products if it gets them. That it does not get them very often is caused not so much by commercialism as such as by too little discernment and, paradoxical though it may seem, too much timidity in its application. Hollywood believes that it must produce "what the public wants" while the public would take whatever Hollywood produces. If Hollywood were to decide for itself what it wants, it would get away with it—even if it should decide to "depart from evil and do good." For, to revert to whence we started, in modern life the movies are what most other forms of art have ceased to be, not an adornment but a necessity.

That this should be so is understandable, not only from a sociological but also from an art-historical point of view. The processes of all the earlier representational arts conform, in a higher or lesser degree, to an idealistic conception of the world. These arts operate from top to bottom, so to speak, and not from bottom to top; they start with an idea to be projected into shapeless matter and not with the objects that constitute the physical world. The painter works on a blank wall or canvas which he organizes into a likeness of things and persons according to his idea (however much this idea may have been nourished by reality); he does not work with the things and persons themselves even if he works "from the model." The same is true of the sculptor with his shapeless mass of clay or his

untooled block of stone or wood; of the writer with his sheet of paper or his dicta-phone: and even of the stage designer with his empty and sorely limited section of space. It is the movies, and only the movies, that do justice to that materialistic interpretation of the universe which, whether we like it or not, pervades con-temporary civilization. Excepting the very special case of the animated cartoon, the movies organize material things and persons, not a neutral medium, into a composition that receives its style, and may even become fantastic or pretervol-untarily symbolic, not so much by an interpretation in the artist's mind as by the actual manipulation of physical objects and recording machinery. The medium of the movies is physical reality as such: the physical reality of eighteenth-century Versailles—no matter whether it be the original or a Hollywood facsimile indis-tinguishable therefrom for all aesthetic intents and purposes—or of a suburban home in Westchester; the physical reality of the Rue de Lappe in Paris or of the Gobi Desert, of Paul Ehrlich's apartment in Frankfurt or of the streets of New York in the rain; the physical reality of engines and animals, of Edward G. Robinson and Jimmy Cagney. All these objects and persons must be organized into a work of art. They can be arranged in all sorts of ways ("arrangement" comprising, of course, such things as makeup, lighting, and camera work); but there is no run-ning away from them. From this point of view it becomes evident that an attempt at subjecting the world to artistic prestylization, as in the expressionist settings of *The Cabinet of Dr. Caligari* (1919), could be no more than an exciting experi-ment that could exert but little influence upon the general course of events. To prestylize reality prior to tackling it amounts to dodging the problem. The prob-lem is to manipulate and shoot unstylized reality in such a way that the result has style. This is a proposition no less legitimate and no less difficult than any propo-sition in the older arts.

NOTE

1. I make this distinction because it was, in my opinion, a fall from grace when *Snow White* introduced the human figure and when *Fantasia* attempted to picturalize The World's Great Music. The very virtue of the animated cartoon is to animate, that is to say, endow lifeless things with life, or living things with a different kind of life. It effects a metamorphosis, and such a metamorphosis is wonderfully present in Disney's animals, plants, thunderclouds, and railroad trains. Whereas his dwarfs, glamourized princesses, hillbillies, baseball players, rouged centaurs, and *amigos* from South America are not transformations but caricatures at best, and fakes or vulgarities at worst. Concerning music, however, it should be borne in mind that its cinematic use is no less predicated upon the principle of coexpressibility than is the cinematic use of the spoken word. There is music permitting or even requiring the accompaniment of visible action (such as dances, ballet music, and any kind of operatic compositions) and music of which the opposite is true; and this is, again, not a question of quality (most of us rightly prefer a waltz by Johann Strauss to a symphony by Sibelius) but one of intention. In *Fantasia* the hippopotamus ballet was wonderful, and the Pastoral Symphony and "Ave Maria" sequences were deplorable, not because the cartooning in the first case was infinitely better than in the two others (cf. above), and certainly not because Beethoven and Schubert are too sacred for picturalization, but simply because Ponchielli's "Dance of the Hours" is coexpressible while the Pastoral Symphony and

the "Ave Maria" are not. In cases like these even the best imaginable music and the best imaginable cartoon will impair rather than enhance each other's effectiveness.

Experimental proof of all this was furnished by Disney's recent *Make Mine Music* where The World's Great Music was fortunately restricted to Prokofieff. Even among the other sequences the most successful ones were those in which the human element was either absent or reduced to a minimum; Willie the Whale, the Ballad of Johnny Fedora and Alice Blue-Bonnet, and, above all, the truly magnificent Goodman Quartet.

Thomas Y. Levin

Iconology at the Movies: Panofsky's Film Theory

In the *New York Herald Tribune* of 16 November, 1936, below the involuntarily ironic headline "FILMS ARE TREATED AS REAL ART BY LECTURER AT METROPOLITAN," one could read at some length about how "For the first time in the history of the Metropolitan Museum of Art the motion picture was considered as an art during a lecture there yesterday afternoon by Dr. Erwin Panofsky [sic], member of the Institute for Advanced Study at Princeton University [sic]." What made this event so newsworthy, besides the incongruous union of the plebeian medium of the movies with such an austere institution and famous art historian, was the rather unusual cultural legitimation of the cinema that it implied. While the study of film continues to this day to struggle for a modicum of institutional legitimacy within the academy, in 1936 the notion of any scholar lecturing anywhere on film (much less this particular scholar speaking and showing films from the collection of the Museum of Modern Art Film Library to an audience of 300 at that particular museum) was nothing short of remarkable.[1] What could possibly have motivated the recently immigrated, renowned art historian and theorist Panofsky to undertake such an excursion into the domain of popular culture in the form of a lecture entitled "The Motion Picture as an Art"?[2]

The canonical account is that Panofsky was approached by Iris Barry in 1934, who was in the process of gathering support for a new Film Department at the Museum of Modern Art of which she would later become the founding curator. For alongside architecture, which was already being established as a department at the MoMA following a highly successful 1931–1932 exhibition, the museum's young director Alfred H. Barr—who himself published articles on cinema in the late 1920s and early 1930s—had also announced in July 1932 the plan to establish a "new field" at the museum that would deal with what he felt was the "most important twentieth century art": "motion picture films."[3] When, with the help of a $100,000 grant from the Rockefeller Foundation and $60,000 from MoMA trustee John Hay Whitney (who had also been one of the major financial backers of *Gone with the Wind*), the Film Department of the MoMA officially opened in June 1935 (initially housed in one room piled high with films and books in the old CBS building on Madison Avenue), it was also thanks to the engagement of Panofsky, who

The Yale Journal of Criticism 9, no. 1 (1996): 27–55. © 1996 by The Johns Hopkins University Press. Reprinted by permission.

Figure 1. Charles Chaplin, City Lights *(1931). The Tramp and the Girl.* © Roy Export Company Establishment.

had agreed to lend his voice to promote what was then considered, as he himself put it, "a rather queer project by most people."[4] This solidarity first manifested itself in the form of an informal lecture "On Movies" presented in 1934 to the faculty and students of the Art & Archaeology Department at Princeton University and subsequently published in the Departmental Bulletin in June 1936.[5] "And so," as Robert Gessner notes, emphasizing the legitimation function which Panofsky's text was meant to serve, "the respectability of the front door was opened." Merely by speaking on film in Princeton and, subsequently, in other contexts explicitly associated with the fledgling film library,[6] Panofsky gave an intellectual (art-historical) and cultural (continental) imprimatur to MoMA's pioneering move to establish a serious archival and scholarly center for the study, preservation, and dissemination of the history of cinema. Indeed, once the Film Department was founded, Panofsky was named as one of the six members of its advisory committee in March 1936, a position he held well into the 1950s.[7]

Panofsky's surprising scholarly interest in cinema is, however, not nearly as punctual and radically exceptional as it is usually claimed to be. In fact, he continued to present his ideas on film in public lectures and in print long after the MoMA film library had become a firmly established part of the New York cultural landscape. In 1937 a slightly revised version of "On Movies" appeared under the new title "Style and Medium in the Moving Pictures" in one of the leading organs of the international avant-garde, Eugene Jolas's Paris-based English-language jour-

nal *Transition*.[8] The "final" version of the film essay, now entitled "Style and Medium in the Motion Pictures," was not published until 1947 in the short-lived New York art journal *Critique*, whose editors had prompted Panofsky to substantially rework and expand upon his earlier text.[9] This significant rewriting of the essay—the one later widely reprinted and translated—also occasioned a new round of public presentations. According to one eyewitness account, "Panofsky took such delight in the movies that in 1946–1947 he traveled to various places in and around Princeton, to give his talk as a *tema con variazioni*. He would end by showing one of his favorite silent films, such as Buster Keaton's *The Navigator*, which he would accompany with an extremely funny running commentary."[10] Furthermore, Panofsky's engagement with the cinema extended well beyond the immediate context of the various versions of film essay and included, for example, his discussion of "the 'cinematographic' drawings of the Codex Huygens,"[11] his informal address at the first meeting of The Society of Cinematologists (the first incarnation of today's Society for Cinema Studies) in 1960,[12] and the ensuing correspondence with Robert Gessner concerning what Panofsky referred to as the "*Grund begriffe* of cinematology,"[13] as well as his not infrequent discussions of films well into the 1960s.[14]

The various manifestations of Panofsky's cinephilic passion are generally explained as just that, simply a function of his long-standing love of a medium almost exactly as old as he. Indeed, in a rather autobiographical passage from "On Movies," which is subsequently dropped in later versions of the text, Panofsky says as much himself, admitting to the reader that

> I for one am a constant movie-goer since 1905 (which is my only justification for this screed), when there was only one small and dingy cinema in the whole city of Berlin. . . . I think, however, that few persons are so inveterate addicts as I.[15]

Seemingly taking its cue from such lines, Panofsky scholarship has cast the work on film as one of his charming "intellectual hobbies and idiosyncrasies" (Heckscher), as a serious excursion on a "frivolous theme" (Lavin), or as an index of the intellectual freedom afforded the recent immigrant by the much less stuffy art-historical discipline in the United States (Michels).[16] Motivated at worst by an unreflected high cultural contempt for the cinema, there has thus been—until only very recently—a virtually complete lack of serious scholarly work on Panofsky's film essay in the art-historical secondary literature.[17] While to some degree this is perhaps a function of art history's long-standing resistance to the cinema, the failure to engage an analysis of cinema from well within the art-historical ranks is curious indeed.[18] It is particularly puzzling given that the "epochal"[19] film essay supposedly "has been reprinted more often than any of his other works" and only recently has even been characterized by Panofsky's successor at the Institute for Advanced Study, Irving Lavin, as "by far Panofsky's most popular work, perhaps the most popular essay in modern art history."[20]

The seeming incongruity between the film essay's ostensible popularity and its consistent scholarly neglect is not only highly symptomatic but, as I shall suggest, is in fact necessary: Panofsky's remarks on film can only maintain their harmless renown as long as they remain unread. According to a classically Morellian logic, however, careful attention to this seemingly marginal and inconsequential moment in Panofsky's oeuvre might well serve—precisely thanks to its incidental and informal character—to expose the epistemic limits of his project more readily than the more carefully elaborated works. As will become clearer below, Panofsky's interest in cinema is anything but accidental. Rather, the response to the "movies" betrays unambiguously the centrality of a certain model of experience, a privileging of the representational, of the thematic, and of continuity, all of which are vital to Panofsky's critical, historical corpus even as they demarcate its theoretical limits. The cinema essay thus turns out to be of great methodological significance not where one might expect it (i.e., in the context of film studies) but rather in current art-historical debates about the aesthetic-politics of the iconographic project.

The reception of Panofsky's film essay within the context of film theory is no less curious than that accorded it by art history. On the one hand, despite its anthological "popularity" in collections of film theory and criticism, Panofsky's essay is almost completely absent from the canonical historiography of film theory.[21] On the other hand, the essay has not suffered quite the same critical neglect in cinema scholarship as it has in art history, although the very few sustained responses to the text—discussed below—are far outnumbered by passing references to it in the form of isolated citations.[22] This is no accident, since Panofsky's wonderfully cinephilic meditation on film is less a sustained argument than a paratactic series of sometimes more and sometimes less elaborated reflections. While some of these are very insightful, the essay as a whole is largely derivative, an eloquent restatement of positions familiar from so-called "classical" French and German film theory of the 1920s. Possibly as a result (and certainly overdetermined by disciplinary myopia), cinema studies has largely failed to take up other of Panofsky's essays which, while not explicitly concerned with the cinema, are nevertheless of some methodological and philosophical relevance to contemporary discussions in the field. Indeed, in a chiasmus as formally elegant as it is—so I will argue—true, just as art history has much to learn from Panofsky's texts on cinema, film studies would do well to attend to some of Panofsky's work in art history and theory, in particular his early discussion of mechanical reproducibility and the recently translated study of "Perspective as Symbolic Form."[23]

In terms of the history of film theory, Panofsky's film essay manifests many of the hallmarks of the first generation of theoretical writings on the cinema, which are, by and large, the product of the silent cinema era. Primarily concerned with legitimating the new medium by establishing that it too was "art," the first generation of film theoretical texts—as represented, for example, by the work of Rudolf Arnheim, Hans Richter, or Béla Balázs—often invoked the Lao-

coönian rhetoric of aesthetic specificity to articulate the differences between film and more established media such as theater or opera, in order subsequently to establish, in an often prescriptive and normative fashion, the medium's distinctive aesthetic provinces (at the level of both form and content). Panofsky's film essay, although chronologically later than the bulk of "classical film theory" from which it borrows quite liberally,[24] clearly adopts that paradigm's central rhetorical strategy, as evidenced in its repeated attempts to establish the medium's "unique," "specific," "exclusive," and above all "legitimate" aesthetic capacities.[25] However, having insisted at the start that the specificity of the medium must be a function of its technology, the essay struggles with the conflicting ramifications of that genealogy, vacillating between the two antinomial fields of the film theory landscape, i.e., the position that holds that cinema's technology lies first and foremost in its "fantastic," transformative capacities (cut, dissolve, superimposition, slow motion, etc.) versus the position that regards cinematic technology as first and foremost photographic. Indeed, the drama both within Panofsky's essay and across its various versions resides in its symptomatic negotiation of the tension between what one could loosely call the "constructivist" and the "realist" accounts of the motion picture "medium" and the consequences of each for its "style."

The most explicit—and consequently often cited—of Panofsky's specificity arguments is the claim that cinema's "unique and specific possibilities can be defined as dynamization of space and, accordingly, spatialization of time."[26] While the second half of this definition, an important topos of early film theory,[27] is left completely undeveloped, Panofsky does articulate at some length how, in contrast to the space of the theater which is (more or less) static, film space is utterly dynamic. Although the movie spectator is physically immobile, Panofsky insists that

> aesthetically, he is in permanent motion as his eye identifies itself with the lens of the camera, which permanently shifts in distance and direction. And as movable as the spectator is, as movable is, for the same reason, the space presented to him. Not only bodies move in space, but space itself does, approaching, receding, turning, dissolving and recrystallizing as it appears through the controlled locomotion and focusing of the camera and through the cutting and editing of various shots—not to mention such special effects as visions, transformations, disappearances, slow-motion and fast-motion shots, reversals and trick films. This opens up a world of possibilities of which the stage can never dream.[28]

What defines the cinema over and against other media, Panofsky claims, is the unique capacity afforded it by its range of technical features to construct space through or in time. From the start, then, the aesthetic significance of the technological apparatus seems tied to cinema's formally transformative potential.

Of course, the full range of these cinematically specific possibilities were only taken up slowly, the history of early cinema being effectively the testing

ground for the new syntactic devices made possible by the technology—through cutting, editing, and other capacities of the apparatus—and often referred to as film language. According to Panofsky, the formal development of the cinema "offers the fascinating spectacle of a new artistic medium gradually becoming conscious of *its legitimate, that is, exclusive possibilities and limitations.*"[29] Elaborating this teleology of specificity, Panofsky compares cinema's halting development from early attempts at self-legitimation (through the imitation of enshrined art forms such as painting and theater, effectively denying its own specificity, to the later articulation of its increasingly film-specific formal arsenal) with the evolution of the mosaic (first simply a practical means of making illusionistic genre paintings more durable and later leading to "the hieratic supernaturalism of Ravenna") and to line engraving (first a cheap and easy substitute for precious book illuminations, later leading to Dürer's purely "graphic"style). In all three cases the onset of something akin to medium specificity takes place only once the content of the new medium is no longer a prior medium. Explicitly invoking the linguistic metaphor that would become the cornerstone of semiotic film theory decades later, Panofsky writes that

> the silent movies developed a definite style of their own, adapted to the specific conditions of the medium. A hitherto unknown language was forced upon a public not yet capable of reading it, and the more proficient the public became the more refinement could develop in the language.

Rehearsing a claim about the historicity of perceptual skills in their relation to reigning modes of representation, Panofsky is here arguing (as did other theorists such as Dziga Vertov and Walter Benjamin, albeit with radically different conclusions) that cinema not only stages a new visual episteme, but simultaneously schools a new mode of vision. As documented amply by the early history of cinema, with its accounts of horrified misreadings of close-ups as dismemberment, generalized confusion regarding temporal and spatial continuity across cuts, the use of live film narrators to "tell" the story along with the images, etc.,[30] it took some time before people began to master the rather extensive repertoire of formal cinematic devices—p.o.v. shot, parallel action, shot-reverse-shot, etc.—which constitutes the seemingly automatic (because habitualized) "cinematic literacy" of the contemporary moviegoer.

At this point, however, Panofsky's essay takes a dramatic turn. Given that cinema's formal lexicon effectively constitutes a new representational space, one that both extends the spatial illusion of perspectival depth across time and also creates new spatio-temporal folds and voids, one could expect at this point an analysis of the socio-epistemic stakes of this new representational regime along the lines articulated in Panofsky's perspective essay of 1924–1925. Indeed, the explicit filiations between cinema and perspective—the cinematic photograms based qua photographs on the optics that gave rise to perspectival space—call out for such a synchronic analysis that would map cinema onto twentieth-century

theories of substantiality, materiality, spatiality, being, models of the subject, etc. And in fact, Panofsky himself commented on the relationship between single-point perspective and the new representational technologies. Accounting for the fact that none less than Kepler recognized that a comet moving in an objectively straight path is perceived as moving in a curve, Panofsky writes:

> What is most interesting is that Kepler fully recognized that he had originally overlooked or even denied these illusory curves only because he had been schooled in linear perspective. . . . And indeed, if even today only a very few of us have perceived these curvatures, that too is surely in part due to our habituation—further reinforced by looking at photographs—to linear perspectival construction.[31]

Just as in the essay on perspective Panofsky showed how "perspectival achievement is nothing other than a concrete expression of a contemporary advance in epistemology or natural philosophy,"[32] just as there Panofsky described how the actual painted surface is present in the mode of denial, repressed in favor of an imaginary, projected space—this structure of disavowal being a central film theoretical topos—so too one could imagine a reading of film language that articulated the epistemic correlates of cinema as symbolic form, showing how it too, as Panofsky said of perspective, is "a construction that is itself comprehensible only for a quite specific, indeed specifically modern, sense of space, or if you will, sense of the world."[33] Having raised the question of cinema's specificity and its relationship to film language and a transformation of perception, Panofsky has set the stage, as it were, for an iconological reading of cinematic form as sedimented content (Adorno), the term understood as Panofsky defined it in opposition to the content-based analysis which is the province of the iconographic interpretation.

Instead of an iconological reading of cinema as symbolic form, however, such as is undertaken in various ways in Benjamin's 1935–1936 essay on the "Artwork in the Age of Its Technological Reproducibility," Heidegger's "The Age of the World Picture," Jean-Louis Baudry's "Ideological Aspects of the Basic Cinematic Apparatus," or Deleuze's *The Time-Image* and *The Movement-Image*, to name just a few,[34] Panofsky's essay takes a crucial methodological swerve in another direction. Instead of engaging film form as such—as Balázs does, for example, when he suggests that "the camera has a number of purely optical techniques for transforming the concrete materiality of a motif into a subjective vision. . . . These transformations, however, reveal our psychic apparatus. If you could superimpose, distort, insert without using any particular image, if you could let these techniques have a dry run, as it were, then this 'technique as such' would represent the spirit [*Geist*]"[35]—Panofsky instead focuses on the intelligibility of the *content* of the images. Comparing the initial unintelligibility of early cinema with similar difficulties at other points in the history of art, Panofsky writes:

> For a Saxon peasant of around 800 it was not easy to understand the meaning of a picture showing a man as he pours water over the head of another man,

and even later many people found it difficult to grasp the significance of two ladies standing behind the throne of the emperor. For the public of around 1910 it was no less difficult to understand the meaning of the speechless action in a moving picture.[36]

Having reduced the question of specificity to the fact that early cinema was silent—thereby effectively bracketing the question of film language[37]—Panofsky focuses on the means employed by early cinema to help render these mute images intelligible. Besides the use of cinematic intertitles (which Panofsky compares to medieval *tituli* and scrolls), another technique used to foster comprehension was the employment of easily recognizable types and actions:

> Another, less obtrusive method of explanation was the introduction of a fixed iconography which from the outset informed the spectator about the basic facts and characters, much as the two ladies behind the emperor, when carrying a sword and a cross respectively, were uniquely determined as Fortitude and Faith.[38]

In order to ensure that the meaning of its sequences would be grasped, early cinema made use of a wide range of types (the Vamp, the Villain, etc.) and genres (Westerns, melodramas, etc.), which—conveniently—are ideal material for iconographic analysis. So, for example, Panofsky reads the Vamp and Straight Girl as modern equivalents of the medieval personifications of the Vices and Virtues. But of course there is *nothing film-specific* about these types or genres. Indeed, their very function as aids to deciphering the cryptic new film language *requires* that their readability depend on pre- or extra-cinematic knowledge. This shift of focus serves to justify the iconographic excursions on early cinema types and genres, acting styles, etc., which occupy Panofsky for much of the remainder of the essay, allowing him to display his often magisterial command of film history and genre filiations. Remaining resolutely at the representational level of the photographic image, these readings of genres must even remain blind to the more subtle genre iconographics of the complex cinematic syntagm (which would require an attention to cinematic language even within a strictly iconographic project). As a result, in order to invoke his iconographic method, Panofsky, the theorist of cinematic specificity, must reduce film to precisely that aspect which, according to his own definition, is not specific to cinema.

Unless of course—as turns out to be the case—Panofsky has introduced a new, rather debatable criterion of the medium's specificity, namely, the photographic. Once one realizes to what extent Panofsky, as Jan Bialostocki once perceptively remarked, "thought of film as an extremely 'iconographic' art, the heir of the tradition of symbolism and of the old meanings connected with image,"[39] then many of the otherwise puzzling moves in the film essay begin to make sense. The utterly uncritical commitment to, and exclusive concern with, Hollywood narrative cinema, the micrological analysis of differences in acting styles in silent and sound film, the excursion of certain favorite film stars (Garbo, Asta Nielsen),

indeed, in general, a focus on content which almost completely disregards questions of cinematic form—all of these stem from the imperatives of a motion picture iconography. Such a project depends, however, on a complete shift in Panofsky's conception of cinematic specificity. Abandoning the focus on film language implied in the "dynamization of space" argument, Panofsky has now located the specificity of the medium in that aspect of its technology which guarantees the survival of depicted content, namely, its photographic foundation. As already indicated in the shift in the essay's title away from the dynamics of "movies" to the emphasis on moving or motion *pictures*, the later versions of the film essay will focus increasingly on the photographics—instead of the cinematics—of film.[40] This explains both Panofsky's insistence that the cinema is first and foremost a moving picture—using historical precedence (films had images before they had spoken sound) to make claims of ontological priority (film is first and foremost visual)—and the resulting, aesthetically rather reductive "principle of co-expressibility" (first added in 1947), which argues that sound must be subservient to the image. Compared to Adorno and Eisler's much richer and exactly contemporaneous argument for what they called "contrapuntal" sound-image relations, which emphasizes the autonomy of both the acoustic and the visual and their reciprocal enrichment through a logic of montage, Panofsky's position clearly wants to maintain the priority of the (photographically) represented space over a more cinematic, poly-semiotic sound-image construct.[41]

Nowhere is the iconographic emphasis on content over form more strikingly evident than in the extensive new concluding argument of the final version of the film essay. Panofsky argues here that, unlike other representational arts which work "top down"—i.e., from an idea which serves to shape inert matter—film works from the bottom up. Unlike the "idealistic" media of painting, sculpture, drama, and literature, all of which, no matter how "realistic," construct their "worlds" on the basis of ideas, film draws upon that world itself:

> The medium of the movies is physical reality as such: the physical reality of eighteenth-century Versailles—no matter whether it be the original or a Hollywood facsimile indistinguishable herefrom for all aesthetic intents and purposes—or a suburban home in Westchester. . . . All these objects and persons must be organized into a work of art. They can be arranged in all sorts of ways ("arrangement" comprising, of course, such things as make-up, lighting, and camera work); but there is no running away from them.[42]

For Panofsky, cinema's elective affinity with the physical world is what assures its status as an iconographic "good object" and, as such, the legitimate heir to the traditional pictorial arts. Unlike Siegfried Kracauer, for whom film's photographic basis became an argument for its elective affinity with the quotidian and the marginal; unlike Louis Aragon, for whom the same iconico-indexicality enabled film to capture and reveal the unseen, hidden meanings of everyday objects (a surrealist aesthetic program rearticulated in Walter Benjamin's notion of the "optical

unconscious");[43] unlike Béla Balázs's "physiognomic" theory, which focused as early as 1924 on film's capacity to give a face to inanimate objects;[44] unlike André Bazin, for whom film's grounding in the photographic served as an argument against montage and in favor of a long take that supposedly respects rather than violates the pro-filmic,[45] ostensibly allowing the viewer's gaze to roam freely through the deep-focus field; unlike Georg Lukács, who argued (as early as 1911) that it was precisely cinema's combination of a photographic realism with the anti- or super-naturalism of the cut that afforded it what he called a "fantastic realism,"[46] Panofsky's insistence on the importance of cinema's relation to "physical reality" is something else entirely. What Panofsky does here is to ground an aesthetics of cinema in the imperatives of its photographic basis, in order, almost as a corol- lary, to justify the continued relevance of the content-based methodology of the iconographic project. He is thus understandably allergic to any cinematic prac- tices (such as expressionism) which subject the pro-filmic to processes of abstrac- tion: "To prestylize reality prior to tackling it amounts to dodging the problem. The problem is to manipulate and shoot unstylized reality in such a way that the result has style. This is a proposition no less legitimate and no less difficult than any proposition in the older arts."[47] As a result, *The Cabinet of Dr. Caligari*, praised as an "expressionistic masterpiece" in the first version of the essay, is reduced to "no more than an interesting experiment" in the essay's final version ten years later.

The most articulate formulation of Panofsky's theory of cinema's photo- graphic specificity is, however, not contained in any of the versions of the film essay. It can be found, rather, in the context of his correspondence with Siegfried Kracauer, who, upon the recommendation of Rudolf Arnheim, sought out Panof- sky shortly after his arrival in the United States in 1941. While the majority of the letters between the two exiled scholars—sometimes in German, sometimes in English—deal with the pragmatics of intellectual networking (letters of recom- mendation, scheduling of meetings, organizing of contacts), these are punctuated every so often by more substantive epistolary responses to each other's works.[48] Just as Kracauer was struck by the methodological elective affinity between his own micrological approach and Panofsky's *Dürer*, Panofsky was also very enthu- siastic in his response to many of Kracauer's writings, recommending that Prince- ton University Press publish *From Caligari to Hitler* and even suggesting jokingly that Kracauer write a sequel study to be called "From Shirley Temple to Tru- man."[49] While Kracauer's relentlessly complimentary remarks on the first two versions of Panofsky's film essay seem a bit (strategically) exaggerated in light of the text's negligible presence in his published work,[50] the concluding argument about film's relation to "physical reality" which first appears in the final version of Panofsky's film essay (published the same year as Kracauer's *Caligari*) may well have made a significant impact. Indeed, Panofsky's observation that "it is the movies, and only the movies, that do justice to that materialistic interpretation of the universe which, whether we like it or not, pervades contemporary civiliza-

tion"[51] is the only passage marked "important" in Kracauer's copy of *Critique*.[52] Whatever its importance as an overdetermination might have been, it would not become manifest until over a decade later in Kracauer's next major book on film. But when it finally appeared in print over ten years later, Kracauer's *Theory of Film* did carry a subtitle with a decidedly Panofskian resonance: "The Redemption of Physical Reality." And it is a preliminary outline of this very book, which he had been asked to review for Oxford University Press shortly after the publication of the *Critique* essay, that provokes Panofsky to articulate in unprecedented detail the role of the photographic in his conception of cinema's specificity. As he explains to Mr. Philip Vaudrin at OUP, in a letter dated 17 October 1949:

> The outline of Mr. Kracauer's book interested me so much that I could not withstand the temptation to read it right through in spite of my being somewhat busy these days, and that is perhaps the best testimonial I can give in its favor. So far as anyone can judge from a mere outline, Mr. Kracauer's book promises to be a really exciting and fundamentally important work, and his main thesis—the intrinsic conflict between cinematic structure and "story," endlessness and finiteness, episodic atomization and plot logic, strikes me as being both original and fundamentally correct.
>
> I only wonder whether the argument may not be carried even further in saying that this conflict is inherent in the technique of photography itself. Mr. Kracauer interprets, if I understand him rightly, photography as one pole of the antinomy, saying that the snapshot "tends to remove subjective frames of reference, laying bare visible complexes for their own sake" and that the narrative furnishes the other pole. I wonder whether this conflict is not inherent in the photographic medium itself. There has been a long discussion as to whether photography (not cinematic photography but just ordinary photography) is or can ever become an "art." This question, I think, has to be answered in the affirmative, because, while the "soulless camera" relieves the artist of many phases of the imitative processes normally associated with the idea of art, [it] yet leaves him free to determine much of the composition and, first and foremost, the choice of subject. We find, therefore, even in snapshots not only an interest in "fragments of reality for their own sake" but also an enormous amount of emotional coloring, as in most snapshots of babies, dogs, and other vessels of sentimentality. This, I think, accounts for the very early appearance of sentimental or sanguinary narratives in films as well, a phenomenon which Mr. Kracauer seems to underestimate, directly opposing as he does the purely factual incunabula of the film to the purely fantastic productions of Méliès. The addition of motion and, later on, sound, transfers this inherent tension to the plane of coherent, and possibly significant, narratives; but I think that it may be inherent in the photographic medium as such—a proposition which is by no means an objection to Mr. Kracauer's theory but would rather invest it with a still more general validity.[53]

Leaving aside the fascinating issue of Panofsky's reading of Kracauer and the latter's response to Panofsky's criticisms, which must be explored elsewhere, what

is crucial for the present context is Panofsky's remarks on the aesthetics of photography. Elaborating on comments made almost two decades earlier on the freedom of the photographer to concentrate on the choice of subject matter,[54] Panofsky here suggests that this license afforded by the photograph results in the privileging of subject matter with overdetermined emotional markings, the provenance of which it is the task of an iconographic analysis to reveal. This, in turn, grounds the necessity of an iconographic practice in the specificity of the photographic medium itself, and then, by extension, in that of narrative cinema as well. One is now in a position to understand what is at stake when, in response to a letter in which Kracauer expresses his tremendous enthusiasm upon reading the Dürer book, Panofsky writes:

> You are the first person by whom I feel that I have been, like Palma Kankel, "understood profoundly," and I cannot thank you enough for that. I was particularly pleased by your interest in such a detail as the internal relationship between technology and content, which the 19th century in its peculiar blindness overlooked in both the ostensibly extra-"artistic" technological domain as well as the ostensibly equally extra-"artistic" material domain. This stems from the fact that we have both learned something from the movies![55]

If Panofsky claims that cinema is an "art originating from and always intrinsically connected with technical devices,"[56] the invocation of that technological foundation allows him to solidify what one could now call, rephrasing the title of his essay, the relationship between content and medium in the motion pictures which, in turn, makes iconography indispensable to the study of the cinema.

Panofsky's insistence on content in the cinema is highly overdetermined, as Regine Prange has recently demonstrated in a very convincing manner.[57] For the essays on cinema are written at a time when iconography's methodological relevance is being threatened by the increasing abstraction of modern art. The hidden agenda of Panofsky's seemingly progressive endorsement of film's mass appeal, of its "communicability," may well be a direct response to modernism and modern art, a resistance to abstraction that can be traced quite consistently from the early 1930s (at which point Panofsky felt that he could still integrate Cézanne and Franz Marc into his universal iconological model) through the mid-1940s.[58] While the open-minded Panofsky may well have been—as many people insist— very sympathetic to and interested in modern art as such, it also seems quite clear that at a certain level contemporary art did pose a special challenge to his methodological program. This tension between modern art and certain practices of art history is made explicit in a short book review that Panofsky published in 1934 in the *Museum of Modern Art Bulletin* (and which is curiously absent from the otherwise quite exhaustive bibliographies of Panofsky's writings).[59] Panofsky is unequivocal here about recommending James Johnson Sweeney's *Plastic Redirection in 20th Century Painting* (The Renaissance Society of the University of Chicago, 1934) "because Mr. Sweeney's book is one of the few attempts at approaching

the problems of contemporary art from the standpoint of scholarly art history." Interestingly enough, both of Panofsky's conclusions in the review—that "it is possibly a privilege of American scholarship to construct the history of an art which in itself is not yet an 'historical phenomenon'" and that Sweeney's book "has now proved that it is, after all, possible to apply the methods of art-history to contemporary art"—could easily be read as a description of the program of his own exactly contemporaneous study of cinema.

Film's photographic basis, its "materialism," marks the welcome return of the signified, of content, as an alternative to an insistence on the signifier—this too a sort of materialism, albeit in a different sense—in abstraction. Panofsky uses cinema, as Prange rightly points out, to rehabilitate as an artistic norm the world of "nature" which contemporary art has abandoned. Film, to the extent that it can be argued to be essentially photographic, and narrative cinema, to the extent that it too maintains the emphasis on the signified (unlike the reflexive involution of avant-garde film), restores the legitimacy of the iconographic method and the model of immediate experience and transparent perception upon which it depends. In so doing, however, it serves to further confirm various methodological critiques of iconography that have been voiced in recent art theory. Just as an encounter with modern art, with its problematization of the supposed immediacy of perception, might have forced a reflection on the theory of experience upon which iconography depends, so too an engagement with avant-garde film might have thrown into question some of the assumptions left unexamined by the ready intelligibility of narrative cinema. Similarly, the decidedly anti-modernist stance evident in the film essay's exclusive focus on narrative cinema and the resulting privileging of genre and types only further buttresses the claim that iconology has an elective affinity with thematic continuity and is therefore structurally blind to radical shifts in the development of representational and perceptual practices. This in turn limits the analytic scope of the iconographic project, as Oskar Bätschmann has astutely pointed out:

> The only certain contribution of Panofsky's model seems to be the history of types, i.e., the understanding of how specific themes and ideas are expressed by objects and events under changing historical conditions. . . . Because the possibility of a history of types is tied to thematic continuity, it is incapable of grasping not only ruptures in tradition, as Kubler established, but also relatively simple and frequent transformations of formal schemata. This is why the contribution of a history of types to a history of art can only be of limited value.[60]

However controversial Bätschmann's remarks may be for debates in art-historical methodology, they are undoubtedly correct as a description of the circumscribed validity of Panofsky's remarks for the study of film.

To the extent that it has been received at all, Panofsky's film essay has enjoyed its most serious and productive response within that province of film

studies concerned with the history of cinematic types, stereotype-formation, and genre theory. The project of a cinematic iconography has been taken up in a variety of ways which range from the highly cinephilic but methodologically pious essay by French film critic Jean-Loup Bourget[61] to feminist film theorists such as Clair Johnston, for whom "Panofsky's detection of the primitive stereotyping which characterized the early cinema could prove useful for discerning the way myths of women have operated in the cinema."[62] Panofsky's bracketing of film form in favor of content also explains the sustained response to his text by another theorist, Stanley Cavell, who shares his fascination with film as a medium of the "real." Indeed in his study *The World Viewed: Reflections on the Ontology of Film*,[63] Cavell calls Panofsky one of "two continuously intelligent, interesting, and to me useful theorists I have read on the subject [of what is film?]." The other theorist is, symptomatically, André Bazin, the high priest of realist film theory. It was these two figures, so Cavell explains in a postface to the second, "enlarged" edition of his book, that prompted him to explore the question of film's relation to reality:

> I felt that, whatever my discomforts with their unabashed appeals to nature and to reality, the richness and accuracy of their remarks about particular films and particular genres and figures of film, and about the particular significance of film as such, could not, or ought not, be dissociated from their conviction that film bears a relation to reality unprecedented in the other arts. (166)

While sympathetic to Panofsky's position in general, Cavell's homage to the film essay takes the form of a relentless, careful critique which discerns, even more precisely than the text's own author, some of the key issues at play in Panofsky's reflections.[64] Indeed, Cavell not only pushes Panofsky at times toward the iconology of cinema which the essay fails to deliver,[65] he even goes so far as to defend Panofsky against himself, challenging his claim that once film literacy had developed sufficiently, the genre and type cues originally invoked to help the viewer navigate cinema's complex formal innovations became superfluous. "Devices like these," Panofsky had argued, "became gradually less necessary as the public grew accustomed to interpret the action by itself and were virtually abolished by the invention of the talking film."[66] If the principal contribution of Panofsky's work on film consists in this iconographic analysis of types and genres, and if the employment of such conventions was indeed abandoned or at best reduced as film literacy became widespread, then, so Cavell argues, if Panofsky is right he has proven that his own project is either superfluous, or at best relevant exclusively to silent film. But, writes Cavell, pointing to the continued existence of the western, gangster, and other film genres, Panofsky is simply mistaken here: while it is true that the particulars of the iconography accorded the villain-type change with time, what does survive is the iconographic specificity of such a type. Indeed, Cavell argues in rather Panofskian fashion that the continued dependence upon film types and genres is

accounted for by the actualities of the film medium itself: types are exactly what carry the forms movies have relied upon. These media created new types, or combinations and ironic reversals of types; but there they were, and stayed.[67]

What Cavell has effectively done here—for better or for worse—is argued for the continuing validity of a Panofskian iconographic program for the study of film. And in fact Cavell's second book on film, *Pursuits of Happiness: The Hollywood Comedy of Remarriage*,[68] is nothing less than just such an iconographic study of a specific film genre which Cavell here articulates for the first time. Indeed, one could certainly claim that this book—and to a lesser extent perhaps the very domain of film studies that focuses on genre and types, on the meaning of gesture and scenes, etc.—is, in its iconographic dimensions, indebted to and in some sense a continuation of the program proposed by Panofsky—but of course not only by him—in his essay on film.

It is, however, not in film studies, but in the context of a politicized re-reading of Warburg and Panofsky in contemporary German art history, that the photographic specificity of Panofsky's film essay, as well as its epistemic over-determinations, are of greatest significance today. According to the historiographic map sketched by Johann Konrad Eberlein, one must distinguish between two phases of iconology, the first of which—iconology in the narrower sense—had Panofsky as its main protagonist, and concentrated primarily on the Renaissance and human-ism. Criticized by a younger generation for what was perceived as a too mecha-nistic relation to sources taken from a too narrow spectrum, and for a denigration of the image in order to simply illustrate these sources, a second iconological epis-teme then developed in the late 1980s which focused more on questions of style, reception, and sociological issues. Whether one marks the onset of this new par-adigm, as Eberlein does, by the appearance of Horst Bredekamp's 1986 essay "Göt-terdämmerung des Neoplatonismus"[69] or dates it back to Martin Warnke's session on "Das Kunstwerk zwischen Wissenschaft und Weltanschauung" (The Artwork between Science and World View) at the 12th German Art History Congress in Cologne in 1970,[70] in both cases the good object of this second phase of iconology was, of course, Aby Warburg. Both Panofsky and Warburg, so this story goes, began their careers with a complex, Riegelian method that, as Benjamin once put it, undertook "an analysis of artworks which considers them as a complete expres-sion of the religious, metaphysical, political and economic tendencies of an epoch and which, as such, cannot be limited to a particular discipline."[71] But in contrast to Warburg's approach to iconology (which was decidedly inflected toward *Kultur-geschichte* [cultural history]), Panofsky's work came to be seen increasingly as an example of *Geistesgeschichte* (history of ideas), more traditionally art-historical in its almost exclusive focus on questions of interpretation and content, on the depicted rather than on the very conditions and cultural stakes of depiction. It was thus Warburg who became the patron of a new critical art history, an attempt to

Figure 2. D. W. Griffith, Broken Blossoms *(1919).*
The Yellow Man (Richard Barthelmess). Museum of
Modern Art, New York.

confront iconology with the social theory of the Frankfurt School in order to recast
art history as a historical science, integrated into a larger interdisciplinary cultural
science which would analyze the constantly shifting functions of all images,
including those of "low," trivial, and popular culture.

Perhaps feeling the need to prove that Panofsky too could be marshaled
for such a project, scholars such as Volker Breidecker have recently turned to the
film essay as a seemingly obvious example of such a Warburgian sensibility in
Panofsky's corpus. Arguing that it demonstrates Panofsky's interest in a popular
and even "low" art form and that it is explicitly sociological in orientation, this
line of argument points to statements such as Panofsky's claim that narrative film
is not only art

> but also, besides architecture, cartooning and "commercial design," the only
> visual art entirely alive. The "movies" have reestablished that dynamic con-
> tact between art production and art consumption which, for reasons too
> complex to be considered here, is sorely attenuated, if not entirely interrupted,
> in many other fields of artistic endeavor.[72]

Leaving aside the profoundly anti-modernist cultural politics of such a seemingly
progressive aesthetic populism, the attempt to rehabilitate Panofsky as a theorist
of popular culture calls attention instead to his ingenious (and oft-cited) response
to the charge that cinema is simply "commercial":

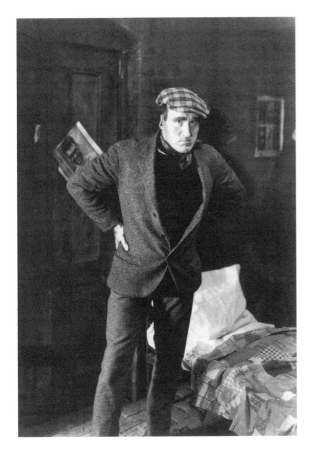

Figure 3. D. W. Griffith, Broken Blossoms *(1919). Battling Burrows (Donald Crisp).* Museum of Modern Art, New York.

> If commercial art be defined as all art not primarily produced in order to grat-ify the creative urge of its maker but primarily intended to meet the require-ments of a patron or a buying public, it must be said that noncommercial art is the exception rather than the rule, and a fairly recent and not always felic-itous exception at that. While it is true that commercial art is always in dan-ger of ending up as a prostitute, it is equally true that noncommercial art is always in danger of ending up as an old maid.[73]

This rejection of the classical model of aesthetic autonomy—all art being exposed as somehow contaminated by cinema's oft-maligned commercialism—is an important variation on Benjamin's elaboration of Paul Valéry's suggestion that cinema, rather than being an art, will transform the very notion of the aesthetic. As Brecht once put it in the early 1930s: "It is not true that film needs art, unless of course one develops a new understanding of art."[74] However, despite this insis-tence on the irreducibly commercial, corporate—which is to say political—dimen-sion of the medium, even a cursory reading of Panofsky's film essay will confirm that the sociological component of the argument remains superficial at best. This is not to say that Panofsky was blind to the political dimension of the cinema, as indicated by his fascinating comment in 1942, in response to Kracauer's study of

Nazi propaganda films, that "there is no such thing as an authentic 'documentary film', and that our so-called documentaries are also propaganda films only—thank God—usually for a better cause and—alas—usually not as well made."[75] However, due to a constellation of overdeterminations, some of which have been sketched above, his sensitivity to that dimension of cinema remains strikingly undeveloped in the film essay. Taken as a whole, and despite its extended and sympathetic discussion of film's folk-art genealogy, despite its discussion of film spectatorship and exhibition practices, and despite its meditation on the relation of the actor to the apparatus,[76] the film essay simply will not serve, as Breidecker claims it does, to overturn the critique that Panofsky's later work privileges the "content" of works over their formal or stylistic characteristics, the iconographic at the cost of the political, or that his approach was largely *"geistesgeschichtlich,"* ignoring material and technical conditions and social effects of the works.[77] The film essay's astonishing silence on questions of ideology, alienation, profit, monopoly structures, corporate capital, etc., its romanticization of the spectatorship "community," its endorsement of viewer "identification" with the camera—almost point for point the exact antithesis to Adorno and Horkheimer's contemporaneous "culture industry critique"—would if anything actually buttress such objections.

Panofsky's bracketing of almost all questions dealing with film language, with cinema as symbolic form and thus with the issue of cinema's socio-political imbrications is, Prange argues, a symptomatic myopia of *Stilgeschichte*. And despite admirable attempts to redeploy its iconographic project as a proto-semiotics—as in Peter Wollen's important study, which not only echoes unmistakably the syntax of Panofsky's essay in the title *Signs and Meaning in the Cinema* but also provides a triptych of film stills that effectively illustrate Panofsky's typological examples[78]—the film essay remains anything but Warburgian. Rather than marshalling it as an index of Panofsky's supposed sensitivity to mass culture, one would do better to study it as an important document which in its very unselfconsciousness can teach art history (perhaps more readily than many of Panofsky's other writings) about the methodological pitfalls and elective affinities of the iconographic program. By the same token, the film scholar interested in discovering relatively unexplored resources in the archeology of film theory would do better to look at Panofsky's study of perspective rather than the essay on film. For while the numerous film-theoretical insights in "Perspective as Symbolic Form" remain for the most part in embryonic form, it nevertheless gives an inkling of what such an—iconological—Panofskian reading of cinema might look like. Indeed, the perspective essay has given us more than an inkling, for it is precisely also as a reading of this text that one can understand another work exactly contemporaneous with Panofsky's film essay—Benjamin's "Art in the Age of Its Capacity of Technical Reproduction"[79]—which is perhaps the prototype of a Panofskian "cinema as symbolic form." One can describe it as such not because it is known that as Benjamin was preparing to defend this text in the form of theses in front of the Schutzenverband Deutscher Schriftsteller in Paris on 20 and 26

June 1936, one of the texts he turned to was Panofsky's "Perspective as Symbolic Form,"[80] nor because this essay became one of the key texts in the so-called "Warburg Renaissance."[81] Rather, what justifies considering Benjamin's difficult and often misread essay as an attempt to read "cinema as symbolic form" is the fact that the questions he asks there—how cinema corresponds to a new order, structure, tempo of experience, how it has transformed perception, revolutionizes the status of the artwork, how it relates to earlier technologies of iteration, to fascism and to class struggle, in short, how it stages a certain cultural episteme—are the very matters one might expect to find in what would effectively be a reading of "Cinema as Symbolic Form." To understand to what extent Benjamin on cinema is Panofskian, and why Panofsky's essay on cinema is, in an important sense, not—this is the challenge posed by "Style and Medium in the Motion Pictures."

NOTES

This is a revised version of an essay presented at the Panofsky Centennial Conference held at the Institute for Advanced Study in November 1993, and first published in the volume of conference proceedings edited by Irving Lavin as *Meaning in the Visual Arts: Views from the Outside* (Princeton: Institute for Advanced Study, 1995), 313–333. Among the many people who generously shared their thoughts and comments on earlier versions of this text, I would like especially to thank Irving Lavin (Princeton), whose invitation to explore the film essay for the centennial conference was the initial impulse for this study; Gerda Panofsky, who graciously allowed me to cite from Panofsky's correspondence; and Volker Breidecker (Berlin), who kindly shared with me his excellent work on the Panofsky–Kracauer correspondence prior to its publication. Further thanks are due as well to Horst Bredekamp (Berlin), Wolfgang Liebermann (Berlin), Charles Musser (New York), Regine Prange (Tübingen), and the helpful staff at the Museum of Modern Art Film Library.

1. To get a sense of the symbolic capital that Panofsky's lecture on film represented, one must recall that, despite the fact that the first film library in the United States was established as early as 1922 at the Denver Art Museum by its director, George William Eggers, cinema did not begin to be recognized as a subject worthy of being taught at the university level in any form in the United States until the mid-1930s. Indeed, in 1937, when New York University began a pioneer film appreciation course and Columbia University offered a new class in the "History, Aesthetic and Technique of the Motion Pictures" (taught by Iris Barry and John Abbott of the MoMA film library, together with Paul Rotha), this was a curricular innovation of such importance that *Time Magazine* ran a story on the birth of college-level courses on film ("'Fine Arts Em1-Em2,'" *Time Magazine* 30.15 [11 October 1937]: 36). As an index of the unabated intensity of the anachronistic resistance to academic study of cinema to this day, consider the following vitriolic remarks by Hilton Kramer:

> About the first, the study of the arts and the humanities in the colleges and universities, I want to begin with a modest but radical proposal: that we get the movies out of the liberal arts classroom. We've simply got to throw them out. There is no good reason for the movies to be there, and there is every reason to get rid of them. They not only take up too much time, but the very process of according them serious attention sullies the pedagogical goals they are ostensibly employed to serve. The students are in class to read, write, learn, and think, and the movies are an impediment to that process. Students are going to go to the movies anyway, and to bring them into the classroom—either as objects of study or as aids to study—is to blur and destroy precisely the kind of distinction—the distinction between high and low culture—that it is now one of the functions of a sound liberal education to give our students. (Hilton Kramer, "Studying the Arts and the Humanities: What Can be Done?" *The New Criterion* [February 1989]: 4)

For an articulation of the counterargument, see Colin MacCabe, *On the Eloquence of the Vulgar: A Justification of the Study of Film and Television* (London: British Film Institute, 1993), a lecture held in October 1992 to inaugurate a new M.A. course in media studies.

2. Since the archives of the Metropolitan Museum are closed to the public and, according to the staff there, ostensibly contain no information about this event, I have determined the title of the talk, which is not given in the *Herald Tribune* report, from the "What Is Going On This Week" section of the *New York Times* of 15 November 1936, II:4N, which listed the event but, curiously, did not carry a story on it. It is also listed as a public lecture in the *Bulletin of The Metropolitan Museum of Art* 31.10 (October 1936): 217. The title recalls that of a very popular exhibition, "The Moving Picture as an Art Form," organized at the New York Public Library by Romana Javitz of the library's Picture Collection in 1933 and then again in the library's Hudson Park Branch in 1936: see the lavishly illustrated story "The Magical Pageant of the Films" in the *New York Times Magazine* of 7 May 1933 (sec. VI: 10-11, 17). According to Iris Barry ("Motion Pictures as a Field of Research," *College Art Journal* 4.4 [May 1945]: 209), it was "the text of a lecture he had addressed to a possibly startled audience at The Metropolitan Museum of Art" that Panofsky published soon thereafter in *Transition* (see below).

3. Barr's writings on cinema include: "The Researches of Eisenstein," *Drawing and Design* 4.24 (June 1928): 155–156; "S.M. Eisenstein," *The Arts* 14.6 (December 1928): 316–321; and "Notes on the Film: Nationalism in German Films," *The Hound & Horn* 7.2 (January–March 1934): 278–283. The first public announcement of Barr's plan to establish a "new field" at the museum that would deal with "motion picture films" was in a high-production-value publicity pamphlet entitled "The Public as Artist" and dated July 1932. The justification for this unprecedented move and the planned scope of the new department's activities were articulated as follows:

> The art of the motion picture is the only great art peculiar to the twentieth century. It is practically unknown as such to the American public. People who are well acquainted with modern painting and literature and drama are almost entirely ignorant of the work of such great directors as Gance, Stiller, Clair, Dupont, Pudovkin, Feyder, Chaplin and Eisenstein.
>
> The Film Department of the Museum, when organized, will show in its auditorium films which have not been seen publicly, commercial films of quality, amateur and "avant-garde" films, and films of the past thirty years which are worth reviving either because of their artistic quality or because of their importance in the development of the art. Gradually a collection of films of great historic and artistic value will be accumulated. (MoMA scrapbook #31 [1934])

For more on Barr's interest in film, including his encounters with Sergei Eisenstein in the Soviet Union in 1928, and for details of his strategic lobbying to establish the MoMA film department, see Alice Goldfarb Marquis, *Alfred H. Barr Jr.: Missionary for the Modern* (Chicago/New York: Contemporary Books, 1989), 126ff.

4. Panofsky in a letter to the editors of *Filmkritik* which is cited in the introductory remarks to the first German translation of the film essay, "Stil und Stoff im Film," trans. by Helmut Färber, *Filmkritik* 11, 1967: 343. Another account of the genesis of Panofsky's film essay can be found in an obituary written by Robert Gessner, professor of cinema at New York University: Robert Gessner, "Erwin Panofsky 1892–1968," *Film Comment* 4.4 (Summer 1988): 3.

5. Erwin Panofsky, "On Movies," *Bulletin of the Department of Art and Archaeology of Princeton University* (June 1936): 5–15 [hereafter referred to as EP1936]. There are conflicting accounts as to when the text was actually written: the widely available reprint (of the 1947 version of the essay) in Gerald Mast, Marshall Cohen, and Leo Braudy, eds., *Film Theory and Criticism* (New York: Oxford University Press, 4th ed., 1992) incorrectly dates the first publication of the text as 1934, a mistake which can be traced to the editorial note accompanying the 1947 version of the essay in *Critique* (see below). A 1941 reprint of the second version of the essay claims that it was written in 1935 (see Durling et al., eds., *A Preface to Our Day*, below, 570).

6. One such event organized by MoMA's Princeton Membership Committee at the Present Day Club on 10 January 1936, featured a screening of *A Fool There Was* from the MoMA film library collection after which, according to the invitation, "Dr. Erwin Panofsky will give a short introductory talk on Moving Pictures" (invitation to Mr. and Mrs. [John] Abbott, MoMA Film Library Press Clippings Scrapbook #2, 35; the reference to Panofsky's talk was written by hand on the invitation).

7. The other members of the committee, which was chaired by Will H. Hays (the president of the Motion Picture Producers and Distributors of America, Inc.), were David H. Stevens (director of humanities, Rockefeller Foundation), Stanton Griffis (chairman of the Finance Committee and Trustee of Cornell University, chairman of the executive board of Paramount Pictures, Inc.), Jules Brulatour (president of J.E. Brulatour, Inc.), and J. Robert Rubin (vice-president of MGM). For more details on the founding and early activities of the Film Library, see A. Conger Goodyear, *The Museum of Modern Art: The First Ten Years* (New York, 1943), 117–124; "The Founding of the Film Library," *MoMA Bulletin* 3.2 (November 1935): 2–6, and "Work and Progress of the Film Library," *MoMA Bulletin* 4.4 (January 1937): 2–7; Iris Barry, "Film Library, 1935–1941," *MoMA Bulletin* 8.5 (June–July 1941): 3–13; and also John Abbott, "Organization and Work of the Film Library at the Museum of Modern Art," *Journal of the Society of Motion Picture Engineers* (March 1937): 294–303.

8. Behind the title pages by Duchamp, Léger, Miró, and others, the remarkable *Transition* (published in Paris from 1927 to 1938 and reissued in facsimile by Kraus Reprint in 1967) featured work by writers such as Artaud, Beckett, Breton, Kafka, Moholy-Nagy, and Joyce, including various installments of his work in progress that would later become *Finnegan's Wake*. It was in the penultimate issue of this journal—alongside texts by Joyce, Hans Arp, James Agee, Paul Eluard, and Raymond Queneau, and images by Kandinsky, De Chirico, Miró, and Man Ray—that the second version of Panofsky's film essay appeared in February 1937: "Style and Medium in the Moving Pictures," *Transition* 26 (1937): 121–133 [hereafter referred to as EP1937]; rpt. in Dwight L. Durling et al., eds., *A Preface to Our Day: Thought and Expression in Prose* (New York: Dryden, 1940), 570–582. Panofsky's essay was the last in a series of texts on photography and cinema in *Transition* which included Antonin Artaud's scenario "The Shell and the Clergyman" and S. M. Eisenstein's "The Cinematographic Principle and Japanese Culture" (*Transition* 19–20, June 1930), Paul Clavel's "Poetry and the Cinema" (*Transition* 18, November 1929), L. Moholy-Nagy's "The Future of the Photographic Process" and Jean-George Auriol's "Whither the French Cinema" (*Transition* 15, February 1929), Elliot Paul and Robert Sage's "Artistic Improvements of the Cinema" (*Transition* 10, January 1928), and the surrealist anti-Chaplin manifesto "Hands Off Love" (*Transition* 6, September 1927). Curiously, not one of these is included in the anthology of writings from the journal published as *In Transition, A Paris Anthology: Writing and Art from* Transition *Magazine 1927–1930*, introd. by Noel Riley Fitch (New York: Doubleday, 1990).

9. Erwin Panofsky, "Style and Medium in the Motion Pictures," *Critique* (New York) 1.3 (January–February 1947): 5–28 [hereafter referred to as EP1947; pagination according to the widely available reprint in Mast, Cohen, and Braudy, *Film Theory and Criticism*]. In an explanatory footnote we read (5): "At the request of the Editors of *Critique* . . . Prof. Panofsky consented to revise and bring up to date the original version, first published in 1934 [sic]. . . . For *Critique*, Prof. Panofsky has rewritten it extensively, expanding both length and scope."

10. William S. Heckscher, "Erwin Panofsky: A Curriculum Vitae," *Record of the Art Museum, Princeton University* 28.1 (1969): 18; rpt. in Erwin Panofsky, *Three Essays on Style*, ed. Irving Lavin (Cambridge, Mass.: MIT Press, 1995), 219; all subsequent citations will be to this reprint.

11. Erwin Panofsky, *The Codex Huygens and Leonardo Da Vinci's Art Theory* (1940; rpt. Nendeln: Kraus Reprint, 1968), 122ff. The "subterranean" afterlife of Panofsky's early essay on film in this study was first pointed out by Horst Bredekamp in his "Augenmensch mit Kopf. Zum hundertsten Geburtstag des Kunsthistorikers Erwin Panofsky," *Die Zeit* (27 March 1992).

12. As Robert Gessner recalls: "When the Learned Society of Cinema was founded in 1960 Erwin Panofsky was appropriately elected the first honorary member; it was my delightful duty to confront him in his Princeton Pantheon, then presided over by his dear friend, J. Robert Oppenheimer, and induce Panofsky to address the opening session of The Society of Cinematologists. His rare mixture of wit and scholarship will always be remembered and cherished by the members privileged to be present at the NYU Faculty Club on Washington Square" (Gessner, "Erwin Panofsky," 3). In the minutes from what was the first national meeting of the society on 11–12 April 1960, the secretary George Pratt reports that, following a luncheon at which Panofsky sat together with Parker Tyler and Siegfried Kracauer, "in a short acceptance speech, Mr. Panofsky said, 'I had the courage to go to the movies in 1903 . . . I have tried to preserve an innocence of soul in judging movies . . . I have simply tried to rationalize my own feelings as to what constitutes

a good film or a bad one . . . Good luck to your efforts!'" (Society of Cinematologists file, Museum of Modern Art Film Library). See also the short notice "Film Scholars Meet" in the *New York Times* of 13 April 1960 (45).

13. In a most interesting exchange of letters—which I will treat in greater detail in a forthcoming essay on Panofsky and the founding of film studies in the United States—Panofsky and Gessner discuss in great detail the latter's attempt at developing an analytic vocabulary for the evaluation of film. This project first appeared in print—with extensive references to Panofsky—in Gessner's "The Parts of Cinema: A Definition" published—appropriately—in the inaugural issue of the *Journal of the Society of Cinematologists* (July 1962): 25–39 and then in a slightly revised version as "An Introduction to the Ninth Art" (*Art Journal* 21.2 [Winter 1961–1962]: 89–92). It subsequently formed the basis for Gessner's *The Moving Image: A Guide to Cinematic Literacy* (New York: Dutton, 1968), a fact made explicit in the acknowledgments (16).

14. In a letter to Siegfried Kracauer dated 9 April 1956, Panofsky laments the miserable film culture in Princeton in the context of his comments on an article by Kracauer entitled "The Found Story and the Episode" (*Film Culture* 2.1/7 [1956]: 1–5):

> I read it, as you can imagine, with great interest, and I am quite convinced that you are right. I must confess, though, that it made me realize how much I have lost contact with the movies in later years; only a fraction of the instances you cite is known to me by direct experience, which is in part due to the fact that good moving pictures very rarely reach this town and that, with advancing years, I am simply too lazy to undertake a trip to New York to keep up-to-date. I am all the more touched that you still refer to that old article of mine, which is now more than twenty years old. (Kracauer papers, Deutsches Literaturarchiv, Marbach [hereafter DLA])

However, Panofsky obviously did see contemporary films on occasion, as evidenced by an account of his remarks about the formally complex film by Alain Resnais just two years before his death. According to William S. Heckscher:

> It was strangely touching to hear Panofsky discuss (on February 2, 1966) the enigmatic film [based on a screenplay written] by Alain Robbe-Grillet, *L'Année dernière à Marienbad*, which in 1961 had been filmed not there but at Nymphenburg and Schleissheim. As those who have seen the film will remember, the heroine, Delphine Seyrig, remains ambiguously uncertain whether or not she remembers what can only have been a love affair "last year at Marienbad." Panofsky said he was immediately reminded of Goethe, who at the age of seventy-four (Panofsky's own age at that point) had fallen in love with Ulrike von Levetzow, a girl in her late teens, whom he saw during three successive summers at Marienbad. The elements of Love, Death, and Oblivion in Goethe's commemorative poem, the "Marienbader Elegie," seemed to Panofsky to anticipate the leitmotifs of the film. He noted the opening words of the elegy ("Was soll ich nun vom Wiedersehen hoffen . . . ?") and pointed out how the elements of clouded remembrance and erotic uncertainty were shared by both the poem and the film. He added that the director, Alain Resnais, had a way of leaving his actors uncommonly free to chart their own parts. Miss Seyrig might well have been familiar with Goethe's poem and its ambiguous message. Was she not, after all, the daughter of a famous and learned father, Henri Seyrig, archaeologist, former Directeur Général des Musées de France, and on repeated occasions a member of the Institute for Advanced Study at Princeton? (Heckscher, "Erwin Panofsky," 186–187).

15. EP1936, 5–6.

16. Heckscher, "Erwin Panofsky," 186; Irving Lavin, "Panofsky's Humor," in Erwin Panofsky, *Die Ideologischen Vorläufer des Rolls-Royce-Kühlers & Stil und Medium im Film* (Frankfurt/M./New York: Campus Verlag, 1993), 9; an expanded version of this essay, with the term "frivolous" now in quotation marks, was published as the editor's introduction to Panofsky, *Three Essays on Style*, 3–14; Karen Michels, "Die Emigration deutschsprachiger Kunstwissenschaftler nach 1933," in Bredekamp et al., eds., *Aby Warburg. Akten des internationalen Symposions Hamburg 1990* (Weinheim: VCH Verlagsgesellschaft, 1991), 296.

17. To my knowledge, the present essay is the first sustained examination of Panofsky's film essay in the English-language secondary literature on Panofsky. The quite consistent neglect of the film text—even where, as in Michael Ann Holly's *Panofsky and the Foundations of Art History* (Ithaca/London: Cornell University Press, 1984) to take just one representative example,

there is an intelligent discussion of the early essay on "Perspective as Symbolic Form" in the context of contemporary debates on the representational politics of photographic culture—is itself, as I will suggest below, quite symptomatic. In German, besides Irving Lavin's introduction to the German reprint of the film essay and the study of the Rolls-Royce radiator ("Panofsky's Humor," op. cit.), Regine Prange has recently published what is effectively the first close reading of the film essay in the context of Panofsky's oeuvre—"Stil und Medium. Panofsky 'On Movies,'" in Bruno Reudenbach, ed., *Erwin Panofsky. Beiträge des Symposions Hamburg 1992* (Berlin: Akademie Verlag, 1994), 171–190. According to Prange, the occasional references to Panofsky's film essay in the German art-historical literature arise in discussions of the proto-cinematic structure of antique and medieval image sequences; cf. Georg Kauffmann, *Die Macht des Bildes—über die Ursachen der Bilderflut in der modernen Welt* (Opladen, 1987), 31f., and Karl Clausberg, "Wiener Schule—Russischer Formalismus—Prager Strukturalismus. Ein komparatisches Kapitel Kunstwissenschaft," *Idea* 2 (1983): 151, 176f.

18. A telling index of the methodological threat which cinema poses for the history of art can be found in Martin Warnke's mapping of the "Gegenstands bereiche der Kunstgeschichte" [provinces of art history] in the very popular introduction to the discipline edited by Hans Belting and others: *Kunstgeschichte. Eine Einführung* (Berlin: Reimer, 1985; rpt. 1988):

> If one considers the media as part of a visual culture which can be subject to scholarly analysis, then this widens the field of inquiry of concern to the history of art, making not only so-called *trivial art* (such as the production of comics, magazines, posters or department-store paintings) but also the entire domain of the *new media* into objects of art-historical research. Research on the history of *photography* has in fact taken on some momentum within art history during the last few years (in America it has long been an accepted practice). By contrast, the study of film (not to mention television) has not yet found scholarly footing within art history; they are currently becoming the province of a *media science* now in the process of being established. *One wonders whether the discipline of art history is capable of surviving if it fails to take account of this formative medium of visual experience;* but one can also have one's doubts as to whether the discipline has the methodological and personnel resources needed to expand its scholarly enterprise into the field of the mass media, and whether in order to do so it might not have to sacrifice essential presuppositions and goals. Art history has experienced a comparable extension of its field of inquiry only once, when, in the second half of the 19th century, arts and crafts museums were established everywhere. The discipline mastered the demands made upon it then very well: indeed, the collections of the arts and crafts museums contain photographs, posters, and advertisements which provide a point of departure for the new perspectives oriented around media-studies. Even the inclusion of design within the art historian's field of inquiry is easily reconciled with long-standing tasks of the arts and crafts museums. To some extent, therefore, the new expansionist tendencies are breaking down doors that have long been open. *This is not true, however, of the media of film and television.* The fact that these domains of inquiry will not be touched upon here is not meant to be a statement against these new expansionist proposals. One can already predict, however, that the discipline will not be able to avoid these media completely if only because films about artists are already among the primary sources of the history of art and also because since the 1960s artists themselves have been making use of videos, either for documentary or for creative purposes. (21–22; emphasis added; this and all subsequent translations are, unless otherwise noted, my own)

While, indicatively, the bibliography at the back of the volume does not contain one single reference to the film theory literature, in a section entitled "Beispiele grenzenüber-schreitender Untersuchungen aus der Kunstgeschichte" [Examples of Art Historical Studies That Go Beyond the Confines of the Discipline] there is exactly one essay listed that deals with film: Panofsky's.

19. Karen Michels, "Versprengte Europaër: Lotte Jacobi photographiert Erwin Panofsky," *Idea. Jahrbuch der Hamburger Kunsthalle* 10 (1991): 13, note 9. This reading of a photograph of Panofsky is one of the rare texts that broaches the question of his position on technological reproducibility.

20. Heckscher, "Erwin Panofsky," 186; Lavin, "Panofsky's Humor," 10, and "Introduction" in Panofsky, *Three Essays on Style*, 10. The republication history of the "final" 1947 version of the essay—which has just been published again, this time illustrated with a series of beautifully reproduced film stills, in Panofsky, *Three Essays on Style* (1995), 91–125—can be divided loosely

into two periods and discursive contexts. An initial wave of reprints occurred in the 1950s (and again in the 1970s) in anthologies on theater, the contemporary arts, and aesthetics, as represented by volumes such as Eric Bentley, ed., *The Play* (New York: Prentice-Hall, 1951), 751–772; T. C. Pollock, ed., *Explorations* (Englewood Cliffs: Prentice-Hall, 1956), 209–217; Morris Weitz, ed., *Problems in Aesthetics* (New York: Macmillan, 1959, rpt. 1970, both editions with an incorrect singular of "motion picture" in the essay title), 663–680; and then, over a decade later, Harold Spencer, ed., *Readings in Art History*, vol. II: *The Renaissance to the Present* (New York: Charles Scribner's Sons, 2nd ed., 1976), 427–447; and Richard Searles, ed., *The Humanities through the Arts* (New York: McGraw-Hill, 1978). A second wave of reprints within the context of film studies was initiated by Daniel Talbot's *Film: An Anthology* (New York: Simon and Schuster, 1959; rpt. Berkeley/Los Angeles: University of California Press, 1975), 15–32, following which the essay reappeared in Charles Thomas Samuels, ed., *A Casebook on Film* (New York: Van Nostrand-Reinhold, 1970), 9–22 (without Panofsky's footnotes); T. J. Ross, ed., *Film and the Liberal Arts* (New York: Holt, Rinehart and Winston, 1970—here misleadingly with the title and credit of the 1936 version "On Movies"), 375–395; John Stuart Katz, comp., *Perspectives on the Study of Film* (Boston: Little, Brown, 1971), 57–73; Gerald Mast and Marshall Cohen, eds., *Film Theory and Criticism* (New York/London/Toronto: OUP, 1974; 2nd ed., 1979; 4th ed., 1992); David Denby, ed., *Awake in the Dark: An Anthology of American Film Criticism* (New York: Vintage, 1976), 30–48; and John Harrington, ed., *Film and/as Literature* (Englewood Cliffs: Prentice-Hall, 1977).

The vast majority of the translations (always based on the 1947 version of the text) also appeared in journals or volumes devoted to mass media: in German—"Stil und Stoff im Film," trans. Helmut Färber, *Filmkritik* 11, 1967: 343–355, rpt. with slight modifications (and the images adopted later in the reprint in Panofsky, *Three Essays on Style*) in Erwin Panofsky, *Die Ideologischen Vorläufer des Rolls-Royce-Kühlers & Stil und Medium im Film* (Frankfurt/M./ New York: Campus Verlag, 1993), 17–51; compare also the translation by Meggy Busse- Steffens, "Stilarten und das Medium des Films," in Alphons Silbermann, ed., *Mediensoziologie. Band I: Film* (Düsseldorf/Vienna: Econ Verlag, 1973), 106–122—French—"Style et matériau au cinéma," trans. Dominique Noguez, *Revue d'Esthétique* 36, 2–4 (Special Film Theory Issue, 1973): 47–60—Danish (in: Lars Aagaard-Mogensen, ed., *Billedkunst & billed tolkning* [Copenhagen: Nyt Nordisk Forlag Arnold Busck, 1983]: 152–167; 206f.)—Hebrew (in: H. Keller, ed., *An Anthology of the Cinema* [Tel Aviv: Am Oved Publishers, 1974], 12–27)—Polish ("Styl i tworzywo zo filmie," in Erwin Panofsky, *Studia z Historii Sztuki*, edited and translated by Jan Bialostocki [Warsaw: Painstwowy Instytut Wydawniczy, 1971], 362–377)—Serbo-Croatian ("Stil in snov v filmu" in *Ekran* 1:9/10 [1976]: 11–13 and 2:1/2 [1977]: 58–61)—and Spanish (in Jorge Urrutia, *Contribuciones al Analisis Semiologico del Film* [Valencia: Fernando Torres, 1976], 147–170).

21. Although a thorough history of film theory still remains to be written, it is nevertheless worth noting that there is barely even a reference to Panofsky in either of the two works which currently serve to temporarily bridge that gap: Guido Aristarco's *Storia delle Teoriche del Film* (Torino: Einaudi, 1951/ rev. 1963) and J. Dudley Andrew's *The Major Film Theories* (New York/London: Oxford University Press, 1976). An intelligent exegetical summary and citation cento of Panofsky's essay does appear, interestingly enough, in a more recent overview of the history of film theory written by a film scholar from the former GDR: cf. Peter Wuss, *Kunstwert des Films und Massencharakter des Mediums. Konspekte zur Geschichte des Spielfilms* (Berlin: Henschel Verlag, 1990), 248–254.

22. In *Visionary Film* (New York: Oxford University Press, 1980), for example, P. Adams Sitney invokes Panofsky's critique of films that "prestylize" their objects (as in the expressionist cinema) in a discussion of ritual and nature in the films of Maya Deren, without, however, further engaging the essay (25). In his study *Film and Fiction: The Dynamics of Exchange* (New Haven/London: Yale University Press, 1979), Keith Cohen also cites a number of passages from Panofsky's film essay in various contexts but does not undertake a reading of the text as a whole. Interestingly enough, Panofsky's essay is accorded much more substantive treatment in texts that locate it in terms of current debates in philosophical aesthetics, such as Joseph Margolis, "Film as a Fine Art" (*Millennium Film Journal* 14/15 [Fall–Winter 1984–1985]: 89–104), and, above all, Terry Comito, "Notes on Panofsky, Cassirer, and the 'Medium of the Movies'" (*Philosophy and Literature* 4.2 [Fall 1980]: 229–241). Another unexplored avenue by which one might approach Panofsky's work in the context of film studies is suggested by the following comment

from the director Douglas Sirk: "Another influence on me was Erwin Panofsky, later the great art historian, under whom I studied. I was one of the select in his seminar, and for him I wrote a large essay on the relations between medieval German painting and the miracle plays. I owe Panofsky a lot" (*Sirk on Sirk: Interviews with Jon Halliday* [New York: Viking, 1972], 16).

23. Erwin Panofsky, "Original und Faksimilereproduktion," *Der Kreis* 7 (1930), rpt. in *Idea* 5 (1986): 11–123, and "Die Perspektive als 'Symbolische Form'" (1924–1925), rpt. in: Panofsky, *Aufsätze zu Grundfragen der Kunstwissenschaft*, ed. Hariolf Oberer and Egon Verheyen (Berlin: Wissenschaftsverlag Volker Spiess, 1985), 99–167; translated by Christopher Wood as *Perspective as Symbolic Form* (New York: Zone Books, 1991) [hereafter referred to as *Perspective*]. While art historians have already located their readings of this text within current debates on perception directly relevant to film theory (see, for example, Michael Ann Holly, *Panofsky and the Foundations of Art History*, 130–157), it is virtually unknown in film studies. One of the rare exceptions is Gabriele Jutz and Gottfried Schlemmer's "Zur Geschichtlichkeit des Blicks," in Christa Blümlinger, ed., *Sprung im Spiegel. Filmisches Wahrnehmen zwischen Fiktion und Wirklichkeit* (Wien: Sonderzahl, 1990), 15–32.

24. Although it is beyond the scope of this essay to trace these filiations, one can get a sense of Panofsky's sizable debt to the established film theoretical discourse if one reads the film essay against the backdrop of Arnheim's 1932 *Film als Kunst* (Berlin: Ernst Rowohlt Verlag, 1932) and other of his feuilleton essays from the late 1920s and early 1930s. Particularly striking are the parallels with Arnheim's 1931 "Zum ersten Mal!" (rpt. in Rudolf Arnheim, *Kritiken und Aufsätze zum Film*, ed. Helmut H. Diederichs [München/Wien: Carl Hanser Verlag, 1977], 19–21).

25. Indeed, according to the editorial remarks introducing a later reprinting of the text, this specificity argument forms the article's core: like Aristotle's *Poetics*, "the heart of the essay is in the statement of essential differences between stage and screen [. . . in order] to define the potentialities and limitations of the moving picture as a medium and its special artistic province" (D. L. Durling et al., eds., *A Preface to Our Day*, 570). Other republications in anthologies of film theory also invariably group the text with others focused on "the medium" (as, for example, in Mast, Cohen, and Braudy, eds., *Film Theory and Criticism*).

26. EP1947, 235. In Kracauer's *From Caligari to Hitler: A Psychological History of the German Film* (Princeton: Princeton University Press, 1947), for example, a book whose publication by Princeton University Press had been decisively mediated by Panofsky, the only citation from Panofsky's essay in the entire book is a reference to this argument which, indicatively, leaves out the undeveloped discussion of the "spatialization of time" (6).

27. As Brigitte Peucker rightly points out in her recent study of relations between film and the other arts, "Erwin Panofsky's famous assertion that film's unique possibilities lie in its 'dynamization of space' and 'spatialization of time' is not the first such claim" (Brigitte Peucker, *Incorporating Images: Film and the Rival Arts* [Princeton: Princeton University Press, 1995], 170). For a stimulating discussion of some of the earlier attempts at articulating the medium's spatio-temporal specificity, see Anthony Vidler, "The Explosion of Space: Architecture and the Filmic Imaginary," *Assemblage* 21 (1993): 45–59. Vidler cites Elie Faure's 1922 essay on "ciné-plastics" (a term he coined in 1922 under the influence of Léger to capture film's particular synthesis of space and time) where he states: "The cinema incorporates time to space. Better, time, through this, really becomes a dimension of space" (Elie Faure, "De la cinéplastique," *L'Arbre d'Éden* [Paris: Editions Cros, 1922], rpt. in Marcel L'Herbier, *L'Intelligence du cinématographe* [Paris: Editions Corrêa, 1946], 266f.). The space of cinema, Faure suggests, is a new space similar to that imaginary space "within the walls of the brain" (an issue taken up in recent work on "narrative space") in which Faure sees "the notion of duration entering as a constitutive element into the notion of space."

28. EP1947, 236.

29. Ibid., 240; emphasis added.

30. As an example of a rather complex visual convention which only began to enjoy widespread intelligibility much more recently, consider the technique used to mark two episodes shown in sequence as having taken place simultaneously. The original Batman television series developed a rather striking visual means to convey such temporal simultaneity, a spinning of the last image of the first sequence in its own plane around its visual center, perhaps readable as the visual equivalent of a fast rewind, which effectively signified "meanwhile back in . . . "

31. *Perspective,* 34.

32. Ibid., 65.

33. Ibid., 34.

34. Walter Benjamin, *Das Kunstwerk im Zeitalter seiner technischen Reproduzierbarkeit* (Frankfurt/M.: Suhrkamp, 1963), translated by Harry Zohn as "The Work of Art in the Age of Mechanical Reproduction," in Hannah Arendt, ed., *Illuminations* (New York: Schocken, 1969), 217–251; Martin Heidegger, "Die Zeit des Weltbildes," *Holzwege* (Frankfurt/M.: Klostermann, 1950), translated by William Lovitt as "The Age of the World Picture," *The Question Concerning Technology* (San Francisco: Harper and Row, 1977), 115–154; Jean-Louis Baudry, "Effets idéologiques produits par l'appareil de base," *L'Effet cinéma* (Paris: Albatros, 1978), 13–26, translated by Alan Williams as "Ideological Aspects of the Basic Cinematic Apparatus," in Phil Rosen, ed., *Narrative, Apparatus, Ideology: A Film Theory Reader* (New York: Columbia University Press, 1986), 286–298; Gilles Deleuze, *L'image-mouvement* (Paris: Editions de Minuit, 1983), translated by Hugh Tomlinson and Barbara Habberjam as *Cinema 1: The Movement-Image* (London: Athlone, 1986), and *L'image-temps* (Paris: Editions de Minuit, 1985), translated by Hugh Tomlinson and Robert Galeta as *Cinema 2: The Time-Image* (London: Athlone, 1989).

35. Béla Balázs, *Der Geist des Films* (1930), rpt. in *Schriften zum Film,* vol. II, ed. Helmut Diederichs et al. (Berlin/Budapest: Hanser, 1984), citation 135; translation cited from Gertrud Koch, "Béla Balázs: The Physiognomy of Things," trans. Miriam Hansen, *New German Critique* 40 (Winter 1987): 171.

36. EP1947, 240.

37. The analogy with the Saxon peasant is revealing in that the cultural intelligibility or unintelligibility of this gesture of pouring is here not a question of the form or mode of its representation (which would be the appropriate analogon to cinematic language): the Saxon peasant, one can assume, recognizes what is depicted, but has difficulty knowing what it means. It is the meaning of that configuration, and not the intelligibility of the representation as such, which is at issue here. The question, in other words, is one of content, not form.

38. EP1947, 240.

39. Jan Bialostocki, "Erwin Panofsky. Thinker, Historian, Human Being," *Simiolus* 4 (1970): 82.

40. For a discussion of some of the implications of the changes in the essay's titles, see Irving Lavin, "Panofsky's Humor."

41. Hans Eisler [and Theodor Adorno], *Composing for the Films* (New York: Oxford University Press, 1947). For a discussion of the aesthetic politics of contrapuntal sound, see my "The Acoustic Dimension: Notes on Cinema Sound," *Screen* (London) 25.3 (May–June 1984): 55–68.

42. EP1947, 247–248.

43. On the epistemological issues at stake in this Benjaminian topos, see Miriam Hansen, "Benjamin, Cinema and Experience: 'The Blue Flower in the Land of Technology,'" *New German Critique* 40 (Winter 1987): 179–224, esp. 207ff; on the complex surrealist genealogy of Benjamin's "optical unconscious," see also Josef Fürnkäs, *Surrealismus als Erkenntnis. Walter Benjamin, Weimarer Einbahnstrasse und Pariser Passagen* (Stuttgart ,1988).

44. Béla Balázs, *Der sichtbare Mensch oder die Kultur des Films* (1924), rpt. in Béla Balázs, *Schriften zum Film,* ed. Helmut H. Diederichs et al. (Munich: Carl Hanser Verlag, 1982), vol. I, 43–143, and esp. "Das Gesicht der Dinge," 92–98. For a discussion of this unfortunately still untranslated study, see Koch, "Béla Balázs: The Physiognomy of Things."

45. On Bazin's film theory, see the special issue of *Wide Angle* 9.4 (1987), ed. Dudley Andrew.

46. Georg von Lukács, "Gedanken zu einer ästhetik des 'Kino'" (1911/1913), rpt. in: *Kino-Schriften 3. Jahrbuch der Gesellschaft für Filmtheorie* (Vienna: Verlag der wissenschaftlichen Gesellschaften österreichs, 1992), 233–241, translated by Barrie Ellis-Jones as "Thoughts on an Aesthetic for the Cinema," *Framework* (London) 14 (Spring 1981): 2–4. For a contextualizing reading that corrects some mistakes in the translation and locates the essay within Lukács's aesthetics in general and his other writings on film in particular, see my "From Dialectical to Normative Specificity: Reading Lukács on Film," *New German Critique* 40 (Winter 1987): 35-61.

47. EP1947, 248.

48. Cf. *Siegfried Kracauer und Erwin Panofsky: Briefwechsel 1941-1966.* Mit einem Anhang

"Kracauer und 'The Warburg Tradition'" herausgegeben und kommentiert von Volker Breidecker (Berlin: Akademie Verlag, 1996).

49. In a letter to Kracauer dated 29 April 1947, Panofsky apologizes for not yet having had time to properly read Kracauer's "Hitler-Caligari" but makes the following comment: "But already at this point I am very excited and convinced by the fundamental correctness of your thesis. Naturally for someone like me who—unlike most Americans—has seen all, or at least most, of these German films from 1919–1932 (often in special circumstances which are unintentionally associated with the film), there is also a strange feeling of personal recollection mixed in which makes it difficult to perceive the things in an entirely analytical fashion—as if one were, so to say, a contemporary of Jan van Eyck to whom Jan van Eyck's images were suddenly being explained. But this strange feeling—to call it 'nostalgic' is too much while 'retrospective' is too little—merely heightens the pleasure of the reading all the more" ["Aber schon jetzt bin ich sehr begeistert und überzeugt von der fundamentalen Richtigkeit Ihrer These. Natürlich mischt sich für einer, der—im Gegensatz zu den meisten Amerikanern—alle, oder doch die meisten, dieser deutschen Filme von 1919–1932 gesehen hat—oft in speziellen und unwillkürlich mit dem Film assoziierten Situationen, ein merkwürdiges Gefühl von persönlicher Erinnerung mit ein, das es einem schwerer macht, die Dinge ganz rein analytisch zu nehmen (als ob man sozusagen ein Zeitgenosse des Jan van Eyck wäre, dem plötzlich Jan van Eyck's Bilder 'erklärt' werden. Aber dieses merkwürdige Gefühl—'nostalgisch' ist zu viel, 'retrospektiv' zu wenig—erhöht die Freude an der Lektüre nur noch mehr"]. Kracauer's grateful response, dated 2 May 1947, is equally fascinating: "How well I understand that the encounter of objective analyses and personal recollections touches you in a strange way. I myself was pulled back and forth between the foreign and the familiar, was at times astonished that I knew something that I was observing from the outside so well from the inside—much like today when one hears German spoken and is simultaneously behind and in front of the linguistic wall—and was happy when from time to time my judgment from back then proved to be the same as the product of my current analysis. As I was writing I felt like a doctor who was doing an autopsy and in the process also dissects a piece of his own past which is now definitively dead. But naturally, some things do survive—in however transformed a fashion. It is a tightrope walking between yesterday and today" ["Wie sehr ich es verstehe, dass Sie das Rencontre von objektiven Analysen und persönlichen Erinnerungen merkwürdig berührt. Ich selber war hin und her gezerrt zwischen Fremdheit und Nähe, wunderte mich manchmal, dass ich etwas von aussen beobachtetes so gut von innen kannte—wie wenn man heute deutsch sprechen hört und zugleich hinter und vor der Sprachwand ist—, und war glücklich wenn sich bei Gelegenheit mein damaliges Urteil und meine heutige Erkenntnis als eins erwiesen. Im Schreiben kam ich mir wie ein Arzt vor, der eine Autopsie vornimmt und dabei auch ein Stück eigener, jetzt endgültig toter Vergangenheit seziert. Aber natürlich, einiges lebt, wie immer verwandelt, fort. Es ist ein tightrope walking zwischen und über dem Gestern und Heute"] (Kracauer Papers, Deutsches Literaturarchiv Marburg [DLA]). For a discussion of the relationship between Panofsky and Kracauer, see Volker Breidecker, "Kracauer und Panofsky. Ein Rencontre im Exil," *Im Blickfeld: Jahrbuch der Hamburger Kunsthalle Neue Folge* 1 (1994): 125–147, which was announced in a short advance review by Henning Ritter, "Kracauer trifft Panofsky: Eine Autopsie," *Frankfurter Allgemeine Zeitung* 85 (13 April 1994): N5. For a sketch of Kracauer's contemporaneous relationship with another major figure in the New York art-historical community, see Ingrid Belke, "'Das Geheimnis des Faschismus liegt in der Weimarer Republik': Der Kunsthistoriker Meyer Schapiro über Kracauers erstes Film-Buch," *FilmExil* 4 (1994): 35–49, and Mark M. Anderson, "Siegfried Kracauer and Meyer Schapiro: A Friendship," *New German Critique* 54 (Fall 1991): 19–29.

50. Kracauer repeatedly professes his admiration for the film essay, as early as his second letter to Panofsky on 1 October 1941, in which he writes: "Let me add that I really admire your essay 'Style and Medium in the Moving Pictures'; I am so glad about the fact that my own thoughts on film which I hope to develop now finally in form of a book, take almost the same direction" (Kracauer Papers, DLA). But the slight reserve evident in the qualification "almost" in the final phrase manifests itself subsequently in Kracauer's published work: in *Caligari*, for example, there is only one passing reference to Panofsky's essay (see note 26 above), which is striking given the nearly two dozen citations of other contemporary writers on film such as Harry Potamkin or Paul Rotha. Even the final version of the essay, about which Kracauer was

also enthusiastic—claiming in a letter to Panofsky on 6 November 1949, that "Das rote Heftchen der 'Critique' mit Ihrer Abhandlung—a true classic—habe ich immer bei der Hand" [I always have the red 'Critique' pamphlet with your essay—a true classic—within arm's reach]—is only cited in passing on four occasions in Kracauer's *Theory of Film* (Kracauer Papers, DLA).

51. EP1947, 247.

52. Kracauer's copy of *Critique,* which Panofsky had sent him, carries the following dedication: "To Dr. S.K. with best wishes, E.P. An old, old story with a few new trimmings" (Kracauer Papers, DLA Marbach).

53. Kracauer Papers, DLA.

54. In the 1930 essay on "Original und Faksimilereproduktion" Panofsky had already noted that a photograph is a "durchaus persönliche Schöpfung . . . bei der der Photograph . . . in Bezug auf Ausschnitt, Distanz, Aufnahmerichtung, Schärfe und Beleuchtung nicht sehr viel weniger 'frei' ist als ein Maler" [thoroughly personal creation . . . in the production of which the photographer . . . is not much less 'free' than the painter in terms of framing, distance, orientation, sharpness of focus and lighting] (Cited in Michels, "Versprengte Europäer," 12).

55. Handwritten letter from Panofsky to Kracauer, dated 23 December 1943 (DLA; emphasis added): "Aber Sie sind der erste, von dem ich mich, wie Palma Kankel, 'tief verstanden' fühle, und dafür kann ich Ihnen garnicht dankbar genug sein. Besonderen Spaß hat es mir gemacht, daß Sie gerade eine Einzelheit wie die innere Beziehung zwischen Technik und Inhalt, die das 19. Jahrhundert in seiner sonderbaren Blindheit *sowohl* für das angeblich außer-'künstlerisch' Technische als für das angeblich ebenfalls außer-'künstlerisch' Gegenständliche übersehen hatte, interessant fanden. Das kommt daher, da\s wir beide etwas von den Movies gelernt haben!"

56. EP1937, 133.

57. Prange, "Stil und Medium."

58. Cf. Adolf Max Vogt, "Panofsky's Hut. Ein Kommentar zur Bild-Wort-Debatte," in Calpeter Braegger, Hrsg., *Architektur und Sprache* (Munich, 1982), 279–296. Compare also Regine Prange, "Die erzwungene Unmittelbarkeit. Panofsky und der Expressionismus," *Idea* 10 (1991): 221–251. On Panofsky's infamous quarrel with Barnett Newman in the early 1960s, cf. Beat Wyss's hilariously typo-ridden but most interesting essay, "Ein Druckfehler," in Reudenbach, ed., *Erwin Panofsky,* 191–199.

59. Erwin Panowsky [sic], "Book Comment: Plastic Redirection in 20th Century Painting, by James Johnson Sweeney," *Museum of Modern Art Bulletin* 2.2 (November 1934): 3. The most comprehensive bibliography of Panofsky's writings can be found in Panofsky, *Aufsätze zu Grundfragen der Kunstwissenschaft,* 1–16.

60. Oskar Bätschmann, "Logos in der Geschichte. Erwin Panofskys Ikonologie," in Lorenz Dittmann, ed., *Kategorien und Methoden der Deutschen Kunstgeschichte 1900–1930* (Stuttgart: Franz Steiner Verlag, 1985), 98–99. Kubler's critique of iconography, which Bätschmann discusses at some length, can be found in *The Shape of Time: Remarks on the History of Things* (New Haven/London: Yale University Press, 1962), 127.

61. In his richly illustrated essay "En relisant Panofsky" (*Positif* 259 [September 1982]: 38–43), Bourget takes up Panofsky's tripartite model and argues that, since most film criticism jumps all too hastily from the pre-iconographic to the iconological, the urgent task facing film criticism is to develop a proper cinematic iconography. To this end Bourget expands upon a number of Panofsky's examples, providing a list of at least ten films in which—to cite only one example— one finds a checkered tablecloth and coffee on the breakfast table as a sign of domestic happiness.

62. Clair Johnston, "Women's Cinema as Counter-Cinema" (1973), rpt. in Bill Nichols, ed., *Movies and Methods* (Berkeley/Los Angeles: University of California Press, 1976), 209.

63. Stanley Cavell, *The World Viewed: Reflections on the Ontology of Film* (Cambridge, Mass.: Harvard University Press, 1971, [enlarged edition] 1979), 16.

64. Ibid.,166. Citing Panofsky's line that "the medium of the movies is physical reality as such," Cavell earlier points out that "'physical reality as such,' taken literally, is not correct: that phrase better fits the specialized pleasures of *tableaux vivants,* or formal gardens, or Minimal Art." Rather, as he explains, what Panofsky means is that film is fundamentally photographic, and "a photograph is of reality or nature." This, however, raises the question "what happens to reality when it is projected and screened?" (16).

65. Commenting on the fact that films allow us to see the world without ourselves being seen, i.e., that films afford us the power of invisibility, Cavell writes: "In viewing films, the sense

of invisibility is an expression of modern privacy or anonymity. It is as though the world's projection explains our forms of unknownness and of our inability to know. The explanation is not so much that the world is passing us by, as that we are displaced from our natural habitation within it, placed at a distance from it. The screen overcomes our fixed distance; it makes displacement appear as our natural condition" (*The World Viewed*, 40–41).

66. EP1947, 241.

67. Cavell, *The World Viewed*, 33.

68. Stanley Cavell, *Pursuits of Happiness: The Hollywood Comedy of Remarriage* (Cambridge, Mass.: Harvard University Press, 1981).

69. Horst Bredekamp, "Götterdämmerung des Neoplatonismus," *Kritische Berichte* 14/4 (1986): 39–48; rpt. in Andreas Beyer, ed., *Die Lesbarkeit der Kunst. Zur Geistes-Gegenwart der Ikonologie* (Berlin: Verlag Klaus Wagenbach , 1992), 75–83. This text, which attempted to undertake an ideological reading of iconology as a project, argued—as the title already indicates—that its central philosopheme was a neoplatonism that functioned as a symptomatic escape from the threatening rise of nationalism in the 1920s. It functioned not as an attack but as a defense of iconology, and especially of Warburg.

70. Michael Diers, "Von der Ideologie- zur Ikonologiekritik. Die Warburg-Renaissancen," in *Frankfurter Schule und Kunstgeschichte* (Berlin: Reimer, 1992), 27. The papers from this session were published as Martin Warnke, ed., *Das Kunstwerk zwischen Wissenschaft und Weltanschauung* (Gütersloh: Bertelsmann Kunstverlag, 1979).

71. Walter Benjamin, "Drei Lebensläufe," in *Zur Aktualität Walter Benjamins*, ed. Siegfried Unseld (Frankfurt a.M.: Suhrkamp Verlag, 1972), 46; translation cited from Thomas Y. Levin, "Walter Benjamin and the Theory of Art History: An Introduction to 'Rigorous Study of Art'," *October* 47 (Winter 1988): 78.

72. EP1947, 234.

73. Ibid., 244.

74. "Es ist nicht richtig, daß der Film die Kunst braucht, es sei denn, man schafft eine neue Vorstellung von Kunst" (Bert. Brecht, "Der Dreigroschenprozeß," *Versuche 8–10*, vol. 3 [Berlin, 1931]: 301).

75. The full passage, in response to Kracauer's *Propaganda and the Nazi War Film* (New York: Museum of Modern Art, 1942) shortly after its publication, reads: "Inzwischen habe ich Ihre Schrift mit der grössten Bewunderung gelesen und finde, dass Sie nicht nur das spezielle Problem glänzend gelöst haben, sondern auch einen höchst wichtigen allgemeinen Beitrag zur Struktur des 'Documentary Film' geliefert haben. Ich glaube nämlich—sagen Sie das nicht weiter—dass es einen echten 'Documentary Film' überhaupt nicht gibt, und das unsere sogenannten Documentaries auch Propaganda-Films sind, nur Gott sei Dank, meistens für eine bessere Sache, und, leider Gottes, meistens nicht so geschickt gemacht. Ich hoffe zu Gott, dass wir von Ihren Erkenntnissen Nutzen ziehen werden und das Nazi-Pferd vor anstatt hinter unsern Wagen spannen" (Kracauer papers, DLA).

76. Reversing the traditional argument that contrasts the "authenticity" of the theatrical performance (resulting from the shared spatio-temporal space of actor and audience and the resulting "I-Thou" intensity) with the alienated (because technologically mediated, discontinuous) performance for the camera, Panofsky argues—in quite dialectical fashion—that this very discontinuity requires a massive identification on the part of the actor with his or her role in order for the coherence of the fictitious role to be maintained across the multiple interruptions and alienations. While this is charming as a thought, it is, of course, quite naïve, in that it (again) fails to take into account the extent to which the work of the apparatus—not least, the capacity to repeat a scene 100 times until it is "right"—compensates for much of the intensity "lost" in the mediation.

77. Cf. Breidecker, "Kracauer und Panofsky," 128.

78. Peter Wollen, *Signs and Meaning in the Cinema* (Bloomington and London: Indiana University Press, 1969; "new and enlarged edition," 1972), 143ff.

79. This, Benjamin's own English rendering of the title of his "artwork" essay in a letter of 17 May 1937, to Jay Leyda concerning the possibility of its being translated and requesting that Leyda put him in touch with the Museum of Modern Art (Leyda Papers, New York University).

80. See Walter Benjamin, *Gesammelte Schriften* (Frankfurt/M.: Suhrkamp Verlag, 1974), I/3, 1049f., and VII/2, 679. In his 1933 essay "Strenge Kunstwissenschaft," Benjamin cites the Warburg

Institute as an example of the new type of art history at home in the margins: "Rather, the most rigorous challenge to the new spirit of research is the ability to feel at home in marginal domains. It is this ability which guarantees the collaborators of the new yearbook their place in the movement which—ranging from [Konrad] Burdach's work in German studies to the investigations of the history of religion being done at the Warburg Library—is filling the margins of the study of history with new life" (Walter Benjamin, "The Rigorous Study of Art," trans. Thomas Y. Levin, *October* 47 [Winter 1988]: 84–90). See also my "Walter Benjamin and the Theory of Art History: An Introduction to 'Rigorous Study of Art'," *October* 47 (Winter 1988): 77–83, and Wolfgang Kemp, "Walter Benjamin und die Kunstwissenschaft. Teil 2: Walter Benjamin und Aby Warburg," *Kritische Berichte* 3.1 (1975): 5–25.

81. See, for example, Franz-Joachim Verspohl, "'Optische' und 'taktile' Funktion von Kunst. Der Wandel des Kunstbegriffs im Zeitalter der massenhaften Rezeption," *Kritische Berichte* 3.1 (1975): 25–43. On Benjamin's relation to the Warburg Institute, cf. Momme Brodersen, "'Wenn Ihnen die Arbeit des Interesses wert erscheint . . . ' Walter Benjamin und das Warburg-Institut: einige Dokumente," in Bredekamp et al., eds., *Aby Warburg. Akten des internationalen Symposions Hamburg 1990* (Weinheim: VCH Verlagsgesellschaft, 1991), 87–94.

Iconophobia
and Iconophilia

Béla Balázs

The Close-Up and
The Face of Man

The Face of Things
———

The first new world discovered by the film camera in the days of the silent film was the world of very small things visible only from very short distances, the hidden life of little things. By this the camera showed us not only hitherto unknown objects and events: the adventures of beetles in a wilderness of blades of grass, the tragedies of day-old chicks in a corner of the poultry-run, the erotic battles of flowers and the poetry of miniature landscapes. It brought us not only new themes. By means of the close-up the camera in the days of the silent film revealed also the hidden mainsprings of a life which we had thought we already knew so well. Blurred outlines are mostly the result of our insensitive short-sightedness and superficiality. We skim over the teeming substance of life. The camera has uncovered that cell-life of the vital issues in which all great events are ultimately conceived; for the greatest landslide is only the aggregate of the movements of single particles. A multitude of close-ups can show us the very instant in which the general is transformed into the particular. The close-up has not only widened our vision of life, it has also deepened it. In the days of the silent film it not only revealed new things, but showed us the meaning of the old.

Visual Life
———

The close-up can show us a quality in a gesture of the hand we never noticed before when we saw that hand stroke or strike something, a quality which is often more expressive than any play of the features. The close-up shows your shadow on the wall with which you have lived all your life and which you scarcely knew; it shows the speechless face and fate of the dumb objects that live with you in your room and whose fate is bound up with your own. Before this you looked at your

From *Theory of the Film: Character and Growth of a New Art*. Translated by Edith Bone. (1953) New York: Dover Publications, 1970: 52–88. Reprinted by permission of the publisher. Reprinted in *Film Theory and Criticism: Introductory Readings*. Edited by Leo Braudy and Marshall Cohen. 5th edition. New York: Oxford University Press, 1999: 304–311.

Figure 1. Fritz Lang, Still life from M *(1931).* Museum of Modern Art, New York.

life as a concert-goer ignorant of music listens to an orchestra playing a symphony. All he hears is the leading melody, all the rest is blurred into a general murmur. Only those can really understand and enjoy the music who can hear the contrapuntal architecture of each part in the score. This is how we see life: only its leading melody meets the eye. But a good film with its close-ups reveals the most hidden parts in our polyphonous life, and teaches us to see the intricate visual details of life as one reads an orchestral score.

Lyrical Charm of the Close-Up

The close-up may sometimes give the impression of a mere naturalist preoccupation with detail. But good close-ups radiate a tender human attitude in the contemplation of hidden things, a delicate solicitude, a gentle bending over the intimacies of life-in-the-miniature, a warm sensibility. Good close-ups are lyrical; it is the heart, not the eye, that has perceived them.

Close-ups are often dramatic revelations of what is really happening under the surface of appearances. You may see a medium shot of someone sitting and conducting a conversation with icy calm. The close-up will show trembling fingers nervously fumbling a small object—sign of an internal storm. Among pictures of a comfortable house breathing a sunny security, we suddenly see the evil grin

of a vicious head on the carved mantelpiece or the menacing grimace of a door opening into darkness. Like the leitmotif of impending fate in an opera, the shadow of some impending disaster falls across the cheerful scene.

Close-ups are the pictures expressing the poetic sensibility of the director. They show the faces of things and those expressions on them which are significant because they are reflected expressions of our own subconscious feeling. Herein lies the art of the true cameraman.

In a very old American film I saw this dramatic scene: the bride at the altar suddenly runs away from the bridegroom whom she detests, who is rich and who has been forced on her. As she rushes away she must pass through a large room full of wedding presents. Beautiful things, good things, useful things, things radiating plenty and security smile at her and lean toward her with expressive faces. And there are the presents given by the bridegroom: faces of things radiating touching attention, consideration, tenderness, love—and they all seem to be looking at the fleeing bride, because she looks at them; all seem to stretch out hands toward her, because she feels they do so. There are ever more of them—they crowd the room and block her path—her flight slows down more and more, then she stops and finally turns back. . . .

Having discovered the soul of things in the close-up, the silent film undeniably overrated their importance and sometimes succumbed to the temptation of showing 'the hidden little life' as an end in itself, divorced from human destinies; it strayed away from the dramatic plot and presented the 'poetry of things' instead of human beings. But what Lessing said in his *Laokoön* about Homer— that he never depicted anything but human actions and always described objects only inasmuch as they took part in that action—should to this day serve as a model for all epic and dramatic art as long as it centers around the presentation of man.

The Face of Man

Every art always deals with human beings, it is a human manifestation and presents human beings. To paraphrase Marx: "The root of all art is man." When the film close-up strips the veil of our imperceptiveness and insensitivity from the hidden little things and shows us the face of objects, it still shows us man, for what makes objects expressive are the human expressions projected onto them. The objects only reflect our own selves, and this is what distinguished art from scientific knowledge (although even the latter is to a great extent subjectively determined). When we see the face of things, we do what the ancients did in creating *gods* in man's image and breathing a human soul into them. The close-ups of the film are the creative instruments of this mighty visual anthropomorphism.

What was more important, however, than the discovery of the physiognomy

of things, was the discovery of the human face. Facial expression is the most subjective manifestation of man, more subjective even than speech, for vocabulary and grammar are subject to more or less universally valid rules and conventions, while the play of features, as has already been said, is a manifestation not governed by objective canons, even though it is largely a matter of imitation. This most subjective and individual of human manifestations is rendered objective in the close-up.

A New Dimension

If the close-up lifts some object or some part of an object out of its surroundings, we nevertheless perceive it as existing in space; we do not for an instant forget that the hand, say, which is shown by the close-up, belongs to some human being. It is precisely this connection which lends meaning to its every movement. But when Griffith's genius and daring first projected gigantic "severed heads" onto the cinema screen, he not only brought the human face closer to us in space, he also transposed it from space into another dimension. We do not mean, of course, the cinema screen and the patches of light and shadow moving across it, which being visible things, can be conceived only in space; we mean the expression on the face as revealed by the close-up. We have said that the isolated hand would lose its meaning, its expression, if we did not know and imagine its connection with some human being. The facial expression on a face is complete and comprehensible in itself and therefore we need not think of it as existing in space and time. Even if we had just seen the same face in the middle of a crowd and the close-up merely separated it from the others, we would still feel that we have suddenly been left alone with this one face to the exclusion of the rest of the world. Even if we have just seen the owner of the face in a long shot, when we look into the eyes in a close-up, we no longer think of that wide space, because the expression and significance of the face has no relation to space and no connection with it. Facing an isolated face takes us out of space, our consciousness of space is cut out and we find ourselves in another dimension: that of physiognomy. The fact that the features of the face can be seen side by side, i.e., in space—that the eyes are at the top, the ears at the sides, and the mouth lower down—loses all reference to space when we see, not a figure of flesh and bone, but an expression, or in other words when we see emotions, moods, intentions, and thoughts, things which although our eyes can see them, are not in space. For feelings, emotions, moods, intentions, thoughts are not themselves things pertaining to space, even if they are rendered visible by means which are.

Melody and Physiognomy

We will be helped in understanding this peculiar dimension by Henri Bergson's analysis of time and duration. A melody, said Bergson, is composed of single notes

which follow each other in sequence, i.e., in time. Nevertheless a melody has no dimension in time, because the first note is made an element of the melody only because it refers to the next note and because it stands in a definite relation to all other notes down to the last. Hence the last note, which may not be played for some time, is yet already present in the first note as a melody-creating element. And the last note completes the melody only because we hear the first note along with it. The notes sound one after the other in a time-sequence, hence they have a real duration, but the coherent line of melody has no dimension in time; the relation of the notes to each other is not a phenomenon occurring in time. The melody is not born gradually in the course of time but is already in existence as a complete entity as soon as the first note is played. How else would we know that a melody is begun? The single notes have duration in time, but their relation to each other, which gives meaning to the individual sounds, is outside time. A logical deduction also has its sequence, but premise and conclusion do not follow one another in time. The process of thinking as a psychological process may have duration; but the logical forms, like melodies, do not belong to the dimension of time.

Now facial expression, physiognomy, has a relation to space similar to the relation of melody to time. The single features, of course, appear in space; but the significance of their relation to one another is not a phenomenon pertaining to space, no more than are the emotions, thoughts, and ideas which are manifested in the facial expressions we see. They are picture-like and yet they seem outside space; such is the psychological effect of facial expression.

Silent Soliloquy

The modern stage no longer uses the spoken soliloquy, although without it the characters are silenced just when they are the most sincere, the least hampered by convention: when they are alone. The public of today will not tolerate the spoken soliloquy, allegedly because it is "unnatural." Now the film has brought us the silent soliloquy, in which a face can speak with the subtlest shades of meaning without appearing unnatural and arousing the distaste of the spectators. In this silent monologue the solitary human soul can find a tongue more candid and uninhibited than in any spoken soliloquy, for it speaks instinctively, subconsciously. The language of the face cannot be suppressed or controlled. However disciplined and practicedly hypocritical a face may be, in the enlarging close-up we see even that it is concealing something, that it is looking a lie. For such things have their own specific expressions superposed on the feigned one. It is much easier to lie in words than with the face and the film has proved it beyond doubt.

In the film the mute soliloquy of the face speaks even when the hero is not alone, and herein lies a new great opportunity for depicting man: The poetic significance of the soliloquy is that it is a manifestation of mental, not physical, loneliness. Nevertheless, on the stage a character can speak a monologue only when there is no one else there, even though a character might feel a thousand times

more lonely if alone among a large crowd. The monologue of loneliness may raise its voice within him a hundred times even while he is audibly talking to someone. Hence the most deep-felt human soliloquies could not find expression on the stage. Only the film can offer the possibility of such expression, for the close-up can lift a character out of the heart of the greatest crowd and show how solitary it is in reality and what it feels in this crowded solitude.

The film, especially the sound film, can separate the words of a character talking to others from the mute play of features by means of which, in the middle of such a conversation, we are made to overhear a mute soliloquy and realize the difference between this soliloquy and the audible conversation. What a flesh-and-blood actor can show on the real stage is at most that his words are insincere and it is a mere convention that the partner in such a conversation is blind to what every spectator can see. But in the isolated close-up of the film we can see to the bottom of a soul by means of such tiny movements of facial muscles which even the most observant partner would never perceive.

A novelist can, of course, write a dialogue so as to weave into it what the speakers think to themselves while they are talking. But by so doing he splits up the sometimes comic, sometimes tragic, but always awe-inspiring, unity between spoken word and hidden thought with which this contradiction is rendered manifest in the human face and which the film was the first to show us in all its dazzling variety.

Polyphonic Play of Features

The film first made possible what, for lack of a better description, I call the "polyphonic" play of features. By it I mean the appearance on the same face of contradictory expressions. In a sort of physiognomic chord a variety of feelings, passions, and thoughts are synthesized in the play of the features as an adequate expression of the multiplicity of the human soul.

Asta Nielsen once played a woman hired to seduce a rich young man. The man who hired her is watching the results from behind a curtain. Knowing that she is under observation, Asta Nielsen feigns love. She does it convincingly: the whole gamut of appropriate emotion is displayed in her face. Nevertheless we are aware that it is only play-acting, that it is a sham, a mask. But in the course of the scene Asta Nielsen really falls in love with the young man. Her facial expression shows little change; she had been "registering" love all the time and done it well. How else could she now show that this time she was really in love? Her expression changes only by a scarcely perceptible and yet immediately obvious nuance—and what a few minutes before was a sham is now the sincere expression of a deep emotion. Then Asta Nielsen suddenly remembers that she is under observation. The man behind the curtain must not be allowed to read her face and learn that she is now no longer feigning, but really feeling love. So Asta now pretends to be pretending. Her face shows a new, by this time threefold, change. First she feigns love, then she genuinely shows love, and as she is not permitted to be

in love in good earnest, her face again registers a sham, a pretense of love. But now it is this pretense that is a lie. Now she is lying that she is lying. And we can see all this clearly in her face, over which she has drawn two different masks. At such times an invisible face appears in front of the real one, just as spoken words can by association of ideas conjure up things unspoken and unseen, perceived only by those to whom they are addressed.

In the early days of the silent film Griffith showed a scene of this character. The hero of the film is a Chinese merchant. Lillian Gish, playing a beggar-girl who is being pursued by enemies, collapses at his door. The Chinese merchant finds her, carries her into his house, and looks after the sick girl. The girl slowly recovers, but her face remains stone-like in its sorrow. "Can't you smile?" the Chinese asks the frightened child who is only just beginning to trust him. "I'll try," says Lillian Gish, picks up a mirror, and goes through the motions of a smile, aiding her face muscles with her fingers. The result is a painful, even horrible mask which the girl now turns toward the Chinese merchant. But his kindly friendly eyes bring a real smile to her face. The face itself does not change; but a warm emotion lights it up from inside and an intangible nuance turns the grimace into a real expression.

In the days of the silent film such a close-up provided an entire scene. A good idea of the director and a fine performance on the part of the actor gave as a result an interesting, moving, new experience for the audience.

Microphysiognomy

In the silent film facial expression, isolated from its surroundings, seemed to penetrate to a strange new dimension of the soul. It revealed to us a new world—the world of microphysiognomy which could not otherwise be seen with the naked eye or in everyday life. In the sound film the part played by this microphysiognomy has greatly diminished because it is now apparently possible to express in words much of what facial expression apparently showed. But it is never the same— many profound emotional experiences can never be expressed in words at all.

Not even the greatest writer, the most consummate artist of the pen, could tell in words what Asta Nielsen tells with her face in close-up as she sits down to her mirror and tries to make up for the last time her aged, wrinkled face, raddled with poverty, misery, disease, and prostitution, when she is expecting her lover, released after ten years in jail; a lover who has retained his youth in captivity because life could not touch him there.

Asta at the Mirror

She looks into the mirror, her face pale and deadly earnest. It expresses anxiety and unspeakable horror. She is like a general who, hopelessly encircled with his whole army, bends once more, for the last time, over his maps to search for a way out and finds there is no escape. Then she begins to work feverishly, attacking

Figure 2. Asta Nielsen in Hamlet *(1920) by Svend Gade and Heinz Schall.* Museum of Modern Art, New York.

that disgustingly raddled face with a trembling hand. She holds her lipstick as Michelangelo might have held his chisel on the last night of his life. It is a life-and-death struggle. The spectator watches with bated breath as this woman paints her face in front of her mirror. The mirror is cracked and dull, and from it the last convulsions of a tortured soul look out on you. She tries to save her life with a little rouge! No good! She wipes it off with a dirty rag. She tries again. And again. Then she shrugs her shoulders and wipes it all off with a movement which clearly shows that she has now wiped off her life. She throws the rag away. A close-up shows the dirty rag falling on the floor and after it has fallen, sinking down a little more. This movement of the rag is also quite easy to understand—it is the last convulsion of a death agony.

In this close-up microphysiognomy showed a deeply moving human tragedy with the greatest economy of expression. It was a great new form of art. The sound film offers much fewer opportunities for this kind of thing, but by no means excludes it, and it would be a pity if such opportunities were to be neglected, unnecessarily making us all the poorer. . . .

Mute Dialogues

In the last years of the silent film the human face had grown more and more visible, that is, more and more expressive. Not only had microphysiognomy developed

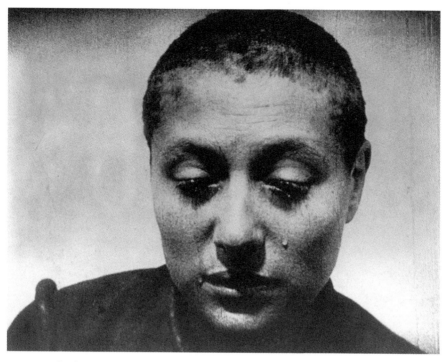

Figure 3. Carl Theodor Dreyer, Renée Falconetti in The Passion of Joan of Arc *(1928).* Museum of Modern Art, New York.

but together with it the faculty of understanding its meaning. In the last years of the silent film we saw not only masterpieces of silent monologue but of mute dialogue as well. We saw conversations between the facial expressions of two human beings who understood the movements of each other's faces better than each other's words and could perceive shades of meaning too subtle to be conveyed in words.

A necessary result of this was that the more space and time in the film was taken up by the inner drama revealed in the microphysiognomic close-up, the less was left of the predetermined 8,000 feet of film for all the external happenings. The silent film could thus dive into the depths—it was given the possibility of presenting a passionate life-and-death struggle almost exclusively by close-ups of faces.

Dreyer's film *Jeanne d'Arc* provided a convincing example of this in the powerful, lengthy, moving scene of the Maid's examination. Fifty men are sitting in the same place all the time in this scene. Several hundred feet of film show nothing but big close-ups of heads, of faces. We move in the spiritual dimension of facial expression alone. We neither see nor feel the space in which the scene is in reality enacted. Here no riders gallop, no boxers exchange blows. Fierce passions, thoughts, emotions, convictions battle here, but their struggle is not in space. Nevertheless this series of duels between looks and frowns, duels in which

eyes clash instead of swords, can hold the attention of an audience for ninety minutes without flagging. We can follow every attack and riposte of these duels on the faces of the combatants; the play of their features indicates every stratagem, every sudden onslaught. The silent film has here brought an attempt to present a drama of the spirit closer to realization than any stage play has ever been able to do.

Jacques Aumont

The Face in Close-Up

It is actually the face that most perfectly performs this task of producing, with a minimum of modification of detail, a maximum of modification in the impression of the whole. In order to resolve the basic problem of any artistic activity–to make each of the formal elements of an object intelligible, to interpret the invisible by its correlation with the visible–it is the face that seems the best suited, because in it each trait is, in its destination, interdependent with each of the others, that is to say with all. The reason for this–and at the same time the consequence of it–is the tremendous mobility of the face: in the absolute, this mobility has, of course, only minimal movements, but, through the influence of each on the overall habitus of the face, it manages to create the impression of powerful changes. It might even be said that there is a maximum quantity of movements invested in its resting state or, further, that the resting state is nothing but that moment, without duration, in which innumerable movements have converged, from which innumerable movements will diverge.

<div align="right">—Georg Simmel</div>

What 'ave you ever seen in 'im to love?
—It may be that I sees the soul in 'im . . . that 'e don't know 'e's got 'imself.
<div align="right">—Intertitle from *The Blackbird* (referring to the face of Lon Chaney)</div>

Readable Face, Visible Face

The ordinary face in film was not invented overnight; it first required the experimental years of early cinema. But, at the heart of this passage from one readability to another, more discrete, there occurred, in that portion of the silent cinema that is most closely researched as art, a reaction as violent as it was temporary, and always in the minority. A fundamental reaction, however, because it invented not so much a use as a concept of the face, and it remained at the source of all excitement, enthusiasm, error, and nostalgia. How did this approach contrast the primitive face with the classical face? By refusing to read in order to be better able to see.

The claim that an object is visible only is an ambiguous claim. The visible would be that inert realm, still unstructured, in which pure appearances reign,

Translated by Ellen Sowchek. From *Du visage au cinéma.* Paris: Editions de l'Etoile, 1992. © *Cahiers du cinéma.* Reprinted by permission of *Cahiers du cinéma.*

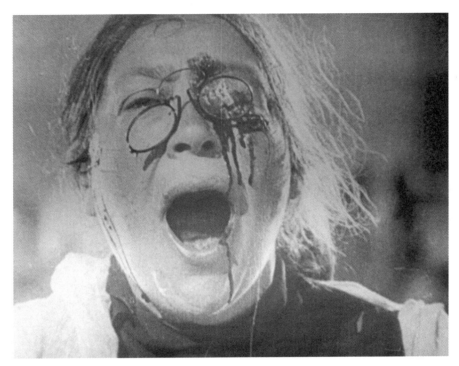

Figure 1. Sergei Eisenstein, A woman's face in "The Odessa Steps" from Battleship Potemkin *(1925)*. Museum of Modern Art, New York.

predating the intelligence that the act of perception imposes on them. But this side of the intellect, of the conscious, is also the other side of sense. This is the revelation Western art experienced with Cézanne; this is what, in the 1920s, avant-garde artists such as László Moholy-Nagy were prophesizing. To show the world and its reality as they are prior to our gaze, and therefore outside it, is to desire another relationship with the visual than that which leads to understanding it. At this point in the history of the pictorial arts, the desire to see without reading is not a regression toward the absence of meaning but, on the contrary, an advance to the very heart of things, and often a setting aside of the subject and its consciousness, which have become burdensome.

Cinema in 1920 was certainly not a committed participant in this type of philosophical enterprise. It was in the hands of cameramen of all types and all levels of ability, among whom perhaps none knew, then or later, what a revolution in seeing they were working. Therefore, the coincidences in dates should be taken for just that. What could this contrasting of the readable to the visible have meant, as applied to the face in film? First, perhaps, a contrast between the immediate and the mediate. The visible originates in itself; it does not need to speak in order to exist or to make its presence known, at least theoretically. It signals without being overladen with signs; it is based on the immediacy of appearance. The silent face is an immediate face, in both senses. It gives itself whole and at once; it presents itself to the intuition, and is not for deciphering. It is not a montage, a

deliberate composite as is the primitive face, but something organic, living. Immediate and organic, it is therefore real, not by being more real than another object, but by offering a link with the truth.

This silent face was one of the stars of the 1920s. It appeared everywhere, even in Hollywood films, which never ceased in their attempts to reject it as an undesirable parasite of narrative fluidity—after perhaps having invented it, if *The Cheat* and the transparent acting of Sessue Hayakawa are considered as prime movers of the European art film. It took numerous forms, and it is perhaps difficult to isolate it in its pure state, except for specific, fleeting moments. But this state of purity, eternally elusive in cinema, is almost ideally found in the thinking engendered by film, and is very often combined with a reflection on the face in film.

There are concepts of the silent face: this is even more remarkable as they are practically the only concepts of the face in film. This is the paradox of a minority form of representation: it gave rise to the most articulate, the most serious, the most profound thinking. Moreover, it is possible to see a kind of logic in this paradox: if the silent face remained a rare practice, wasn't it because it was the subject of too much thought? Or, more positively: if it was possible to think about it at such great length, isn't it because there was no real, solid practice that could have served as an obstacle to the extravagances, the digressions, that prevented critical thought from becoming theoretical?

Concepts of the silent face originated, for the most part, in Europe. To say that they accompanied the flowering of European silent film would be to say too much. There was often very little relation between these concepts and what they were describing. Sometimes it seems that they do not apply to any film at all, that they are not meant to be applied to any; there is perhaps only a vague generic appropriateness, transferable from one to another. Conversely, these concepts would be difficult to account for in mainstream cinema, whether from Hollywood or Neubabelsberg. Occasionally, attempts by critics to adapt them produced strange results, such as when Jean Epstein sets up Charlie Chaplin as a paradigm of photogeneity, or when Béla Balázs looks for physiognomies in the films of Asta Nielsen. But let us not get ahead of ourselves.

The hypothesis of the visible may have come, at least in part, from the well-known title of the first book by Béla Balázs. When *Der sichtbare Mensch* (*The Visible Man*) appeared in 1924, Balázs had already been a film critic for some time. Moreover, this book is barely a book. Written in rather short fragments (of no more than a few paragraphs), it is, for the most part, a compilation of criticism, sometimes reprinted without revision, that had been published from the years 1922 to 1924 in the newspaper *Der Tag*. Thus it is not a book of theory—not a thesis in form, not an articulated argument, and not without occasional contradictions. In this aesthetic-critical patchwork, however, there appears the clearest description of an initial concept of the face, of an initial thematic constellation, one developed and solidified throughout the book.

The face in film is double, because the film actor represents both himself and another: this initial theme gives rise to a subsidiary one. The doubling of the face has first a pragmatic aspect, responding to creative necessities, to the concerns of the filmmaker. In representing both the actor and the character, the face can have only one appearance. It is therefore necessary to relieve the face of a portion of the task, by choosing its ad hoc appearance.

This idea was in the air, frequently expressed at the time in the form of a comparison between the theater actor and the film actor. Georg-Otto Stindt (*Das Lichtspiel als Kunstform,* 1924) is more concretely explicit than Balázs, when he states that while the face of the theater actor, a virtual support for innumerable masks, basically has no specific characteristics, the film actor expresses (*ausprägt*) one and only one mask, and thus his face must have salient and marked characteristics. The film actor, he says, must possess everything in an innate fashion: "Beauty, courage or concupiscence must be visible in the film, and cannot be replaced using adjuvants." Moreover, makeup must not destroy this innate face: as for the director, his task is to have the actor play "within his limits," in a univocal (*eindeutig*) fashion.

As for Balázs, he evokes more globally the action of "typing": a face is never totally a face in and of itself, and what comes from the individual must always be combined with that which comes from the type. The type can be an employment, a character, an indication of class, and all would appear as such, somewhat later, in the work of Soviet filmmakers. To this Balázs adds, in a manner that seems strangely exotic today, race (*die Rasse*): race is to the personality what type is to the individual.

Later on, this doubling would have other names. It would contrast—always by combining them—the *Es* and the *Ich*, the innate and the acquired, fate and free will, destiny and the soul. Balázs turns this idea around for a long time, approaching it in a hundred different ways, picking up as many models as possible, from Freud to *Gestalttheorie*, from Friedrich Hebbel to the traditional bases of Western religions. Elsewhere still, the metaphor would finally be bluntly stated: the face is double because it superimposes a kind of transparent mask on another face that is deeper, thus more real. This implicit and perhaps unconscious reference to the Rilkean "earlier-face" describes it as follows: that which the face reveals and conceals at the same time is what is under it—the invisible that it makes visible. The face provokes the vision, is vision.

If the face is actually two faces, superimposed or based one over the other, it is also multiple in a completely different sense, because it is capable of expressing several emotions at the same time. There is, says Balázs, a polyphony of the face, which expresses the "chord" of emotions, in the musical sense of the word. Just as polyphonic music follows several paths, several lines concurrently, the face in film can say several things at a time because, playing in space and in time, it is not condemned to the linearity of writing. Several simultaneous lines: at the very least, there is the possibility of a double play, as in the film in which Emil Jannings,

having to play a sympathetic thief, plays the two terms, *thief* and *sympathetic*, at the same time. (Or, more precisely, thief *but* sympathetic since, in the film used as an example by Balázs, the thief is revealed, in the end, to be good.)

This game is thus that of any ambitious film, even American, and many films tell the story of double characters, enabling their actors to spread one face out under another, to move from one to the other, without stopping. An actor like Lon Chaney ("The Man with a Thousand Faces") made it a specialty in his short career, and in most of his films he can be seen doubled at least. In *The Blackbird*, he plays two brothers, the Blackbird, a thief with a big heart, and the Bishop, an evil and hypocritical bigot. During the film, we learn that the two characters are really one, thus returning this diegesis to the internal, but without diminishing the performance of the transformation that takes place before our eyes of the actor's body and face (a transformation all the more visible because Chaney's face, dreamy, round, soft, and good in its natural state, was amazingly elastic, making it possible for him instantly to produce any kind of mask). Talking films would continue with this theme for a long time, but in them the doubling of the face would become a minor art, that of the makeup artist, as is grotesquely seen at the end of Victor Fleming's *Dr. Jekyll and Mr. Hyde*, with its frontal close-ups that dissolve to show the stages of the final transformation, from one mask to the next (Jerry Lewis, in his film *The Nutty Professor*, would give it the final version, obvious mask and makeup).

Interminable doubling of the face: it unites the individual and the "dividual," but this first double is still further split in silent films by the polyphonic play of expressions. All of this, presented for viewing, is maintained as visible and strictly visible, as immediate and truthful as possible, as organic.

The polyphony of expressions that play on the face is thus everything but a montage. No sharing of expressive tasks between the parts of the face, an eyebrow responsible for denoting anger while the corner of the mouth gives a nuance of irony: this makeshift job, this mechanism of the senses is appropriate for Asian theater, for Eisenstein, or for the primitive face in film. Balázsian polyphony is both more subtle and less analytical, since each of the lines of music affects, or can affect, the entire surface of the face. It is Jannings's entire face (or that of the Blackbird) that is the thief, and all of his face that is sympathetic, even if, perhaps, the bandit is seen more in some places, the sympathetic person in others.

How is this theoretically possible? Balázs does not explain this miracle, unless we accept as explanation the reference to the phlogistic in film thinking in the 1920s—mobility. Film is endowed with mobility, or rather, with variability in time. It is therefore able to fix that which is basically mobile, basically variable. Specifically, it alone is capable of rendering in real time the lability of certain emotions. However, the latter are precisely defined, according to Balázs, by their fleeting, elusive character, and also by their rhythm, their speed. Consequently, film is better equipped to represent the polyphony of these sentiments. The explanation is tight but at the cost of circularity.

The explanation of film as a mobile image, as an image also of time (in a sense, it should be emphasized, totally different from that of Deleuzian "image-time"), is the *pons asinorum* of the criticism of the 1920s. The mediocre lampoon of one Hermann Vieth (*Der Film: Ein Versuch*, 1926) claims, for example, that as photography shows reality as it is (to the extent that, for him, the artistic photograph would be nothing more than a photograph of artistic objects), the material of film is the already expressive movement, to which the film will not add anything of itself, but which it will faithfully reproduce. This idea, reworked, becomes interesting, in the Balázsian quasi-system, because of its insistence on immediacy and truth. That which can be shown in real time without having been analyzed in order to reconstruct it will be truthful, access to it will not be mediated. The mobile is no longer basic or an end in itself, but a means to an end, which is the real.

The actor is himself and another, cinema is the art of the mobile: two themes, each of which, when taken separately, is simplistic and hardly original. It is, however, on this foundation, and supported by a multitude of quick examples, that Balázs develops his principal thesis, which is what made him famous and which concerns the concept of physiognomy.

"Concept," moreover, is not excessive. For Balázs, himself, physiognomy is "a necessary category of our perception," connected with each spectacle and qualifying it. It is the quality, the value of the object seen. This statement is deceptively simple, and presumes, in fact, a great deal since, if it is to be taken seriously, any object in the world seen as spectacle (that is to say, performed) assumes a quality which, among other things, is physiognomic in nature—which means that it is seen the way the quality of a face is seen by means of a configuration of its characteristics. Physiognomy is therefore, among other things, a moral doctrine. It immediately gives the truth to its bearer, since, for this successor to the last of the "physiognomists" the possibility of any changes to the soul is written on the face from the outset. (Balázs, in turn, takes up Hebbel's idea: "Was aus einem werden kann, das ist er schon"—That which an individual can become, he already is.)

Balázs goes far, too far, in the confidence he places in this magical category. The history of the word, that of the beliefs that it describes, should have caused him to be wary if he had been careful. Some, of course, do not hesitate to make fun of his tendency to give a physiognomy, a face, to everything. "Everything has a face!" ironically commented Rudolf Harms in 1926 (which did not prevent him, in turn, from using some of the conclusions of Balázs's thesis on the individual and the type, or the remark that an unconscious gesture or gesticulation can reveal more than words).

Excessive "visagification" is perhaps laughable, unless one chooses to find it disturbing. However, it is his own excess that made it possible for Balázs to go beyond the simple catalogue of commonsense statements, whereas the aesthetic offered by the majority of his contemporaries was limited. If everything has a physiognomy, citing the decor as one (important) example, care must be taken that the partial physiognomies of a scene in a film do not contradict each other:

The general physiognomy of a face is made variable at any given moment by the play of gestures, which makes a particular character of a general type. The physiognomy of clothing and of the immediate environment is not that mobile. A very specific kind of care, a particular tact . . . is needed in order to give to this stable background only those characteristics that do not contradict the animated and living gestures.

With this requirement for the expressive unity of the component parts of a film, Balázs goes well beyond the aporias touched on by Harms, for example—the tired comparison between the beautiful and the characteristic, understood as the respective manifestations of organic, progressive, and harmonic unity, and the prevention of this unity, by interruption and irregularity. The expressive unity (organic, if this is to be believed) includes for Balázs—who here, at least, took his cue from painting—both the beautiful and the "characteristic," surpassing both.

(The way in which he resolves the question of the beauty of actors is quite instructive on this point. If female movie stars must be beautiful—he is not much concerned with male stars—it is because, in cinema, appearance is not pure decoration, but already an interiority. The stars' beauty, in film, is simply beauty, that symbol of good hoped for by Kant—because their beauty is a physiognomical expression.)

Physiognomy is thus both appearance, the face of things, of beings, of places, and the window to their soul. Among these many physiognomies, one towers above all: the human face. To film a face is to confront all of the problems of film, all of its aesthetic problems and therefore all of its ethical problems. It is the special place given to the human face that justifies, in Balázs's system, the equally central place given to a form—the close-up. Definition: the close-up is "the technical condition of the art of the film." Each word should be underlined, because while art begins with the close-up, needs the close-up, this condition, described as "technical," is perhaps not sufficient. But the proof offered by Balázs is somewhat deceptive, as he can only support this strong equation by the flat comparison between film and theater. In the theater, words distract from faces; moreover, they also distract the actor, who must speak, and therefore cannot concentrate on his facial expression; in addition, we are seated too far away. In cinema, the opposite is the case: without parasitic verbal discourse, the spectator, like the actor, is free to think about faces, to think only of faces, their expressions, their physiognomy. And then we can, since the cinema endows us with a virtual and magical ubiquity, be seated as close as needed. The proximity (it seems not to matter whether psychic or perceptive) is essential:

> A face must be pressed [*gerückt*] as close to us as possible, as distinct as possible from any environment capable of distracting us. . . . We must be able to stay as long as needed to contemplate it [*Anblick*] in order to be able to actually read (something) in it.

Material distance, psychic distance: we are engulfed in this face and there is nothing to distract us. And also, temporal nearness: it must be possible to maintain,

or to sustain, the contemplation, to suspend (action) time, to better follow the time (of the face), without distance.

Thus it is the face that says everything, and it is much more than a simple face. When the close-up spreads a face across the entire surface of the image, this face becomes the all in which the drama is contained. Simply put, what Balázs did not see, what no one saw at the time except perhaps for Eisenstein, is the premise, and at the same time the consequence, of this equation. A face that is filmed intensively is always in close-up, even if it is far away. A close-up always shows a face, a physiognomy. "Close-up" and "face" are thus interchangeable, and what is at their common root is the process that produces a surface that is both sensitive and readable at the same time—that produces, as Deleuze says, an Entity.

Balázs avoided this idea, for which, however, he, better than anyone, had outlined the consequences. The face is so much the focal point of the aesthetic operation of the film that this point is magic, it generates the permanent miracle. The miracle of physiognomy: it has no need to materialize in a concrete gesture in order to exist, to be visible. It is this astonishing play on the invisible face (*Antlitz:* the German word contains an untranslatable nuance of nobility) that Balázs affirms produces the actual appearance of the soul:

> Thus the movements of the face also have the possibility of expressing that which is not shown and, equally, of showing the invisible between its features. Physiognomy, itself, has its significant pauses and lines. And more distinct because it is more significant than any other, is the invisible face. ("Das unsichtbare Antlitz," 1926)

However, this is only normal since, unlike the theater actor behind whom there are the poet and his words, the film actor

> is himself the most interior substance of the film, his being is its human content, his gestures its style. . . . The film actor is the sole creator of his figures [*Gestalten*], and that is why his personality, like the poet's, denotes style and Weltanschauung. In the face of the human being can be seen his view of the world. (1924)

From this intensity, from this immediacy, one example is given as the major paradigm: the face of Asta Nielsen. From this visage "shines an intensity 'in and of itself,' without object," that captures our attention as soon as it appears in close-up, even before we have entered into the story that the film is telling, even before we know what character the actress is playing. Other actresses, little by little, would become part of Balázs's critical pantheon: Pola Negri, Lillian Gish, even Gloria Swanson. But none would equal Asta Nielsen, because, as he said in reference to Pola Negri: "She does it in an excellent manner, but she does what Asta Nielsen quite simply is" (1923).

Nielsen's art first of all is admirable quantitatively because of the impressive, "deafening" variety of expressions that she knew how to produce. But above all, what is exceptional about her, is her naturalness: the naturalness of a child,

which makes her a thousand times more erotic than any famous belly dancer; the naturalness of a plant, which makes her innocent in the most serious of roles.

Childhood, once again, is the image and the key to the photogenic expression. The latter, in fact—it is the miracle intensified—is not only capable of making the soul visible under the face, or better, on it, but also of filling the great absence of silent cinema, the absence of the spoken word.

> Asta Nielsen's facial expressions, like those of small children, imitate the expressions of the other during conversation. Her face is not only the bearer of her own expression, but, barely detectable (although always palpable), it reflects the expression of the other as if in a mirror. (*The Visible Man*)

By means of this last characteristic, the aesthetic of physiognomy avoids losing itself in contemplation, in the solipsism of the face; it becomes the accomplished miracle of the face.

At the same time, in the same territory, but elsewhere—so much so that Balázs never speaks of it—another concept of the face in film was developed, based on a term hackneyed enough to be problematic: photogeneity.

At the same time that attempts were made to define its photogeneity, cinema had to learn how to deal with its photographic inheritance. Beginning with the "photogenic drawings" of William Henry Fox Talbot—simple prints, in white on black, of a luminous situation—the word, in fact, had quite a history. During the early days of photography, photogeneity was simply the power that certain objects had to give a clean, contrasted image (Emile Littré: "A white dress is not photogenic"). But during the age of cinema it had already been defined, sometimes as the more or less inexplicable power of the photograph to reveal reality, of "adding truth to the naked facts" (Henry Peach Robinson, 1896), sometimes as a property of certain objects, and especially of certain beings who, by a kind of magical power, acquired unexpected qualities when photographed, a charm, and sometimes as that "complex and unique quality of shadow, of reflection and of double that made it possible for the affective powers appropriate to the mental image to become fixed to the image resulting from photographic reproduction" (Edgar Morin, 1956).

This is an idea that is complex and confusing, pushing photography, perhaps abusively, toward magic, miracle, the ineffable. It is possible to perceive its connection with a concept of cinema as revelation, but also as increase (photography and cinema—which is also a photographic image—add [qualities] to what already is).

It can be seen that its application to cinema did not originate in itself. Louis Delluc, whose name is mentioned here because he entitled one of his works *Photogeneity* (1920), never knew how to define it, although he circled around it:

> Our best films are sometimes very ugly, due to too much laborious and artificial conscience. Occasionally . . . the highlight of an evening spent in front of the screen is seen in the news, where a few seconds give an impression so

strong that we consider them as artistic. The same cannot be said of the dramatic film that follows. Few people understood the importance of photogeneity. Moreover, they don't even know what it is. I would be delighted if a mysterious agreement between the photo and genius was assumed. Alas, the public is not stupid enough to believe that. No one will convince the public that a photo could ever have the unexpectedness of genius, since no one, as far as I know, is convinced of it. (*Cinema and Company,* 1919)

This is as sibylline as one could wish, and leaves us on a par with the ordinary audience that does not even know what photogeneity is. Two things should be remembered: first, photogeneity is better defined in the negative, since it is based on the non-deliberate, the non-artificial, the non-constructed, the non-conscious, and the non-laborious. Second, and more positive, is its association with the unexpected and the fleeting, as in those cases where it suddenly appears, as in a documentary film. (In 1925, at Vieux-Colombier, Jean Epstein showed a montage film with the title *Photogeneities,* consisting of outtakes and bits of newsreels.)

It is, therefore, not in Delluc, but in his friend Epstein, that we perhaps find the key to "photogeneity." Not that Epstein's ideas are always more firm; in a few years, he had changed them considerably (sometimes correctly: in 1928, he noted that, the audience having progressed in its comprehension of film, it would be better to project films more quickly, otherwise they would seem slow). But, in his lyric style and his apparent hesitations, he developed theses which he maintained firmly enough to repeat, sometimes more than twenty years later.

The first of these theses: photogeneity exists only in movement (variation: in time). It can involve only the mobile aspects of the world. It resides in the incomplete, the unstable, in that which tends toward a state without achieving it. It is basically labile, fleeting, discontinuous. The shot of a face, therefore, can only be photogenic in flashes, when such movement occurs, when such an expression streaks it the way a flash of lightning streaks the sky. Thus, noted Epstein, photogenic (meaning: easily photogenic) faces are often nervous faces, agitated ones, such as that of Charlie Chaplin.

Corollary: it is not the objects, the faces themselves, that are photogenic, but their avatars or their variations. "A face is never photogenic, but its emotion, sometimes." Another corollary: photogenic shots are not so photogenic all the time. Specifically, a close-up can, and even must be brief, since it contains only an instant, or at best a few instants, of photogeneity, beyond which it is useless to go.

A banal and important thesis, like all those resembling it in the literature of the time, it evidences a shared fascination for the new that was still that of cinema. It fixes the movement, the mobile, the moment, the duration—the time. What sets Epstein apart is the importance he gives to this theme. In all of his later writings, especially *The Intelligence of a Machine,* written in 1946, he makes cinema something more and better than a simple machine for representing time, a "machine for thinking time," the tool and the place of a unique philosophy. Cin-

ema is concerned with time absolutely and on all levels: ontological, phenome-nological, but also aesthetic and ethical. This is the subject of Epstein's second thesis.

The film image is a psychic revelation. This is also a potentially banal the-sis, but one which gains in acuity and originality, and is to be taken completely seriously. It is no longer a question of the vague revelatory power originally assumed by the tired word "photogeneity," but of a revelation that is strong, pre-cise, useful, and even socializable. Two recurring anecdotes are signposts of this belief: the anecdote of the young girls who were filmed for the first time and, upon seeing themselves on the screen, did not recognize themselves; and the anecdote of the American judge, a new Solomon, who had to decide which of two women was the real mother of a child, and was able to identify her by filming the reac-tions of the child to each of the putative mothers.

This double illustration of the thesis seems paradoxical. Doesn't the sec-ond anecdote contradict the first? Isn't cinema sometimes an instrument of recog-nition, sometimes of ignorance? In reality, this paradox is that of photogeneity, and more generally, of all of cinema. Photogeneity reads the face in a new way, as it has never been read before—hence the ignorance, and especially the self-ignorance—but by doing so, it delivers a truth, or, perhaps, the truth.

While the image is psychic revelation, it is also moral revelation. This is the famous definition dating from 1923:

> What is photogeneity? I will call photogenic any aspect of things, of beings, and of souls that increases their moral quality by means of cinematographic reproduction. ("On Some Conditions of Photogeneity")

And, as this definition threatens to remain vague, it is also combined with the first thesis, that of mobility:

> I now state: only the mobile aspects of the world, of things and of souls, can have their moral value increased by cinematographic reproduction.

Immediate consequence: the work of the filmmaker, his job of obtaining photo-geneity, is not work that is formal, or even simply aesthetic, it is work that is psy-chological and moral. In *The Fall of the House of Usher*, by the use of slow motion, "a new perspective, *purely psychological*, is obtained" (my emphasis). The mobile and the moral are thus respectively identified as the domain and the aim of pho-togeneity, that is to say of cinema. It remains to define the means: this would be the subject of a third thesis.

Cinema is a machine, "an eye outside of the eye," whose power to see surpasses my own and adds to it.

> That which no human eye is capable of capturing, any pencil, brush, feather of fixing, your camera captures without knowing what it is and fixes it with the scrupulous indifference of a machine. (Robert Bresson)

In his most carried-away moments, Epstein no longer assigns any limits to this power. The cinema is linked, directly, to the spirit:

> It may be that it is not an art, but something else, something better. It is distinct in that it uses bodies to record thought. It amplifies thought and even occasionally creates it where it did not exist.

Cinema is even connected to the soul, and finally, sometimes, to Being itself, to life. "Animist," it "abolishes the barriers between the dead and the living"; it "makes a living life out of a still life"; it is "mystical"; it has its own philosophy.

What does this concept of cinema say, fundamentally? First of all, that photogeneity is a value that involves the mind, the psychological side, or the moral side. Finally, that this value is the result of a production, of an addition that is performed by the cinematographic representation, the cinematographization: cinema adds to what it films as thought adds to what it is reflecting on. This is the meaning of the "intelligence" attributed to the machine, and produced, itself, by a specialized instrument, the magnifier. Magnification, spatial enlarging of a close-up; also, magnification, temporal enlarging of the *Zeitlupe*, of slow motion. As in Balázs, and more clearly, still, thanks to the metaphor of the machine, it is this operation of amplification that is seen by Epstein as essential to the close-up, and thus as the motor itself of the cinema-machine. The cinema is a machine for enlarging, for amplifying, but in the way that thought enlarges, amplifies.

This theme of amplification is so strong that it even ends, often, by dissociating itself from any basis in the photogeneity of a face. The films of Epstein—which must not be confused with his writings, but which, all the same, accompany them—speak freely of a photogeneity of animals, of plants, a photogeneity of the earth, of water, especially of water, his favorite theme. In *The Fall of the House of Usher*, the animal world, and, more important, the plant world and the water element, are the subject of entire sequences, arranged around themes: the inextricable interlacing of plants, the stagnant water crossed by a light lapping; the clouded-over landscape; later, the pair of toads and the mysterious, luminescent owl. This organization in themes removes all traces of reality, and it is easier to establish links among the water, the tangled branches, the mud in the earlier shots (the friend's arrival at the inn), and the shots of nature that emphasize the burial, for example, than to mentally reconstitute a coherent view of the walls of the chateau. Still more obviously, the hero of *La Belle Nivernaise* is the glistening water of the canal—and not the insipid young people whose story is being told by the film.

Alongside these effects, in which photogeneity is vaguely combined with music, the effort of Epstein the filmmaker to film faces seems more constrained. The effect on the face of cinema-thought, of cinema as thought, should be the revelation of aspects that are unknown, original, invisible in this face—that is to say, the vision of affects, of the spirit, of the soul, but this is hardly what appears in his films. Cinema is "a photo-electric psycho-analysis," but in order for this

1946 expression not to be the simple mouthing of the words of the century, we need to know what is to be analyzed. The discourse on photogeneity, which speaks much of psychology, does not replace a plausible thought by the actor. It is not a coincidence if this is completely otherwise in the work of a filmmaker barely concerned with theory, determined, on the contrary, to move, quickly, incessantly, from the affect in films, as in *Faces* (John Cassavetes)—faces in close-up that combine movement and revelation, without ever including them for the benefit of a mechanical "intelligence" (but, on the contrary, always on behalf of the emotionality of the filmmaker and his actors).

Concepts of the Silent Face

Perhaps others writing at the same time as Balázs and Epstein touched on this definition of the silent face—even though the only "others" that immediately come to mind, the Soviets, did so on different grounds. Vsevolod I. Pudovkin, Lev Kuleshov, victims of "Americanity," were already searching for the ordinary face; Dziga Vertov, almost the only one of his kind, wanted an anonymous face; Eisenstein, perhaps . . .

Moreover, photogeneity and physiognomy are difficult to localize in films, dangerous, often deceiving (what, was that all?). The young filmmakers of the French First Wave who, with Epstein, Abel Gance, and Marcel L'Herbier in the lead, drove the photogeneity-effect into a corner, used and abused soft focus, the movements of lighting equipment, slow motion. They would only achieve a photogeneity that was constructed, voluntarist, far from the ideal (except in proving that photogeneity is also a matter of technique, of machines, of *savoir-faire*). Physiognomy, which it appears no filmmaker consciously wished to produce, is largely a matter of critical sensitivity. Its presence is still more uncertain, fragile.

In their crossings and their resonances, these two concepts outline an aesthetic of the face in film. Idealistic aesthetic that it is, it is based on the hope of a revelation that it believes is possible because it believes fundamentally in the face as an organic unit, infrangible, total. The form of this revelation is, above all, that magical tool we have already encountered: the close-up.

The close-up is therefore that "technical" condition of the art in which the usage—in the service of physiognomy, of photogeneity—of the face created an artistic condition, or better, a method of seeing. It is less a question of making close-ups than of seeing in close-up, which means, first of all, a total vision of the surface of the screen, and even an all-embracing vision. In the close-up, it has been said, the screen is completely invested, invaded; it is no longer an assemblage of elements of representation within a scene but a whole, a unit. If this close-up is a close-up of the face, the screen becomes all face.

This invasion, this investment does not always require the technical use of

a close-up, of a tight framing. A medium shot, even sometimes a rather wide shot, can produce the same effect, provided it contains an object that, by a particular virtue, diffuses throughout the image and completely invests it with its physiognomy. Although neither of them named it or identified it (it was their contemporary Eisenstein who would do so), both Balázs and Epstein recognized this close-up effect. It is useless to say that it is often localized on a face, isolated and emphasized by lighting, a specific position in the decor, but it can also result from another object, from a fragment of the set, provided that the latter radiates, that it emanates a charm—in other words, provided that it behaves like a face, that it has a physiognomy.

(The ordinary face communicates, it can even seduce, but its role is to disseminate words—words of order. The face in close-up impresses, fascinates; it is always a bit Mabuse, it imposes its world.)

The global aspect of vision in close-up has another consequence: it sees only one thing at a time, to the exclusion of all the rest—even if this often means seeing a face, a physiognomy, the action of an expressive polyphony. The essential is that nothing else be seen outside this small, closed world.

An object of vision is the ideal example of this exclusive vision: children and animals, forever linked by all the German authors, as a perfect paradigm. Children and animals make ideal close-ups, because they are always *eindeutig*, univocal (Stindt), because they always act "within their limits," without wanting to add anything to what is theirs by nature. They are "non-spiritual representatives" (Harms), the kinds of things that desire only to be there and who act "on the basis of a simple naïveté, which does not understand the thought but simply takes it and lives it." For Balázs himself, "their specific attraction lies in the fact that they show a nature absolutely uninfluenced by man, the most original," a nature all the more natural than that which we see in our daily life (and here we are reminded that Asta Nielsen is praised, specifically, for her childlike quality, which makes her innocent and makes her right).

In short, this role of exemplum that is given them means the following: vision in close-up, enlarged vision, is also a vision that is "big," obvious, simple, "univocal." The close-up effect is contradictory: it pins on faces the complicated, the evil, to better dream of the simple, the idyllic, the good savage.

It is perhaps because the actual essence of this effect does not reside in either, neither in the global and occasionally somewhat terrorist relationship with the viewer, nor in the temptation to see the world as a collection of univocal things. Perhaps the essence of the close-up effect is the most indefinable, that which is concerned with the production of charm—with all the precious ambiguity of the word.

The German-speaking Balázs had an advantage over the French in having a word to describe this charm. *Stimmung* is a magical word, still more magical than physiognomy. The physiognomic experience belongs, somewhat distantly, to all Western culture, while *Stimmung* can only be had on German soil. Moreover,

the word cannot be translated, and neither "humor" nor "atmosphere" nor "harmony" can convey all of its flavor. That does not matter: *Stimmung* exists, and has existed at least since the Age of Romanticism, which popularized and perhaps invented the idea. It is, above all, that which diffuses, from a source, a kind of invisible radiance, auratic, ethereal. If this radiance is strong, it wins easily; it contaminates nearby objects and slowly suffuses the entire area. *Stimmung* is contagious, but the word also comes from *stimmen,* to be in agreement. The close-up, saturated with *Stimmung,* amplifies its resonance and vibrates with a unique, intense quality.

In a chapter in *The Image-Movement,* Gilles Deleuze identifies two extremes of the presence of the face in silent film, which he calls, respectively, the "reflexive face" and the "intensive face." It would be superficial to see in this division a copy of the contrast between a primitive face (in the process of being made normal, ordinary) based on meaning and exchange, and a silent face based on presence and contemplation. (Deleuze himself did not base his distinction on this, because he lumped together all faces predating the talkies: Griffithian, primitive, theatrical, photogenic.) The division between reflexive and intensive is based on other main themes.

But, perhaps, the face in silent film, as defined by the combination of physiognomy and photogeneity, could be considered as belonging to the category of *intensive:* a face whose characteristics are not "grouped under the domination of a fixed idea," but freer, subject to this incessant play that "shifts from one quality to another." The intensive face is that which, in the terms of technical portraiture, escapes from the facial contour to permit the facial features to rise to the surface and have free rein, a matter of "power," not of "quality." The face in close-up would thus be the presence of a face in the film that remains indefinitely emotive, affective, without ever spilling over into the semiotic. This is why, as rare as it is in a pure state, it is the model, the type of the face in silent film.

> The psychological level, the broad foreground, as we call it, is the actual thought of the character projected on the screen. It is his soul, his emotion, his desires.
>
> The close-up is also the impressionist note, the temporary influence of the things that surround us. (Germaine Dulac, 1924)

The close-up was, as we know, the generic theoretical lever of an entire filiation, of a family of theoreticians, for whom it was the tool, and at the same time the symbol, of a "heterological" conception (Pascal Bonitzer) of cinema. Between Balázs and this conception, there are parallels, and a few links. For both, the close-up is a factor of perceptive and psychic proximity; it fully deserves its old name of "foreground" (Eisenstein: "My first conscious impression was a close-up"). It is also, as it has just been described, the mechanism of totalization, readily slipping towards totalitarianism (Eisenstein again: "A cockroach filmed in close-up appears more formidable than a herd of elephants in a distance shot").

But an enormous touchstone separates them: they never search—quite the contrary—for the physiognomical unity that is the basis of the Balázsian sensibility. For them, the close-up is an instrument of dislocation, as in this deep reverie following a bout of drinking described by Eisenstein:

> Once upon a time, after an abundant meal at the Poudovs, in a sun setting cold and humid above a small, nameless river, I had the strange impression of seeing appear before my eyes, tangible, in a bizarre farandole, first a giant nose by itself, then a cap with a life of its own, then an entire garland of dancers, then an outrageous moustache, or simply the small crosses embroidered on the collar of a Russian shirt, or the far-off view of a village slowly engulfed by the darkness, then again, disproportionately enlarged, the blue tassel of a silk cord around a waist, or a pendant caught in a curl of hair, or a rosy cheek.

The close-up fractures the film narrative, and in this way serves to avoid that which horrified Eisenstein: soliloquizing. Moreover, a close-up never arrives alone; it is neither produced nor contemplated for itself, as a moment of stasis and of exception, as Balázs wanted it to be. For Eisenstein, on the contrary, who criticized Balázs in 1926 for "forgetting the scissors," the close-up enters into a logic, into a combination, as in his dream description (and also as it does in this type of montage sequence in *The General Line* and *October*), or else it survives as the acme, the moment of ecstasy, a kind of punctuation but dynamic (such as those in *The Battleship Potemkin*).

Why this difference between two contemporaries, both Germans in culture, both Marxist? Simply, because of the face. The Balázsian close-up is valid as the synonym of "physiognomy" and of *Stimmung*; it closes in on itself the way a face can, it is self-sufficient. The aesthetic and ideological basis, as it was easy for Eisenstein to emphasize, is that of a burdensome idealism, all of which makes for a bit too much confidence in the ineffable. However, playing the face card and its unity as humanity par excellence, this idealism itself makes for the most coherent of silent film aesthetics, in spite of its limits or because of them.

An influence here can be read just beneath the surface: that of Georg Simmel, the sociologist who, at the turn of the twentieth century, had made his mark on European intellectual life. Simmel was rediscovered a decade ago, and specifically for his work, which was considered minor at the time, on the sociology of daily life. Rereading his article from 1901, "The Aesthetic Meaning of the Face," today leads us unmistakably to Balázs:

> There is . . . a maximum quantity of movement invested in its resting state or, further, the resting state is nothing but that moment, without duration, in which innumerable movements have converged, from which innumerable movements will diverge.

And while the fleeting expressions of the face harden into a permanent expression (which only became banal with the advent of psychology), this permanent expression, in turn, exists only as a reservoir of fleeting expressions, the same that Balázs

would pursue. On a more fundamental level, Simmel's article forcefully articulates the theme of the unity of the face. The face is "the part of the body that most possesses the property of unification," to the point that "a minimum modification of detail in it produces the maximum modification in the impression of the whole," that "the modification of one part affects all the others," or better, that "each characteristic is, in its destination, interdependent . . . with all." The face thus expresses "an individualistic spirituality" making "centrifugality" and "despiritualization" impossible.

The consequences are soon evident (and the traces can be seen in Balázs): the human face should not be treated like a puzzle, since its parts are interdependent, and eternal in the dependence on the All. An eminently organic unity, which guarantees spirituality and authenticity, it cannot be constructed according to a vocabulary. At the same time, this unity is dynamic, since it is not only in permanent—or at least virtual—motion but, even when stopped, its two halves act upon each other in a relationship of dissimilar resemblance that (unlike sculpture) still emphasizes pictorial representation, obliged as it is to render these two halves in a differentiated manner. The expression of the face is thus everything except a path from pose to pose: it is mobility itself.

That Simmel, in 1901, was easily tempted to refer to the distinction between sculpture and painting is hardly surprising. After all, the famous thesis by Adolf Hildebrand (*Das Problem der Form in der bildenen Kunst*, 1893) was still rather recent. But it should be quickly noted that, for Balázs, the cinema is to the photograph what sculpture is to painting: the possibility of a point of view that is variable, turning, multiple, that also integrates the intrinsic mobility of the expression of the face, its variations in time, or, quite simply, its way of being in time. It is understood that it is not a matter of reducing this dynamism, keeping only the immobility of the face in order to include it in a montage.

It is also understood that, while the idea of photogeneity is more universal than the categories—physiognomy, *Stimmung*—that Balázs uses, it is his approach, so Germanically European, that had the greatest effect on silent film. If Lon Chaney's face in *He Who Gets Slapped* becomes, in defeat, a pitiful thing that eliminates any psychology, any play by the actor for the benefit of "physiognomic" harmonics, it is perhaps quite simply because physiognomy crossed the ocean with Victor Sjöström. If the "physiognomized" trees, if the entire evil and eminently personified landscape watches Snow White during her escape in the forest (in the Disney version), it is perhaps because of the Brothers Grimm, but it is definitely a reminder, still fashionable in the Hollywood of 1937, of the German *diabolic*.

Between photogeneity and physiognomy there are many nuances. Their conception of dynamism in particular, of movement and its role in the appearance of properly cinematographic values, is rather different. Sometimes it is a matter, more or less, of groping for a coincidence, a flash of truth, sometimes it is a matter of constructing a polyphony, a network of temporal lines. But the common goal

is to record a reality that it is assumed has something to reveal; cinema is thus a systematic operator on the truth, adding nothing of itself except its magical, ineffable power of revelation. While photogeneity is the other name for this magical power, physiognomy is a sensitive, sensorial incarnation of the truth brought to light, its visagification.

This position is remarkable, in many respects. It would not be too much to note, among other things, how different it is from all expressionism, from all symbolism. The cinema is particularly capable of letting the expression of the world (or of "nature"?) occur: expressionism would thus be only a more or less perverse deviation, in which only a manufactured expression is recorded, the expression of expressionism. (Neither Balázs nor Epstein had been very kind to the so-called expressionist cinema.) As for symbolism, it disturbed Balázs, who was occasionally tempted to recognize and to confirm the aesthetic of painting or of the visual metaphor. But for him, it would never be the essence of film, as can be seen in his two later essays, one dating from the arrival of talkies (1930) and one from just after the war (1945), in which the thesis and the tone vary little from that of *The Visible Man*.

Revelation: this word heavy with connotations pulled Balázs, Epstein, and the concept of the face in silent film, in a very specific direction, as is illustrated by Siegfried Kracauer in *Theory of Film* (1960), for whom

> the cinema is basically an extension of the photograph and, as a consequence, shares with it a marked affinity for the visible world around us. Films play their part when they record and reveal physical reality.

The difference is that the silent film aims less at physical reality than at a human reality, up to and including the metaphysical. (Epstein could make allusion, with his pages on the "machine," to the cinema as an "intelligent" tool—but it will be seen that, in the end, it is even more radically idealist, and also unrealistic.)

Once again, it is, above all, a matter of the face. The close-up effect, Deleuze notes once again, causes the face to lose its individualizing, socializing, communicating aspects, in order to give it the impersonality of the affect. But the metaphor of the affect suggests far too much the closing of a face that, becoming an entity by virtue of the close-up, completely closes in on itself. The face in silent film, on the contrary, opens up a circulation that is potentially infinite, because it is potentially valid for the world, because it is the face-landscape, the face-world, the reflection and at the same time the sum total of the world.

The close-up of the face is therefore the site of a privileged and, at the same time, somewhat out-of-step relationship with that which is represented. If, as Epstein maintained, the filmmaker looking in close-up escapes from vision as control and perspective to practice, with the help of a mechanical eye, a new way of seeing and of feeling, the viewer, in turn, finds himself caught up in this communion between the eye and the objects. Captured by the image, following the example of the filmmaker captured by the world, the viewer finds himself in an

absolute "intimacy" with it, he "smells" it, he "eats" it, making it the object of a sacramental transubstantiation (Epstein), or feels it like music, like "polyphony" (Balázs). By immersing himself in the image, he dives directly into the heart of the world that is represented, into its very vibration.

(Only one more step needs to be taken, and this view would become the actualization of a reserve, of a virtuality that is in things, in the world, in the "photography that is already in things" as described by Bergson as revised by Deleuze. But this step is not taken, and we remain with a diffuse idea of the "world." Above all, if looking transports us, by means of the camera, into the visagified world of things, it is us, always us, that it transports.)

Conversely, the close-up projects us into a world that is a face. What it reveals is a psyche—a soul. This theme also reaches beyond the 1920s. It is found, erratically, in a short book by Hugo Münsterberg (1916), elaborating on the subject of empathy. Recognizing that there exists, for the cinema, another, more "distancing" possibility (which was little used in the cinema that he knew), Münsterberg suggests that the emotion of the film spectator reflects that of the character; further, "we have the impression of directly seeing the emotion itself." We vibrate with the faces shown; at the very heart of these faces, the cinema is this vibration.

More obviously, the same theme is found again, after the war, in the work of Edgar Morin, who makes cinema the place of the imaginary man: the visible man of Balázs, revised and "imaginized" by phenomenology and filmology. Morin is sensitive to the "psycho-analytic" power of film; he willingly adopts as his own this idea of Epstein's: that the cinema makes what it shows both the same and something else (that is why we do not like autoscopy, or filmed posing). For him, the cinema, via the close-up, makes it possible to discover the face and to read what is in it. Moreover, an impeccable syllogism, the face is the mirror of the soul, which is the mirror of the world: what the close-up sees is thus more than the soul, it is the world at the root of the soul.

There are, says Morin, thus reconciling Epstein and Balázs, unending transfers between microcosm and macrocosm, face and landscape, anthropomorphized objects and cosmomorphized faces. The face has a soul, objects have a soul (as proven by the films of objects from the 1920s), and cinema has a soul. But this excess of soul did not please Morin, who reproached Epstein for having reversed his axiology: if the world as seen in the cinema is/has a soul, it is false, like the soul. "What is the soul: the psychic processes in their nascent materiality or their decadent residuality." The cinema, in the end, only shows us ourselves and, further, in our most uncertain areas. What we project on the screen, or, similarly, what is projected to us on the screen, is of the soul, ever and always, and in the last analysis, all of this soul with which cinema and our times in general are "scribbled" prevents us from seeing. . . .

The exact same power is given to film in the close-up—but for opposite conclusions. Perhaps, coming after neorealism, after the war, arriving at the same

time as Bazin, Morin could no longer see as a positive value the "unrealism" advocated by Epstein, any more than he could be content with accepting it as a "revelation" ("revelation" also means, and meant particularly in 1950, "apocalypse"). Invaluable in its very discrepancy, Morin's book confirms this paradox of the close-up, the face in silent film: the desire for both realism and non-realism, the desire to see man and the desire for the image at the same time, the desire to contemplate uncontemplatable mobility, the desire simultaneously to stop time and to let it elapse.

The Silent Face: A Time-Face

The form of the silent face, its kingdom, is the close-up. But this form hides within itself another, or perhaps lets it be seen, if once again we consider the close-up not as a question of distance, but of enlargement. In the obsessional elegy composed by Epstein on slow motion can be read, bluntly, this central intuition: that the close-up is the enlargement of our sensory experience, of all of our experience, including time—*Zeitlupe*, the temporal close-up. The silent face is an enlarged face, but also, more profoundly and more immediately, a face of time, a time-face. It is not a matter, in fact, of seeing the face as a book, in which are written the traces of the passage of time (as in the series of self-portraits by Rembrandt). It is a matter of making time itself visible. This is the meaning of the famous remark by Balázs, by Epstein, by all their contemporaries, that photogeneity, or the art of film in general, concerns the mobile and the labile, that the cinema and certain emotions for which it represents fugitiveness, mobility, are consubstantial. If it personifies this type of cinema, the silent face is defined by what incessantly appears on it, by time.

One film deserves additional commentary here. *The Fall of the House of Usher* is both a practical illustration of elegiac and revealing slow motion and a bringing into play of the face, by means of the subject of the portrait. By a transposition of the well-known theme of *The Oval Portrait*, the hero of the film, Roderick Usher, paints a portrait of his wife, Madeline, without noticing that the painting, magically, feeds on the very life substance of the young woman. When he finally finishes the painting, exclaiming: "It is life itself!", she falls dead (it matters little that a rather arbitrary finale brings her back from the dead).

Consciously or not, the treatment of the portrait of the young woman in the film is unique. The painting is richly surrounded, with an ornate gilded frame, but sometimes, in this frame, we see the actress who plays the role of Madeline, sometimes a crudely painted sketch, sometimes, even, nothing at all. The film, in fact, truly reflects on the act of painting a portrait, but by shifting the emphasis: it is not the portrait of the model, but that of the painter, that the film is drawing.

Painting, in general, is related to time, since the act of painting is recorded

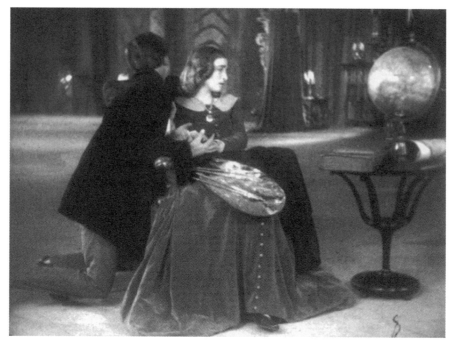

Figure 2. Jean Epstein, The Fall of the House of Usher *(1928).* Museum of Modern Art, New York.

in it; since, more fundamentally, painting is the immortalizing of that which is painted, suspended in time, the transformation of a material time into a transcendental time. But what Epstein speaks about goes beyond this generic relationship between painting and time: it is no longer simply a matter of painting in time, with it or against it, but of painting time, of becoming time, of being time with time. The painter Roderick Usher is seeking less to capture life, the vital and absolute resemblance (as in the "themes" of Poe from which Epstein departs), than to be equal to time itself, to identify with it, to interfere with it.

A succession of images here is particularly noteworthy. It begins after an intertitle which indicates that "since Madeline's burial, the hours, the days, pass in a frightening monotony, in an excruciating silence," and returns to the "musical" landscapes which, somewhat later, accompany the scene of Roderick's melancholy. But this return is followed by a very long sequence in which a new series is introduced, using the instruments of time, in the form of extreme close-ups of the parts of the clock: pendulum (filmed very obliquely and in extreme slow motion), top of the face, bell and hammer of the chimes, the clockwork gears.

This basic constellation, associating melancholy and the music of time, gives three images of time. The mechanical instruments which, by measuring its passage, filmed in close-up, suggest the idea of penetrating into time itself; the slow motion, which "depersonalizes the movement" (Deleuze) and thus connects it with Time, to its intimate pulsation represented by the enormous and harrowing pendulum (a distant reminder, perhaps, of *The Pit and the Pendulum*); finally

a splitting in two, a vibration that spreads through the air and affects things and places, the guitar, the gallery. The latter image of time is the most remarkable: time here is presented as being subject to an echo from which it resonates and which punctuates the drawing out of the slow motion. The Deleuzian image of the crystal, its power of double refraction, perhaps comes to mind, but the film at this point appears equally coherent in another sense, and this admirable trembling of time must appear there as the actualization, finally recognized, for which the first series, the timeless and "musical" landscape, was the metaphor, and only the metaphor.

In this way—and in this way alone, if one does not want to read this as a simple grimace— can be understood the shots of Roderick's face as he is painting, the famous close-ups of the actor Jean Debucourt, as shot in slow motion, repetitive, rehashed; shots in which the image of an ecstasy that is already dead (as we speak of being brain-dead) is recorded. Roderick, and through him perhaps the House of Usher, is the real subject of the portrait. The themes of the film, its series (music, landscape, time divided and resonant) are the means of this portrait, from which Epstein's logic, as has been said, creates a single means, time—otherwise known as the cinema, the image-time. There are portraits painted in oil, but what Epstein presents for us to see is, in actuality, a portrait painted "in film."

Modernisms
and Subjectivities

Rudolf Arnheim

Painting and Film

Since photography's beginnings, painters have often become photographers, although there is scarcely an example of an important film artist who was formerly a painter—aside from, possibly, Walter Ruttmann. It is possible that the factor which determines actual film talent is not so much the creation of the image in space as the creation of a series of dramatic events that develops over time. (Ruttmann's films are specifically non-dramatic!)

All the same, painting has had a strong influence on film insofar as it deals with the creation of an image, and this influence has had its effects by way of a detour through photography. Film almost never deals with non-moving pictures as do painting and photography, and thus we cannot speak here strictly of the composition of a static image. Practically, however, it is still the case that the same principles of the division of space, as painters have applied them for ages, and as photographers have adapted them, can also be applied to film: for instance, every good film shot groups the objects in the image into simple mathematical figures, eye-catching lines organize and unify the many visible objects, the spaces are balanced according to size, form, and light, etc. It can probably be said that during the course of a good film these well-composed shots appear one after the other as accents in short intervals, and are connected by passages of movement, or strung together by cuts. All the same, it would certainly be wrong merely to try to trace the creation of the filmic image back to the static, for there is also a specific composition of movement for which fitting termini can be better borrowed from music than from painting: crescendi and decrescendi, staccati and legati, chromatic progressions and jumps in intervals.

One would think that graphic art, far more than color painting, would be influential on current black-and-white film. In reality, though, painting is still more related to film, insofar as it allows space, as the limitation to three-dimensional bodies, to speak without strong emphasis on the drawn line. Graphic art, on the other hand, has a much looser relationship to the film image.

The introduction of color film will create a new relationship between painting and film. Until then, film's interest lies, aside from the compositions of line and space, in lighting. Film people have just gradually learned not to use lighting as a mere naturalistic imitation of natural light sources, and that it is not just

From *Film Essays and Criticism.* Translated by Brenda Benthien. Madison: The University of Wisconsin Press, 1997: 86–88. © 1997 by The University of Wisconsin Press. Reprinted by permission.

Figure 1. Original cover of Film als Kunst *(1933) by Rudolf Arnheim, designed by Gyorgy Kepes.* Photo credit: Christopher Campbell.

an irreplaceable aid to making the scenes visible. They have also learned that it is a wonderful tool for directing the viewer's eye to the center of action, for accentuating the significant, and for suppressing the insignificant. This art of light direction can be found with painters—primarily, of course, with Rembrandt, whose name is used to describe a certain technique of backlighting.

As far as the direct application of painting to film goes, it is common knowledge that paint and paintbrush are just as essential for the film designer as for the stage designer—but here there seems to be a characteristic restriction. Whereas in painting (and also on stage), the objects of reality may seem painted—that is, they are *supposed* to seem as though they were painted—this seems to be impossible and distracting in film. A tree stylized with painterly means, for example, seems unreal because it gives away the fact that it is made from a different material than that from which trees are customarily made. This was very noticeable in the so-called expressionist films, which the set designers purposely stylized in a painterly fashion. Above all, it is the actors, as beings of flesh and blood, that compromise the painter's world of appearances—although, since the human actor and the unnaturally painted theater sets tolerate each other on stage, special conditions seem to exist in film. Perhaps this has to do with the fact that natural reproduction of material is so essential to film, and that it forms one of its

means of expression. Thus, one can paint for film, and one can also paint things that do not exist in reality, but they must always be painted so that we believe we are seeing these things ourselves, rather than just copies that can be recognized as such.

This rule is apparently true for film in general: one can show a giant dragon (as in the *Nibelungen* film), but it must seem like a live animal, not like a moving cardboard model.

Things are very different, though, when we are talking about a film style that eliminates everything naturalistic from the very beginning, thereby shifting the nature of the entire film to a different plane. It is common knowledge that the drawings in animated films do not just seem to be drawn, but are *supposed* to seem like it. The same goes for marionette or puppet films.

One can imagine animated film, at least color animation, as developing into a painting on film, which would by no means have to utilize only caricature, but could expand the means of painting into an art of time and motion. A surface art, like the animated film, as well as a spatial one, like the puppet film, would be possible—and the addition of color might offer incredible possibilities.

Finally, as far as the influence of film on painting is concerned, it is probably correct to speak more generally of the influence of photography. Certain slanted perspectives in modern paintings—for instance, the daring view from above—point to the influence of film, and the change in our ideas of motion since the invention of snapshot photography constitutes a particularly interesting chapter. (We are reminded of the typical story told by Demeny, in which the painter Meissonier, when he had seen Marey's chrono-photographs of galloping horses, drew a running horse on a piece of paper and said: "Show me a horse that runs like that, and I'll be satisfied with your invention!") This self-assurance of the painter when confronted with photography, and thereby with nature, is deeply justified. Yes, the gap between painting and reality will surely become increasingly obvious, now that photography and film have taken over the great task which was put to the painter until our times: to copy and conserve reality in a manner that is true to life. It is not easy to say to what extent painting's very obvious rejection of naturalism in the past decades is already connected to the emergence of photography and film.

For the sake of completeness, I would like to add in closing that a series of short films entitled "Creative Hands" (*Schaffende Hände*) has been produced by the Berlin Institute for Cultural Research under the direction of Dr. Hans Cürlis, in which well-known painters and sculptors were filmed at work. Such films can be of particular importance to art since they show the process of a work's creation and the nature of the technique used—for instance, color mixture, hand position, and hand motions, etc. Furthermore, there are educational possibilities not just in showing photographs of paintings, but in using the moving camera, which, by focusing on isolated sections, functions as a pointer to demonstrate the construction of painterly composition in film.

Ara H. Merjian

Middlebrow Modernism: Rudolf Arnheim at the Crossroads of Film Theory and the Psychology of Art

One might say that the task is no longer to produce another instance of art but a new medium within it.... It follows that in such a predicament, media are not given a priori. The failure to establish a new medium is a new depth, an absoluteness of artistic failure.
—Stanley Cavell, *The World Viewed: Reflections on the Ontology of Film*[1]

Despite the clamor of the Parisian avant-garde in the 1920s for the recognition of film as an art form, such a status was hardly patent at the time of Rudolf Arnheim's now legendary work, *Film als Kunst* (*Film as Art*, 1932).[2] If, in the words of Dudley Andrew, "the first [film] 'theories' sound more like birth announcements than scientific inquiries," Arnheim's treatise resonated quite differently, in that it was a preemptive anatomization of a threatened form—namely, the black-and-white silent film.[3] This text proffered the first exhaustive formulation of film as a unique medium: a taxonomic inventory of visual maneuvers that could, in the best of circumstances, set film apart from the other arts while simultaneously ensuring its place among them.[4] *Film as Art* adduces lengthy comparisons of visual media, seeking to substantiate film's aesthetic and expressive characteristics as well as its philosophical import. At turns contentious, tautological, and intractably prescriptive, Arnheim's essay battles, above all, the "corrupting elements" of sound and color, staking out cinema as an unequivocally achromatic and optical apparatus.

Most German silent filmmakers of the years after 1910 had struggled—in many cases quite successfully—to show that film was an art, rather than a facile reproduction of reality. However, the emergence and popularization of sound film in the late 1920s, along with the increasing use of film for commercialized entertainment and political propaganda (on both left and right), resulted in a general dissipation of aesthetic standards. It is this predicament at which Arnheim aimed

his strident intervention, *Film als Kunst*. Arnheim's exacting principles and exasperated tone reflect the degree of his investment in a cinema that could transfigure and refract the visible world, rather than merely duplicate it. Developing his ideas contemporaneously with various studies in experimental and gestalt psychology, Arnheim sought not only to establish the parameters of film art, but to develop a parallel argument about perception and communication. His text remains today a notoriously resolute work of theory—not simply for the absolutism of its doctrines, but for the author's refusal to redact his conclusions, even up to the present day. This rigidity has ensured Arnheim's place at the heart of film historiography, but so too has it clouded the particulars of his career, as well as his centrality to the incipient dialogue between film and the plastic arts.

Writing in the early 1920s for the satirical magazine *Das Stachelschwein* (*The Porcupine*), and from 1928 to 1933 for the weekly journal *Die Weltbühne*, Arnheim published several reviews of contemporary German cinema and international productions (works by Charlie Chaplin, Sergei Eisenstein, Fritz Lang, Vsevolod Pudovkin, Josef von Sternberg, and others).[5] He also wrote a number of shorter theoretical pieces (of which "Painting and Film" appears here) which may be read as prolepses and excurses to his *Film as Art*.[6] Arnheim conceived this first major piece of writing in the twilight of the Weimar Republic and its "Golden Age" of cinema, 1932—the same year that Joseph Goebbels declared that the "Fighting League for German Culture" (Deutsche Kultur-Wacht) would "lead the struggle . . . in all areas of art."[7] The following year witnessed Hitler's definitive rise to power, the boycott of Jewish businesses, and the opening of the Dachau concentration camp. Arnheim's essay was summarily banned—an event owing less to the essay's propositions than to its author's ethnicity.[8] He fled Berlin in 1933, along with two thousand other intellectuals associated with Germany's film scene, including Siegfried Kracauer.[9]

Arnheim spent the next five years in Rome, where he served on the editorial board of the International Institute for Educational Film and wrote regularly for the newly established journal, *Cinema*. Formed in 1935–1936, the *Cinema* group was made up of various Italian intellectuals of diverse political inclinations who were committed to developing a more "populist" cinema.[10] While in Italy, Arnheim contributed to an (unfinished) *Enciclopedia del cinema*, before moving to the United States in 1940, where a Guggenheim fellowship led him to extend his study of perception into the fields of the plastic arts and architecture.[11] He developed his theory of the psychology of art at various American institutions and universities, writing during the postwar trend toward "general systems theory."[12] The contemporary drive to "understand the world in holistic terms"[13] found a striking resonance in Arnheim's gestalt psychology approach, with its emphasis upon whole systems and the cohesion of forms.

In tandem with the legacies of gestalt theory, the most consistent aspect of Arnheim's methodology has been his emphasis upon vision and its role in reflecting and shaping consciousness. Culminating in his best-known works, *Art and*

Visual Perception: A Psychology of the Creative Eye (1954) and *Visual Thinking* (1969), Arnheim's project propounds that the mind not only processes information through concepts, but also *percepts*—the unmediated expression of which are visual forms. In this schema, visual art and perception are not mere supplements or subordinates to language, but equal, if not superior, means to understanding. Perception and thought, vision and intellection, are unified processes rather than separate events.

Much of Arnheim's motivation has been the desire to illuminate the mysteries of aesthetic practice, and to rescue its exegesis from the "nightmare of unbounded subjectivism" and "the easy pleasures of relativism."[14] "Beyond our blundering," Arnheim writes, "there are inherent forces that, in the long run, overcome error and incompleteness, and direct human action toward the purity of goodness and truth."[15] And as the "inherent force" underlying Arnheim's project, gestalt psychology possesses, "perhaps as its most characteristic aspect, a profound respect for the 'givenness' of the world as an objectively existing cosmos held together by law and order."[16] Such unrepentant faith in universal truths makes Arnheim a perfect *bête noire* for postmodernism's savvy dismantlings.[17] Nevertheless, he remains unshaken in his relative intellectual isolation, declaring in 1992,

> Speaking for myself, I confess to be thoroughly uninterested in such current notions as modernism, premodernism, or postmodernism. They are products of the myopia generated by the *faits divers* of the day, which look to the busy commentator like milestones marking history, whereas actually their noise hides the slow and silent growth of true cultural achievement.[18]

The present work seeks neither to exonerate Arnheim's theories of their shortcomings, nor to champion those postwar epistemologies that controvert or challenge his claims.[19] Nor, for that matter, shall I offer an exhaustive recapitulation of Arnheim's film theory—something already treated in other film scholarship.[20] Rather, I intend this essay as a kind of primer on the role of gestalt psychology in Arnheim's work, as well as an interrogation of Arnheim's precocious and notable position at the crossroads of film and art theory.

Arnheim is known primarily through the theses—at once generalized and stringent—of his major writings (*Film as Art, Art and Visual Perception*, and *Visual Thinking*). While these works epitomize Arnheim's project, he has also produced numerous other pieces, many of which I shall address here, which evince more nuanced arguments about film, visual art, and their affinities and disjunctions. As a scholar whose career spans numerous disciplines, languages, mediums, and decades, Arnheim has engaged with some of the most eminent theoreticians of modern art and film, whether directly or obliquely, in alliance or opposition (among them Jacques Aumont, André Bazin, David Bordwell, Stanley Cavell, E. H. Gombrich, Clement Greenberg, Michael Fried, Siegfried Kracauer, and Rosalind Krauss). As the critical encounter of art history and cinematic studies gains momen-

tum and breadth, it seems fitting to turn back to some of the inceptive theses on art and film as they took form in Rudolf Arnheim's influential body of work.

From Gestalt to *Guernica:* Arnheim's Psychology of Perception

A perception of the whole is more natural and more primary than the perception of isolated elements. . . . The perception of forms, understood very broadly as structure, grouping or configuration should be considered our spontaneous way of seeing.
　　　—Maurice Merleau-Ponty, "The Film and the New Psychology" (1945),
　　　　　　　　　　　　　　　　　　　　　Sense and Non-Sense[21]

Certainly, the problem of consciousness is too important to leave to philosophy and the natural sciences alone. Since thinking involves scenography, the staging flow of perceptions, and a warehouse of memories into the spectacle of ideas, shouldn't its study also be aestheticized?
　　　—Barbara Stafford, *Good Looking: Essays on the Virtue of Images* (1996)[22]

Arnheim's justification for his approach to film and art would likely echo Barbara Stafford's query above. Arnheim pretends to be neither film theorist nor art historian.[23] By his own admission, his primary interests as a scholar concern the relationship between art and cognition. More specifically, he seeks to account for the ebb and flow between expression and perception, and, in turn, to employ the visual arts as the "proving ground" for his arguments about the psychology of perception. Arnheim's method, whether applied to film or art, has always taken gestalt psychology as its point of departure.

A Brief History of Gestalt Theory

Beginning with principles already outlined at the turn of the century, Max Wertheimer and Wolfgang Köhler first developed the tenets of gestalt psychology in Germany between 1910 and 1920, seeking to elucidate universal patterns of perceptual and mental life. Conceiving of their discipline as a kind of mediation between philosophy and science, and furthermore as a vinculum between the hard and natural sciences, gestalt scholars wished to ground perception in a general theory of structure and configuration.[24] The word "gestalt" translates from the German as "shape" or "form," and gestalt theory deals foremost with the identification of whole entities, whether mental, visual, or physical. Gestaltists argue that structures in nature tend toward the cohesion of clear, orderly patterns. Rather than perceive individual or separate parts, the mind naturally discerns organized constellations.[25] These configurations, in turn, reflect and guide our mode of thinking. The emphasis, then, is upon reciprocity and interaction of organic and mental forms. Gestalt psychology, in fact, derives some of its premises

from an interpretation of twentieth-century atomic physics, and understands cognition, perception, and emotion to be subject to the same (predictable) principles as physical phenomena, particularly vis-à-vis the interrelations of parts and wholes.[26]

The Berlin school of gestalt psychology, during its heyday in the Weimar period, conducted hundreds of experiments, the majority of them involving visual stimuli, in attempting to prove generalized laws of harmony and order, intelligibility and coherence, in perceptive acts. Such an approach has played a prominent role in Arnheim's study of aesthetics, in which he often uses diagrams and schemata to illustrate arguments about perceptive processes. Yet gestalt theory is not, as it were, a monolithic body of thought. It changed throughout the twentieth century in relation to the sociopolitical context of its practice, as well as the individual interpretations of its adherents.[27]

With the forced exile of Wertheimer, Köhler, and their colleague Kurt Koffka from Germany during the Nazi era, gestalt psychology began to take root in North America.[28] In its later manifestations, gestalt theory directly opposed the principles of behaviorist psychology, which maintained that consciousness could not be accounted for in a priori terms, and that psychological aspects could only be defined through the study of human action and response to stimuli. The gestaltists also opposed the British empiricist philosophy that undergirded much American psychology, and which emphasized the subjectivity of individual sensory experience.[29] The gestaltists reject positivism in favor of more universal fundaments of perception. Rather than concentrate upon the individual building blocks of (psychological, perceptual, emotional) experience, gestalt theory attempts to identify common structural systems that inhere in them all. "Gestalten," Arnheim writes, "exist in perception, in mental imagery, in the dynamics of the human personality, in physiological and physical states of interaction, but they can be conceptualized only through networks of relations."[30]

For the gestaltists, art represents the ideal counterpart, or equivalent, of human perception. As a new medium of visual expression, film offered Arnheim a fresh model—which he has come to amply expand—for arguments about the affinities between visual creativity and our ordinary ways of seeing. As Wertheimer's and Köhler's student at the Psychological Institute of the University of Berlin, Arnheim completed a doctoral dissertation entitled "Experimental-psychological Investigations on the Problem of Expression" (1928). He soon came to apply his gestalt training to film criticism and theory, describing his method as a "Kantian turn of the new doctrine [of gestalt theory]."[31]

The gestaltists, and Arnheim with them, argue not only against purely empirical science, but against Immanuel Kant's belief that the mind imposes form upon an otherwise completely unordered nature.[32] Yet Arnheim is otherwise sympathetic to a Kantian line of thought, particularly Kant's emphasis on the importance of intuition in understanding, as well as his general faith in ideal principles.[33] Kant maintains that nature exists in harmony with human mental capac-

ities, and that "the cognitive powers of all human beings are constituted alike so far as the apprehension of aesthetic wholes is concerned."[34] In his drive to deflate the idea of artistic genius, Arnheim strongly advocates Kant's belief that aesthetic perception "can never be taken out of circulation and made private property," and that the artist does not have a "privileged relation" to his art.[35] Arnheim's application of gestalt theory to film and art seeks precisely such a reappropriation of creativity, claiming artistic expression as the shared property of the public.

Gestalt theory remains a topic much written about, but often with contradictory conclusions. Received notions about gestalt psychology are often limited to soundbites or anecdotes, such as Max Wertheimer's (often misquoted) declaration that the structure of a whole is different from its parts,[36] or else a 1915 experiment by the Danish gestalt psychologist Edgar Rubin, which demonstrated how certain cutout, black-and-white forms may reveal either a vase or two profiles, but never both at once.[37] Nevertheless, a range of other, more nuanced principles inflects the gestaltist approach to perception, particularly in the matter of vision and art. Arnheim himself has served as a primary (and prolific) expositor of these nuances. Here I will outline some of the gestaltist principles that underlie Arnheim's theory of art and film, before entering into a more sustained discussion of Arnheim's larger project.

The Importance of the Whole

The gestaltist method arose, in great measure, out of a belief that structures cannot be known through a simple examination of their individual components ("from below"), but rather through a consideration of the parts' overall interrelation ("from above").[38] Concerning vision, gestaltists argue that shapes take their meaning only as constitutive elements of a whole entity, otherwise deemed "the field." Thus, figures may only be perceived in relation to their ground, and vice versa; parts make sense only in relation to the whole which they constitute, and vice versa. A visual property possesses meaning only insofar as it forms part of a larger pattern.

Arnheim also advocates the gestaltist notion of isomorphism, which upholds a correspondence between physical and mental phenomena: expression reveals its meaning transparently, independent of any arbitrary relationship between signifier and signified, independent of the abstractions of language.[39] Simply put, content and expression in images are more or less commensurate: "The basic affordance of a work of art," Arnheim claims, "is that of being readily perceivable."[40] Arnheim's model of "visual thinking" maintains that the mind thinks in images (percepts), obviating the need for verbal intermediation, and, in hermeneutic terms, downplaying the consideration of contextual and cultural influences upon perception. Such a notion—that cognition and perception are not mutually exclusive—has provided the basis for the philosopher Maurice Merleau-Ponty's evaluations of film as the perfect reflection of perceptual faculties.[41]

Arnheim has persistently sought to cleave art and (especially) film from written and spoken language. While language organizes information diachronically, temporally, vision is able to transmit information synchronically, spatially. In Arnheim's view, verbal language may convey information piecemeal, in fragments that the mind adds up; vision, by contrast, affords a contemplation of overall, hierarchical organization in one glance.[42] It follows from this reasoning, then, that vision is a more efficient transmitter of information than language, and thus the most perfect of perceptual tools. In more recent scholarship, Barbara Stafford has advocated for "the *intelligence* of sight" in a vein clearly informed by Arnheim; Stafford argues that "imaging, ranging from high art to popular illusions, remains the richest, most fascinating modality for conveying ideas," and that in turning away from a purely linguistic model of cognition to embrace perceptual thinking, "good looking can be agreed upon or fostered."[43]

Since it is by nature subliminal, *invisible,* the unconscious proves of little consequence to Arnheim—or at least, it cannot fit within the parameters of his approach.[44] To relegate any part of vision to the subconscious would be to locate perception beneath reason, whereas Arnheim insists upon their parity. Furthermore, the unconscious deals with the particulars of subjective experience, while Arnheim's psychology of perception is aimed at establishing collectively shared principles of cognition. To the inner eye, to the private realm of experience, Arnheim prefers that which can be seen and known; in the words of the art historian Rosalind Krauss, "In this it is a space that is fundamentally *visible* . . . it is the space in which 'form' will come into being; the space of good form, of the gestalt."[45] Arnheim's method stands in direct opposition to Krauss's, whose hermeneutic invocations of the body, subjectivity, and desire challenge the historical paradigms of a modernism grounded in pure visuality.[46]

As Krauss discusses in her influential book *The Optical Unconscious* (1993), psychoanalysis allows for several things to occupy the same (imaginary) space.[47] And spatial ambiguity, comments the art historian E. H. Gombrich, has been an inextricable part of artistic vision since "art [began] to cut itself loose from anchorage in the visible world."[48] Such contradictory spatiality (for example, visual "condensation") is inconceivable in Arnheim's model, hence his aversion to surrealism. For Arnheim, art suspends the matrix of spatial coordinates, but the act of perception reinstates the physical integrity of the (symbolically) violated structure. The psychoanalytic (Freudian, Kleinian) implications of the "part object," then, are of little interest to Arnheim. For the mind, in his assessment, rather than investing a dislodged fragment with new meaning (based upon its semantic dislocation) or even being jarred out of its logical classificatory habits, will summarily compensate for visual breaks and fill up the caesurae in meaning as a matter of course. Good art, moreover, is what hones these perceptual skills.

As an example of his model of visual perception, Arnheim offers a diagram of Paul Klee's *Vigilant Angel.* Klee's deployment of ambiguity and overlapping, Arnheim argues, spurs perceptual compensation rather than confusion.[49] In another

instance, Arnheim maintains that even in the wake of Piet Mondrian's flagrant asymmetry, the viewer will perceive an intended, assumed center in his can-vases.[50] The gestalt-oriented art critic Anton Ehrenzweig has come to echo these arguments about the psychology of perception; like Arnheim, he posits that the viewer "tends to perceive the 'constant' properties of the things, their 'real' form, size, tone, and colour, and tries to eliminate (repress) their accidental distortions."[51] Repression, in gestaltist terms, thus signals a shoring-up against chaos, a visual (and psychological) emendation of disarticulations even as they are enacted by (or in) art.

This, in Arnheim's view, is what art and film do—they shatter given visual totalities and only partially reassemble them, in anticipation of their completion by the viewer. "The film artist," Arnheim writes, "arranges the objects as he wishes, puts what seems to him important in the foreground, hides other things, suggests relationships."[52] In order for art to be art (and not merely a simulacrum of reality), it must interrupt or challenge the conventions of visual logic—but only partially and only temporarily, for "no statement can [ultimately] be understood unless the relations between its elements form an organized whole."[53] Finally, the act of experiencing a work of art or film, the process of filling in the lacunae in meaning, produces a gestalt in its own right.

Practicing Perception

Like Kant, Arnheim valorizes the formal truncation of art from the normal flow of the world. Film art is obtained only through the use of a frame, lack of sound, black-and-white film, and so on; in painting or sculpture, art issues from the mere application of paint or the carving of material. Arnheim's approach is comparable to that of the first major film theorist, the Harvard psychologist Hugo Münster-berg (1863–1916), who regarded the cinematic apparatus as a projection of the mind.[54] Münsterberg had discounted the mimetic aspects of film in his early effort to distinguish it as an art form, describing the ways that filmic procedures trans-figured reality and transcended the theater. Like Münsterberg's, Arnheim's theses about the role of perception in film have since influenced recent applications of cognitive psychology to film studies, particularly the drawing of parallels between cinematic imagery and rational (conscious) thought.[55] But whereas Münsterberg's approach is a singularly "mentalist" one, Arnheim emphasizes the consistency between vision in art and vision in everyday life.

In sifting, tessellating, and shaping form, the artist replicates and intensi-fies the (normal) act of seeing. As Arnheim declares in *Art and Visual Perception*, "Eyesight anticipates in a modest way the justly admired capacity of the artist to produce patterns that validly interpret experience by means of organized form."[56] An individual uses the same perceptive tools when viewing a landscape as when viewing Van Gogh's rendering of a landscape, except that the painting causes the viewer to perceive its organization of shapes in a more deliberative fashion. Arnheim

argues that while the same process of perception applies to both quotidian life and the viewing of art or film,

> in one important respect the work of art is not like the creations of nature. It can never just *be there*, the way a stone, an animal, or an ocean can just *be there*. Being a product of human beings, the work of art can be there only for a purpose, or, at least, for a reason.[57]

Thus Arnheim again follows a Kantian line of argument in concluding that "a work of art is not an object."[58] The removal of the image from reality intensifies its organizational configurations; this prompts a scrutiny of the relationship between the image's form and subject matter, and hence a sharpening of sentience on the viewer's behalf.

For Arnheim, seeing is a means of survival. Consequently, art is a tool, a method of learning about the world so as to more easily inhabit it. Film and the plastic arts stand as different means to the same end: the shaping of reality into a discernible, meaningful image. Viewing art is a form of necessary mental and perceptual exercise. By challenging our processes of perception, art coaxes and coaches our nervous systems, serving as both a testing ground and a microcosm of visual encounter with the world: "What concerns us here is that this state of equilibrium is tested, evaluated, and corrected entirely by direct perceptual experience, the way one keeps one's balance on a bicycle by responding to the kinesthetic sensations in one's body."[59] When a form or image successfully balances simplicity and complexity, it achieves the state of *Prägnanz*.

Prägnanz, *or "Good Gestalt"*

In German, the adjective *prägnant* denotes "clear-cut," "succinct," or "concise," while the verb *prägen* means to stamp, mint, strike; and, by extension, to shape, mold, characterize. As a noun, *Prägung* denotes "stamping," "minting," "shaping," "molding," or, in a more figurative sense, "character." As a concept of perception applied to art, *Prägnanz*—or as it is sometimes called, "good gestalt"—refers to the equipoised state between simplicity and complexity, the state in which an image presents itself most perfectly.[60] Despite widely held opinions to the contrary, Arnheim argues that gestalt theory should not be taken only as the desire for pure simplicity or stasis.

Instead, two opposing tendencies (intensification and simplification, complexity and order) must be at work in the same given image, and correspondingly on behalf of the viewer's perception, in order for *Prägnanz* to occur.[61] Impressionist and pointillist painting provide an example of the invisibility of reality that results from utter optical monotony (thus Seurat is nearly as distasteful to Arnheim as Jackson Pollock). Without a counteracting element of articulation, mere simplified shapes will add up to an obscure haze, he contends. An image must possess both intensity and attenuation, dynamism and restraint. An effective image will hold the factors poised in tension with each other.

In his piece *Entropy and Art: An Essay on Disorder and Order* (1971), Arnheim gives an example of how simplification *alone* engenders not order, but an indistinguishable mass. Arnheim wrote this essay partly out of frustration with much contemporary art (particularly the minimalist and earth art of the 1960s and 1970s); he indicts, for example, the writings of the artist Robert Smithson for their celebration of the principles of entropy in large-scale sculpture and monuments. Smithson's deliberate courting of impermanence and structural decay is, for Arnheim, tantamount to the "degradation of culture."[62] Arnheim takes an image of Poussin's *Holy Family on the Steps* (1666–1688) and shows the photograph in increasing gradations of blurriness—a move intended to illustrate his negative surmise of "'minimal' art and the pleasures of chaos."[63]

A work of art which, by contrast, emulates Arnheim's gestalt-derived theorems, and one which has obsessed him throughout his career, is Pablo Picasso's *Guernica* (1937) (fig. 1). Arnheim's 1962 treatise *The Genesis of a Painting: Picasso's Guernica*, examines—in typical gestaltist fashion – the individual passages within the painting in relation to the whole image, as well as the painting's phases leading up to its final state, famously recorded by Dora Maar's camera.[64] Arnheim's analysis of Picasso's painting mirrors his arguments about film montage; he shuttles back and forth between smaller components and their placement within the larger work. Arnheim (indirectly) compares the painting with film in several ways: the monochrome image unifies "everything contained in the picture"; the "panorama-like sprawling of the horizontal" makes for a "lack of compactness"; the various planes offer up a "loose enumeration of separate happenings"; the progression of the imagery even evinces a temporal, "rightward current."[65]

The use of montage—or the fracturing of the picture plane in an (analytic) cubist or futurist painting—carries the risk that the individual passages dissipate into a desultory jumble, preventing the spectator from organizing the various elements.[66] *Guernica*, in Arnheim's interpretation, succeeds in counterbalancing dissipation with a general compositional order. Like the slices of montage in

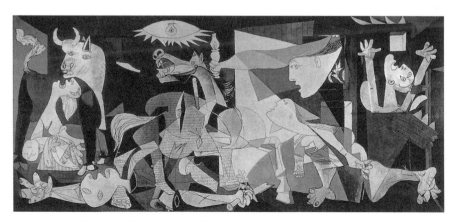

Figure 1. Pablo Picasso, Guernica *(1937). Museo Nacional Centro de Arte Reina Sofia, Madrid, Spain.* © Art Resource, NY.

Pudovkin's *The End of St. Petersburg* (1927), the individual fragments of *Guernica*—each of which possesses a semiautonomous completion of its own—coalesce into a larger whole, tingeing each segment with the prevailing motif of the "plot."[67] Picasso's style, moreover, fuses the intensity and articulation of expressionist anguish with the simplification of classicizing order, evincing the fundamental elements of a "good gestalt."

Along with the master of montage, Sergei Eisenstein, Arnheim views film montage as a means of shaping and interpreting form, and thus of imparting meaning. For both theorists, the "interweaving" of montage units generates the cumulative significance of a sequence. As opposed to his contemporary Walter Benjamin, for whom the violent cut of montage wrenches the spectator out of passive distraction, Arnheim views the device as but a circuitous means to organic closure. The viewer in Arnheim's model perceives the lacunae between images, yet this acknowledgment does not lead to any materialist questioning of—as Benjamin puts it—"how matter plays tricks on man."[68] Arnheim writes, "Montage, in the real sense of the word, requires that the spectator should observe the discrepancy among the shots that are joined together; it is intended to group slices of reality in an integrated whole."[69]

Such an understanding of montage as an integrative maneuver can be traced back to Max Wertheimer's famous early gestalt essay, "Experimental Studies on the Seeing of Motion" from 1912, in which he concluded that "successive exposures . . . under the best conditions, continually join together, giving rise to a single, continuous, total event."[70] Indeed, Arnheim's *Film as Art* specifically links Wertheimer's investigation to film montage, which, Arnheim claims, fuses "objectively separate stimuli into one *unified impression.*"[71] For example, Arnheim cites the various images of lion statues in Eisenstein's *Battleship Potemkin* (1925)—a lion crouching, a lion rising, a lion roaring—as producing a single (symbolic) effect of dynamism and power. In this view, film montage can overcome the synchronic progression of time and the "jumps in intervals," and ultimately offer up a unified effect of *Prägnanz*—that is, if the director adequately handles the material.[72]

Gestalt and Its Critics: Arnheim's Interlocutors

Arnheim's faith in the absolute "givens" of gestalt theory shackles his method to a rather limited appraisal of art and film—a fact not lost on his many interlocutors. The primary criticism that most theorists and scholars have leveled against Arnheim is his failure to account for the various contingencies (historical, subjective, political) that inform both individual artistic creation and the resonance of artistic expression in the social sphere. Arnheim at once insists upon the pedagogical and demotic purpose of aesthetics, yet paradoxically divests them of sociopolitical context. He even manages to argue that *Guernica* does not constitute "a political statement"![73] If psychoanalysis proves too subjectivist for Arnheim, so too does a contextualizing or sociological approach fall short of his sweeping formalist imperatives.

Jacques Aumont, who otherwise praises Arnheim's film scholarship, crit-
icizes Arnheim's disregard for the viewer's expectations (a reproach also leveled
by E. H. Gombrich in *Art and Illusion*). Aumont writes, "As far as visual surfaces
are concerned, and hence images, this is a wholly learned, cultural phenomenon."[74]
In his *Studying Visual Communication*, Sol Worth, a scholar of visual studies,
takes issue with Arnheim's absolute privileging of vision over language, as well
as his essentializing of perceptual phenomena. In Worth's view, Arnheim "under-
estimates or denies the extent to which symbolic systems or conventions medi-
ate our knowledge of the world."[75] In turn, Worth mentions various scholars who
make such systems central to their accounts, among them Franz Boas, E. H. Gom-
brich, Ernst Kris, and Erwin Panofsky. The film historian Noël Carroll's meticu-
lous analysis respectfully takes issue with Arnheim's theory of film theory on the
grounds that, while clearly of service to the development of film art, his essen-
tialist categories often lead to "physiological reductionism."[76] And in his largely
sympathetic review of Arnheim's *Visual Thinking*, Hans Jonas joins the prevail-
ing fray: "The whole iconography, e.g., of medieval painting and sculpture, pre-
supposes the spiritual teachings of the Christian faith. As those works in color
and stone were inspired by them, so they can only be understood in the light of
them."[77]

The list could go on. Arnheim, in fact, has alienated himself from any
method that deviates from the idea of art or film as a tool of perception—lumping
into the same dismissive category (as recently as 1999) "fancy language" and
"fashionable topics such as pornography, feminism, and postmonumentality."[78]
Needless to say, I cannot undertake a lengthy discussion of such a statement here,
but I would note that the polemics of Arnheim's position are partly rooted in a
self-declared evangelicalism (to wit, his declared intent to "rescue" art and the
"common core of sensory expression" from "social determinants and esoteric the-
ory").[79] Arnheim makes a claim for art as neither an aesthetic end in itself, nor a
practice informed by the desires and wants (whether psychological or materialist)
of its makers and receivers.[80] The imaginary subject assumed by Arnheim's work
is, for this reason, a difficult one to imagine, both despite and because of Arn-
heim's aspiration to include every kind of viewer under its rubric.

To the Rescue of Film: *New Laocoöns*
and the Paradigms of Aesthetic Purity

*Exactly how the movies escape theater is a difficult question, and there is no
doubt but that a phenomenology of the cinema that concentrated on the sim-
ilarities and differences between it and stage drama—e.g., that in the movies
the actors are not physically present, the film itself is projected away from us,
and the screen is not experienced as a kind of object existing in a specific
physical relation to us—would be rewarding.*
—Michael Fried, "Art and Objecthood," 1967[81]

One of the most basic artistic impulses derives from man's yearning to escape the disturbing multiplicity of nature and seeks, therefore, to depict this bewildering reality with the simplest means. For this reason a medium of expression that is capable of producing complete works by its own resources will forever keep up its resistance against any combination with any other medium.
—Rudolf Arnheim, "A New Laocoön:
Artistic Composites and the Talking Film," 1938[82]

In his 1766 essay *Laocoön*, G. E. Lessing mapped out some prominent differences between painting and poetry, positing the unique artistic capacities of each (the poetic arts are said to be temporal; the visual arts, spatial), and arguing that only one or the other medium could best express certain meanings or modalities of experience. Updating Lessing in his renowned essay of 1940, "Towards a Newer Laocoön," the art critic Clement Greenberg sought to free painterly practice from the responsibilities of representation. Perhaps the most controversial critic of the latter half of the century, Greenberg called upon painting to abandon the narration characteristic of literature and to exploit its own intrinsic qualities of flatness and truncation from the world of objects. Greenberg's dictate emerged alongside of—and certainly subtended—a postwar painting style that refused figurative depiction in favor of self-reflexive expression. With characteristic imperiousness, Greenberg proclaimed that "the arts lie safe now, each within its 'legitimate' boundaries, and free trade has been replaced by autarchy. Purity in art consists in the acceptance, willing acceptance, of the limitations of the medium of the specific art."[83]

Yet in "hunting the arts back to their mediums," in "isolating, concentrating, and defining"[84] the domains of artistic practice, Rudolf Arnheim beat Greenberg to the punch by a couple of years. Arnheim's 1938 essay, "A New Laocoön: Artistic Composites and the Talking Film," furthered the propositions already outlined in his *Film als Kunst*, particularly the demand that film accept its own limitations in order to distinguish itself as an art form.[85] "Each medium," Arnheim wrote, "must treat the subject in its own way, and the resulting differences must be in accordance with those that exist between media."[86] Greenberg's subsequent mandate that each art "determine, through the operations peculiar to itself, the effects peculiar and exclusive to itself"—by now one of the hallmarks of modernist criticism—resonates strikingly with Arnheim's foregoing pronouncements.[87] To be sure, Greenberg defined purity much more rigidly than Arnheim, particularly in his exclusion of all referentiality—barring that of the plastic materials themselves—from the domains of painting and sculpture. Nevertheless, Arnheim's rhetorical circumscription of film, I hope to demonstrate, must be seen as an integral part of the "idea of the separation of the senses on which modernism's logic is built."[88]

Arnheim designates the nervous system as the underlying receptor and impetus, the agency *and* the exigency, of visual expression. And the cinema can best attend to the "needs" of the spectator's nervous system, Arnheim argues, by

exercising its own intrinsic "pure powers."[89] Film's "pure powers" derive from the Arnheimian concept of *Materialtheorie*, which holds that "artistic and scientific descriptions of reality are cast in molds that derive not so much from the subject matter itself as from the properties of the medium—or *Material*—employed."[90] In its application to film, Arnheim's *Materialtheorie* comes up with far fewer requisitions than proscriptions: film must derive its uniqueness as a medium from its own (welcome) encumbrances.

While the particular faculties of the cinema differ from those of other mediums, the *way* in which each medium must exploit its own faculties is identical. Just as the theater reproduces reality in a contrived setting that its audience accepts as peculiar to the medium—that is, a contrived, three-walled room—so too does (black-and-white, silent) film attain artistic stature through its own limitations.[91] Film vividly resurrects reality before our eyes, but it is a reality crushed into silhouettes against a flat plane, a reality radically severed from the surrounding world, a reality stripped of its colors and sounds—in short, an image rather than a simulacrum. This idea of a visual and perceptual limbo—a "partial illusion"—forms the shibboleth of Arnheim's theory of film.

In Arnheim's view, the "partial illusion" is what characterizes painting, sculpture, and the graphic arts a priori, whereas film (by virtue of its mimetic predisposition) must continually strive toward this state if it is to achieve the status of art. For film's illusion to be only "partial," and thus not a mere reproduction of the visible world, it must willfully incur certain limitations. While a degree of removal, and thus expressiveness, necessarily inheres in painting, Arnheim contends, the film artist may achieve a similar expressiveness only through a visual ruse that injects something of the artist's will into the image.

This notion of the plastic arts' *imperfect* illusionism, their voluntary detachment from (or perversion of) visual reality, is explicable only from a position that rejects the notion of realism or mimesis as art's duty. Arnheim's theory appropriates a distinctly modernist conception of art in its battle against filmic realism. Absolute faith to appearances, to similitude, forsakes film's potential artistry: "The curious paradox in the nature of any image is . . . that the more faithful it becomes, the more it loses the high function of imagery, namely, that of synthesizing and interpreting what it represents. And thereby it loses interest."[92] Modernist painting, whether that of Kandinsky or Klee or Matisse, thus stands for Arnheim as the point of departure for film art, since, unlike Renaissance or history painting, modern art attempts to transform and distort reality, and to impart that very mutation with meaning. The disproportions and deformities that traditional realist painting so assiduously struggles against, Arnheim contends, must become for the film artist (as for the modernist painter) the basis of artistic effect. In an intimation of what would later become the backbone of postwar, formalist art criticism, Arnheim rhetorically transfigures the negative "necessities" of distortion into the positive constituents of film art.[93]

Superimpositions, close-ups, fade-outs, and slow motion all find their place

in Arnheim's catalogue of artistic camera maneuvers. Foremost among those at the disposal of the film artist, however, is the inventive angle. Arnheim cites the Russian tendency for "worm's-eye view" shots as exemplary of how a "virtue is made of necessity."[94] Such unlikely angles and deliberately skewed perspectives force the viewer to work, to question why the composition is arranged as such, to seek meaning in formal distortion. Illustrating a successful application of "effects purely of the camera," Arnheim cites a scene from Pudovkin's *The End of St. Petersburg,* in which the director juxtaposes a giant statue of the czar with two miniscule peasants. The scene succeeds for two reasons: first, because Pudovkin has made symbolic use of a formal manipulation; second, because the director achieves such a manipulation without actually altering physical reality.[95]

Arnheim is not concerned with how cinema may reference the history of art. Film does not become art by "quoting" painting or sculpture, or by enacting tableaux vivants. According to the tenets of *Materialtheorie,* film should not simply cite the composition of an actual Rembrandt (think, for example of Carl Theodor Dreyer's *Dies Irae* [1943] and its stylizing of *The Anatomy Lesson* [1632]), but rather should translate the "Rembrandt-style" chiaroscuro lighting into a cinematic idiom (as did Cecil B. DeMille). Fritz Lang's *Die Nibelungen* (1924), for instance, interests Arnheim not in its deployment of Arnold Böcklin's painting, but rather in Lang's use of dramatic lighting effects to underscore narrative. In its stage effects and set-work, much expressionist film stands as mere hybridized *maquillage*—Arnheim indicts *The Cabinet of Dr. Caligari* (1919) in particular. This film represents for him an alchemical disaster, a grafting of painted and architectonic artificiality onto the pure surface of film.[96] Instead, film should use symbolic and perspectival tropes without plastically altering the environment. Form, Arnheim argues, should remain elusive, hard to pin down, embedded in the work as a whole, not unlike—in his words—"the ingredients of a good salad dressing."[97]

As I have already mentioned, although Arnheim wishes to ontologize film as a unique medium, he often allies it with painting in order to justify its artistry. Arnheim's early essays endow film with an aesthetic pedigree wedded to painting and drawing, even as they carve out the trajectory of film's separate, intended posterity. In this sense, Arnheim's "creationist" theory of film is not itself without precedent. The futurists' 1916 "Manifesto on Futurist Film" had, albeit only schematically, adumbrated a similar path: "The cinema is an autonomous art. The cinema must therefore never copy the stage. The cinema, being essentially visual, must above all fulfill the evolution of painting, detach itself from reality, from photography."[98] Nevertheless, it was Arnheim's *Film als Kunst* that first made these formal principles the basis for an entire program of cinematic theory. Since Arnheim seeks to distinguish the cinema, on the one hand, from the theater, and, on the other hand, from the documentary photograph, he ends up appropriating numerous faculties of the plastic arts to establish film's own ambivalent plasticity— its straddling of three-dimensional corpulence and the flat, chimerical shadows of Plato's cave.

One clear example of this emerges in his discussion of the silent film versus the talkie: "It is obvious that speech cannot be attached to the immobile image (painting, photography); it is equally ill-suited for the silent film, whose means of expression resemble those of painting."[99] Because silent film tells stories visually, it translates verbal language into visual language—concepts into percepts—and in so doing achieves a level of abstraction necessary for artistic effect. Like painting, film may use fragments of imagery as objective correlatives in order to shape meaning: "In the universal silence of the image, the fragments of a broken vase 'talk' exactly the way a character talk[s]."[100] Such talk must remain metaphorical at all costs, however. For Arnheim, the prattling of words distracts the viewer from the primary, visual display of film; as proof of this he declares, "One cannot put sound in a painting!"[101]

Arnheim offers a scene from Josef von Sternberg's *The Docks of New York* (1928) as an example of the film image that expertly compensates for its lack of sound. As a way of conveying a gunshot, the director shows a disturbed flock of birds in the wake of the gun's explosion. Such an effect, Arnheim reasons, makes perfect use of a necessary contradiction, namely, the ocular depiction of a sound: the "indirect representation of an event in a material that is strange to it."[102] The incompatibility of sound and sight forces the film artist to employ a new representational logic, whose "strangeness" transforms the event.[103]

Contemporaneously with Arnheim's elaborations, Roman Jakobson was developing his theses on linguistics and modern poetics. Although Jakobson's propositions form part of an expressly semiotic theory, his focus upon the arbitrary relationship between signifier and referent resonates here with Arnheim's propositions: both critics clamor for the "making strange" (or "defamiliarization") of semantic expression so as to disrupt, and hence sharpen, the perception of reality.[104] While such a trope was common, if not central, to certain approaches in modernist literature, film in no way "owned" any exclusive bag of formal tricks, as it were. What are, from our perspective, commonplaces of "art film" were for Arnheim weapons in his crusade against those who viewed the film (and by extension, the photograph) strictly as the medium of mimesis. "The film," he writes in "A New Laocoön," "will be able to reach the heights of the other arts only when it frees itself from the bonds of photographic reproduction."[105] And his *Film as Art* similarly importunes, "Art begins where mechanical reproduction leaves off."[106]

Just as the absence of sound forces the viewer to concentrate upon the form and significance of the image, the absence of color brings into relief compositional hierarchies otherwise ignored in color film. As an illustration of this principle, Arnheim compares the actor's face in black-and-white film to "a good lithograph or woodcut."[107] Greta Garbo's face appears upon the screen not merely as a living, fleshly countenance, but as a composition of contours and symmetries, drawn out by monochrome's ascetic re-presentation. The color in painting, Arnheim asserts, "serves the objects" depicted and brings them into relation within

the frame, while a color photograph or film is made up of mere (unshaped, unselected) blobs of pigment. The result is a reproduction of chaotic color schemes in all of their natural discordance. By contrast, the black-and-white film—for example, Alexis Granowsky's *Song of Life* (1930)—develops a visual symbolism that undergirds its plot by virtue of dramatic tonal contrasts (the "long white operating coats, the white sterile sheets . . . and the dark rubber gloves of the doctors with their dark instruments").[108]

The principles that most embody Arnheim's association of film and painting are his notions of flatness and framing. The projection of forms against the planar screen, as well as the screen's truncation from reality, invoke the once-removed world of painting and thus trigger certain psychological expectations and contingencies: "As soon as a piece of nature becomes an image, we consider it with different eyes. . . . It seems that we consider it like a painting and therefore require different values."[109] The very physical boundaries of the screen circumscribe time and space, preserving them in an artificial abeyance. Whereas our vision is boundless, the margins of the screen impose spatial (and thus visual and perceptual) restrictions upon the image. Not surprisingly, such a notion of the film frame differs sharply from that of realist film theorists—most notably Siegfried Kracauer, who posits that "photography tends to suggest endlessness," and André Bazin, who asserts that "the screen is not a frame like that of a picture, but a mask which allows us to see a part of the event only."[110] For Bazin, "a frame is centripetal, the screen centrifugal."[111] Arnheim sees no such distinction. He peremptorily dismisses such concepts as alien to art, as belonging to mere "journalism," or else to the "keyhole pleasures of the peeping Tom."[112]

Likening the screen to the painter's domain, Arnheim argues that "one can only consider the filling of the canvas . . . if there are definite limits to act as framework for the pictorial design."[113] The frame not only delimits what may be seen, but its contrasting vertical and horizontal elements serve as references to all linear elements used within the frame. Thus, the screen's edges impose upon the images a set of autonomous, formal laws. Arnheim's postulations on the autonomy of medium have crept beyond the sphere of film into his art criticism:

> Since abstract painting is . . . on the decline, my guess is that once the artist abandons image-making he has no longer any reason to cling to the two-dimensional surface, that is, the twilight area between image-making and object-making. Hence the temporary or permanent desertion of so many artists from painting to sculpture and, as I said, the attempts to make painting three-dimensional or attach it to architecture.[114]

In this 1965 essay Arnheim compares the vitiation of the art film by sound and color to the invention of "three-dimensional oil painting"—in other words, the senseless hybridization of genres in order to attain more convincing illusionism.[115] Arnheim's jeremiads against the wide-screen film format echo in his objections to contemporary painting's physical metamorphoses: "As the painters took

to large-size canvases in order to immerse the eye in an endless spectacle of color, blurring the border between the figment and the outer world, cinema expanded the screen for similar purposes."[116] Arnheim also mentions the "so-called happenings" as "the most drastic move toward undisguised action"[117]—a measure of censure militantly adopted by himself and formalist critics of the 1960s and 1970s against the increasing popularity of performance and conceptual art.

In this vein, Arnheim anticipates the art historian Michael Fried's lament for the seemingly inexorable adulteration of painting by language and mere "objecthood." Fried's own (in)famous essay "Art and Objecthood" (1967), which attacked minimalist art for its "literalism," its endless "duration," and its affinity for actual space rather than flatness, invokes a reasoning not only informed by Greenberg's writings, but also analogous to Arnheim's foregoing film and art theory: the abdication of a circumscribed, flat surface erases the crucial boundaries between art and life, image and object. Fried's project, like Arnheim's before it, takes the indemnification of the image and the primacy of flatness as its primary burdens. Indeed, in its will to specificity, and its extensive juxtapositions of various mediums, Arnheim's diktat on film answered Fried's query for a formal distinction between film and stage drama, even before Fried posed it: Arnheim's *Film als Kunst* sought to establish a purely visual and flat realm, free from the hybrid sensorium of the theater or the literary cast of the novel.[118]

It is with these interventions into "'frame-bounded' visual practice"[119] that Arnheim betrays his early contribution to modernist purism, expanded and crystallized by Greenberg and Fried in their own critical practices. This "fetishization of internality," as John Welchman has called it, represents one of modernism's paradigmatic prescripts: "Notions of the frame, the edge, or the limit have been inscribed into the history of modern art such that they have become crucial (if always ambiguous) items on the menu of autonomy conditions imagined by formalist criticism to construct and position the modernist work."[120] I think it apropos to cite here, as does Fried in "Art and Objecthood," Clement Greenberg's 1962 essay, "After Abstract Expressionism":

> By now it has been established, it would seem, that the irreducible essence of pictorial art consists in but two constitutive conventions or norms: flatness and the delimitation of flatness; and that the observance of merely these two norms is enough to create an object which can be experienced as a picture: thus a stretched or tacked-up canvas already exists as a picture—though not necessarily a *successful* one.[121]

As Fried points out, Greenberg's statement "suggests that flatness and the delimitation of flatness ought not to be thought of as the 'irreducible essence of pictorial art,' but rather as something like the *minimal conditions for something's being seen as a painting.*"[122] This idea of formal modicums as the defining difference between art and non-art (or between art film and non-art film), this willful stripping of the medium in order to safeguard its integrity, is clearly one of the

seminal aspects of Arnheim's writing on film, and must be considered as part of the trajectory of Greenbergian, modernist purity—despite Arnheim's avowed indifference to the *"faits divers"* of epistemological dialectics.[123] I am not positing a direct methodological genealogy here—Greenberg and Fried do not mention Arnheim in their respective works. Rather, I wish to illustrate some remarkable confluences between Arnheim's early theory of film and the rigorous delineation of artistic mediums that has characterized important—and polemical—postwar art criticism.

Noël Carroll rightly notes that "Arnheim's specificity thesis is not a description; it is a recommendation."[124] And Arnheim's *Film as Art* itself warns that it addresses not so much what film *is*, as what it "can or ought to be."[125] I would carry this further and argue that we should read Arnheim's cinematic theory, with all of its inflexibilities and absolutisms, its anaphora and enumerations, much as we read a modernist manifesto. The rigidity of Arnheim's film theory clearly limits the applicability of its principles. Yet it is precisely such unyielding parochialisms (regarding vision, delimitation, flatness, and so forth) that distinguish the theory as both an emblem of modernist dogma and a forerunner of Greenberg's peremptory purism.

Modernism Unshaped: Realism, the *Informe*, and the Melancholy of Chaos

For academic men to be happy, the universe would have to take shape. All of philosophy has no other goal: it is a matter of giving a frock coat to what is, a mathematical frock coat. On the other hand, affirming that the universe resembles nothing and is only formless amounts to saying that the universe is something like a spider or spit.
—Georges Bataille, "Formless," *Critical Dictionary,* from *Documents,* 1929-1930[126]

Film brings the whole material world into play; reaching beyond theater and painting, it for the first time sets that which exists into motion. It does not aim upward, toward intention, but pushes toward the bottom, to gather and carry along even the dregs. It is interested in the refuse, in what is just there—both inside and outside the human being.
—Siegfried Kracauer, "Notes for a Book on Film Aesthetics," 1940[127]

It has become necessary to point out that genuine realism consists in the interpretation of the raw material of experience by means of significant form and that therefore a concern with unshaped matter is a melancholy surrender rather than the recovery of man's grip on reality.
—Rudolf Arnheim, "Melancholy Unshaped," 1963[128]

As we have seen, Arnheim stands as one of the most forceful defenders of aesthetic autonomy. To such an eminently modernist position, however, Arnheim

attaches certain stipulations. While he advocates the autonomy of film and painting, he cannot brook their *automatism*—the use of accident or chance that some (mostly post–World War II) artists and filmmakers have employed as both subject and style of their works. The epitome of (high) modernism's infractions, for Arnheim, is the painting of Jackson Pollock. Pollock's lacy skeins, with their "allover" appearance that relinquishes meaningful gestalt, fractiously defy Arnheim's demand for "overall" unity: "The phenomenal chaos of accident, from which man seeks refuge in art, has invaded art itself," bemoans Arnheim.[129] In his essay, "Accident and Necessity of Art" (1957), Arnheim goes so far as to compare Pollock's putatively uniform and fortuitous texture—which in actuality is highly variegated and methodically applied—to "a random field of 19,600 cells."[130] Rather than engage the viewer with its dynamism, he argues, Pollock's courting of unpredictable elements alienates him with monotony. Pollock's repudiation of any gestalt represents for Arnheim an embrace of mere "raw material," unshaped by hand or by consciousness.

Arnheim does not limit his crusade here to painting. In fact, it is precisely the issue of "formlessness" that brings film—and its relations to contemporary painting—back into Arnheim's purview after some years of reticence. And the text that rouses Arnheim out of quiescence, *Theory of Film: The Redemption of Physical Reality* (1960), comes from his old compatriot and colleague, Siegfried Kracauer. Kracauer's book proposes that film turn toward mundane experiences and objects in search of reunification with the world of estranged things, forsaking pronounced style for a "redemption of reality."[131] In "Melancholy Unshaped," his 1963 review of Kracauer's book, Arnheim draws parallels between the developments of realist film theory and the plastic arts' growing predilection for amorphousness and the sovereignty of accident.

Arnheim calls Kracauer's work "probably the most intelligent book ever written on the subject of the film" but emphatically criticizes the text's elisions of content and subject. Kracauer advocates not only the filming of unshaped matter, but a style that itself eschews any guiding form, preserving instead the "virgin indeterminacy" of its objects.[132] For Kracauer, the "photographic veracity" of film, its detached rendering of nature, is what separates it as a medium from the "formative impulses" of painterly subjectivism.[133] "If film is an art at all," Kracauer writes, "it certainly should not be confused with the established arts."[134] Why such a proposition would be distasteful to Arnheim should be eminently clear by now, although we find one central reason perfectly articulated by Stanley Cavell in *The World Viewed*: "Photography overcame subjectivity in a way undreamed of by painting, a way that could not satisfy painting, one which does not so much defeat the act of painting as escape it altogether: by *automatism*, by removing the human agent from the task of reproduction."[135] Arnheim's theory of film art, as we have seen, is largely based upon the need to abjure photography's automatic documentarism, the need to ally film with painting in order to certify its artistry.

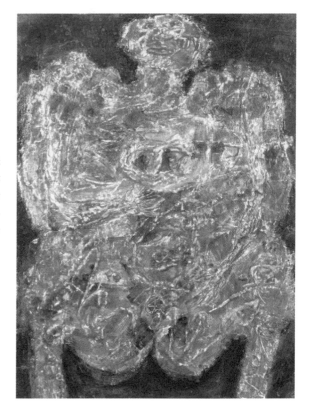

Figure 2. *Jean Dubuffet*, Corps de Dame: Blue Short Circuit (Court-circuit bleu) *from the Corps de Dames series (1951)*. Museum of Modern Art, New York. The Sidney and Harriet Janis Collection. Photograph © 1994 The Museum of Modern Art, New York.

In this same review, Arnheim compares Kracauer's theory not to Pollock's works, but to those of the French painter and avatar of Georges Bataille's *informe*, Jean Dubuffet (fig. 2).[136] Rosalind Krauss, one of the most prominent expositors of the *informe*, clarifies Bataille's philosophy thus: "Shapeless matter, like spittle or a crushed worm . . . are instances of formlessness. . . . The *informe* is a conceptual matter, the shattering of significant boundaries, the undoing of categories. In order to knock meaning off its pedestal, to bring it down in the world, to deliver it a blow."[137] For Arnheim, "intellectual abstractions" must be "metabolized into visual qualities."[138] To do away with shapes, to jettison deliberate form, to dissolve boundaries, leads either to ethereal conceptual tropes or to a "primitivist aesthetics"—or else, as in Dubuffet's case, a conflation of the two. For Arnheim, reality may be "redeemed" only through its aesthetic disarticulation and rearticulation. In short, by *doing* something to it.

Therefore, Dubuffet's affinity for—in the artist's own words—"homogeneous worlds with neither landmarks nor boundaries" further exemplifies for Arnheim both late modernism's and Kracauer's "relinquishment of the active grasp of meaning."[139] Dubuffet's viscous emulsions, his amalgams of butterfly wings and sand, are as distasteful to Arnheim as Kracauer's unfiltered cinematic realism: both amorphously reproduce reality without significantly endowing it with meaning.[140] The pure photographic image, like the materials of Dubuffet's

creations, is randomly extracted from life and thus unformed, unmeaningful. Even as Arnheim (frock coat and all) grapples with Kracauer's theory of film, he also attacks the larger cultural trends that Bataille's "anti-canon" of formlessness has come to signify.

Of course, Kracauer does not need Arnheim in order to elucidate the affinities of his propositions—even if accidental, or indeed antithetical—to those of Bataille's *informe*. The downward and inward impulsion of Kracauer's theory of film brings some of its imperatives into line with those of the anti-gestalt, "low" proclivities of the *informe*.[141] I would argue that despite the fundamental differences of Bataille's worldview from Kracauer's, a Bataille-like voice may be heard (obliquely) in *Theory of Film* clamoring for the retrieval of matter merely as matter, "both inside and outside the human being," submitting to the camera, offering it "ample opportunity to satisfy its inborn curiosity and function as a rag-picker."[142] Indeed, Kracauer's crusade against "instrumental rationality" and his Freudian-informed belief that film embodies "psychological dispositions which 'extend below' the dimension of consciousness" further adumbrate an unlikely affinity with some of the primary tenets of Batailleian and surrealist aesthetics.[143]

This does not mean that Kracauer's humanist investment in a critical cinema is tantamount to Bataille's nihilist erotics. But Kracauer's film *method*, at least, proposes a similar acceptance of the unformed, of dissolution, of chaos as the basis for aesthetic and moral redemption. Kracauer believes that modernity is an alienated condition; as a truthful yet potentially redemptive reflection of this condition, the cinema must use contingency, accident, the unreconstructed detritus of modern life in order to reacquaint the viewer with his own estranged relationship to the world of things. "Unlike painting," he writes, "film images encourage . . . decomposition because of their emphatic concern with raw material not yet consumed."[144] It is precisely this faith in "indeterminacy" that sparked Arnheim's reproof.

In particular, Kracauer's enthusiasm for a film that captures "the flow of life" and "physical existence in its endlessness" completely contradicts Arnheim's lamentations about the "recent vogue of texture painting."[145] Kracauer's litany of realist categories ("The Unstaged," "The Fortuitous," "Endlessness," "The Indeterminate") likely sounded as disagreeable to Arnheim as Bataille's random *Dictionnaire Critique* would have. Kracauer's "revealing functions" of the camera, his concern with the minutiae of everyday life, with "Things Normally Unseen" in all of their scatological banality, all represent for Arnheim a plunge into the "keyhole pleasures of the Peeping Tom."[146] Arnheim's review impatiently (but always politely) wipes the dross of such filthy "recording obligations" from the purist's antiseptic tools. Art and film are instruments of humanity that shape matter into meaning. Art cannot just *be there*.

How, then, should we construe the parameters of Arnheim's own conception of film art and artistic modernism? Arnheim himself supports "the broken chains of time, space, and causality; the fragmentation of episodes; the elusive

settings; the openness and emptiness obtained by omission," since "to exclude such possibilities from the cinema would mean to impoverish it without justification."[147] Yet how may we distinguish "fragmentation" from shapelessness, "omission" from formlessness? Where does one draw the line between meaningful elusiveness and senseless dissipation?

Arnheim's entire oeuvre shuttles between stressing formal elements and stressing the discursive features of art and film. His belief that cinema and art must straddle the real and the stylized (the "partial illusion") generates in his writing an unresolved tension between an idealist imperative and a teleological, almost Aristotelian one. One minute we find Arnheim expounding about the need to transcend "boring realism," and the very next indicting the art historian Roger Fry's wanton formalism as an "estrangement of the sensory experiences from their meaning."[148] Arnheim values abstraction and formal experimentation only to the extent that they cohere; the presentation of contours and lines without organization leads only to decoration and distraction. Hans Richter's *Film Study* (1926) and Man Ray's film *Emak Bakia* (1926), for example, stand for Arnheim as powerful examples of graphic art brought to life, but he ultimately dismisses them as "really only collections of material," as mere "venerable curiosities."[149] "In a good film every shot must be contributory to the action," he declares, and "things which have no significance have no place in a work of art."[150] A viewer of a film or a painting always arrives at its broader significance via the incidents of its surface, but must never remain hypnotized by mere incident.

The increasing destruction of form in the plastic arts has leaked into cinema as well, Arnheim claims at the end of "Melancholy Unshaped." As an eminent example of this, he cites Antonioni's *L'Avventura* (1959) (fig. 3). Arnheim suggests, quite rightly, that the meandering itinerary of Antonioni's film not only *depicts* estrangement, but engenders that very estrangement through its mode of expression: "Is this a new, legitimate way of interpreting dissolution by unorganized form or is it a clinical symptom of the mental dejection it purports to portray—melancholy unshaped?"[151] To put it briefly, Antonioni's unqualified ellipses leave Arnheim lost. *L'Avventura* takes Kracauer's (neo)realism one step further, severing causal links in plot and using absences and voids as the primary, paratactic constituents of its film language. Indeed, Antonioni strives for a kind of narrative formlessness that brings Pollock to mind. The filaments of line and of narrative in Pollock's and Antonioni's respective works do not congeal into any pattern, but rather hover on their own as autotelic traces.[152] The traditional indictment of both artists, furthermore, has been that their works forsake both beginning and end. Arnheim's most carping objection to Pollock's canvases—"nothing happens!"—fittingly echoes a common description (or disparagement) of Antonioni's film style.

Arnheim argues that when chance characterizes the very mode of art practice, then art becomes an erratic palimpsest, rather than a reasoned site of expression. "Painters and sculptors, as they used to be called, seem to have reacted to

Figure 3. Michelangelo Antonioni, L'Avventura (1960). Museum of Modern Art, New York.

the subjectivity and detachment of the modern mind by retreating to the making of objects that betray their human origin as little as possible."[153] Paul de Man once said of modernity (and modernism) that "the human self has experienced the void within itself, and the invented fiction, far from filling the void, asserts itself as pure nothingness."[154] One might say that "filling the void" of modern aesthetic practice has been Arnheim's burden from *Film als Kunst* to essays written sixty-eight years later:

> An artist may undertake to present chaos as a portrait of the world or of our civilization, but since chaos is by its nature unstructured it cannot offer anything but the monotony of shapelessness; and whatever changes occur in it will make no difference. . . . Of course, one can intend to create confusion, but that may be dangerous or at least unproductive ("From Chaos to Wholeness," 1996).[155]

Since order, for Arnheim, is the prerequisite for the expression and comprehension of meaning, then art must exhibit definite hierarchies and patterns, even in the realm of "invented fictions." The gestaltist idea here is that the physical presence of the object or image corresponds to and guides our own thought processes. Because they affect society as a whole, aesthetics for Arnheim are charged with an ethical imperative in which shape and form are commensurate with moral integrity, and the predicament of an image stands as the visual litmus for general cultural health.

Arnheim's Middlebrow Modernism and the Democratization of Visuality

The early Weimar cinema's alchemy "both of science and the imagination"[156] proved to be one of the most decisive elements in shaping Arnheim's aesthetic

demiurge. According to Arnheim, nineteenth-century culture had done much to estrange art from science, causing a general depreciation of vision.[157] He takes particular issue with the "genius cult" born of Romanticism and symbolism, which, he claims, located art in the rarefied strata of melancholic solipsism and *Erlebniskunst* (art as an expression of individual experience), and which severed art from rational practicality.[158] Again and again, Arnheim's writings have attempted to mend this fissure, seeking, in his words, to "rescue intuition from its mysterious aura of 'poetical' inspiration and to assign it to a precise psychological phenomenon that is badly in need of a name."[159] As we have seen, the phenomenon behind the veil of "mysterious aura," is, for Arnheim, the sober order of gestalt psychology.

Arnheim's application of gestaltist theories to art and film generates a series of checks and balances ("the way one keeps one's balance atop a bicycle"): part and whole; percept and concept; simplicity and articulation; universal and particular; autonomy and engagement; sensation and cognition, and so on. (Not incidentally, Jacques Aumont has called gestaltist laws "semi-empirical, semi-intuitive combinations," conjuring up once again Arnheim's Kantian origins.)[160] Film must fight against its affinity to reality, but not so hard as to be totally abstract; art must strive toward realism, but not so hard as to lose itself in "texture." To the dialectic belligerence of the avant-garde, Arnheim prefers the tended equilibrium of art-as-reason: in other words, he refuses to rock the proverbial boat. Marcel Duchamp's putative debunking of artistic "genius"—with his (proto)conceptual Readymade objects, Dadaist wordplay, and rejection of the frame—is to Arnheim simply another kind of aesthetic rarefication, an infection of visuality with the messiness of language. Likewise, in the wake of postwar artists such as Mel Bochner and Allan Kaprow, Joseph Beuys and Antonioni, Arnheim clings furiously to *Guernica*'s stately *Prägnanz*—a kind of pier, tattered but steadfast, amid the centrifugal surge of the "frame-busters."[161]

In some ways, Arnheim's withdrawal into the boundaries of the frame shares Clement Greenberg's (quite political) desire to save art from infection by both commodity culture and totalitarian ideology.[162] But despite his conditional affinities with Greenberg's elitist formalism, Arnheim's is a definitively middle-brow modernism. Art is not unruly, but prescribable; art is not the reserve of the pontifical critic, but the democratic tool of education. This is not to say that Arnheim valorizes a *Saturday Evening Post* cover over the painting of Georges Braque.[163] He does not champion kitsch over high art. He does, however, call for intelligibility in art above all else. The hermetic nature of much high art, Arnheim contends, forces too many individuals to search for visual stimulation in popular culture and superficial entertainment. Arnheim wishes to secure a noble—and ecumenical—purpose for the plastic arts and film as *the* foci of education and cultural discourse. In pointing out and encouraging the universal elements of seeing, gestalt criticism opens up this discourse for everyone.

But in addition to discounting the rootedness of much artistic expression in language, and ignoring the very conditions of its making, Arnheim's method focuses on a very narrow aspect of imagery: its immediate appearance and its (supposedly immediate) meaning. The problem here is that art, particularly modern art, often purposefully presents its meanings in a circuitous and fragmented manner, and intends that circuity, that fragmentation, as a valid expression in its own right.[164] Art and film often proffer a surface specifically to show how surfaces can lie, or else reveal their truths only at a later time. In his insistence upon intelligibility, Arnheim is forced to disavow or to ignore the *deliberate* irrationality and lawlessness of modernist art and film, their *refusals* of the yoke of meaning. Arnheim's oeuvre too often instrumentalizes art and film—not politically, but scientifically, clinically. While the focus upon the contingencies of perception constitutes a necessary and important contribution to the mechanisms of cognition, it frequently forsakes a scrutiny of the artwork itself, or else reduces images to their strictly informative capacity.

And here we find ourselves in the position of submitting Arnheim's work to that which it has most deliberately avoided: historicization. Arnheim's enterprise has been a uniformly apolitical one; as a scholar, he has avoided ideological subscriptions outright. The affinities between Arnheim's political reserve and his aesthetic penchant for symmetry, balance, and the "Power of the Center," are by no means accidental: "In both aesthetics and politics he sought a position in the radical middle," writes gestalt historian Mitchell Ash.[165] Arnheim intended his *Film as Art* to "preserve the remnants of the attempts to reflect our century in undisturbed animated images."[166] But what—at the risk of a postmillennial truism—was the last century, if not disturbed and disturbing? Arnheim's own suffering as one of its victims and exiles makes his assurance of the rectitude of culture all the more quixotic.

In opposition to Siegfried Kracauer's approach, Arnheim's method suggests a willful retirement from the political extremes that he had fled from in life, and a kind of Jeffersonian populism redolent of the promises of his adoptive land. Rather than view cultural mechanisms themselves as fair game for artistic irony or distancing or parody, he maintains absolute faith in the parameters of established cultural principles. Such a stance safeguards art from the taint of reactionary politics (think National Socialism), but so too does it forestall institutional critique, or even the scrutiny of critical practice itself. If art cannot invoke language, then how can it challenge the discourses of power? Arnheim's persistent claims for a universal mode of perception must be linked to the two major contexts of their elaboration: first, the Weimar aspiration toward holism and an integrative worldview; second, the postwar, American "culture of the whole," marked by centralization, a development of "general systems theory" across disciplines, and an international assimilationism in the wake of the war's destruction.[167] And to these factors we might also add the modernist ideal of a cosmopolitan subject. Such historical

and intellectual circumstances do not in and of themselves account for Arnheim's theory, but perhaps help to situate the development of his approach and to explain the consistency of his position.

Perhaps the most confounding aspect of Arnheim's film and art theory is its strange marriage of modernist rigidity and forbearing accommodation. On the one hand, Arnheim's utopian ideal of vision-as-truth is something he shares with not a few of modernism's usual suspects. Is it any surprise that Arnheim invokes Piet Mondrian in his defense of essences, of the Platonic "grasp of generalities"?[168] Yet on the other hand he has sought to mitigate and moderate modernist dogma: he champions modernism's disfigurations only so long as they are followed by a subsequent reaffirmation, a perceptual compensation of semantic loss. Antonioni's *L'Avventura*, as we have seen, is all negation for Arnheim. His disapproval of the film—now decades in the past—raises an issue still central to postmodernist debate: namely, the function of vision and its relationship to truth. Arnheim may be seen as a kind of unwitting crystallizer of the confrontation between postmodernism's will-to-language and fragmentation, and the modernist faith in sight and totality.

The conceptual artist Mel Bochner declared in 1966 that "Art need no longer pretend to be about Life. . . . Art is, after all, Nothing, [and] invisibility is an object."[169] But challenges to Arnheim's "visual thinking" have not been strictly verbal. An artist in the early 1980s produced an assemblage wryly entitled *Homage to Arnheim* that "consisted of ten identical mousetraps arranged in a row. At the spot where the bait was to be affixed, [the artist] had written the titles of [*Art and Visual Perception*'s] ten chapters, one on each contraption."[170] The obstinacy of Arnheim's art and film theory could hardly be more mordantly metaphorized. That such a jab would come in the form of conceptual art is, of course, a fitting irony, since Arnheim rejects this mode of art-making outright.

Arnheim's early battles with those who would forsake image-making for illusionism—or at least the stakes of such a confrontation—have not faded away. Such concerns remain central to the polemics of modern and contemporary art and film criticism, from Allan Kaprow's expansion of Pollock's painting into performance, to the recent "Total Installations" of Ilya Kabakov.[171] These synaesthetic *Gesamtkunstwerke* are for Arnheim tokens of "vain attempt[s] to reduce an object of art to mere existence"[172]—at once a new kind of (lawless) medium and a throwback to the Romantic, Wagnerian drive for a "total art." Whether earthwork or installation, video art or the "complete film," such works obliterate for Arnheim the hallowed "differences between model and copy"[173]—that is, the difference between life and its re-presentation. A passage from *Film as Art* quips impatiently,

> The temptation to increase the size of the screen goes with the desire for colored, stereoscopic, and sound film. It is the wish of people who do not know that artistic effect is bound up with the limitations of the medium and who

want quantity rather than quality. They want to keep on getting nearer to nature and do not realize that they thereby make it increasingly difficult for film to be art.[174]

Indeed, installation seems to be the site where art and film most frequently converge these days. And if, as one critic recently avowed, the "average viewer" responds to the challenge of installation, then it would seem that the stakes of accessibility and intelligibility have changed.[175]

Yet establishing the paradigms of new artistic media (as well as parameters for their criticism) within an all-pervasive visual culture has become an increasingly difficult task.[176] At a time when new media seem to emerge daily, and art and visuality are increasingly bound up with the advertising, technology, and entertainment industries, Arnheim's arguments take on a renewed urgency. The excesses and anachronisms of Arnheim's film writings must not occlude their positive resonances for all aspects of art-making: the drive to preserve some aspect of visual experience as a distinct, redemptive act, independent of commodity culture; the call for an art practice that challenges the senses rather than merely indulging or obviating them. Arnheim's profound respect for the image, his desire to refine the terms of its presentation and reception, intends a space for art separate from the entangling webs of information highways and the estranged swell of realities only virtual. On this intention, I hope, we can all agree.

NOTES

For their helpful advice, constructive suggestions, and encouragement, I wish to sincerely thank Dudley Andrew, Huey Copeland, Angela Dalle Vacche, Gerard Dapena, Martin Jay, Anton Kaes, and John Tain. Thanks also to Wendy Wipprecht for her support and her keen editing eye.

1. Stanley Cavell, *The World Viewed: Reflections on the Ontology of Film* (New York: Viking, 1971), 103.

2. Arnheim's *Film als Kunst* was first translated into English in 1933 under the title *Film*, and reproduced only his original *Film als Kunst* essay. Subsequent editions by both the University of California Press (Berkeley, 1957) and Faber and Faber (London, 1958) included four of Arnheim's related essays on film from the 1930s. All references to *Film as Art* in the present essay refer to the group of 1930s essays as an ensemble, since they manifest a common line of thought and consequently have been published as such. All page citations are from the University of California Press edition of 1957.

3. J. Dudley Andrew, *The Major Film Theories: An Introduction* (Oxford: Oxford University Press, 1976), 11. The historian Mitchell Ash writes, "New in the 1920s . . . was the emergence of a sophisticated discussion of the film medium as such and its problematic embodiment of cultural modernity. To that process Arnheim made an original contribution." See Mitchell G. Ash, *Gestalt Psychology in German Culture, 1890–1967: Holism and the Quest for Objectivity* (Cambridge: Cambridge University Press, 1995), 299.

4. See Guido Aristarco, "Destroyed Cathedrals," in *Rudolf Arnheim: Revealing Vision*, ed. Kent Kleinman and Leslie Van Duzer (Ann Arbor: University of Michigan Press, 1997), 32. For a brief description of some earlier formulations of film art by Vachel Lindsay, Louis Delluc, and others, see Andrew, *The Major Film Theories*, 11–13. See also, David Bordwell, *Film Art: An Introduction* (New York: McGraw-Hill, 1997) and *French Impressionist Cinema: Film Culture, Film Theory, Film Style* (New York: Arno, 1980); Richard Abel, *French Film Theory and Criticism: A History/Anthology, 1907–39* (Princeton: Princeton University Press, 1988).

5. Brenda Benthien has recently translated the collection of Arnheim's early film essays,

originally published in 1977 as *Kritiken und Aufsätze zum Film*. See Rudolf Arnheim, *Film Essays and Criticism* (Madison: University of Wisconsin Press, 1997).

6. Between 1928 and 1938 Arnheim wrote numerous shorter, theoretical pieces which appeared in various publications in Germany and Italy. These shorter pieces, on topics ranging from "Sound Film Confusion" (1929) to "Who Is the Author of a Film?" (1935), treat isolated themes, and thus serve as essential supplements in considering Arnheim's cinematic writings. See Arnheim, *Film Essays and Criticism*, part 1, "Film Theory." Hereafter when I refer generally to Arnheim's film theory, I shall mean his collected writings on film, not merely *Film as Art*.

7. Anton Kaes, Martin Jay, and Edward Dimendberg, eds., *The Weimar Republic Sourcebook* (Berkeley: University of California Press, 1994), 143.

8. Kent Kleinman and Leslie Van Duzer, introduction to *Rudolf Arnheim: Revealing Vision*, 1–5. In addition to several essays and interviews with Arnheim, the book contains a brief chronology of his life and work. For writings on cinema and culture by various Weimar contemporaries, as well as a synopsis of different artistic circles and media, see Kaes, Jay, and Dimendberg, *The Weimar Republic Sourcebook*. See also the special issue entitled, "Distractions: A Dossier on Weimar Culture," *Qui Parle* 5, no. 2 (Spring–Summer 1992).

9. Kaes, Jay, and Dimendberg, *The Weimar Republic Sourcebook*, 619. See also Martin Jay, *Permanent Exiles: Essays on Intellectual Migration from Germany to America* (New York: Columbia University Press, 1985).

10. For a brief discussion of the *Cinema* group, see Sam Rohdie, *Antonioni* (London: British Film Institute, 1990), chapter 1.

11. Although Arnheim's work after the 1930s has concentrated on the psychology of art, his initial theorizations of the cinema still resonate in his approach. A span of almost twenty years intervenes between Arnheim's first work on the cinema and the ensuing study of art and perception that has largely occupied him since. Nevertheless, he has written a few interesting pieces on film since arriving in the United States. Arnheim himself acknowledges the resonance of his film theory in his later work, noting as an example his arguments about motion in *Art and Visual Perception* (Berkeley: University of California Press, 1954).

12. William Graebner, *The Age of Doubt: American Thought and Culture in the 1940s* (Boston: Twayne, 1991), 86. Arnheim has held various professorships in the United States, among them appointments at Sarah Lawrence College (faculty of psychology, 1943–1968); the New School for Social Research (lecturer and visiting professor, 1943–1968); Columbia University (visiting professor, 1967–1968); Harvard University (professor of the psychology of art, 1968–1974); and the University of Michigan (visiting professor, 1974–1984).

13. Ibid.

14. Arnheim, introduction to *Art and Visual Perception*, 6; Arnheim, "In Favor of Confrontation," in *To the Rescue of Art: Twenty-Six Essays* (Berkeley: University of California Press, 1992), 6.

15. Arnheim, "A New Laocoön: Artistic Composites and the Talking Film," in *Film as Art*, 230.

16. Arnheim, "What Is Gestalt Psychology?" in *To the Rescue of Art*, 205.

17. On Arnheim's status as a "champion of Enlightenment principles," see David Pariser, "Arnheim as Gadfly for the Postmodern," in Kleinman and Van Duzer, eds., *Rudolf Arnheim: Revealing Vision*.

18. Arnheim, introduction to *To the Rescue of Art*, ix.

19. On the challenge against vision and "Ocularcentrism" in modern French scholarship and culture, see Martin Jay's comprehensive *Downcast Eyes: The Denigration of Vision in Twentieth-Century French Thought* (Berkeley: University of California Press, 1993). While Jay's volume specifically addresses the French context, the epistemologies that he traces are related (and often identical) to those that have opposed Arnheim's method. In addition, Jay briefly treats the problem of vision and purity in the context of American art criticism and theory; see especially 160–163.

20. The two comprehensive treatments of Arnheim's theory of film are Noël Carroll, *Philosophical Problems of Classical Film Theory* (Princeton: Princeton University Press, 1988); and Andrew, *The Major Film Theories*. Guido Aristarco's "Destroyed Cathedrals" offers a lively discussion of Arnheim's film theory and its contexts.

21. Maurice Merleau-Ponty, "Film and the New Psychology," in *Sense and Non-Sense* (Chicago: Northwestern University Press, 1964).

22. Barbara Stafford, *Good Looking: Essays on the Virtue of Images* (Cambridge, Mass.: MIT Press, 1996).

23. In the introduction to *Art and Visual Perception,* in fact, Arnheim apologizes "to the art historians for using their material less competently than might have been desirable" (7).

24. See the introduction to Ash, *Gestalt Psychology in German Culture.*

25. An example of gestaltist reasoning would be as follows: take a picture of a house and tear it into pieces; now paste it back together in a rough reassemblage. Because human beings perceive images as whole systems, rather than fragmented elements, a viewer of the montage automatically sutures the spaces between fragments, and understands the image as conveying "house," rather than a number of individual, autonomous pieces assembled in vague association.

Arnheim offers another example from the work "which gave gestalt theory its name," *Über Gestaltqualitäten* (1890), by Christian von Ehrenfels. Ehrenfels posited that if twelve individuals each listened to one of twelve notes in a melody, their composite experience would not equal that of listening to the entire melody (see Arnheim, *Art and Visual Perception,* 5; and David J. Murray, *Gestalt Psychology and the Cognitive Revolution* [New York: Harvester Wheatsheaf, 1995], 16, 25–26). Jacques Aumont offers a simple demonstration of how a "form can change its size, its place, even some of its constituent elements, without being altered as a form," namely, in transforming the filament of a sinuous line into a series of dots. See Aumont, *The Image* (London: British Film Institute, 1997), 46.

26. In line with this mode of thought, for example, Arnheim argues that a natural human tendency to perceive an internal center in objects or images is informed by neurological factors, just as centering in physical phenomena is influenced by gravitational factors. See Arnheim, "The Center Surviving Mondrian," *Journal of Aesthetics and Art Criticism* 44, no. 3 (Spring 1986): 292–293.

On the relations between gestalt theory and modern physics, see especially Max Wertheimer's *Productive Thinking,* ed. Michael Wertheimer (New York: Harper and Row, 1959). The same basic "formulation of whole-qualities," Wertheimer argues, applies equally to vision, mathematics, and modern physics—"allowing for varying behavior in the smallest parts" (139–140). See also Wolfgang Köhler, *Gestalt Psychology: An Introduction to New Concepts in Modern Psychology* (New York: Liveright, 1947), 98–99. On gestalt psychology's affinities for scientific methodology, even in the realm of aesthetics, see Ash, *Gestalt Psychology in German Culture,* passim.

27. For a discussion of principles of gestalt theory by some of its founding theorists, see Köhler, *Gestalt Psychology;* and Kurt Koffka, *Principles of Gestalt Psychology* (New York: Harcourt, Brace, 1935). Another important early source is George W. Hartman's *Gestalt Psychology: A Survey of Facts and Principles* (New York: Ronald, 1935).

The definitive treatment of the subject, which meticulously contextualizes the gestalt movement, its origins and development, is Mitchell G. Ash's *Gestalt Psychology in German Culture.* Another recent, important collection of work on gestalt comes from the proceedings of a conference in Florence, Italy, in 1989: Stefano Poggi, ed., *Gestalt Psychology: Its Origins, Foundations, and Influence* (Florence, Italy: Florence Center for the History and Philosophy of Science, 1989). Jacques Aumont offers a succinct and lucid sketch of gestalt principles of perception and its disputants in *The Image,* 45–50.

Needless to say, Arnheim has written extensively on gestalt psychology vis-à-vis vision and art. See his "Max Wertheimer and Gestalt Psychology," in *New Essays on the Psychology of Art* (Berkeley: University of California Press, 1986); "The Gestalt Theory of Expression," in *Toward a Psychology of Art* (Berkeley: University of California Press, 1966); and "What Is Gestalt Psychology?" and "The Two Faces of Gestalt Psychology," in *To the Rescue of Art;* see also the introduction to *Art and Visual Perception.*

28. Murray, *Gestalt Psychology and the Cognitive Revolution,* 1.

29. See Arnheim, "Max Wertheimer and Gestalt Psychology," 34.

30. Arnheim, "What Is Gestalt Psychology?" in *To the Rescue of Art,* 203.

31. Arnheim, introduction to *Film as Art,* 3.

32. Ash, *Gestalt Psychology in German Culture,* 2, 4.

33. See Murray, *Gestalt Psychology and the Cognitive Revolution*, 13.

34. The paraphrasing of Kant's *Critique of Judgment* is by Stephan Körner, *Kant* (London: Penguin, 1964), 187.

35. Frances Ferguson, "Legislating the Sublime," in *Studies in 18th Century British Art and Aesthetics*, ed. Ralph Cohen (Berkeley: University of California Press, 1985), 145.

36. Arnheim himself has countered the received notion of gestalt theory as limited to Wertheimer's original maxim: "Actually, something much more complex takes place. The structure of the whole, certainly of dominant importance, is influenced by the parts, which in turn depend on the whole as to their shapes and interrelations" ("What Is Gestalt Psychology?" in *To the Rescue of Art*, 203). Mitchell Ash writes, "Max Wertheimer, Wolfgang Köhler, and Kurt Koffka did not claim that the whole is *more* than the sum of its parts. Rather, they maintained, there are experienced objects and relationships that are *fundamentally different* from collections of sensations, parts, or pieces, or 'and-sums,' as Wertheimer called them" (Ash, *Gestalt Psychology in German Culture*, 1).

To cite Wertheimer himself, a pronouncement from 1922 summarizes some of his main theses:

> The given is itself in varying degrees "structured" [*gestalten*], it consists of more or less definitely structural wholes and whole-processes with their whole-properties and laws, characteristic whole-tendencies and whole-determinations of parts. "Pieces" almost always appear "as parts" in whole processes. (Cited in Murray, *Gestalt Psychology and the Cognitive Revolution*, 31.)

37. Gestalt theory first reached America in the mid-1920s with the translations of Koffka's and Köhler's works, and interest in gestalt theory took root at Harvard (Sokal, "Gestalt Psychology in America in the 1920s and 1930s," 94–95). For a reproduction of Rubin's experiment, see Hartman, *Gestalt Psychology: A Survey of Facts and Principles*, 23–30.

38. See Arnheim, "What Is Gestalt Psychology?" in *To the Rescue of Art*, 201; and Ash, *Gestalt Psychology in German Culture*, 224.

39. It could be argued, I think, that Arnheim's belief in isomorphism is derived in part from Kant's equation of aesthetic and moral essences. The dangers of this kind of thinking are, I believe, self-evident. Some of gestalt's sympathies with essentialism have led to results both specious and disturbing in their near phrenological bent. In one such instance, Arnheim mentions the experiments of expression measured in the "Szondi test": "If an integral feature of the test consists in establishing the reactions of people to the personalities of homosexuals, sadistic murderers, etc., two questions arise: (a) Is there a sufficient correlation between these pathological manifestations and certain clear-cut personality structures? (b) Are the latter suitably expressed in the photographs?" Cited in "Gestalt Theory of Expression" (1949) in *Toward a Psychology of Art*, 57 n. 1.

40. "Art Among the Objects," in *To the Rescue of Art*, 12. On the "special relationship" between image and meaning in Arnheim's theory, see Barbara Moore, "Mind and Body, Percept and Concept: Towards a Perfect Harmony," *Salmagundi*, nos. 78–79 (Spring–Summer 1988): 70–82. This special issue was called "Visual Thinking: On Rudolf Arnheim."

41. On the relevance of gestalt psychology to the very essence of film, the philosopher Maurice Merleau-Ponty writes, "This psychology shares with contemporary philosophies the common feature of presenting consciousness as thrown into the world. . . . [T]he philosopher and the movie-maker share a certain way of being. . . . It offers us yet another chance to confirm that modes of thought correspond to technical methods" ("Film and the New Psychology," 58–59). As Martin Jay points out, Merleau-Ponty derived much of his earlier theoretical arsenal from gestalt psychology in defending vision against the prevalent "anti-locularcentrism" of his contemporaries. See *Downcast Eyes*, 299–301. In her discussion of Merleau-Ponty's film theory, Vivian Sobchack also notes the linking of technology and modes of thought in Heidegger's "The Question Concerning Technology." See Sobchack, *The Address of the Eye: A Phenomenology of the Film Experience* (Princeton: Princeton University Press, 1992), 165 n. 1.

42. "Language is fine for describing diachronic/sequential events/logic, but cannot account for the integrative/holistic experience of 'field processes,' namely the synchronic experience of works of art, and more specifically, visual perception." (See Arnheim's "The Double Edged Mind," in *New Essays on the Psychology of Art*, 21). On the same subject, Rosalind Krauss writes

of the "staccato break-up of the spatial medium which is that of speech," in *The Optical Unconscious* (Cambridge, Mass.: MIT Press, 1993), 218. Krauss's writings form part of the poststructuralist and Lacanian methodology that has challenged the ocularcentric epistemology of which Arnheim's work is emblematic. Poststructuralist and psychoanalytic methods have emphasized the importance of both verbal language and the unconscious in articulating aesthetic experience.

43. Stafford, *Good Looking: Essays on the Virtue of Images*, 4, 11.

44. On the relationship of Arnheim's psychology of perception to psychoanalysis, see Stefano Ferari, "Freud and Arnheim: Psychoanalysis and the Visual Arts," *Salmagundi*, nos. 78–79 (Spring–Summer 1988): 83–97. In his article "Accident and Necessity of Art," Arnheim writes: "Accident is a shrewd helper, and the unconscious is a powerful one. Art has always profited from both—but only as assistants" (*Toward a Psychology of Art*, 178).

45. Krauss, *The Optical Unconscious*, 218. Emphasis in original.

46. Rosalind Krauss and Yve-Alain Bois have been two of the most prominent contemporary art historians to engage with gestalt theory, notable for its opposition to their account of modernist practice. See Krauss's *The Optical Unconscious*, especially chapters five and six; Bois and Krauss also discuss the antithesis of gestalt theory to the *informe* (formless) in art. See Yve-Alain Bois and Rosalind Krauss, *Formless: A User's Guide* (New York: Zone, 1997), especially the entries "Entropy," "Gestalt," "Horizontality," and "Water Closet."

47. Krauss, *The Optical Unconscious*, 218.

48. Gombrich, *Art and Illusion*, 262.

49. Arnheim, *Art and Visual Perception*, 250–251.

50. See Rudolf Arnheim, *The Power of the Center: A Study of Composition in the Visual Arts* (Berkeley: University of California Press, 1982), and "The Center Surviving Mondrian," 292–293.

51. Anton Ehrenzweig, *The Psycho-analysis of Artistic Vision and Hearing* (London: Routledge, 1999), xii. In her essay on Jackson Pollock, Rosalind Krauss summarizes Ehrenzweig's distinctions between "surface" perception and "depth" perception—and its implications for how gestalt theory accounts for visual confusion. See *The Optical Unconscious*, 303–307.

52. Arnheim, *Film as Art*, 49.

53. Arnheim, "Accident and Necessity of Art" (1957), in *Toward a Psychology of Art*, 170. Here Arnheim's logic follows the gestalt "law of continuity": "when a form is incomplete, there is a 'natural' tendency to see it as complete" (Aumont, *The Image*, 48). The quotations surrounding 'natural,' are, I assume, Aumont's.

54. Hugo Münsterberg, *The Film: A Psychological Study* (New York: Dover, 1970). See also Andrew's chapter on Münsterberg in *The Major Film Theories*, as well as Noël Carroll's essay, "Film/Mind Analogies: The Case of Hugo Münsterberg," *Journal of Aesthetics and Art Criticism* 66, no. 4 (Summer 1988): 489–499. I have not found any in-depth reference to Arnheim's knowledge of Münsterberg's theories, though by 1932 he must have been familiar with Münsterberg's work.

55. See Dudley Andrew, "Cognitivism: Quests and Questionings," *Iris: A Journal of Theory on Image and Sound*, no. 9 (Spring 1989): 9 n. 3. This essay is the introduction to the special issue on "Cinema and Cognitive Psychology."

56. Arnheim, *Art and Visual Perception*, 46.

57. Arnheim, "The Reach of Reality," in *To the Rescue of Art*, 33. Emphasis in original.

58. See Michael Fried, "Art and Objecthood" (1967), in *Art and Objecthood: Essays and Reviews* (Chicago: University of Chicago Press, 1998), 170 n. 15. Fried writes, "In a discussion . . . with Stanley Cavell it emerged that [Cavell] once remarked in a seminar that for Kant in the *Critique of Judgment* a work of art is not an object."

59. Arnheim, "The Double-Edged Mind," in *New Essays on the Psychology of Art*, 17.

60. Arnheim discusses the definition of *Prägnanz* in "The Two Faces of Gestalt Theory," in *To the Rescue of Art*, 213. George W. Hartman also discusses the term in various places in his *Gestalt Psychology* (see especially page 48). For a thorough definition and contextualization of the concept, see Ash, *Gestalt Psychology in German Culture*, passim.

61. Arnheim has repeatedly insisted that equilibrium and stasis are not the sole objectives of gestalt principles, and that *Prägnanz* occurs only when there is a counteracting "structural theme." See especially "The Two Faces of Gestalt Psychology," in *To the Rescue of Art*; "Order and Complexity in Landscape Design," in *To the Rescue of Art*; and, more recently,

"The Completeness of Physical and Artistic Form," *British Journal of Aesthetics* 32, no. 2 (April 1994): 109–114.

62. Rudolf Arnheim, *Entropy and Art: An Essay on Disorder and Order* (Berkeley: University of California Press, 1971), 11–12.

63. Ibid., 30–33. As Arnheim notes, Gombrich had already performed a similar experiment (albeit for different purposes) using Bonnencontre's painting, *The Three Graces*. See E. H. Gombrich, "Psychoanalysis and the History of Art," *Journal of Psycho-analysis* 35 (1954): 1–11. Arnheim cites in particular Robert Smithson's 1966 article, "Entropy and the New Monuments" (reprinted in *Robert Smithson: The Collected Writings* [Berkeley: University of California Press, 1996]) and its assertion that recent sculpture has "provided a visible analogue for the Second Law of Thermodynamics." Arnheim writes, "Surely the popular use of the notion of entropy has changed. If during the last century it served to diagnose, explain, and deplore the degradation of culture, it now provides a positive rationale for 'minimal' art and the pleasures of chaos" (*Entropy and Art*, 11–12).

64. Rudolf Arnheim, *The Genesis of a Painting: Picasso's Guernica* (Berkeley: University of California Press, 1962).

65. Ibid., 26–27.

66. Arnheim concurs with Malraux, Pudovkin, and Eisenstein that montage is essential to film's status as an art (see Andrew, *The Major Film Theories*, 156), but he places a number of conditions upon its successful deployment. See, for example, his discussion of montage in Russian film in *Film as Art*, 87–102. Although he largely avoids the subject, Arnheim describes cubism as "the spectacle of alienated units *conforming to a bold new unity,*" evidently claiming a governing gestalt for (at least some instances of) the cubist aesthetic. See "For Your Eyes Only," in *To the Rescue of Art*, 72 (emphasis mine). I have not encountered any mention of futurism in his writing, although his assertion that painting and sculpture are "static arts" and "cannot show . . . temporal unfolding" adumbrates at least a partial verdict (see *Film as Art*, 161–162). This last point is contradicted by his later remark (in *The Genesis of a Painting*) that *Guernica* evinces a temporal "current."

67. Ibid., 19.

68. Walter Benjamin, "The Work of Art in the Age of Mechanical Reproduction," in *Illuminations*, ed. Hannah Arendt (New York: Schocken, 1968), 247 n. 11. Incidentally, Benjamin briefly cites Arnheim's *Film als Kunst* in this essay. See also Anton Kaes, "Modernity and Its Discontents: Notes on Alterity in Weimar Cinema," *Qui Parle* 5, no. 2 (Spring–Summer 1992): 135–142. Not surprisingly, Benjamin and Arnheim diverge on a host of points, particularly the nature of perception, which Benjamin sees as historically determined; in addition, Benjamin's affinity for the (individual, unreconstructed) fragment flies in the face of Arnheim's gestaltist imperative. (On Benjamin's "insistence on the significance of the fragment and . . . mistrust of systems," see David Frisby, *Fragments of Modernity: Theories of Modernity in the Work of Simmel, Kracauer and Benjamin* [Cambridge, Mass.: MIT Press, 1986], especially 211–220.)

69. Arnheim, *Film as Art*, 101. Needless to say, the subject of montage touches most profoundly upon Arnheim's gestaltist sensibilities: "Since montage separates things that are spatially continuous and joins together things that have no inherent space-time continuity, the danger arises that the process may not be successful and that the whole may disintegrate into pieces" (ibid., 92).

70. Cited in Joseph and Barbara Anderson, "Motion Perception in Motion Pictures," in *The Cinematic Apparatus*, ed. Teresa de Lauretis and Stephen Heath (London: Macmillan, 1980), 82.

71. Arnheim, *Film as Art*, 99. Emphasis mine.

72. Arnheim, "Painting and Film," in *Film Essays and Criticism*, 86. Although Arnheim states in this essay that "it would certainly be wrong merely to try to trace the creation of the filmic image back to the static," his writing largely does just that—it attempts to reconcile film's distended temporality with (or even subsume it under) the fixity of (spatial) imagery.

73. Arnheim, *The Genesis of a Painting*, 21.

74. Aumont, *The Image*, 47.

75. Sol Worth, *Studying Visual Communication*, ed. Larry Gross (Philadelphia: University of Pennsylvania Press, 1981), 166.

76. See Carroll, *Philosophical Problems of Classical Film Theory*, 46.

77. Hans Jonas, review of *Visual Thinking*, in *Journal of Aesthetic and Art Criticism*, no. 30

(1971): 111–117, 116. See also Arnheim, *Visual Thinking* (Berkeley: University of California Press, 1969).

78. Arnheim, review of *The Rhetoric of the Frame: Essays on the Boundaries of the Artwork*, ed. Paul Duro (Cambridge: Cambridge University Press, 1996), in the *British Journal of Aesthetics* 39, no. 1 (January 1999): 86–88.

79. Arnheim writes in his introduction to *To the Rescue of Art* that his project seeks to "revive and explore the principles on which all productive functioning of the arts is based" as "an effective means to rescuing the arts from their present predicament." The predicament to which he refers is the ignoring of the "common core of sensory expression in all its manifestations" in favor of "social determinants and esoteric theory" (ix).

80. In his book *Theory of the Avant-Garde*, Peter Bürger writes of Kant's *Critique of Judgment*, "'The delight which determines the judgment of taste is independent of all interest,' where interest is defined by 'reference to the faculty of desire.'" The same disavowal of desire informs Arnheim's assessments—not of taste, but of the etiology and teleology of artistic practice. See Peter Bürger, *Theory of the Avant-Garde,* trans. Michael Shaw (Minneapolis: University of Minnesota Press, 1984), 42.

81. Fried, "Art and Objecthood," 171 n. 20.

82. Arnheim, "A New Laocoön: Artistic Composites and the Talking Film," in *Film as Art*, 201–202.

83. Clement Greenberg, "Towards a Newer Laocoön," *Partisan Review* 4, vol. 7 (July–August 1940), reprinted in *Pollock and After: The Critical Debate*, ed. Francis Frascina (New York: Harper and Row, 1985), 41–42.

84. Ibid., 42.

85. Originally published as "Nuovo Laocoonte" in the Italian journal *Bianco e Nero* (Rome), no. 8 (31 August 1938). The inflection of Greenberg's "Newer Laocoön," seems intentionally to emphasize a departure from Arnheim's "New Laocoön," although I have not been able to find any reference to this nuanced distinction.

86. Arnheim, "A New Laocoön," in *Film as Art*, 216.

87. Clement Greenberg, "Modernist Painting," *Art and Literature* 4 (Spring 1965): 194; partially reprinted in Charles Harrison and Paul Wood, eds., *Art in Theory, 1900–1990* (Oxford: Blackwell, 1992). Harrison and Wood write, "More than any other text in English, this essay has come to typify the Modernist critical position on the visual arts" (754).

88. Krauss, *The Optical Unconscious*, 217. Guido Aristarco points out the important fact that the Italian author/critic Massimo Bontempelli preceded Arnheim in his support of a film art unvitiated by sound or color, as well as in his call for a limited medium (see Aristarco's "Destroyed Cathedrals," 31). Notwithstanding Bontempelli's assertions, Arnheim's tract proffered the first lengthy, detailed inventory of how such limitations may be maintained.

89. Arnheim, "After Fifty Years," preface to *Film as Art*.

90. Arnheim, *Film as Art*, 2. Arnheim also comments, "The basic requirement of every art is that it cover and reveal the non-sensory contents of its subject using the sensorially ascertainable material particular to it" ("Silent Beauty and Noisy Nonsense" [1929], in *Film Essays and Criticism*, 148).

Compare Arnheim's *Materialtheorie* to Kracauer's *Materialgerechtheit* (Kracauer, *Theory of Film: The Redemption of Physical Reality* [Princeton: Princeton University Press, 1997]). Both theorists maintain that the medium must provide the point of departure in aesthetics, yet Kracauer privileges subject matter and content in film above all else. See Arnheim's "Melancholy Unshaped," in *Toward a Psychology of Art*, 183.

91. In considering Arnheim's film theory, it is essential to keep in mind that it is based, with very few exceptions, on silent, black-and-white film. Arnheim lists the elements of film art as the following: (1) reduction of depth; (2) black-and-white film; (3) combination of three-dimensional image projected on a flat surface; (4) use of the frame as an organizing principle; (5) interruption of a linear space-time continuum through montage; (6) exclusion of senses other than sight. These formal elements form the subject of extensive enumeration in *Film as Art*. For a more complete recapitulation and discussion, see Andrew, *The Major Film Theories*.

92. Arnheim, "Art Today and Film" (1965), in *Film Essays and Criticism*, 26. See also *Film as Art*, 158–159. Such a position forms, of course, one of the cruxes of Arnheim's opposition to realist film theory.

93. See *Film as Art*, 60. Arnheim gives the example of hands placed too close to the camera, making them disproportionately large, and charged with potentially symbolic meaning. Clement Greenberg's essay "Modernist Painting" (1960) maintains a similar critique of illusionism, and points out modernism's deliberate incursion of limitations:

> Realistic, illusionist art had dissembled the medium, using art to conceal art. Modernism used art to call attention to art. The limitations that constitute the medium of painting—the flat surface, the shape of the supports, the properties of pigment—were treated by the Old Masters as negative factors that could be acknowledged only implicitly or indirectly. Modernist painting has come to regard these same limitations as positive factors that are to be acknowledged openly.

See Harrison and Wood, eds., *Art in Theory*, 755–756.

94. Arnheim, *Film as Art*, 38–39. Such awry, point-of-view shots originating in photography, Arnheim argues, not only engender much of film's artistry, but have in turn influenced modern painting. See "Painting and Film" (1934), in *Film Essays and Criticism*, 88.

95. Arnheim, *Film as Art*, 61–62.

96. Despite their generally opposed views—or perhaps because of them—Arnheim and Panofsky agree that film must take the unadulterated objects of the world as its building blocks. Panofsky rejects *Caligari* on grounds similar to Arnheim, namely, that "prestylized" reality "dodges the problem" of making art. See Panofsky, "Style and Medium in the Motion Pictures" (1934), in *Film: An Anthology*, ed. Daniel Talbot (Berkeley: University of California Press, 1966), 31–32; and Arnheim's "Dr. Caligari Redivivus" (1925) and "Expressionist Film" (1934), in *Film Essays and Criticism*. It must be noted, however, that Arnheim credits expressionist film with the impetus for much of film's subsequent creative impulses and attention to form, in spite of its artificial stylizations and "mannerism" (Arnheim names Fritz Lang in particular).

97. Arnheim, *Film as Art*.

98. F. T. Marinetti et al., "The Futurist Cinema" (1916), reprinted in R.W. Flint, ed., *Marinetti: Selected Writings* (New York: Farrar, Straus, and Giroux, 1972), 131.

99. Arnheim, "A New Laocoön," 229.

100. Arnheim, *Film as Art*, 227.

101. Ibid., 203. Arnheim still views the sound film as a "mongrel" medium, and as recently as 1995 declared that "the chatter of words still proves to be a misuse of a means of expression befitting the theater, the radio play, and poetry" (Rudolf Arnheim, introduction to *Film Essays and Criticism*, 5).

102. "What it wishes particularly to emphasize in an audible occurrence is transposed into something visual; and thus instead of giving the occurrence 'itself,' it gives only some of its telling characteristics, and thereby shapes and interprets it" (*Film as Art*, 109). See also Arnheim's original review of *The Docks of New York*, from *Die Weltbühne*, 1929, *Film Essays and Criticism*, 147–148. He offers as another example the rippling rings of water substituted for the actual suicide that they signify.

103. Such a position resonates with the notion of "making strange" (*ostranenie*) elaborated by Russian formalists like Viktor Schlovski. Victor Erlich writes, "Rather than translating the unfamiliar into the terms of the familiar, the poetic image 'makes strange' the habitual by presenting it in a novel light, by placing it in an unexpected context." Victor Erlich, *Russian Formalism: History, Doctrine* (London: Mouton, 1965), 176.

104. Erlich treats Jakobson's theory in *Russian Formalism*, passim. See especially page 181 on the "function of poetry" in Jakobson's "Co je poesie?" (1933). Jakobson writes, "The function of poetry is to point out that the sign is not identical with its referent. Why do we need this reminder? . . . This antinomy is essential, since without it the connection between the sign and the *object becomes automatized and the perception of reality withers away*." Emphasis mine.

105. Arnheim, "A New Laocoön," 213. See also his "On the Nature of Photography," in *New Essays on the Psychology of Art*.

106. *Film as Art*, 57.

107. Ibid., 68.

108. Ibid., 67.

109. Arnheim, "Remarks on Color Film" (1935), in *Film Essays and Criticism*.

110. Kracauer, *Theory of Film*, 19; Bazin, "Theatre and Cinema," in *What Is Cinema?* 1:105. In his piece "Painting and Cinema," Bazin further discusses this concept: "The outer edges of

the screen are not, as the technical jargon would seem to imply, the frame of the film image. They are the edges of a piece of masking that shows only a portion of reality. . . . What the screen shows us seems to be part of something prolonged indefinitely into the universe" (*What Is Cinema?* 1:166).

111. Bazin, "Painting and Cinema," 166.

112. Arnheim, "Art Today and Film," 26. Some film theorists, such as Jean Mitry, have attempted to reconcile these opposed notions of the frame. See Brian Lewis, *Jean Mitry and the Aesthetics of Cinema* (Ann Arbor: UMI Research Press, 1984). Lewis discusses some of Mitry's debts to, and quibbles with Arnheim, 12–24. J. Dudley Andrew (*The Major Film Theories*, 185–211, passim) notes Mitry's attempts to reconcile some of Arnheim's tenets with those of other theorists, such as André Bazin.

113. Arnheim, *Film as Art*, 74. Arnheim subsequently develops a more extensive theory of the frame in "Limits and Frames," a chapter of *The Power of the Center*.

114. Arnheim, "Art Today and Film," in *Film Essays and Criticism*, 26.

115. "People who did not understand anything of the art of film used to cite silence as one of its most serious drawbacks. These people regard the introduction of sound as an improvement or completion of silent film. This opinion is just as senseless as if the invention of three-dimensional oil painting were hailed as an advance on the hitherto known principles of painting" (*Film as Art*, 106).

116. Arnheim, "Art Today and Film," in *Film Essays and Criticism*, 25. Compare Michael Fried's lament in his essay "Art and Objecthood" (164) that "the arts are in the process of crumbling . . . and that the arts themselves are sliding towards some kind of final, implosive, highly desirable [not for Fried, of course] synthesis." One important difference to point out is that Arnheim depreciates color field painting, whereas Fried is one of its most vocal supporters.

117. Arnheim, "Art and Film Today," 24.

118. It is in his insistence upon the medium as the ultimate maker of meaning, I think, that Arnheim has most strongly influenced subsequent film and art historians alike. As J. Dudley Andrew has noted, a huge number of formalist film theories "are the offspring (desired or not) of Arnheim's *Film as Art*" (Andrew, *The Major Film Theories*, 77). It should be noted, in a different vein, that Michael Fried himself argues in "Art and Objecthood" (164) that film does not constitute a modernist art.

119. The term is John C. Welchman's, from "In and Around the 'Second Frame,'" in Duro, ed., *The Rhetoric of the Frame*, 203.

120. Ibid., 301 n. 2.

121. Clement Greenberg, "After Abstract Expressionism," *Art International* 6 (25 October 1962). Cited in Fried, "Art and Objecthood," 168–169 n. 6 (emphasis in original). For more recent discussions on the reception of Fried's polemical essay, see Hal Foster, ed., *Discussions in Contemporary Culture* (New York: Dia Art Foundation, 1987), particularly part 2, "1967/1987: Genealogies of Art and Theory."

122. Fried, "Art and Objecthood," 169. To be sure, despite his provisional affinities with Greenberg's stance, Fried has carved out his own—often oppositional—theoretical model, arguing specifically with "[Greenberg's] notion that modernism in the arts involved a process of *reduction* according to which dispensable conventions were progressively discarded until in the end one arrived at a kind of timeless, irreducible core (in painting, flatness and the delimitation of flatness)." See Michael Fried, "Theories of Art after Minimalism and Pop," in Foster, *Discussions in Contemporary Culture*, 56–57. On the primacy of vision in Greenberg's work, and its subsequent critique in American art theory, see Jay, *Downcast Eyes*, 160–162.

123. To be sure, Arnheim has not consciously aligned his propositions with any nominatively "modernist" ones; indeed, as recently as 1999, he has stated, "This negative condition of value by subtraction was by no means new, either in the arts or indeed in the sciences. It was the time-honored principle of parsimony, which prescribed that a valid statement shall contain nothing but the necessary." See "Composites of Media: The History of an Idea," *Michigan Quarterly Review* 38, no. 4 (Fall 1999): 558–563.

124. Carroll, *Philosophical Problems of Classical Film Theory*, 82.

125. Arnheim, "After Fifty Years," preface to *Film as Art*.

126. Georges Bataille, *Visions of Excess: Selected Writings, 1927–1939*, trans. Allan Stoekl (Minneapolis: University of Minnesota Press, 1985), 31. Translated from the original "Dictionnaire Critique," *Documents* (Paris: Gallimard, 1968), 178.

127. Cited in Miriam Bratu Hansen, introduction to Siegfried Kracauer, *Theory of Film*, vii.

128. First published in *Journal of Aesthetics and Art Criticism* 3 (Spring 1963); reprinted in *Toward a Psychology of Art*.

129. The description of Pollock's style between 1947 and 1950 as "allover" was first coined by Michael Fried in his essay, "Three American Painters: Noland, Olitski, Stella" (1965), in *Art and Objecthood*, 213–269.

Krauss discusses Arnheim's denunciations of Pollock, situating Pollock's automatism and "resistance of the superego of form" vis-à-vis Arnheim's *Gestalten*. Krauss also discusses Anton Ehrenzweig's criticisms of Pollock's work, which derive from, although ultimately diverge from, Arnheim's. See *The Optical Unconscious*, especially 303–307.

130. See Arnheim's "Accident and Necessity of Art," in *Toward a Psychology of Art*, 162–180.

131. Obviously I cannot enter into a lengthy discussion of Kracauer's text here. For some synopses and clarifications, see Andrew, *The Major Film Theories*; and Miriam Bratu Hansen, introduction to Siegfried Kracauer, *Theory of Film*.

132. Kracauer, *Theory of Film*, 69. Martin Jay remarks that "wholeness" and "final meanings" were antithetical to Kracauer's project—a fundamental difference with Arnheim's gestaltist approach. See Jay, *Permanent Exiles*, 153. For treatments of the content and context of Kracauer's theory of film, see ibid., chapters 11, 12, and 13; and Gertrud Koch, *Siegfried Kracauer: An Introduction* (Princeton: Princeton University Press, 2000).

133. Kracauer, *Theory of Film*, 39.

134. Ibid., 40. In a footnote justifying this point, Kracauer invokes a statement by the art historian Arnold Hauser: "The film is the only art that takes over considerable pieces of reality unaltered; it interprets them, of course, but the interpretation remains a photographic one."

135. Cavell, *The World Viewed*, 23. Emphasis in original.

136. As Yve-Alain Bois notes, Dubuffet's relationship to the rubric of *informe* is a fraught one, as Dubuffet has traditionally been categorized as a painter of the (quite different) *art informel* movement. (See Krauss and Bois, *Formless: A User's Guide*, 138–143.) Bois writes that Dubuffet's affinities for the figure and for the recuperation of waste material largely exclude him from a nominative association with the *informe*. My point here is not to contest Dubuffet's or his colleagues' art-historical categorization; I wish to point out Arnheim's conflations of Dubuffet's and Kracauer's film theory. For Arnheim, Dubuffet's work exhibits the same relinquishment of meaningful shaping that informs Kracauer's theory of film.

137. Krauss, *The Optical Unconscious*, 157.

138. Arnheim, *The Genesis of a Painting*, 10.

139. Arnheim, "Melancholy Unshaped," in *Toward a Psychology of Art*, 190.

140. Rosalind Krauss's recent essay, *'A Voyage on the North Sea': Art in the Age of the Post-Medium Condition* (New York: Thames and Hudson, 1999), adumbrates this very association (albeit in a general sense) suggested by Cavell's term "automatism." "The word 'automatism,'" she writes, "captured for [Cavell] the sense in which part of the film—the part that depends upon the camera—is automatic; it is also plugged into the Surrealist use of 'automatism' as an unconscious reflex" (5).

141. Miriam Hansen's account of Kracauer's theory makes an unlikely association of his methods with the *informe* and with surrealism seem, in my opinion, quite convincing: "Kracauer participates in an alternative position that locates the film experience in psychic regions closer to those explored by Freud in *Beyond the Pleasure Principle* (1920), particularly through concepts of shock, primary masochism, and the death drive" (*Theory of Film*, xxi). Hansen also mentions Kracauer's "cinema's decentering mode of reception ('distraction')," as well as his link to Benjamin's metaphor of an "optical unconscious" (xi, xxix). Kracauer writes, "Any huge close-up reveals new and unsuspected formations of matter; skin textures are reminiscent of aerial photographs, eyes turn into lakes or volcanic craters. Such images blow up our environment in a double sense: they enlarge it literally; and in doing so, they blast the prison of conventional reality, opening up expanses which we have explored at best in dreams before" (xxix).

The relationships between Kracauer's theorization of film as the proper medium for a "disintegrating world" (xi) and those propositions of the *informe* in the plastic arts, as laid out by Krauss and Bois, merit further attention. See especially Krauss, *The Optical Unconscious*, and "Horizontality" in Bois and Krauss, *Formless: A User's Guide*.

142. Kracauer, *Theory of Film*, 54, under the heading "The Refuse."

143. See Ian Aitken, *European Film Theory and Cinema: A Critical Introduction* (Edinburgh: Edinburgh University Press, 2001), 174, 177.

144. Kracauer, *Theory of Film*, 56.

145. Ibid., 71; Arnheim, *The Genesis of a Painting*, 27.

146. Stanley Cavell writes, "The ontological conditions of the motion picture reveal it as inherently pornographic (though not inveterately so)." See *The World Viewed*, 45.

147. Arnheim, "Melancholy Unshaped," 185.

148. Arnheim, "Form and the Consumer," in *Towards a Psychology of Art*, 9. In *Film as Art*, Arnheim also roundly condemns "Form for form's sake" as "the rock on which many film artists, especially the French, are shipwrecked" (41).

149. Arnheim, "The End of St. Petersburg, Plus Peripheral Comments and Side-glances" (1928), in *Film Essays and Criticism*, 132–33; "Art Today and Film" (1965), in *Film Essays and Criticism*, 26. See also "What Became of Abstraction?" in *To the Rescue of Art*.

150. Arnheim, *Film as Art*, 40, 50.

151. "Melancholy Unshaped," 189. I would note that Antonioni's film style, perhaps more than any other modernist director of sound film, (ironically) fulfills Arnheim's exigencies that film "tells its story to the eyes—even when sound is used." See Arnheim, "Epic and Dramatic Film" (1934), in *Film Essays and Criticism*, 78.

152. Arnheim writes, "We cling as closely as possible to what is directly presented to the eyes, on the assumption that in a successful painting the essential meaning is directly expressed in the properties of the visual form" ("Picasso's 'Nightfishing at Antibes,'" in *Toward a Psychology of Art*, 258). As Noël Carroll points out in his discussion of Arnheim's film theory, the quiddidity of artistic expression for Arnheim is the convergence of marks and traces into *Gestalten*. Carroll challenges Arnheim's opposition to formlessness on the grounds that an art object may be amorphous without necessarily *projecting* (the idea of) amorphousness. See *Philosophical Problems of Classical Film Theory*, 60–61.

153. Arnheim, foreword to *Film as Art* (London: Faber and Faber, 1969), 5–6.

154. Paul De Man, *Blindness and Insight: Essays in the Rhetoric of Contemporary Criticism*, cited in Terrence Des Pres, *Writing into the World: Essays: 1973–1987* (New York: Viking, 1991), 11.

155. Arnheim, "From Chaos to Wholeness," in *The Split and the Structure*, 158, 160.

156. See Kaes, Jay, Dimendberg, *The Weimar Republic Sourcebook*, 617–619.

157. Arnheim seeks here to rectify "the pathological disturbance in the relationship between man and perceptual reality that has recently beclouded Western civilization" ("Art History and the Partial God" [1962], in *Toward a Psychology of Art*, 159–160).

In her essay "Grids," Rosalind Krauss outlines some of the ruptures between nineteenth- and twentieth-century aesthetics, particularly as they accrued around the modernist assertion of the grid. Krauss writes, "The grid's mythic power is that it makes us able to think we are dealing with materialism (or sometimes science, or logic) while at the same time it provides us with a release into belief (or illusion, or fiction)" (12). The desire to reconcile rationalist science with spiritualism (which were emphatically teased apart by the symbolists, as Krauss notes) in many ways encapsulates Arnheim's use of gestalt psychology in reading film and art. He wants to battle this "inheritance" of the nineteenth century in twentieth-century modernism (Krauss) by having the frame of art and film serve simultaneously as the surface of aesthetics and the space/ microcosm of science. See Rosalind Krauss, *The Originality of the Avant-Garde and Other Modernist Myths* (Cambridge, Mass.: MIT Press, 1997). In contrast to Arnheim's belief, Jonathan Crary argues that art and science were in fact inextricably linked in nineteenth-century culture. See Jonathan Crary, *Techniques of the Observer: On Vision and Modernity in the Nineteenth Century* (Cambridge, Mass.: MIT Press, 1990).

158. On *Erlebniskunst* in Romantic aesthetics, see Joseph Leo Koerner, *Caspar David Friedrich and the Subject of Landscape* (New Haven: Yale University Press, 1990), especially 13.

159. Arnheim, "The Double-Edged Mind," in *New Essays on the Psychology of Art*, 16.

160. See Aumont's excellent discussion of gestalt in *The Image*, 45–50.

161. The term is John Welchman's. See his "In and Around the 'Second Frame.'"

162. On the politics of Greenberg's writings, especially his relationship to Marxist criticism, see T. J. Clark, "Clement Greenberg's Theory of Art," in *Pollock and After: The Critical Debate*.

163. See Clement Greenberg, "Avant-Garde and Kitsch," reprinted in *Pollock and After.*

164. T. J. Clark writes, "The very way that modernist art has insisted on its medium has been by negating that medium's ordinary consistency—by pulling it apart, emptying it, producing gaps and silences, making it stand as the opposite of sense or continuity. . . . Modernism would have its medium be *absence* of some sort—absence of finish or coherence, indeterminacy, a ground which is called on to swallow up distinctions" ("Clement Greenberg's Theory of Art," 58).

165. Arnheim, *The Power of the Center*; Ash, *Gestalt Psychology in German Culture*, 304. Arnheim recently remarked that his early film writing reflects the "bellicosity" of the late Weimar Republic (see his introduction to *Film Essays and Criticism*, 6); but I would say his aggression seems geared more toward carving out a middle ground amid the extremes of politics than an expressly ideological confrontation. Nevertheless, Arnheim evidently engaged in protests against increasing censorship, even speaking out at demonstrations as late as 1932. Ash notes Arnheim's quixotic belief that film evinces positive political effects not through its content, but through its success as a formal expression. Arnheim in no way equates avant-garde aesthetics with progressive politics. See Ash, *Gestalt Psychology in German Culture*, 303–304.

166. Arnheim, "A Personal Note" (1957), introduction to *Film as Art*, 7.

167. See Ash, *Gestalt Psychology in German Culture*; and Graebner, *The Age of Doubt*, especially chapter 4, "The Culture of the Whole."

168. Arnheim, "Melancholy Unshaped," 186.

169. Welchman, "In and Around the 'Second Frame,'" 216.

170. Arnheim, introduction to *Art and Visual Perception*, 7–8. Arnheim does not name the artist, only that he or she was "a young instructor at Dartmouth College."

171. For a brief discussion of the latest forms of installation art, and their relation to high modernist (particularly Friedian) criticism, see Robert Storr's recent *New York Times* article, "No Stage, No Actors, But It's Theatre (and Art)," 28 November 1999. On the maturation of installation art, see Julie H. Reiss, *From Margin to Center: The Spaces of Installation Art* (Cambridge, Mass.: MIT Press, 1999). For Kabakov's theorizations of his own practice, see Ilya Kabakov, *Uber die "totale" Installation (On the "total" installation)* (Ostfildern: Cantz, 1995).

172. Arnheim, "The Reach of Reality," in *To the Rescue of Art*, 33.

173. Arnheim, *Film as Art*, 159.

174. Ibid., 75.

175. Storr, "No Stage, No Actors."

176. For an excellent discussion of the collapse of high modernist criticism, and the problem of establishing criteria for evaluating contemporary art, see Benjamin D. Buchloh, "Periodizing Critics," in Hal Foster, ed., *Discussions in Contemporary Culture*, 65–70. See also, Krauss, "A Voyage on the North Sea."

The Exploding Image

Sergei Eisenstein

El Greco

Speaking for myself, out of all of El Greco's works, there is only one I dislike.

This is—*The Expulsion of the Moneylenders from the Temple.*

Moreover, I am always irritated by the fact that, even in the most slender and pitiful monographs devoted to the artist, it is namely this picture that almost invariably figures among the reproductions of his most popular pictures.

Why does this picture irritate me so much?

This picture exists in four variants.[1]

The earliest variant is now in the collection of Sir Francis Cook; another variant very close to it is in Minneapolis. The most famous and most often reproduced is in the National Gallery in London. And a variant almost identical to it is in the Frick Collection.

And, finally, a very late variant is in the church of San Gínes in Madrid.

But this picture irritates me because, even in its most popular third variant, it on the whole continues to retain all the features characteristic of the *preecstatic* period of El Greco's painting.

In the very last variant, the work is somewhat mollified by what has become more unusual for the "remarkable" El Greco, the stretching of the figure of Christ upward.

But this is not all.

Because, even in the general composition, the picture is distinguished here from the other variants only because in the distance are painted quite "independent" columns stretching upward, a niche with a sepulchre and an antique, and—for some reason naked—figure with calf muscles so exuberantly presented that they seem to be slipping off the figure like pantaloons!

This group of characters seemed to have been automatically transported from another variant and, like a bas-relief, put in front of this background.[2]

And, insofar as this group is concerned, in the structure of the whole, in the inner composition, in the arrangement of the tiny groups and characters composing it, in the color (and for some reason they especially love to reproduce it in color!), in the general rhythm and dynamics (especially lacking!), this picture is totally conventional, traditional, quite in the manner of El Greco's contemporaries, out of whose milieu in other of his works he burst with such an inimitable

From *Non-Indifferent Nature: Film and the Structure of Things.* Translated by Herbert Marshall. Cambridge and New York: Cambridge University Press, 1987: 112–122. © 1987 by Cambridge University Press. Reprinted with the permission of Cambridge University Press.

explosion into the century ahead (*The Laocoön*, or *The Taking of the Fifth Seal*, or in pure painting—*The Concert of Angels in the Clouds*).[3]

Of course, even comparing the first variant of *The Expulsion* with the last, it is possible within the composition—in the treatment of the movement of the figures and even more in the painting technique itself—to trace the principle of "ecstasy" quite clearly.

Let us just compare the figure of the boy covering himself with his left hand, to the left of the figure of Christ.

Enriqueta Harris[4] considers one of the figures of Michelangelo's *Last Judgment* as its prototype. And in the comparison of this figure of Michelangelo, of its interpretation in the first variant of *The Expulsion* (from Cook's collection) and its last variant in the Church of San Gínes, it is quite clear how the expression of a separate figure changes, from Renaissance "cosmicness" through everyday drama to "ecstasy," on a canvas belonging to the "extravagant" style of the late El Greco.

But this is by no means a caprice of the artist, but a very precise reflection on the techniques and forms of his painting of that profound inner process of reconceiving the essence of the same scene, which he paints at different periods of his life.

On the early canvas, this scene is nothing more for El Greco than a painted embodiment of an everyday episode from the life of Christ.

In the last variant of the theme, El Greco completely departs from the everyday, narrative principles.

Here the scene becomes wholly symbolic, pushing into the foreground its inner significance of allegory and parable.

The National Gallery variant seems to serve as a connecting link between the two.

Here Enriqueta Harris very convincingly remarks:

> Before the Reformation, *The Purification of the Temple* was normally treated as one of a series of scenes from the Life, or from the Passion, of Christ. After the Reformation, however, the story acquired a new importance. Protestants compared it with their own reforming activities; and to the Catholics of the Counter-Reformation it symbolized the purging of the Church of heresy. El Greco's interest in the subject, and his interpretation of it, are certainly connected with these ecclesiastical controversies. In his earliest version he is mainly intent on telling the story as set out in the Gospel. In the National Gallery picture, however, he is more preoccupied with its symbolical meaning. The two reliefs in the background are the Old Testament prototypes of Sin and Redemption; and the two groups on either side of Christ are clearly divided into the unredeemed, placed beneath the *Expulsion of Adam and Eve,* and the redeemed, placed beneath the *Sacrifice of Isaac.* Finally, in the last version of S. Gínes, the interest in the narrative is almost entirely subjugated to its symbolical interpretation. The emphasis on the atmosphere of the Temple, the unearthly figure of Christ sweeping through the crowd, and the divine appari-

tion driving back the sinners with one hand and pointing to heaven with the other, combine to give the scene the quality of a mystic vision—a vision that evokes the fanatical spirit of the Counter-Reformation in the adopted country of El Greco.[5]

However, in spite of this, as I have already shown above, this inner leap from a narrative interpretation into a figurative interpretation (a familiar phenomenon!) in the given case is expressed only in an inner "reconstruction" of the elements of the picture. The picture as a whole does not undergo genuine "ecstasy," a genuine "explosion" in this process. To the very end El Greco remains in the captivity of general compositional "fetters," extending from the first variant that, both as a whole and in its details, is still completely subject to Renaissance conceptions.

And even an excursion into the history of the inner dynamics of *The Expulsion*, through its four variants, is insufficient to capture the power of the ecstatic explosion of the other works of El Greco. Even they cannot "reconcile" me to the picture, which is incapable of giving that strength of direct ecstatic experience that makes the other canvases of this man so remarkable, in whom the concepts of the East and West—the traditions of the Greek and the fanaticism of the Spaniard—experience such a striking unity.

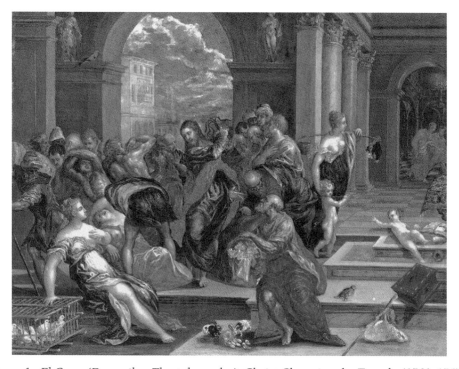

Figure 1. El Greco (Domenikos Theotokopoulos), Christ Cleansing the Temple *(1560–1565)*. National Gallery of Art, Washington. Samuel H. Kress Collection. Photograph © 2001 Board of Trustees, National Gallery of Art, Washington.

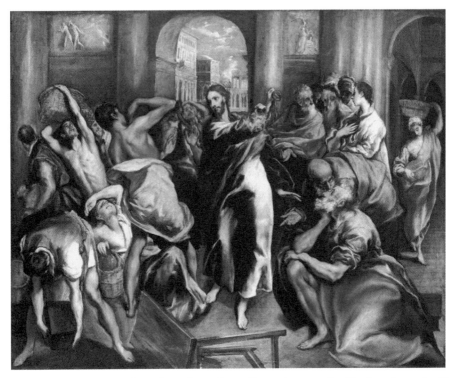

Figure 2. El Greco (Domenikos Theotokopoulos), Christ Driving the Traders from the Temple *(c. 1570)*. National Gallery, London.

And involuntarily, looking at the most popular middle variant of *The Expulsion* in the National Gallery, you begin to mentally estimate how one would "ecstaticize" it in the unique spirit and manner of El Greco.

Let us fantasize here in that direction!

It would follow that, out of the boring horizontal rectangular format of the picture, balanced and impersonal in its proportions (41.5 × 50.5 inches), you would make a rectangle that clearly flies vertically upward.

The miserable arch, carried off into the distance and squeezed by the mass of walls, after having exploded and been hurled forward, would have necessarily seized the entire canvas of the picture as a whole by its edge . . .

In the same way the setting of the boring material surroundings of the confined room would scatter into the immaterial heavenly and cloudy space of the exterior.

The figure of Christ angrily (not too angrily) threatening certainly could not remain on the same level as the other characters in this scene.

The figure would have to hang over them, like an arrow winding into the darkening clouds of the parting background.

The figure to the left of Christ, hardly expressing amazement through foreshortening—with his right elbow lifted up in defense from a blow—taken from the back, would undoubtedly become a figure turned over completely on his back,

his legs up, resting on the ground with his shoulders, neck, and shoulder blade, and under the best conditions having bent one of his legs in the burst of amazement that overturned him.

The old man on the right, not very expressive, phlegmatic, having propped up his cheek, looking at what is occurring almost right next to him, would, of course, begin to expand to the height of the powerful figure of the youth. Forced to look, not at what is occurring on the same level with him and on the same plane, this figure would be hurled daringly forward into the strongly emphasized foreground that almost bursts out of the picture.

And that youth would begin to look at what is happening above and behind him, of course—by bending backward!

Finally—"the masses" from the group of regularly placed mannequins would inevitably have to burst into a chaos of torsos, knees, elbows, forearms, and thighs, spread along the canvas of the picture and interwoven with each other.

And, as if expressing the idea of an ecstatic explosion to the extreme, a rapture of the "bond of time" upward and downward, two figures would burst from the center of the picture: one—the hero—head upward toward the sky, and the other—the figure of the opponent—also vertical, but "mirror image" toward the earth, downward.

In addition, the figures would undoubtedly burst out of their clothes.

And the very theme, of course, would burst beyond the limits of the narrow everyday subject of *The Expulsion of the Moneylenders from the Temple*—despite the whole mysterious figurative and symbolic significance of this biblical tale—into something from the cycle of clearly wonder-working events from the pages of the biblical biography of the central character of the scene.

Something, well, let us say, like . . . *The Resurrection from the Grave* . . .

Stop!

Indeed, just what we sketched in this "desirable" picture is actually reflected in the immortal *Resurrection from the Grave* painted between 1597 and 1604 in the most complete ecstatic manner of El Greco!

At the feet of the *naked* Christ,

in a cloak *being torn*

and *flying*

into the sky's abstract, *swirling*, cloudy expanse

—a *human jumble* of human bodies—shins, shoulders, chests, heads thrown back, and arms uplifted.

Out of this group two figures burst into the center of attention, into the foreground.

Into the foreground—*extremely stretched out, with glance thrown backward*, the *young man's* figure on the right.

And into the center of attention—amazed, completely *turned upside down* on his shoulders, *feet up*—the second—as if turned over "mirror image" in his stunned fall, in contrast to the amazing flight to heaven of the figure of Christ.

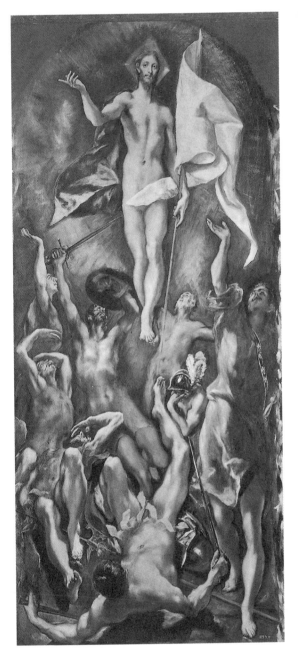

Figure 3. El Greco (Domenikos Theotokopoulos), Resurrection of Christ (1605–1610). Museo del Prado, Madrid, Spain. © Scala/Art Resource, NY.

Christ, not with a pitiful lash, but with the unfurled triumphant banner in his hands!

Isn't it so?!

How was such a "trick" possible of juxtaposing two apparently randomly chosen pictures from the gallery of works of the great Spanish-Greek master of the past?

Two pictures, of which the second actually seemed like an explosion, into which the first burst along the line of all its basic features?

It turned out to be possible because each of these pictures—each in its own way—is truly a precise imprint of two different phases of the creative condition and development that relate to each other as an explosion and the static state preceding it.

These two phases, in the fate of the true artist, stand on either side of that moment when the dungeon of pitiful being is suddenly illuminated by the holy flame of a mission.

When yesterday's simple mortal burns with the creative flame of the preacher, seer, and prophet.

When on the path of every artist there occurs the same thing that happened to Pushkin's "Prophet," growing to the fullness of creative inspiration at his encounter with the "six-winged seraphim" who illuminated his consciousness with his unique creative mission:

And with a sword he clove my breast,
Plucked out my palpitating heart
And deep into my gaping chest
A coal of fire did he implant.
I, corpselike, in the desert lay
And then the voice of God heard say:
"Rise up, Prophet, hear and see,
This my will fulfill and fend
And crossing over land and sea
Burn with words the hearts of men.[6]

Such is this leap within the same creative personality from a state like that of a corpse "rising up" in order to "burn with words the hearts of men."

And such is the expression of this state through all the means and characteristics of the palette, of the course of the brush, of the composition, of the manner of painting, and above all, of conceptions transported from the sphere of balanced and trivial structures done in the manner of numerous contemporaries, into the inimitable area of unique, individual, unrepeatable ecstatic painting, in the transition of El Greco from the epoch of youth to the epoch of creative perfection.

And therefore the "miracle" of a similar dynamic juxtaposition of two different works of his, from different stages of his creativity, turns out to be quite possible.

Actually, the source of both is the same creative individuality represented in two phases of his creative being—"on either side" of the watershed of ecstatic explosion, "enrapturing" the author, carrying his unique spirit up in ecstasy, like the path from one world to the other made by the soul through the two halves of the memorial picture on Count Orgaz's fate beyond the grave!

———

Is a similar experiment possible on the creation and works of any other artists?

If they turn out to be artists communicating *pathos*, then certainly.

And not only are such examples possible, but there is one more we simply must bring in here.

As a necessary third link, it supplements the complete triad of examples from an area of creativity that we began with Frédérick Lemaître and El Greco.

And these three examples are arranged as models from various spheres of art, beginning with the most subjective variant of it to the most objective.

Actually, in terms of the expression of one's self, the most subjective art is the actor's craft, where creativity flows "in and of itself," where the creator is simultaneously the subject and object of creation, where he himself is the material and the architect.

We observed this situation in Frédérick Lemaître.

The second step in this direction is the semiobjective art of the painter.

Here, also reincarnated in various images, the individuality of the artist plays through them; now a self-portrait moves into the foreground—as invariably happens in literature; for example, Lord Byron—then almost hiding behind images of his work, which exist independently and objectively, as if reflecting only objectively existing reality. With them are connected the almost invisible threads of the individual features of the vivid characters expressed in their fullness—so it is in the literature of Gogol, where, from hints of certain features within the character, he engenders an immortal gallery of generalized types, so that in certain cases they seem to dissolve as a whole into objective pictures of the landscape. These landscapes seem to be totally free from the "visible," "concrete" subjectivity of the author, although in his best examples they are entirely woven from rebellious or appeasing rhythms of the state of the soul and character of the author.

Such was the second case analyzed—El Greco: the subjective, ecstatic dissolution of him in the apparently "objective" landscape—this is what makes his *Storm over Toledo* so striking and captivating.[7]

No less striking in this relation is Leonardo da Vinci.

The presence of his vivid self-portrait in his own works, which were apparently already quite abstract, is even more astonishing.

Emil Ludwig noted this very well:[8]

> Leonardo drew a stone-cutter, a crow-bar, a dredging machine—and though these were without landscape, sky, or people, their wood and iron, their stone, wire and plaster seem nothing less than living muscles, pulsing veins, and glowing flesh. The shadows play so musically along the cold and murderous edges of a cannon that no one who knows the madonnas of this master could fail to recognize the same hand here.

And if at this point we note that the Leonardo madonna is a type that permeates all his work, embracing both the *Mona Lisa* and *John the Baptist,* then we would not be surprised that here what reigns over the apparently totally abstract projects of practical objects is that same basic image standing before Leonardo's eyes, an image that through hundreds of variations, as though through hundreds

of mirrors, looks at Leonardo looking at us in them, and through their generally recognized "mystery" he wishes to express certain inner depths of himself.

Andrea del Sarto[9] proceeded in a cruder and simpler way: almost all his works—both *John the Baptist* and *The Madonna*—simply resemble him in face (compare them with his self-portrait).

And if Leonardo proceeds here in a more refined and elegant manner, carrying over into his work not his simple, "crude" appearance but the most complex flutter of inner conflicts of his own inner spiritual nature, passing with a strange smile through the images created by him, then we have no reason to speak of his works as being less of a self-portrait or self-expression.

This self-portrait quality does not impede the objectivity of his painted works, it does not remove the documentary aspect from his sketches of the turbulence of air waves and sea waves, it does not destroy the strictness of the technical invention of war machines, fortification constructions, the passion of his sculptured horses, or the projects of a system of sluice dams.

And the lyric melody of this subjective subtext is hardly less temperamental, less ecstatic than the boiling passion of El Greco thundering through *Storm over Toledo* . . .

And after what has been said, it will be easy to apply here directly a third example taken from a third area.

From an area where subjective experience has already been completely devoured by objective concreteness, through whose exterior depiction the artist's temperament and fantasy are quite unexpectedly and no less intensely aroused.

Architecture.

Having verified the norms of ecstatic construction discovered by us in examples from the first two areas, let us try to show how persuasive they are also in the area of architectural conception, fantasy, and imagery.

We could make this excursion on the principles of the Gothic that seem to explode the balance of the Romanesque style. And, within the Gothic itself, we could trace the stirring picture of movement of its lancet[10] world from the first almost indistinct steps toward the ardent models of the mature and postmature, "flamboyant" late Gothic.

We could, like Wölfflin, contrast the Renaissance and baroque[11] and interpret the excited spirit of the second, winding like a spiral, as an ecstatically bursting temperament of a new epoch, exploding preceding forms of art in the enthusiasms for a new quality, responding to a new social phase of a single historical process.

We could show this clearly in a very concrete example of what was done with the "cosmically balanced" project of the plan of St. Peter's Cathedral in Rome [created by a man of the Renaissance, Bramante[12] (1506)], by Michelangelo, in whom the temperament of a man of the baroque is exploding when this initial project finally falls to him forty years later for its final completion.[13]

But for clarity I would still prefer to trace this case as well—again within

the limits of one biography—by juxtaposing two works of two different stages of the creativity of the same artist—the builder completing his path by a leap from the architect and archeologist into the image of the artist—and the visionary.

Such is the case of Giovanni Battista Piranesi.[14]

If El Greco is known by every youngster in his aspect of an ecstatic mystic, then perhaps it would do no harm for Piranesi if we introduced several "corroborations" of this from "authoritative sources" before rushing into a direct observation of his etchings, although they cry out most eloquently of this themselves!

A. Benois's *History of Painting* has discussed this exhaustively:[15]

> History knows few artists in whom the excitement of creativity would appear with such strength, in whom there would be such *ardor* . . .
>
> . . . A remarkable ability to be at the same time both a *scholar* and a *poet* (no one will say where Piranesi the *archaeologist* ends and where the *artist* begins, where the *poet* passes over into the *scholar* and the *visionary*—into the strict *investigator*) . . .
>
> . . . Myopic minds reproached Piranesi for the fact that in proceeding from his archaeological studies, he was not able to restrain his fantasies. However, one may ask what is essentially more valuable: those grains of so-called knowledge, which a true archaeologist may discover in his investigations, or that new fairytale world which arose in Piranesi's imagination as the result of his *ecstasy* before the power and beauty of Roman architecture?[16]

Even in this short, descriptive discussion, even in these traditional turns of speech, which are always at the service of art critics and historians of art ("where the *archaeologist* ends and where the *artist* begins, where the *poet* passes over into the *scholar* and the *visionary*—into the . . . *investigator*"), even in them we can perceive what we already know as the basis of the characteristic quality of ecstasy, of the ecstatic personality!

Here what is taken, not as a series of rhetorical phrases but as a biographical fact, gives us another broad example of a leap within the biography itself.

We already saw Zola passing from a "novelist" into a "teacher of life"; we know that same evolution from the satirist to the utopianist in the biography of Gogol; we know Leonardo da Vinci, transported from an artist to a scholar. We also know this latter from Goethe's biography, where the jump from poetry into the sphere of pure philosophy (even if it be the second part of *Faust*) is even more striking . . .

However, in his biography Piranesi gives us transitions of a reverse leap instead: from archeologist to artist, from scholar to poet, from investigator to visionary.

Thus at least inner discovery moves through the sequence of a series of etchings, through the etchings themselves, and, finally, through visibly changing editions of the same series in intervals through a period of fifteen to twenty years.

Let us recall something analogous in the regeneration of the pictorial treatment of one and the same theme in El Greco.

NOTES

1. *This picture exists in four variants.* Actually, there are seven canvases of *The Expulsion of the Moneylenders from the Temple* attributed to El Greco and several copies from his studio. It may be that he had in mind the four with the greatest variations from each other. *Trans.*

2. This method of "transporting" an entire compositional group into a new combination with other elements is encountered quite often in El Greco. Just recall the two variants of *Prayer over a Chalice*, where the second—horizontal—is "made" from the first—the vertical—by transporting, without any changes, the entire group of sleeping apostles from the lower part of the first variant into the lateral part of the second.

3. *Laocoön*, the painting by El Greco, created in 1606–1610 (preserved in the National Gallery, Washington); *The Lifting of the Fifth Seal; The Concert of Angels in the Clouds*, detail (upper part) of the El Greco painting *The Annunciation* (1593, Bilbao Museum, Spain). *Trans.*

4. See *El Greco, The Purification of the Temple*, Gallery Book n. 2, London.

5. Op. cit., 11–12.

6. [Herbert Marshall's translation]

7. . . . makes such an astonishing and exciting *Storm over Toledo.* In a section of *Nonindifferent Nature*, Eisenstein analyzes in detail the principle of the "pathetication" of landscape in the painting *Storm over Toledo. Trans.*

8. *Genius and Character*, trans. K. Burke (London: Jonathan Cape; New York: Harcourt, Brace, 1927), 176.

9. Andrea *del Sarto* (1486–1531), Italian painter of the Renaissance, representative of the Florentine school. *Trans.*

10. Lancet arch: sharply pointed arch associated with the Gothic style. *Trans.*

11. . . . *contrast the Renaissance and Baroque.* Eisenstein has in mind the book by the German art critic Heinrich Wölfflin (1864–1945), *The Renaissance and the Baroque. Trans.*

12. Donato *Bramante* (1444–1514), Italian architect of the Renaissance, designer of the Milan cathedral and others. In 1504 he began to work on a project for St. Peter's Cathedral, Rome. *Trans.*

13. After Bramante, the project passes to Raphael. Raphael dies in 1521. The project is continued by Peruzzi and Antonio da Sangallo the Elder. Sangallo dies in 1546 and the next year the work passes to Buonarotti.

14. Giovanni Battista *Piranesi* (1720–1778), Italian engraver and architect. Author of an enormous quantity of engravings, the themes of which are ancient and modern (for Piranesi) Rome and grandiose architectural fantasies. See G. B. Piranesi, *Carceri* (Zurich: Origo Verlag, 1958). In the next chapter Eisenstein analyzes two engravings of Piranesi from his cycle *Fantasy on the Theme of Dungeons* (1745–1750 and 1761). *Trans.*

15. Alexandre Nikolayevich *Benois* (1870–1960), Russian artist, theater designer, art historian, head of the World of Art Group (Mir Iskusstva), Petersburg. Eisenstein quotes from his *History of Painting of All Times and Peoples. Trans.*

16. Issue 16: 486. In the quote I allowed myself to categorically choose those passages that have particularly direct relation to what is relevant to us.

Pietro Montani

The Uncrossable Threshold: The Relation of Painting and Cinema in Eisenstein

In the theoretical work of Eisenstein the concept of cinema as "the contemporary phase of painting" is often illustrated and discussed. Contained within this theory is an idea of the progress or development of the arts. I would like to try to clarify the criteria and true significance of this idea. But first it seems appropriate to linger for a moment on an assumption held within this theory, one that is typical of Eisenstein's thinking and that seems important to me, even though modern film culture—it is difficult to say to what extent Eisenstein's cinema now belongs to it—has largely obliterated it. In speaking of cinema as a "contemporary phase of painting," Eisenstein stresses the fact that cinema inherits certain problems from painting that in general concern what we call "visual representation," rather than emphasizing the specificity—however it may be understood—of the new technological instrument. There is, therefore, in the first place, a substantial *continuity* between painting and cinema: both, for Eisenstein, belong within a *problematic tradition of representation* and have to do with a certain body of problems that have been handed down to the figurative arts over time. These problems are constant, but works of art—and often technical inventions as well—can present themselves as many *exemplifications* of their productivity. In order to begin to introduce Eisenstein's terminology we will say that works of art often assume the task of "putting in-image" the problems of representation; that is, using these problems in order to obtain effects of meaning. In other words, for Eisenstein the solution to the problems of representation does not take place on the theoretical level but coincides with the production of texts, of *discursive manifestations:* in this particular instance, with the production of figurative works of art.

This is an important and explanatory way to interpret what we call "art history." For Eisenstein, a history of art can be formed as a description of paths of this kind of problematic tradition of representation whose course would therefore be marked by the more or less well-chosen inventions with which the different

Translated by Cristina Degli-Esposti Reinert and Renée Tannenbaum. From *Fuori campo: Studi sul cinema e l'estetica.* Urbino: Quattro Venti, 1993: 45–59. Translated and reprinted by permission of the author.

figurative cultures have gradually articulated and exemplified "in-image" the essential questions of representation. The fact that among these inventions there are several that are immediately technical in character, such as cinema, is largely secondary. For Eisenstein an invention makes sense only when it makes the formulation of good answers to the old problems of representation possible, or when it can make us grasp the existence of a problem where we had not seen one before.

From this point of view cinema is a good invention, not because its material technique enables, for example, the representation of movement and temporality, but rather because the *problems* of movement and temporality, which have *always* been two of the great problems of representation, can be put "in-image" in cinema in a particularly rich and positive way. Furthermore, cinema invites an analytical approach toward the figurative tradition that allows new forms of exemplarity to appear. In other words: from cinema, the problematic tradition of representation can be reunderstood to advantage.

Countless examples of this way of looking at painting are found in Eisenstein's writings. Yet, at least in regard to the question of time and movement, he often states that he relies on an already well-established "iconological" literature. Nonetheless there is an indubitable originality in his analytical approach that consists, on the one hand, of the ability to determine general principles under which to subsume the heterogeneous phenomena of representation belonging to different eras and cultures, and on the other hand—and this seems to me most characteristic of Eisenstein—of making these principles always appear in the form of productive matrices, so to speak, in some way figurativized or, if you like, invested in discourse. In other words, Eisenstein does not seek out simple principles or models of composition. He looks for figures of discourse that are at the same time compositional. I will give only one example. In the great studies on montage written between 1937 and 1941, the analysis of an iconographic motif appears numerous times, and is variously used in order to introduce time and movement in pictorial representation; the motif in question is the figure of the *path* or *route* and its numerous transformations "in-image." There is a road in *The Meeting of St. Anthony and St. Paul* by Sassetta that enables the painter to serialize the figure of the saint who "approaches" the meeting place. There is a path in Ghirlandaio's *Adoration of the Shepherds* that makes it possible to join together two temporally distant events—the birth of the baby and the arrival of the Three Wise Men, for example. In these cases, says Eisenstein, the figure of the route operates on the material plane of representation. But it can move to the plane of composition and become a "path for the eye." This is the case in Watteau's *The Embarkation for Cythera,* in which the composition leads the eye to project a narrative temporality onto the representation. The compositive movement, in turn, can appeal to the conceptual as well as illusionist components. That is, it can be based not so much on seeing as on a *knowing* (and here Eisenstein anticipates a typical theory of Sir Ernst Gombrich). This is the case, too, in El Greco's *View of Toledo,* in which the Don Juan Tavera hospital occupies an irregular position whose motivation is

based on the arbitrary montage of a memorized route. Finally—and this is the most surprising transformation of the figure of the route—there is an entire chapter in *The Theory of Montage* (1937) in which, following studies of Auguste Choisy, Eisenstein shows how the placement of the buildings of the Acropolis in Athens was projected according to a predetermined path to be followed by the visitor's movable eye.

Let's be clear: in these analyses we will not find any true systematization. They remain rhapsodic examples of an investigative method that never takes the shape of a true and actual theory. Yet the benefit of Eisenstein's research style seems noteworthy to me, noteworthy precisely for the somehow "impure" character (always invested in the meaning) of the specific subject—the figure of representation—on which he prefers to practice his analytical approach. In the cases that we have just examined, in fact, the figure of the path or route is never thought of as a pure syntactical modifier, but is always based on a constitutive investment of meaning. I realize that this definition is in turn imprecise, or perhaps even misleading, but certainly the constitutive sense of the semanticity of the figure of representation pointed out by Eisenstein is a qualifying and explicit point of his general conception of art and aesthetics. There exists in Eisenstein the idea of an absolute precedence of the "semantic," and the "semantic" is considered something that you experience in essence discursively.

It is necessary at this point to devote a few words to Eisenstein's aesthetic in order to clarify the question that we have just touched on and also to return more precisely to our two initial theories. That is to say: (1) there is a substantial continuity between painting and cinema in that both refer to a problematic tradition of representation; and (2) cinema is "the contemporary phase of painting."

Thus far we have spoken about a "formalist" aspect of Eisenstein's analytical approach to painting. We are tracing certain consistencies that can explain dissimilar facts by means of a single productive principle in order to describe the numerous transformations by which a single constructive figure is set up on different materials. We have also "corrected" this formalism by observing that the problem of representation is considered by Eisenstein to be closely connected with the problem of meaning and discourse: to put a problem of representation "in-image" is always, also, to produce a discourse, in this case, a discourse of a painting, a drawing, a film. And to produce a discourse means to stay in a communicative relationship with a tradition, or with the need to interpret it, or with the desire to introduce innovation into it, within which the need to "say something" takes shape.

We will now say that such a link between form and meaning—a link that *always* qualifies Eisenstein's most reckless "formalistic" journeys—rests on a reflection of a philosophical nature which is most thoroughly clarified in the great aesthetic work entitled *Non-Indifferent Nature*. I will attempt now to summarize its essential points.

Eisenstein's starting point is an anthropological one. He takes note of a kind

of original syncretism of thought and operation, of action and reflection, that characterizes the behavior of man, his typical adaptive behavior. Now, this syncretism always arrives at representation in some way; for example, in the tools that man builds himself. However, more generally speaking, the interdependence between reflective thought and constructive activity can be grasped, according to Eisenstein, in a certain, likely limited, assortment of *figures* that are able to generate, through transformation, infinite applications or manifestations. These figures are therefore formal matrices, rules of production (for example, rules of the metaphorical creativity of language), but the part that more suitably qualifies them (which earlier I called "impure") is rather to be seen in their original rooting in a *defined* horizon of experience, in a determined territory of "meaningfulness" that in some way is always preserved in the applicative moment, be it only as a trace or vestige of a memory.

I will give only one example, recurring in Eisenstein and often employed in *Non-Indifferent Nature:* the ability to interweave plant fibers evenly in order to construct a container, such as a basket, that is visible, says Eisenstein, as a co-essential trait, along with other traits, so as to form a specifically human technology that already contains in itself a reflection related to the act of weaving. This in turn can give rise to an independent figure, to a generative matrix of innumerable shapes. They can be forms of narration, for example—as attested to by the metaphoric definitions with which certain modes and story structures are linguistically drawn: the weaving of the story, plot, intrigue, development, unravelling or dénouement, and so on—but, more generally, the plot is a figure that can act as a "mold" on the most varied semiotic figures and can recognize numerous changes without, however, ever completely dispersing the memory of its most original function and the traces of the meanings that connect it.

This way of understanding the anthropological presumptions of knowing and representing implies significant consequences on the level of an aesthetic theory, and allows, first of all, a very fertile definition of the general statute of art.

In two words: from the original syncretism of action and reflection on action, different specific behaviors can be defined. The one, which specializes the "doing," establishes the context of the actual technological application; the other, which specializes the reflection, establishes the universe of science and abstract thought. Finally, there is a third route, *the least specialized,* which consists of bringing to representation that very syncretism, its processes and figures, and this is the path of art. The task of art is to make us see literally "in action," that is, "placed in-image," the constitutively constructive attitude with which we experience things and the sense of things; to make us see "in action" the work of the figures of representation that form and organize an "image," that is, something sensed on the whole. Eisenstein's aesthetic, which I summarized and simplified on its philosophical-anthropological basis, has therefore strong *cognitive* characteristics. However—and this is an equally important point—also contained within this display of syncretism of reflection and construction, within this showing of

the generation of an image or a meaning, is the emotional and passionate moment of art—*pathos*—that always accompanies each true knowledge-construction. Now, Eisenstein wonders, in what way does the work of art come to exhibit and contain this component of pathos *too?* The answer to this question brings us to the place of the greatest originality of Eisenstein's aesthetic. It is the theory of the "ek-stasis" of representation. According to Eisenstein, the pathos of a work of art coincides with the experience of the representation "going outside of itself," with the experience of the representation projecting itself out of its own representational setup toward the image or the meaning, that is, toward something that is not representable. The essential fact, here, is that this "ecstatic" experience—which is an experience of the unrepresentable—must in some way be given shape by the work of art, which is to say, it must be able to use figures and devices of representability. In this way an aesthetic theory that hinges on the idea of the "unrepresentable"—to mean, beyond any mysticism, the *meaning* that supports any possible *discourse* and, at the same time, subtracts from any possible "direct take"—is transformed in Eisenstein into a true, at times extraordinarily penetrating, instrument of analysis. We will now look at four different examples showing the productivity of the general concept of the "ek-stasis" of representation in the analysis of painting and graphics. But, at this point, we can already specify the first of the two theories we started from, and we can say that one of the problems of representation that cinema inherits from painting is the problem of "ek-stasis" and of the construction of its figures—in other words, the problem of pathos that is tied to the experience of producing meaning.

We will define this first model of the ecstasy of representation as an *explosive* model. The "going outside of itself" is illustrated here as a diachronic relation between two states of a process such that the state of arrival is morphologically "deducible" from the state of departure. It is a matter of showing, in substance, that a certain work of art can be interpreted as the systematic transformation of a previous work and, in the case in point, as its "ecstatization." The example that Eisenstein offers is one of the most spectacular. Eisenstein starts with two works—an etching by Piranesi entitled *Carcer Oscura* and one of the numerous variations of *The Purification of the Temple* painted by El Greco, respectively—and submits them to an "experiment." Try to imagine what would happen if the elements of representation—starting from the format and moving little by little toward the inner compositional structures and fully figurative components—were made to "go outside themselves," as if a dynamic charge made them "explode." What we would obtain, in these two cases, would be a very different configuration "of arrival." However, it is not necessary to stretch the imagination too far, as this new configuration, deducible by "ecstatic transformation" from the configuration "of departure," can be observed in two works that truly exist, as if the two artists' creative process—in an unconscious but completely analyzable way—had acted effectively, conforming itself to the principle of "ek-stasis." The two works are an etching from

the Piranesi *Carceri* series, dated a few years after *Carcer Oscura,* and El Greco's *Resurrection,* housed at the Prado.

This model of the ecstasy of representation is the simplest because it is the most homogeneous: it is applied exclusively to the form that is observed from the point of view of an internal generative principle. It is possible to note that, unlike with Piranesi, in the case of El Greco the morphogenesis of *Resurrection* also presents a clear thematic or content-related motivation. The change of the state of Christ's body is fully interpreted by the aesthetic form of the composition; in the terminology of Eisenstein, it is fully "placed in-image."

The second model that we will now examine is more complex, because the form is no longer, in the strict sense, the point of arrival of the ecstatization process, or if you will, the sense of representation is not entirely saturated by the form. Quite the contrary—it is expelled out of the representation into a space occupied by the observer. It is, then, a fully "pragmatic" model that we will call a model of *expulsion of meaning.* What is trying to be explained with the ecstasy principle is not only the generation of a form, but also the generation of a determined interpretative behavior. Eisenstein shows us here how, in certain recognizable compositive conditions, the pictorial representation projects out of itself certain *directions* for the eye, and how, in the final analysis, the *meaning* of the representation itself—its "image"—can dwell only in such directions. The example chosen by Eisenstein is intentionally very simple: a portrait of the actress Ermolova painted by Valentin Serov in 1905 (figs. 1–4).

Eisenstein begins by asking himself what may be responsible for the meaning, the nearly sacred aura that surrounds the austere figure, the feeling of admiration that the observer experiences before the "inspired elevation," that he or she feels emanating from the protagonist of the portrait. And here is his response: the constructive principle to which is attributed this effect of meaning is a principle of composition, and specifically a phenomenon of *montage.* Serov, in fact, would have used intuitively, but with extreme skill, a procedure that cinema would eventually sanction: the portrait of Ermolova is in fact constructed as an actual montage of four "takes," in which not only the size of the image changes, but also—and this is the most important and unexpected point—the angle of the "shot" is changed.

Starting from the "whole" of the first "take" (shot "from above," since we see the floor on which the figure rests) to the "first level" of the last "take" (decidedly shot "from below"), the eye of the observer has been led to travel an arc of almost 180 degrees, a rotation from top to bottom. And here are Eisenstein's conclusions: the certain fixedness of the figure carries within itself the features of an inner temporality, of a succession, of a montage. But this contrast is not resolved—as happens often in painting—in an illusion of movement or in a dynamization of the figure. In fact, the representation is confirmed in a kind of disquieting immobility. Where, then, does the movement finish? The movement, answers Eisenstein,

Figure 1. Valentin Serov, Portrait of Maria N. Ermolova *(1905).* Tretyakov Gallery, Moscow, Russia.

Figure 2. Portrait of Maria N. Ermolova *(detail).*

has been *expelled out* of the representation, and specifically *into the eye* of the observer, thus making the duration of the contemplation correspond with an arc that, starting from above, leads him or her nearly "to the feet" of the figure, as if following the gesture of a bow. The meaning of the representation—its "image"—is in this way completely saturated by this nearly physical act. In "going outside of itself" the representation has installed and articulated a semantically defined space. It is in this space that, literally, the "elevation" of the represented figure takes place.

The third model of the ecstasy of representation is the most interesting because it introduces us directly into the territory that, for Eisenstein, makes it possible to place the problem of cinema in its proper light. We will call it the model of *expressive conversion* within representation. In this case we are dealing with showing how the ecstatic performance of representation can be fulfilled within the representation itself in the form of a conversion of expressive levels. The "going outside itself," in other words, intervenes on an *inner threshold* upon which, by virtue of an accumulation of expressive tension, the representation undergoes, so to speak, a change in semiotic state; it passes from one level of expression to another. It is already clear that such an internal conversion places us directly before cinema's power as well as alongside the difficulties of this medium, whose semiotic apparatus is defined by its very richness and the heterogeneity of the expressible levels that can be put into play.

The pictorial example chosen by Eisenstein is a large canvas by Vasily Surikov, *The Boyarina Morozova*, painted in 1887 (figs. 5–6). The painting pre-

Figure 3. Portrait of Maria N. Ermolova *(detail).* *Figure 4.* Portrait of Maria N. Ermolova *(detail).*

sents a clear diagonal that emphasizes its compositional setup and that is in its turn cut by two "dramatic" elements in strong opposition: the commanding gesture of the *bojarina* in the upper left and the powerless gesture of the old woman in the bottom right. Within this dramatic space, where all the tension of the represented scene accumulates (building in a crescendo that reaches its peak precisely at the point in which the diagonal is cut by the ordinate relative to one of the two golden sections able to be calculated on the axis formed by its base), the representation is made to "go outside itself" in the sense that its visual nature is converted into a different expressive level, figuratively "not representable," and yet powerfully suggested and nearly imposed. It is the *sound* level, the *voice* of the *bojarina*—not its representation, as it is not of the realm of the visual, but its "image." Therefore, the pictorial representation had to make something intervene that was figuratively not representable—the sound, the voice—in order to be able to continue to maintain its state of representation. It has "gone outside of itself" to remain with itself, but integrated with a new and heterogeneous element.

As is evident, cinema—or rather, cinematographic composition—can take advantage of such a principle of conversion with a breadth of means that painting cannot match. But the principle in itself is *not* specific to cinema, as it is not to painting. The difference, if there is one, is to be sought elsewhere. It lies precisely in the fact that cinema possesses directly representative access to that which painting can introduce only on the level of an image. In other words, something that in painting can function only on the level of a sense—in our case, sound—in cinema can function on a level of expression related to a more complex semantic integration. This is the idea that supports the different Eisensteinian definitions

Figure 5. Vasily Surikov, The Boyarina Morozova *(1887).* Tretyakov Gallery, Moscow, Russia. © Scala/Art Resource, NY.

Figure 6. The Boyarina Morozova *(detail).*

surrounding the concepts of "vertical montage," "organic unity of the work," "polyphony of expressive means," and so on. And this idea, naturally, is also the foundation of the theory according to which cinema would be "the contemporary phase of painting."

In this way Eisenstein's cinema declares, by way of the theory that qualifies it, its powerful calling of "pathos." A great device for liberating the emotion

that is tied to meaning, cinema is but a continuous escape of representation toward the unrepresentable that we can never reach but that is perpetually *marked* and perpetually *deferred* as the extreme threshold of the final conversion—the one which would bring the representation outside the actual dimension of the act of representing. But this impossible feat, that cinema, too, seems to bear as its destiny, ends up forging a path, in Eisenstein's cinema, through the only viable entry, and perhaps this too is fated: a reflection on representing itself. We will give only one conclusive example on this point drawn from Eisenstein's last film. But first we still have to take into account the fourth model of the ecstasy of representation that we find in the Eisensteinian analyses of the figurative arts. We will call this the *implosive* model, and it will be useful because it will bring us to our concluding example.

Until now we have observed the "ek-stasis" of representation as a principle, a constructive rule susceptible to infinite executions. In a central chapter of *Non-Indifferent Nature*, however, Eisenstein asks himself what would happen if this principle were to become the *content* of representation. Eisenstein's answer is that in this case the representation would no longer evoke pathos but it would be *comical*; it would be loaded with a particular comic effect, of the reflective type. The laughter and pleasure experienced by the observer would be joined with a deeper feeling of dizziness or bewilderment. Eisenstein illustrates this with a Saul Steinberg drawing (fig. 7).

The principle of the representation of pathos—the "going outside of itself" remaining in some way with itself—has become here its content, the object that is represented. The drawing sets us, the observer, in a defined space of its indecisiveness: it is a space from which it is not possible to leave *specifically because* it tells us and shows us that there is an exit. But in this paradoxical representation, a determination that we had not yet fully grasped is also revealed to us, in a comical way. That is, that the "ek-stasis," the "going outside of itself" remaining with itself, describes a constitutive device of *representation in general.* The representation merely refers us to "another," merely positions us "elsewhere," keeping us closed in its space from which we cannot leave.

Figure 7. Saul Steinberg, Exit *(n.d.).* © 2001 The Saul Steinberg Foundation/Artists' Rights Society (ARS), New York.

We said that a reflection on representation is something like a destiny inscribed in the way Eisenstein thinks about cinema and constructs his theory within it—that is, let's not forget, the way in which he thinks about continuity and innovation in the sphere of the problematic tradition of representation.

This kind of reflection is often found in Eisenstein's cinema, even though its procedure, nearly as a rule, is implicit (for example, Eisenstein never uses—the sole exception is his first "film,"[1] *Glumov's Diary*—the Vertovian process of "cinema in cinema" that he considered "primitive"). However, we will have to wait for this to be realized, all the more necessarily as the degree of integration and organic unity reached by the film increases. This happens, most completely, in the color episode of *Ivan the Terrible* (Part 2), where the "polyphonic" deployment of the expressive means of cinema also coincides—in the manner of a persistent resonance of "harmonics"—with a reflection on representing (on the power of representation and on the representation of power) that has an explicit, thematic, and narrativized statute. The succession of the episode, as we know, is from top to bottom, and on different planes, a succession of substitutions, disguises, changes in position, duplications. Eisenstein, who undoubtedly has Bakhtin in mind here, speaks of this as a "carnival that spreads into a total disguising." Total: that is undecidable, *without a way out*. Starting with Fëdor Basmanov, who opens the first color sequence dancing in a woman's mask and clothing, everything is represented at the same time, in a theatrical sense, and actually executed, authentic and simulated. The culminating point of this representation is the grotesque investiture of the young Vladimir Andreevich, who is dressed in the vestments of the czar, the signs of this power. The consecration of Vladimir, too, is a representation, a performance and also an actual fact because the signs of the czar *are* the czar. And in fact—the "performative" power of representation—Vladimir corresponds to such an extent to the person whom he represents (but who in reality is elsewhere) that shortly thereafter he will fall beneath the dagger of the assassin sent there to kill the czar. The signs of power represent the czar in him to such an extent that Vladimir lets himself be killed in the czar's stead.

Yet Eisenstein rightly sets the scene of the murder—a scene by now divested of ambiguity—*outside* the last sequence of the color episode, when the film has already reintroduced its spectator into the full flow of the narration, an event marked by the return to black and white; when, that is, but only *après coup*, the entire color episode can be interpreted in a univocally narrative way, like an awful carnival trap plotted by Ivan in order to eliminate the rival.[2]

It is very significant that Eisenstein wanted to mark this passage—the passage from color back to black and white, from the undecidability of the representation of power to the inevitable univocality of death—thematizing and figurativizing the notion of the "threshold" that thus far we have encountered only in his theoretical formulation; that is, as the place in which the representation must "go outside of itself" and transform into a new quality. This threshold we can now see according to two different forms: first as the material threshold, the

door that Vladimir is about to cross; then as a threshold *already* crossed by the moving camera, that is found, beyond that limit, in the area where the course of the narration will be restored, in the area, then, in which this same scene that we are *still* watching—this same scene in which we *still* take up the complementary space—will give rise to a new and different interpretation.

Clearly we are not far from a kind of tragic version of the theme that Steinberg's drawing resolves with the comical: both representations have analogous paradoxical structures. Steinberg's drawing sets us in a space from which we cannot leave, precisely because there is an exit marked. In Eisenstein's film, the threshold crossed by the camera tells us that *we are about* to leave the nightmare of the color episode but, at the same time, it tells us that *this same act of going out*, this "putting us outside," coincides perfectly with the act that *still* keeps us closed inside the space of the representation. To put it another way, we cannot leave the representation because the same going out, the "ek-stasis" that the representation always and constitutively requires, is something that is represented—and therefore also denied, or "representing," its very denial.

NOTES

1. I use quotation marks because we are dealing with a short film, projected in two stages during the theatrical production of *The Essay* (1925).

2. This interpretation must be rectified, at least in part. In reality, the entire final scene of the film is a scene in color that uses black and white (and a bluish color change) in order to represent several internal passages (the murder of Vladimir, the frightful recognition of the victim by his mother, her mournful lamentation at the presence of an impassive Ivan appearing, like a ghost, to reestablish the roles). This correction, however, confirms the conclusions of the analysis, and in fact reinforces them, as the "exit" (from the color scene), at the same time indicated and revoked, imposed and retraced, repeats, in this way, its paradoxical nature of undecidable limits. Furthermore, the color in the full sense returns in the final shot of the film, when the sinister apologia of power is pronounced by an Ivan progressively flooded in red. But he returns there according to an expressive, at least at one time univocal, regime. That red, in fact, must be read only as the color of blood.

The Thinking Image

André Bazin

Painting and Cinema

Films about paintings, at least those that use them to create something of which is cinematic, meet with an identical objection from painters and art critics alike. Of such are the short films of Emmer; *Van Gogh* by Alain Resnais, R. Hessens, and Gaston Diehl; Pierre Kast's *Goya;* and *Guernica* by Resnais and Hessens. Their objection, and I myself have heard it from the very lips of an Inspector General of Drawing of the Department of Education, is that however you look at it the film is not true to the painting. Its dramatic and logical unity establishes relationships that are chronologically false and otherwise fictitious, between paintings often widely separated both in time and spirit. In *Guerrieri* Emmer actually goes so far as to include the works of different painters, a form of cheating hardly less reprehensible than the use by Kast of fragments of Goya's *Caprices* to bolster the editing of his *Misfortunes of War.* The same is true of Resnais when he juggles with the periods of Picasso's development.

Even should the filmmaker wish to conform to the facts of art history, the instrument he uses would still be aesthetically at odds with them. As a filmmaker he fragments what is by essence a synthesis while himself working toward a new synthesis never envisioned by the painter.

One might confine oneself here simply to asking what the justification for this is, were not a more serious problem involved. Not only is the film a betrayal of the painter, it is also a betrayal of the painting and for this reason: the viewer, believing that he is seeing the picture as painted, is actually looking at it through the instrumentality of an art form that profoundly changes its nature. This was true from the first of black and white. But even color offers no solution. No one color is ever faithfully reproduced; still less, therefore, is any combination of colors. On the other hand, the sequence of a film gives it a unity in time that is horizontal and, so to speak, geographical, whereas time in a painting, so far as the notion applies, develops geologically and in depth. Finally and above all—to use a more subtle argument that is never employed although it is the most important of all—space, as it applies to a painting, is radically destroyed by the screen. Just as footlights and scenery in the theater serve to mark the contrast between it and the real world, so, by its surrounding frame, a painting is separated off not only from reality as such but, even more so, from the reality that is represented in it.

From *What is Cinema?* Vol. 1. Foreword by Jean Renoir. Essays selected and translated by Hugh Gray. Berkeley: University of California Press, 1967: 164–169. © 1967 by the Regents of the University of California. Reprinted by permission.

Indeed it is a mistake to see a picture frame as having merely a decorative or rhetorical function. The fact that it emphasizes the compositional quality of the painting is of secondary importance. The essential role of the frame is, if not to create at least to emphasize the difference between the microcosm of the picture and the macrocosm of the natural world in which the painting has come to take its place. This explains the baroque complexity of the traditional frame whose job it is to establish something that cannot be geometrically established—namely, the discontinuity between the painting and the wall, that is to say, between the painting and reality. Whence derives, as Ortega y Gasset has well stated, the prevalence everywhere of the gilded frame, because it is a material that gives the maximum of reflection, reflection being that quality of color, of light, having of itself no form, that is to say pure formless color.

In other words the frame of a painting encloses a space that is oriented so to speak in a different direction. In contrast to natural space, the space in which our active experience occurs, and bordering its outer limits, it offers a space the orientation of which is inward, a contemplative area opening solely onto the interior of the painting.

The outer edges of the screen are not, as the technical jargon would seem to imply, the frame of the film image. They are the edges of a piece of masking that shows only a portion of reality. The picture frame polarizes space inward. On the contrary, what the screen shows us seems to be part of something prolonged indefinitely into the universe. A frame is centripetal, the screen centrifugal. Whence it follows that if we reverse the pictorial process and place the screen within the picture frame, that is if we show a section of a painting on a screen, the space of the painting loses its orientation and its limits and is presented to the imagination as without any boundaries. Without losing its other characteristics the painting thus takes on the spatial properties of cinema and becomes part of that "picturable" world that lies beyond it on all sides. It is on this illusion that Luciano Emmer based his fantastic aesthetic reconstructions, which have served as a starting point for the existing films of contemporary art, notably for Alain Resnais's *Van Gogh* (fig. 1). Here the director has treated the whole of the artist's output as one large painting over which the camera has wandered as freely as in any ordinary documentary. From the "Rue d'Arles" we climb in through the window of Van Gogh's house and go right up to the bed with the red eiderdown. Resnais has even risked a reverse shot of an old Dutch peasantwoman entering her house.

———

Obviously it is easy to pretend that films made this way do violence to the very nature and essence of painting and that it is better if Van Gogh has fewer admirers even if they fail to let on what exactly they admire about him. In short, the argument is that it is a strange method of cultural dissemination that is based on the destruction of its very object. This pessimistic outlook, however, does not bear close examination either on pedagogical or, still less, on aesthetic grounds.

Figure 1. Alain Resnais, Van Gogh *(1948)*. Museum of Modern Art, New York.

Instead of complaining that the cinema cannot give us paintings as they really are, should we not rather marvel that we have at last found an open sesame for the masses to the treasures of the world of art? As a matter of fact there can be virtually no appreciation or aesthetic enjoyment of a painting without some form of prior initiation, without some form of pictorial education that allows the spectator to make that effort of abstraction as a result of which he can clearly distinguish between the mode of existence of the painted surface and of the world that surrounds him.

Up to the nineteenth century the erroneous doctrine that painting was simply a way of reproducing the world outside provided the uninstructed with an opportunity to believe themselves instructed and, thereafter, the dramatic episode and the moral tale multiplied the occasion.

We are well aware that this is no longer the case today, and it is this which seems to me the deciding factor in favor of the cinematographic efforts of Luciano Emmer, Henri Storck, Alain Resnais, Pierre Kast and others—namely, that they have found a way to bring the work of art within the range of everyday seeing so that a man needs no more than a pair of eyes for the task. In other words no cultural background, no initiation is needed for instant enjoyment—and one might add, perforce, of a painting presented as a phenomenon in nature to the mind's eye by way of the structural form of the film. The painter should realize that this is

in no sense a retreat from ideals, or a way of doing spiritual violence to his work, or a return to a realistic and anecdotal concept of painting. This new method of popularizing painting is not directed in any essential way against the subject matter and in no sense at all against the form. Let the painter paint as he wishes. The activity of the filmmaker remains on the outside, realistic of course but—and this is the great discovery that should make every painter happy—a realism once removed, following upon the abstraction that is the painting. Thanks to the cinema and to the psychological properties of the screen, what is symbolic and abstract takes on the solid reality of a piece of ore. It should therefore be clear, from now on, that the cinema not only far from compromising or destroying the true nature of another art, is, on the contrary, in the process of saving it, of bringing it to general attention. More than with any other art, painter and public are far apart. Unless, therefore, we are going to cling to a kind of meaningless mandarinism, how can we fail to be delighted that painting will now become an open book to the masses and without the expense of creating a whole culture? If such economy shocks the cultural Malthusians let them reflect that it could also spare us an artistic revolution—that of "realism" which has its own special way of making painting available to the people.

———————

What of the purely aesthetic objections? As distinct from the pedagogical aspect of the question, these derive clearly from a misunderstanding that demands from the filmmaker something other than what he has in mind. Actually *Van Gogh* and *Goya* are not, or are not exclusively at least, a new rendering of the work of these two painters. Here the role of the cinema is not the subordinate and didactic one of photographs in an album or of a film projected as part of a lecture. These films are works in their own right. They are their own justification. They are not to be judged by comparing them to the paintings they make use of, but rather by the anatomy or rather the histology of this newborn aesthetic creature, fruit of the union of painting and cinema. The objections I raised earlier are in reality a way of giving definition to the new laws following upon this mating. The role of cinema here is not that of a servant nor is it to betray the painting. Rather it is to provide it with a new form of existence. The film of a painting is an aesthetic symbiosis of screen and painting, as is the lichen of the algae and mushroom.

To be annoyed by this is as ridiculous as to condemn the opera on behalf of theater and music.

It is nevertheless true that this new form has about it something definitely of our time, and which the traditional comparison I have just made does not take into account. Films of paintings are not animation films. What is paradoxical about them is that they use an already completed work sufficient unto itself. But it is precisely because it substitutes for the painting a work one degree removed from it, proceeding from something already aesthetically formulated, that it throws a new light on the original. It is perhaps to the extent that the film *is* a complete

work and, as such, seems therefore to betray the painting most, that it renders it in reality the greater service.

I must prefer *Van Gogh* or *Guernica* to *Rubens* or to the film *From Renoir to Picasso* by d'Haesaerts which aims only at being instructive or critical. I say this not only because the freedom that Resnais has allowed himself preserves the ambiguity, the polyvalence characteristic of all truly creative works, but also and supremely because this creation is the best critic of the original. It is in pulling the work apart, in breaking up its component parts, in making an assault on its very essence that the film compels it to deliver up some of its hidden powers. Did we really know, before we saw Resnais's film, what Van Gogh looked like stripped of his yellows? It is of course a risky business and we see how dangerous from those films of Emmer which are less effective. The filmmaker runs a risk, through artificial and mechanical dramatization, of giving us an anecdote instead of a painting. One must also take into account, however, that success depends on the talent of the director and on how deep is his understanding of the picture.

There is also a certain type of literary criticism which is likewise a re-creation—Baudelaire on Delacroix, Valéry on Baudelaire, Malraux on Greco. Let us not blame the cinema for human foibles and sins. Films about painting, once the prestige that comes from surprise and discovery has faded, will be worth precisely as much as the men who make them.

Richard Allen

Representation, Illusion, and the Cinema

No matter how fuzzy, distorted or discolored, no matter how lacking in documentary value the [photographic] image may be, it shares, by the process of its becoming, the being of the model of which it is the reproduction; it is the model.

—André Bazin

Contemporary film theorists have tended to assume that the average film spectator is fundamentally deceived into believing what is seen is real. For example, in his influential essay, "Ideological Effects of the Basic Cinematographic Apparatus," Jean-Louis Baudry argues that projection and narration in film work together to "conceal" from the spectator the technology and technique that underpin the production of the cinematic image, so that the film viewer believes she or he is in the presence of unmediated reality.[1] One task of the film theorist has been to expose the false nature of the beliefs about the image that the spectator is induced to hold by revealing the mechanisms of concealment and deception using Marxist-inspired and psychoanalytically informed semiotics. However, Noël Carroll has argued recently, and in my view correctly, that what he terms the "epistemically pernicious" sense of illusion implied by contemporary film theory's account of spectatorship, in which the spectator involuntarily takes the cinematic image to be real, does not reflect our experience of the cinema. The film spectator is not duped by the cinematic apparatus or forms of narration in the cinema; the spectator is fully aware that what is seen is only a film. However, the problem with Carroll's argument is that he not only rejects contemporary film theory's account of illusion, he rejects altogether the applicability of the concept of illusion to the cinema on the basis that the cinematic image does not differ in any essential aspects from other forms of pictorial representation that do not involve illusion.[2]

In this essay I argue that the experience of illusion, suitably differentiated and correctly construed, is central to our experience of the cinema. My specific claims about the nature of illusion in the cinema are deferred until the third and final sections of the essay. In the second section, I describe a form of illusion the

Cinema Journal 32, no. 2 (Winter 1993): 21–48. © 1993 by the Board of Trustees of the University of Illinois. Reprinted by permission of the author and the publisher.

cinematic image shares with the photograph. It is derived from the photographic properties of the cinematic image. I call this kind of illusion "reproductive illusion" because it trades upon the reproductive properties the cinematic image and the photograph share. In order to understand the significance of these reproductive properties for our experience of photography and film, I begin by contrasting how we perceive photographs and how we look at representational paintings. This distinction paves the way for distinguishing two different kinds of illusionism— trompe l'oeil and reproductive illusion—associated with representational painting and photography, respectively, and leads to my examination of reproductive illusion in the cinema.

A second kind of cinematic illusion derives from the ways in which the projected moving image transforms the properties of the photographic image. I call this kind of illusion "projective illusion." Projective illusion has been the basis of confusing claims about illusion in the cinema. This confusion is due partly to a failure to differentiate projective illusion from reproductive illusion and the properties of the image that may sustain it. But it is also due to a failure to make sufficient discriminations within the concept of illusion itself. Thus, in order to examine projective illusion, in the fourth section of the essay I distinguish varieties of illusion by how they affect the perceiver rather than on the basis of their particular medium. Projective illusion is a unique form of illusion; while it is a form of sensory illusion, it does not encourage us to believe in the reality of what we see. I maintain that the spectator in the cinema can be a medium-aware spectator and yet experience the image as an illusion. The nature of this experience and how it is made possible forms the basis of my concluding discussion.

Seeing-in Paintings and Seeing-through Photographs

To my mind, the most accurate description of the experience of representational painting has been put forward by Richard Wollheim.[3] Wollheim argues that the perception of representational painting involves the particular kind of perceptual capacity invoked by Leonardo da Vinci when he encouraged the aspiring painter to look at damp-stained walls or the surface of stones and to discover dramatic visual images of battles and landscapes. This perceptual capacity is the capacity to see figure-ground relationships. The exercise of this capacity can be described as seeing the figure *in* the surface. The difference between viewing a representational painting and the experience described by Leonardo is that in a representational painting, the artist intends this visual experience. In our experience of representational painting, we attend to the way in which the surface has been intentionally marked in order to produce an image of the object. Seeing-in captures the essential "twofoldedness" involved in our experience of representational paintings and drawings: "when seeing-in occurs, two things happen: I am visually aware of

the surface I look at, and I discern something standing out in front of, or (in certain cases) receding behind something else."[4] Seeing-in explains the fact that when we look at an object in a representational painting, our experience of how that object is represented *necessarily* enters into our experience of the object.

In a photograph, the object depicted has a sense of presence that is lacking in traditional forms of pictorial representation. Or to put it another way, the photograph is transparent in a way that a representational painting or drawing is not. As the quotation from Bazin I began with implies, the explanation for this presence lies in the role of a mechanical apparatus in the production of the photographic image. A photograph is a recording, a mechanical imprint of the image of an object through the causal process by which light reflected from objects registers on photochemical emulsions. The causal basis of the photograph parallels the process underlying human vision: the photograph depends upon a direct causal connection between object and photographic plate just as what we see depends upon a direct causal connection between object and retina. In this sense, looking at an object in a photograph is like seeing that object. As Kendall Walton has suggested, the camera is like other mechanical aids to vision, such as eyeglasses, mirrors, and telescopes, except that unlike them the camera also has the capacity to record or document the object.[5]

Of course, the mechanical ability of the camera to record "reality" is also subject to manipulation and control. A photograph is made through the selection of the focal length, film stock, angle of vision, and so on, and the "finish" of the final image in development. These aspects of the photograph may serve to register the role that human intention has played in its production. A photograph has a pictorial surface and aspect that may enter into our perception of the object photographed in a meaningful way. In this sense, in photographs as in paintings, we can look at the object depicted and contemplate the object through the way it is depicted. However, because of the transparency of the image—the causal relationship the photograph bears to the object photographed—we are also able to view the object without registering the way it has been presented to us. The transparency of the photographic image does not preclude our simultaneous perception of the two aspects of the photograph. It does entail that the character of our simultaneous perception of the two aspects of a photograph is different from the character of our simultaneous perception of the two aspects of a representational painting or drawing. To capture the role the transparency of the image plays in our perception of a photograph, and account for the difference between looking at photographs and representational paintings, Walton suggests that we see the object depicted *through* a photograph.

The term "seeing-through" highlights that the pictorial surface of a photograph can enter into our experience of a photograph, but it does not enter into our experience in the same way a representational painting does. The difference between seeing-through a photograph and seeing-in a painting may be understood in the following way: the "twofoldedness" that characterizes our experience of a

representational painting is intrinsic to our perception of the object of the painting. We cannot see the object of a representational painting without seeing the way it is presented to us. The term "seeing-in" captures the intrinsic or necessary character of this twofoldedness. In contrast, the relationship between our perception of the object photographed and our perception of the photograph as a photograph, particularly, those qualities that index the intention of the photographer, is extrinsic or contingent. The photographer may encourage it, but it is the spectator who chooses to apprehend simultaneously the two aspects of a photograph. In a photograph we may see both the object and the way it is represented. But we do not see the object in the surface of the photograph. For this reason, I reserve the use of Wollheim's term "twofoldedness" to describe our experience of representational paintings and drawings in order to contrast that experience with the case in which we perceive the two aspects of a photograph simultaneously.

Walton provides an explanation for the transparency of the photographic image. We can draw different inferences about the object depicted in paintings and photographs. The object in a photograph necessarily exists or existed (unless the photograph is a fake), whereas the object of a painting may not. Even when the object of a painting does exist, our inference of its existence depends solely on the fact that the artist decided to represent it in the painting. However, we can infer from the photograph that the object exists or existed independently of the fact that the artist decided or intended to represent it there. In Walton's words "photographs are counterfactually dependent on the photographed scene even if the beliefs (and other intentional attitudes of the photographer) are held fixed."[6] That is, the photographic picture would be different if the object depicted were not present when the camera was clicked—even if the photographer believed the object to be present. In the case of representational painting, however, if the artist believed the object to be present, it would turn up in the painting regardless of whether it was in fact present.

There are exceptions to seeing-in paintings and seeing-through photographs. Seeing-in is precluded in nonrepresentational painting and in uses of photography that deny legibility to the object recorded or do not record an object at all. Many abstract paintings involve figure-ground relationships and therefore allow for the possibility of seeing-in that is characteristic of figurative representational paintings. But as Wollheim notes, certain kinds of abstract painting may deny this possibility, such as the giant color fields of Barnett Newmann.[7] Our capacity to see an object or shape through the photograph may be attenuated to the point where we look at the photograph as an abstract or figurative arrangement of line and light, rather than trying to discern an object depicted through the photograph. The cameraless photographs or photograms of Man Ray that record the impact of light reflected from objects directly onto photographic paper often produce this effect. Our capacity to see through the image is also attenuated in out-of-focus photographs; in photographs taken through a lens that has been interfered with by manual means; in photographs in which the image is blown up to the point of

unrecognizability; in "super-contrast" photographs where the object is unrecognizable; and in "constructed" photographs in which an image is manufactured out of several superimposed negatives. Our capacity to see through a photograph is precluded entirely in the case of a completely overexposed photograph or a photograph taken in the dark.

Trompe l'oeil and Reproductive Illusion

There is a second way in which seeing-in paintings may be precluded: through illusion. In a trompe l'oeil painting the viewer is deceived by the character of what is perceived. Instead of seeing an object depicted in the surface of the painting the viewer perceives the object itself. In a trompe-l'oeil illusion, the medium itself is disguised. Some contemporary film theorists contend the cinematic image produces this kind of deception. I argue that what I call "projective illusion" in the cinema does have affinities with trompe l'oeil illusion but does not induce the spectator to believe in its reality. One form of illusion in the cinema does lead the spectator to make false inferences about the status of the image. This form of illusion does not have the character of a trompe l'oeil; rather, it is an illusion that depends on the reproductive properties of the photographic image. I call this form of illusion "reproductive illusion." Paintings and photographs have different ways of producing illusions that correspond to the different representational properties of the two media. While the trompe l'oeil works to undermine our capacity to see the object in the surface of a painting, reproductive illusion uses our capacity to see the object through the photograph. Thus unlike the trompe l'oeil illusion, reproductive illusion is compatible with medium awareness.

In the traditional trompe l'oeil, such as the pictures of cabinets of stuffed birds painted by Leroy de Barde (fig. 1), we seem to be in the presence of an object and not a painting. If we are afforded a closer inspection, we can see a configuration of marks on the surface of the painting. However, we are unable to reconcile our perception of the apparent object with our perception of the surface of the painting and see the apparent object itself in the surface of the painting. When we experience the trompe l'oeil, our customary perception of the painting as a painting is inhibited. We experience a difficulty or an uncanniness in our perception. What we take for granted in our normal experience of representational painting—that our perception of how the object is depicted enters into our perception of the object—is thrown out of kilter. We experience shock or surprise; our interest in the painting is consumed by exploring this effect.

The invention of photography itself afforded a second kind of trompe l'oeil. In photo-realist paintings such as *White Chevy, Red Trailer* by John Salt (fig. 2), we appear to see a photograph and not a painting. From a distance, or in the photographic reproduction printed here, we appear to look through the image

Figure 1. Alexandre Leroy de Barde, Réunion d'oiseaux étrangers placés dans différentes caisses *(n.d.).* Musée du Louvre, Paris, France. © Réunion des Musées Nationaux/Art Resource, NY.

upon the object rather than see the object in the image. However, upon closer inspection, we see that the painting is a painting and not a photograph. We experience the same kind of uncanniness as in the traditional trompe l'oeil—we are unable to reconcile our two perceptions. However, in the case of the photo-realist trompe l'oeil the uncanniness stems from our inability to reconcile seeing the object through the apparent photograph and seeing the object in the painting. The photo-realist painting serves, then, as an effective demonstration of the distinction I have drawn between the different ways in which we see photographs and paintings.[8]

For a photographic trompe l'oeil to occur, it would require that when I perceive a photograph I either believe that what I see is really an object and not a photograph, or I believe that what I see is a nonphotographic representation of an object. To be experienced as an illusion in the first sense the referent of a photographic image would have to be experienced as present in space and we would have to be visually unaware of the surface and boundaries of the image. This condition is not met in photography.

In an argument that has influenced film theory, Roland Barthes suggests that a photograph is never confused with the object photographed on the grounds

Figure 2. John Salt, White Chevy, Red Trailer (*n.d.*). Birmingham (England) Museums & Art Gallery.

that a photograph always carries with it a necessary pastness: "the photograph is never experienced as an illusion, is in no way a presence; . . . its reality [is] that of the *having-been-there.*"[9] It is indeed true that a photograph necessarily records how an object looked at a particular moment in the past. However, it is misleading to claim that it is because of the pastness of photographs that we never mistake photographs for what they depict; often, photographs do *not* wear their pastness on their surface. Whether or not we believe the photograph depicts something from the past depends on the kind of photograph it is, that is, whether or not it is an old photograph, and it depends on how the photograph is used, that is, whether we value it for its age. Photographic portraits of deceased ancestors, for example, meet both requirements. However, many photographs do not reveal their age, in particular, those photographs where we are not interested in the object for its singularity but as an illustration of a type. An awareness of pastness does not accompany our perception of a nature photograph, such as a dew drop on a rose petal, neither does it accompany our perception of an illustrative photograph such as a cereal bowl or a box of cornflakes. The reason for this is that temporal pastness is not a necessary attribute of spatial absence. Thus we may see a photograph as a photograph and be unaware of its temporal aspect. Since we do not invariably perceive the pastness of the photograph then it cannot, in general, be this aspect of the photograph that prevents us from experiencing the illusion of the presence of the object photographed.[10]

Is it possible to experience a photograph as a trompe l'oeil illusion in the second sense, that is, as a nonphotographic representation? In order to experience

this illusion we would need to see the object in the surface of the photographic image and be visually unaware that a real object is being photographed. Given the mechanical basis of photography and the causal process that underlies the production of the photograph, this condition seems hard to meet. In the early years of photography, photographers combined photographic techniques with etchings to produce hybrid forms of representation known as photogravures or photoetchings. Light-sensitive emulsions were placed on a copper plate and the resulting photograph was etched with acid and printed like an ordinary etching.[11] This process resulted in images that have an ambiguous status: Do we see the old farmstead in the photogravure from George Davison's photograph *through* the image or *in* the image (fig. 3)? Unlike the case of the photo-realist trompe l'oeil where we see one thing—a painting—as another thing—a photograph—we do not see the image as something that it is not; we are not simply mistaken in what we see, for the photogravure partakes of both the photograph and the etching. Furthermore, once we are aware of the production process, we see the image for what it is: a mixed media photograph. A more familiar example of mixed media photographs that may cause a similar kind of ambiguity in viewing are hand-tinted color photographs, such as Victorian postcards and some of the illustrations to be found in old magazines. In none of these cases is illusion involved.

The impossibility of trompe l'oeil illusion in photography contrasts with the possibilities afforded by painting. In painting, because the object depicted is

Figure 3. George Davison, The Onion Field (An Old Farmstead) *(1890). Photogravure.* Photograph produced with the kind permission of The Royal Photographic Society, Bath. RPS9535/1.

constituted out of the surface of the paint, the painter can mimic conditions where it does not appear to be constituted out of the surface of the paint. In photography the fact that the object is recorded through the medium of a mechanical apparatus precludes this kind of pretense. However, the causal relationship between the photographic image and its referent affords a kind of reproductive illusion that depends upon the reproductive capacities of photography or the relationship that the photograph bears to reality and hence is not available to the painter. A painting can only mislead us about its own status, not about the status of reality. A photograph cannot mislead us about its own status but can mislead us about reality. A photograph may simply reproduce an illusion, for example, we may see a photograph of a bowl of fake oranges that looks like a photograph of real fruit. In this case the photograph reproduces the confusion in perception set up in the crafting of the object. However, the contribution of the photograph may be greater than this. Face to face, we may see that the trompe l'oeil painting of the cabinet in figure 1 is, in fact, a painting, but in the photographic reproduction it looks like an object; we cannot confirm that it is a painting. A stage set may not be at all illusory in its appearance, but carefully photographed it may look like a real street. The minimal contribution of the photograph, then, is to record an illusion, but the photograph may also contribute to the production of an illusion by presenting the phenomenon in a way that disguises its real status. Reproductive illusion does not preclude looking through the photographic image at the object and hence medium awareness; on the contrary, it trades on the ability of the photograph to provide a transparent access to the referent.

What about the case of the trick or fake photograph such as the photograph of Woody Allen posing with Hitler in the film *Zelig* (1983)? The deception in the trick photograph is achieved by reconfiguring the image so the photograph is constituted as an illusion, rather than simply reproducing an illusion—as in the photograph of the trompe l'oeil painting or the bowl of fake oranges. Yet the trick photograph does not fall easily into either kind of photographic trompe l'oeil category. For we are not deceived about the status of the photograph qua photograph. The photograph is not perceived as something else, it remains a photograph. All the elements within the image of a trick photograph are made photographically. What we are deceived about is the real character of the array of objects that the photograph purports to be a photograph of. The trick or fake photograph trades on our understanding that it is a recording of reality in order to deceive us about the nature of that reality. In this sense, despite the fact that this deception is produced by a manual reconfiguration of the photograph, trick photography is akin to other kinds of reproductive illusion that involve deception. Despite its origins in a reconfiguration of image rather than object, the trick photograph trades on the ability of the photographic image to record reality.

I have defined a reproductive illusion as one in which a staged event in a photograph is perceived as real. Of course, all photographs document the fact of their staging, and if we know the photograph is a staged event, we can explore the

Figure 4. Cindy Sherman, Untitled Film Still #54 *(1980).* Courtesy the artist and Metro Pictures.

relationship between its real and fictional elements. Only if the photograph masquerades as reality when actually it is staged are we deceived. These characteristics of photographic depiction are exploited in a series of photographs by Cindy Sherman called *Untitled Film Stills* (1977–1980). In these photographs Sherman poses like a heroine from American and Italian movies, mostly from the 1950s and 1960s. In figure 4, Sherman looks like Marilyn Monroe, and the lighting, framing, and pose of the figure together with the caption of the photograph, "Untitled Film Still," suggest a real film still. In this sense the image functions as a reproductive illusion in which one staged event, the imaginary film still, is perceived as another staged event, the shot of a scene from a movie. Once one sees the photograph in the context of the series and realizes that this image is posed, in fact a "self-portrait" of the photographer, those aspects of the image that are real and imaginary become legible. Sherman exploits the relationship between the staging of the illusion and the reality of its staging in order to suggest both that the reality of female identity is as an image that exists for the (male) gaze, and that this identity as an image is an illusion, a masquerade controlled by the female as agent.

Reproductive Illusion in the Cinema

The cinematic image is based upon the photographic recording of a referent at successive instants in time. But these successive discrete instants are reconstituted in projection as a spatio-temporal continuum. The cinematic image is a moving

image in two senses: it reconstitutes events in their duration and it registers the movement of the camera at the moment those events were recorded. The cinema thus adds a new dimension of presence to the experience of presence that characterizes photography. The photographic image allows us to perceive an object at a moment in time. In the cinema we can experience actions and events as they unfold in time; we experience them in motion. Minimally, as in early cinema, the filmmaker may record the event in process, whether it is staged or actuality, as it unfolds through real time. But the filmmaker may also contribute to the way the event is understood both in the manner of recording and in the manner of assembly of the image. In the manner of recording, the possibility of moving the camera and recording sound is added to the possibilities of photography. In the manner of assembly, cinema affords the complex possibilities of manipulating the spatial and temporal relationships between shots and the relationship between sound and image.

Despite the greater complexity of film, it is, of course, open to full medium awareness, in a manner akin to our viewing a photograph. We look through the image at the events recorded, fully aware of their status as drama or actuality; perceive the pro-filmic and filmic elements of the shot and their relationship to each other; assimilate the relationship between sound and image; and comprehend the ordering and timing of the events of the film as they unfold. Equally, film may deceive in the manner of the photograph. In a context where we are led to believe the image to be real, we may confuse staged footage with actuality. We continue to look through the image with full awareness of the way the shot is presented to us, but we are, nevertheless, deceived as to its content. Reproductive illusion in the cinema usually occurs in the context of nonfiction film that employs actuality footage as evidence of its subject matter. Our ability to evaluate the status of actuality footage as evidence in a nonfiction film will always be limited by the difficulty of discerning the extent to which the presence of the film unit has affected the filming of events, as Buster Keaton wittily demonstrates in *The Cameraman* (1928). However, we will be deceived outright when the nonfiction film simply fabricates the events it purports to present as actuality, by either presenting a dramatization as if it were real or editing film to falsify the historical record in the manner of the trick photograph.[12]

Nonfiction film often combines actuality with staged footage and it may be composed largely of staged scenes, as in Errol Morris's film *The Thin Blue Line* (1989). Usually the spectator has no problem discerning which parts of a nonfiction film are staged and which parts are real. On the basis of this kind of consideration, Noël Carroll has argued that the documentary film should be defined by its rhetorical form as a discursive genre, a genre of filmed essay, rather than as a putative recording of reality. He concludes that nonfiction films in which shots and their sequencing have the status of a record of the events they depict are "neither the whole of the genre nor a privileged or central instance thereof."[13] In general, I find this argument persuasive. However, the possibility of deception in the

documentary film does suggest that the documentary film involves a relationship to the idea of film as a recording of reality, an idea that threatens to be elided by Carroll's argument. The relationship is that, in the absence of evidence or cues to the contrary, the spectator believes that what is seen in a documentary film is real and not staged.

At times, Carroll implies that a documentary viewer should be singularly skeptical and suspend all assumptions about the image until proven otherwise. He writes that since it is often impossible to tell whether or not an image "physically portrays" its subject matter, or in other words, has an evidentiary status, "we are best advised to treat such images as nominal portrayals," that is, as bearing the same relationship to the recorded material as a character in a fiction bears to the actor playing the role.[14] This state of heightened alertness is no doubt the ideal state for the spectator, but I do not think it is the characteristic attitude of the documentary viewer. The possibility of reproductive illusion certainly does not suppose a spectator who naively believes that all documentary images are recordings of reality. Nevertheless, in order for it to be possible for the spectator to be deceived, there are *some* assumptions about the evidentiary status of the image that the spectator brings to a nonfiction film. The spectator believes that what is seen is actuality, unless there is reasonable evidence to the contrary. Reproductive illusion in the nonfiction film trades upon this reasonable belief in the reality of the image.

Reproductive illusion is particularly prevalent in the mixed genre of pornography. The rationale of so-called hardcore pornography is that the acts of sex and violence depicted actually take place. Hardcore pornography elicits the spectator's voyeurism by purporting to show us real sexual activity, not the pretense or illusion of a sexual act. But as Linda Williams has pointed out, pornography, especially sadomasochistic forms of pornography, readily trades in deception where shots of actual sexual activity seamlessly coexist with simulations of the same activity.[15]

So far I have assumed that cinematic conventions are neutral with regard to reproductive illusion. However, after cinema verité, the filmmaker had a set of techniques and conventions available that actively connoted a sense of "being there," in particular the hand-held camera and live sound recording. These techniques underscore the evidentiary status of the image. Equally they can be used to foster the illusion that the staged events are "actuality" footage captured by the filmmaker. These techniques of illusionism are utilized in sensationalist television current-affair programs such as NBC's *Unsolved Mysteries*, that dramatize, in the manner of "docudramas," real-life unsolved crime stories. Although the action is staged, it is often shot at the actual scene of the crime with verité techniques to give the spectator the illusion of witnessing the event.

Reproductive illusion is rare in the context of fiction film, for most fiction films unambiguously index themselves as fiction. However, in certain cases filmmakers may use documentary techniques to disguise the fictional character

of their work for dramatic purpose. Jim McBride's *David Holtzman's Diary* (1968) is a fictional film of the life of one David Holtzman of New York City, but it is filmed as if it were the autobiographical diary of the filmmaker who is using the name David Holtzman. The spectator is lured into believing that the film is a documentary by the use of a verisimilar pro-filmic style complemented by filmic techniques connoting "liveness." The film is shot on location, its reference is contemporary, and its acting style, costume, and setting are of a contemporary "vernacular." The scenes are shot with a hand-held camera in grainy black-and-white images. The editing appears improvised, and film leader appears at the end of each apparent scrap of film. At the same time, the level of self-consciousness about the cinema exhibited by the protagonist of the film begins to suggest to us that the events are staged. We realize that this is a fiction film whose subject matter—the confusion between film and reality—is performed for the spectator in the presentation of its own fictional staging as documentary actuality. The film's uncanny effect then becomes a source of pleasure, though we are not certain until the final credits roll that the film is scripted and staged.

Varieties of Illusion

Noël Carroll defines an illusion as something that "deceives or is liable to deceive" the viewer.[16] By deception he means that the illusion provokes the viewer to entertain false beliefs about the object. My discussion of reproductive illusion in the cinema conforms with this definition. However, Carroll's definition is qualified with the proviso that there might be an "epistemically benign" sense of illusion in which "x is an illusion of y" simply means "x looks like y" and deception plays no role.[17] In order to isolate the character of what I call projective illusion, I wish to take up Carroll's implication that different kinds of illusion can be distinguished on the basis of the quality of effect they have on the perceiver.

As it stands, Carroll's distinction between malign and benign sense of illusion is unilluminating, for the definition of an "epistemically benign" sense of illusion is a trivial one. To the extent that all pictorial representations might be said to look like what they depict, all pictorial representations are illusions. The key to developing a more fine-grained account of illusion is to differentiate the kinds of deception involved in visual representations that are putatively illusions, rather than to differentiate a form of illusion in which deception plays no role. Most illusions are deceptive in two respects: they deceive the senses, and they lead us to make false inferences. We *see* something that does not exist and *believe* that it does exist. However, these two kinds of deception are distinguishable. We can experience a sensory illusion without being deceived into believing that what we see is real. The limit case of illusion would be one in which sensory illusion was never accompanied by epistemic deception. I argue that this form of illusion

is exemplified in the cinema by projective illusion and qualifies as a genuine example of an epistemically benign form of *illusion,* since while epistemic deception does not occur, sensory deception remains. In order to take account of this possibility the definition of illusion as deception must be modified. An illusion is something that deceives or is liable to deceive the spectator, but the deception need not be of the epistemic kind. Sensory deception does not entail epistemic deception.

I discriminate between varieties of illusion on the basis of two criteria. Certain kinds of visual illusions—particularly those forms of illusion specifically constructed as visual illusions—will always deceive the senses. However, other kinds of illusions that are more context-dependent will not. Thus the first criterion is whether or not the illusion is necessarily experienced as an illusion when it is perceived. A limited but important subset of illusions involve the phenomenon of seeing-as. The classical example of seeing-as is Jastrow's duck-rabbit drawing that seen under one aspect appears as a rabbit and seen under another aspect appears as a duck. An example of this phenomenon that works in three dimensions is the Necker Cube, in which we flip-flop between perceiving two different cubes (fig. 5). The phenomenon of seeing-as is defined by the fact that one cannot see the two aspects of these figures simultaneously but one is obliged to flip-flop sequentially between them. If one aspect of the figure is an illusion, it opens up the possibility of a limited escape from the hold of an illusion that would otherwise be necessarily experienced. Thus the second criterion is whether or not the illusion is one that involves seeing-as.

These two criteria—whether or not the illusion is necessarily experienced and whether or not the illusion is a species of seeing-as—allow me to discriminate four different kinds of illusion: (1) illusions that are necessarily experienced and do not involve seeing-as; (2) illusions that are not necessarily experienced as illusions and do not involve seeing-as; (3) illusions that are necessarily experienced and involve seeing-as; (4) illusions that are not necessarily experienced as illusions and involve seeing-as.

Figure 5. Necker Cube. The foreground outside corner of one cube becomes the background inside corner of the other cube.

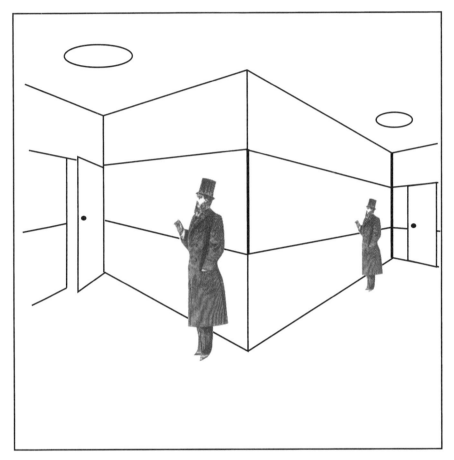

Figure 6. The Müller-Lyer illusion. The corner adjacent to the distant figure is equal to the central section of the corner adjacent to the foreground figure.

Consider a powerful illusion such as the Müller-Lyer illusion in which parallel lines of equal length are perceived as lines of unequal length (fig. 6). The Müller-Lyer illusion is one of a species of illusions that trade on our response to depth cues. In this case, we see the lines as external and internal corners that appear as different lengths because of the different perspectival cues. We do not see the lines as marks of equal length on a page. What is involved in our experience of this illusion? Initially we may be deceived into *believing* that the lines are of unequal length because what we *see* are lines of unequal length. But even when we are persuaded that the lines are of the same length by measuring them or by drawing horizontal lines at each end of the verticals, we still *see* the lines as being of unequal length. The Müller-Lyer illusion and similar illusions are always compelling because the sensory deception continues to exert its force even when we know that what we see is contrary to fact. We experience a conflict between our judgment and our senses; the illusion drives a wedge between thought and perception.[18]

Other kinds of illusion are context-dependent. Consider mirror illusions. When we look in a mirror we are certainly not compelled to view what we see as real. Experience furnishes us with knowledge of how mirrors work and this knowledge allows us to see a mirror image as a mirror image. However, we are deceived by mirrors as children and we might be momentarily deceived by a mirror image as an adult where a mirror has been used to promote our deception. For example, large wall mirrors are sometimes used in narrow bars or other enclosed areas to foster the illusion that the space is double the size. The context-dependent character of the experience of mirror illusions seems to preclude the kind of experience of sensory illusion without epistemic deception that is possible in the case of the Müller-Lyer illusion. Once we *know* that our visual array is an illusion produced by a mirror we no longer *see* it as an illusion. Our knowledge is effective here in countering the illusory effects of mirrors in a way that it is not in the case of the Müller-Lyer illusion. However, deception can occur, and when it occurs it is not an experience we can choose to have. Our knowledge of the way in which mirrors work serves to reduce the probability of the illusion, but not to eliminate the possibility of deception.

The rhetorical and presentational context of an image cues us to its causal history and hence to its status as staged event or actuality. If an image is not contextualized in any way we are not in a position to determine its status as staged event or actuality. Thus whether or not a photographic image is experienced as a reproductive illusion, rather than its status remaining indeterminate, is dictated by its rhetorical and presentational context. For example, as I have already suggested, in a documentary film we assume that what we see is actuality unless we are cued to the staged character of the image. The experience of reproductive illusion results from a failure to be cued to the staged character of an image in the context of other cues that point to the evidentiary status of the image. However, once the viewer establishes the causal history of the image and learns to isolate the deceptive cues, the character of the image will become legible, as in the case where we come to realize that the apparent film still from a 1950s American movie is in fact a photograph of Cindy Sherman. With a reproductive illusion, like a mirror illusion, once the character of the image becomes legible, its effect is neutralized.

How does the phenomenon of seeing-as influence our experience of illusion? In order to answer this question we must be careful to distinguish the characteristics of the phenomenon itself from the case where seeing-as also involves illusion. As I have said, seeing-as is defined by the fact that one cannot perceive the two aspects of certain figures simultaneously but one is obliged to flip-flop, sequentially, between them. In his *Philosophical Investigations*, Ludwig Wittgenstein asks us to consider what has occurred when it dawns on me that I can see the duck-rabbit figure as a rabbit when previously I have only seen a duck.[19] Is it my interpretation (thought) that has changed or my perception? On the one hand the figure remains the same and the change of aspect is subject to the will of the

perceiver, thus we may be inclined to say that our interpretation has changed. On the other hand, seeing an aspect, like seeing and unlike interpretation (thought), is a mental state as opposed to a mental activity or disposition. First, unlike a thought, it has a literal, that is, precisely measurable duration. Second, if it were a thought, then I could be mistaken in my judgment of the change of aspect by misinterpreting what I see. However, seeing the change of aspect leaves no such room for misinterpretation: either you see it or you don't. Hence it cannot be meaningful to say that in this case I *interpret* what I see since no distinctive possibility of error arises.[20] The phenomenon of seeing-as demonstrates the impossibility of divorcing seeing from thinking in the activity of perception. While I see the figure differently, I cannot isolate what it is that marks the change of an aspect when I notice a change of aspect. When I see x as y, I do not first of all see x and infer that it is y. This feature of seeing-as explains why we cannot simultaneously perceive the two aspects of the figure. If our seeing x as y involves a distinct combination of thought and perception, so does our not seeing x as y. When we refuse to see x as y, it is impossible to be aware of the properties of x that would be transformed were we to see x as y. For, as the example demonstrates, what is different in the experience of the two cases cannot be factored out from what is common to the two cases. The properties of x such that I see x as y, are precisely what I cannot see when I choose to see x.

In the duck-rabbit illustration or the Necker Cube there is no "correct" interpretation of the figure. We can say of neither interpretation that it is an illusion, we can say only that the figure is either a duck or a rabbit, or either one cube or the other, according to which aspect is focused upon. These figures are apt for illustrating the phenomenon of seeing-as precisely because they do not involve illusion. What happens, then, when illusion *is* involved in seeing-as? The example of the eggbox illusion (figs. 7–8) is a case of seeing-as that also involves illusion. The eggbox illusion is one of a species of illusions in which contrasts between light and shade give ambiguity to depth perspective. Our perception oscillates between seeing the eggbox as concave and convex, yet only one version is the

Figures 7–8. The eggbox illusion. The convex eggbox on the right is simply an inversion of the concave eggbox on the left. If the page is tilted to the side, viewers should be able to find a point where they can oscillate between seeing the eggbox as concave and convex in both photographs.

correct one. Once we learn the correct designation, say that the eggbox is concave, our perception oscillates between seeing the concave eggbox and the illusion of seeing the concave eggbox as convex. In general cases where seeing-as involves illusion our perception oscillates between seeing x, and seeing x as y where y is the illusion. We leave the safe haven of a congruence between thought and perception to experience an incongruity between the two, rather than a different form of congruity.

The eggbox illusion has the compelling character of the Müller-Lyer illusion in that it is impossible to tell just from looking at the illustration which view is correct. Furthermore, even if we are told the correct view, our knowledge does not prevent us from experiencing the illusion when we flip-flop back again. In this sense, the eggbox illusion, like the Müller-Lyer illusion, is an illusion that is necessarily experienced. It is unlike the mirror illusion, in which contextual information breaks the hold of the illusion on our senses altogether. Nevertheless, the fact that this illusion involves seeing-as modifies our relationship to the illusion in a key respect, for we are afforded the possibility of a correct perception of the phenomenon we are viewing. Unlike the case of the Müller-Lyer illusion, we can bring our perception and our belief into line with one another. Furthermore, our experience of the illusion does not end here for we can also flip-flop back again from the correct perception to the illusion. In an illusion like the eggbox illusion, which also involves seeing-as, the experience of a discrepancy between what we perceive and what we now know to be the case becomes an option we can voluntarily entertain.

The trompe l'oeil illusion also qualifies as an example of seeing-as. Viewing the traditional trompe l'oeil we are unable to reconcile our perception of the painting as a painting with our perception of the painting as an object. Viewing the photo-realist trompe l'oeil we are unable to reconcile our perception of the painting as a painting with our perception of the painting as a photograph. However, these cases of seeing-as differ from the "pure" cases of seeing-as exemplified by the Necker Cube, the duck-rabbit, and the eggbox illusion. The "pure" cases of seeing-as are defined by the fact that we cannot discriminate those aspects of our visual field that sustain one view of the object from those aspects of our visual field that sustain the other view of the object. However, in the case of the trompe l'oeil, the shift in our perception of the character of the object we are seeing is caused by the fact that previously unseen features of our visual field, in particular the surface of the painting, are newly perceived. We are alerted to the actual status of what we see by these distinct visual cues. If the trompe l'oeil still qualifies as an example of seeing-as, as well as an example of an illusion, it is because we remain unable to reconcile the two aspects of our visual field and see the apparent object or photograph in the painting.

The final kind of illusion is like the eggbox illusion or the trompe l'oeil for it involves seeing-as and hence can be voluntarily entertained in the manner of flip-flopping in and out of the illusion. However, unlike the eggbox illusion or

the trompe l'oeil illusion and like the mirror illusion, the illusion itself is not a compelling one. That is, our knowledge of its character may undermine our capacity to experience the illusion at the sensory level. This peculiar combination of qualities renders this illusion epistemically benign in character. The fact that the illusion is embedded in the context of seeing-as affords the possibility of voluntarily entertaining a form of sensory deception. At the same time, the experience of illusion that we flip-flop into lacks in its own right the epistemic force of, say, the eggbox illusion, for we are never confused as to which aspect of the phenomenon is real and which is the illusion. This form of illusion is thus one that is not necessarily experienced, and when it is experienced, the experience is voluntary. The discussion of this form of illusion has necessarily remained abstract and hypothetical up to this point, for the only example I can give is that of projective illusion, which I elucidate below. However, I can at this point place projective illusion within a diagrammatic summary of my argument thus far.

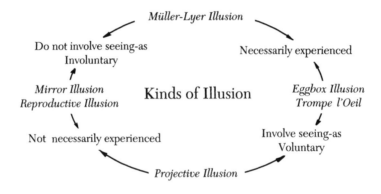

Projective Illusion

One consequence of the status of the photographic image as a recording of what it depicts is that, as Roger Scruton has argued, the photograph is fictionally incompetent. Photography is not a medium of fictional representation, although it can be used as a vehicle to represent fictions[21] If you see the photograph of a film extra dressed as a zombie, what you see is a fictional representation of a zombie, or in Carroll's terms a "nominal portrayal." But the fictional act is not embodied in the activity of taking the photograph, it is embodied in the clothing and makeup of the extra. Of course, the photograph may enhance the presentation of the fiction, but it does not constitute the fiction.

Thus far I have considered cinematography as moving photography. Cinematography adds to photography the possibility of recording and presenting events through time, but it does not necessarily alter our relationship to the image. The cinema inherits the fictional incompetence of the photograph. It has the ability to convey and enhance dramatic fiction, but it is not a medium of fiction. However,

I would suggest that cinema affords a possibility for fictional representation that is lacking in photography. When you see a zombie in George Romero's *Night of the Living Dead* (1968), you may perceive the image realistically, that is, as the recording of a fictional portrayal of a zombie. It is highly unlikely, but you might perceive the zombie as a reproductive illusion and presume that these creatures were out there in this world, for example, if somehow you thought that the film was a documentary. However, there is a third option: you may perceive a world inhabited by zombies. When you see a world inhabited by zombies you do not mistake a staged event for actuality in the manner of a reproductive illusion; rather, you lose awareness of the fact that you are seeing a film. Rather than look through the image "from the outside" at a photographic reproduction of something staged in this world, you perceive the events of the film directly or "from within." You perceive a fully realized, though fictional, world that has all the perceptual presentness or immediacy of our own. I call this form of illusion projective illusion. Through projective illusion the cinema has a capacity for fictional representation that photography lacks, although it is a capacity that is founded upon illusionism.

What are the features of the projected moving image that engender the possibility of projective illusion?[22] In contrast to the photograph, the projected image does not have a surface; only the screen on which the image is projected has a surface. The movement of the projected moving image lends a particular kind of presence to that surfaceless image. As Christian Metz noted in an early essay, the image of movement and movement itself are one; there is no image of recorded movement in the cinema, there is only a moving image.[23] This sense of presence that movement brings to the projected image is complemented by the character of diegetic sound. There is no image or representation of sound; recorded sound, too, is directly experienced. A further way in which the projected moving image departs from the photograph is in our perception of the edge of that image. Because the image is moving, objects within the image appear to enter and leave the frame of the image, and the frame itself moves. Furthermore, through sound we are not only made aware of offscreen events, but those events have the same sense of presence as onscreen events. Thus, in comparison to the photograph, our awareness of offscreen space in the cinema is greatly enhanced. Offscreen space can be understood as an extension of the dramatic space of the image, solidly a part of this world, that we may look upon through the image when it is revealed to us. However, when this awareness of offscreen space is combined with the perception of movement that appears present to us, and is supported by a soundtrack that emphasizes both the presence of the image and the continuum between onscreen and offscreen space, the preconditions for projective illusion are established.

What occurs in projective illusion is that this onscreen/offscreen continuum is, as it were, peeled away or severed from its moorings in this world. It is a continuum that is entirely coextensive with this world, but it has been detached from this world by the fact that it is no longer perceived by the spectator as a reproduction of this world but as an original world of its own making. Projective

illusion is like the eggbox illusion in the sense that we cannot differentiate those features of the image that sustain our perception of the image as a recording from those features of the image that sustain our perception of the image as a projective illusion. Our perception of the image as a projective illusion is incompatible with an awareness of the image as a photographic reproduction of this world and hence with the conventions of the medium as conventions. Like our experience of the eggbox, we can choose to step through the seeing-as corridor into the world of illusion. However, projective illusion is unlike the eggbox illusion because its status is not compelling. We are not uncertain in the cinema as to which version of reality is the correct one. If we do not wish to step through the seeing-as corridor and enter the world of illusion, there is nothing about the phenomenon that compels us to do so.

In the case of the eggbox illusion or the trompe l'oeil illusion, when we experience the illusion, the illusion has the same status as reality. For projective illusion in the cinema to have the status of an event that appears to be actually witnessed, it would have to take the form of a trompe l'oeil. We would have to mistake the film for real life in the manner of the proverbial spectators of Lumière's *Arrival of a Train at the Station* (1895).[24] We have seen that the kind of medium awareness that precluded the possibility of a photographic trompe l'oeil is attenuated in the cinema by the particular combination of movement, sound, and projection to the point where we may no longer be aware of the projected image as a reproduction or recording of anything, and experience the events within the image as if they were present to us. However, the size of the image (its largeness) and its character (its lack of three-dimensionality), in relationship to its varied content and the context where it is seen (the cinema), simply rule out the possibility of trompe l'oeil illusion in the cinema. Thus a unique set of circumstances are set up in cinematic projection in which the possibility of flip-flopping out of medium awareness is promoted by the conditions projection, but the version of reality pulling us into the illusion is not equally compelling as it is in the case of the trompe l'oeil (or the eggbox illusion). The reality of projective illusion is a virtual reality. The experience of projective illusion is thus afforded us by the medium, but we are not compelled to experience it.

The lack of compulsion involved in our experience of projective illusion can be compared with the lack of compulsion involved in our experience of a mirror illusion. As we have seen, in the case of the mirror illusion our knowledge that what we see is only a mirror image undermines our capacity to experience the sensory illusion. In the case of the cinema, too, our medium awareness may undermine our capacity to experience the illusion. We may watch any given film as a medium-aware spectator and never experience the film as a projective illusion. However, in the case of the cinema, unlike the mirror illusion, our capacity to see two different aspects of the image allows us to experience the illusion even when we know that it is only a film we are watching. We cannot *see* the film as a projective illusion and *see* the film as a medium-aware spectator, for such a

simultaneity of perception is excluded by seeing-as. However, we can see the film as a projective illusion and at the same time know that what we are watching is only a film in the manner that we can see the eggbox as convex while knowing that it is concave.

Some contemporary film theorists, following Roland Barthes's argument about photography, have described the experience of projective illusion as an illusion of the presence of something that is past. For example, John Ellis writes that "the cinematic illusion is a very particular one: it is the illusion of something that has passed, which probably no longer exists. The cinema image is marked by a particular half-magic feat in that it makes present something that is absent. The moment shown on the screen is passed and gone when it is called back into being as an illusion."[25] This argument is misleading for the same reason that Barthes's original argument is misleading. Although every genuine photograph is a record of a past moment, there are only certain photographs, at certain times, whose age we perceive. Equally, even though a fiction film is recorded at some time in the past we only perceive its pastness when the film looks dated or aged. Usually when we look at contemporary films, and often when we look at old films too, the age of what we see does not enter into our experience. What prevents a photograph from being experienced as an illusion is our awareness of the surface and edges of the photograph, our awareness of the photograph as a photograph. Equally, what prevents the projected moving image from being experienced as an illusion is our awareness of the photographic character of the moving image. Thus what affords a projective illusion of the projected moving image is that our awareness of the photographic basis of the image is overridden by the combination of movement, sound, and projection.

However, there is a temporal dimension to our experience of projective illusion. Since, in projective illusion, what we perceive appears spatially present to us, what we perceive also appears temporally present to us. In projective illusion the fiction appears to unfold before our eyes as we watch, as if it were live, as if it were created in the moment of projection. The illusion involved is not the illusion of something present that has passed, it is the illusion of something spatially present that is not spatially present. The illusion of presence is not based on a denial of the pastness of the image, it is based upon a denial of the fact that the image is an *image* of something at all. However, since spatial absence is a necessary attribute of temporal pastness (though *not* vice versa), awareness of the datedness of a film is one way that our attention may be drawn to the photographic basis of the medium and will be sufficient to break the hold of projective illusion. This is why some moviegoers have a low tolerance of old black-and-white or silent films.

Noël Burch calls this experience of projective illusion the "diegetic effect." He argues, I think correctly, that the minimum precondition for this effect is movement, or more accurately, the expectation of movement, either of the camera or within the frame.[26] The presence of pro-filmically motivated sound fosters the

possibility of projective illusion. At the other extreme, the possibility of projective illusion is extinguished if the picture track becomes illegible. Strategies that threaten our capacity to see through the image in the cinema will also threaten our capacity to experience projective illusion. These methods may be cinematographic (extreme camera movement); photographic (multiple exposure of the image, manipulation of the camera lens, lensless or cameraless photography); and nonphotographic (manual manipulation of the lens and manual or chemical manipulation of the film strip); or a combination of the above. The films of Stan Brakhage provide a rich source of examples of these techniques. However, as Burch points out and Brakhage's films attest, it is only when our capacity to see through the image is completely obliterated that the possibility of projective illusion is excluded. In *Mothlight* (1963) Brakhage abandons photography entirely and with it the capacity either to see through the film image or experience projective illusion. The original of the film was literally made of moth wings, leaves, and flowers pressed between two strips of transparent editing tape.

So far I have characterized the experience of projective illusion as a loss of awareness of the photographic image as an image in favor of the experience of a fully realized, though fictional, world. We may borrow Christian Metz's formulation here and speak of the spectator's identification with the camera. In projective illusion the spectator occupies the perceptual point of view of the camera upon the events of the film.[27] But how do we experience this illusory world? There are two distinct ways of experiencing projective illusion. In the first kind of projective illusion we take up the position of the camera and inhabit the world of projective illusion through an empathetic identification with one or more characters in the fiction. That is, we actually find ourselves in the mental state of the characters with whom we identify. If they feel terror, we feel terror also. I call this form of projective illusion character-centered projective illusion. It may be possible to identify empathetically with a character and yet fail to experience the world of projective illusion. However, I would suggest that empathetic identification fosters the kind of suspension of judgment entailed by projective illusion. In the second kind of projective illusion we take up the point of view of the camera and inhabit the world of projective illusion by emotionally responding to events we see as if we were witnessing them in person. But where characters are involved in a scene we do not emotionally identify with them. I call this form of projective illusion spectator-centered projective illusion.

Spectator-centered projective illusion is the form taken by projective illusion when characters do not appear in a sequence of film. However, prolonged sequences of fiction film that take place without affording the possibility of character-centered projective illusion tend to foster medium awareness and break the spell of illusion altogether. It is the temporal hook afforded by presence of characters within a developing narrative that allows the experience of projective illusion to be prolonged and sustained. Of course, the presence of characters within

a story does not mean that projective illusion will be sustained or even experienced. However, it seems to me that classical Hollywood cinema can be defined by the fact that it is a form of cinema that has developed a number of interlocking strategies to maximize the possibilities for the perception of filmed drama as projective illusion. The standardization of the stylistic conventions of the classical Hollywood film minimizes audience awareness of the way a Hollywood film is put together by rendering those conventions second nature. Genre conventions blur the boundaries of the individual text by drawing on the themes and images of a broad trans-media intertext. Since this intertext is already part of the spectator's imagination, the individual genre film simply taps into this reservoir of themes and images, minimizing the effort required to understand the film in its singularity. Finally, star persona blurs the boundary between character role and the real-life body of the actor, conflating the distinction between "nominal" and "physical" portrayal. Our identification with, say, the star persona of Robert de Niro, encourages us to fuse the particular role of Jake La Motta in *Raging Bull* (1980) with the range of intertextual associations that accrete around the body of de Niro, the actor, to form de Niro, the star. We are encouraged to switch from the realistic perception of de Niro the actor, playing La Motta, to the projective illusion of de Niro as "Jake La Motta."

When projective illusion does occur in a fiction film with characters, there are at least two contexts in which spectator-centered projective illusion may be privileged over character-centered projective illusion. The first context is where the physical attributes of the human body are emphasized at the expense of the mental attributes of a character. This emphasis is characteristic of certain genres of film such as forms of silent comedy and the musical, as well as certain films of the avant-garde, such as those of Andy Warhol. It is also, in general, characteristic of scenes of sex and violence. Scenes of sex and violence are inarticulate, they reduce the human being to the animal. As a result they tend to short-circuit audience identification with character and to appeal directly to the senses. Such scenes encourage in the spectator a detached, voyeuristic response to what they see, rather than an identification with the feelings of the participants who are performing the activity. Of course, in these contexts where it is an actor's body that is emphasized, the form that our interest in the image takes might not involve illusion at all; the spectator's detachment may be of the kind that characterizes medium awareness. We may simply stare through the frame at the actor's body in real space and forget the fact that she or he is a character in a fiction. However, my point is that this way of looking at the body in film is fully compatible with the experience of projective illusion where we see the actor's body as the character's body.

The second context in which spectator-centered projective illusion may be privileged is where the filmic elements of the shot—camera movement, framing, and distance—are not anthropocentrically organized. Typically, in classical Hollywood cinema, camera movement, framing, or distance position us from the

point of view upon the scene that corresponds to the eyeline of an adult human witness to the scene. However, auteur cinema, for example, characteristically departs from this norm, as in the extended camera movements of Max Ophuls or Stanley Kubrick, or the unusual camera angles of Alfred Hitchcock and Joseph Losey. Often, overt camera shots accompany the display of scenes of sex and violence to heighten the voyeuristic effect. A particularly vivid example is the rape scene in *A Clockwork Orange* (1971), which is filmed with a hand-held camera through a wide-angle lens. Once again, this scene may have the opposite effect to projective illusionism and prompt the spectator to look through the image upon the staged event. However, I would speculate that such a response would have the character of a defensive "it's really only a movie" reaction to the intensity of the projective illusion engendered by this scene.

In fact, *A Clockwork Orange* provides an object lesson in cinematic illusionism. I would suggest that the characteristic experience of fictional cinema is one in which the spectator moves between spectator-centered projective illusion, character-centered projective illusion, and medium awareness. *A Clockwork Orange* dramatizes the relationship between these forms of experiencing the cinema. The first twenty minutes of the film facilitate a particularly intense experience of projective illusion as we alternately identify with the character of Alex through his ingratiating voice-over narration and gaze uncomfortably in detached, voyeuristic fascination upon his acts of sexual violence that are choreographed to music and filmed in brilliant color. Then, as Alex enters prison the pace of events radically slows down, the color becomes a uniform institutional gray-blue, the music stops, and we become bored; we are made aware of the fact that what we are watching is only a film. It is as if the spectator is punished for succumbing to the sensory lure of these opening scenes in a manner that parallels the way that Alex is punished for the activities these scenes depict.

Conclusion

There is obviously much more to say about projective illusion in the cinema than I have sketched here. However, I hope at least in this essay to have provided a context for understanding illusion in the cinema, in a manner that at once recognizes the pitfalls of the account of illusion offered by contemporary film theory but also attempts to redeem the insight of contemporary film theory that illusionism *is* central to our experience of the cinema. I would like to think that the consequence of this argument for film theory is that an illusionist-based psychoanalytic theory and a nonillusionist-based cognitive theory of the cinema need not be seen as antagonistic and mutually exclusive explanations of the same experience; rather, they could be seen as complementary explanatory frameworks that describe two different ways of experiencing the same phenomenon. The explanation I have given

here for how we get in and out of illusion in the cinema is, very broadly speaking, a "cognitive" explanation. However, I believe that the psychoanalytic theory of disavowal, if it could be cast in sufficiently precise and nuanced terms, rather than in the confused and ambiguous Lacanian-influenced terms of contemporary film theory, would provide an explanation that complements the one I have given here. It would not explain how we are able to enter through the seeing-as corridor into the world of illusion, but it may help explain why it is that once we have entered into the world of illusion we have a tendency to remain there.

NOTES

I gratefully acknowledge the generous contribution of Ben Singer to this work. Ben read two versions of this manuscript and on both occasions provided me with cogent criticisms and freely shared his ideas on the subject. It is also my pleasure to thank the following individuals who gave me the benefit of their criticism, advice, and encouragement: John Belton, my respondent at a Columbia University seminar; Tom Drysdale; Tom Gunning; Antonia Lant; Hector Rodriquez; and Michael Zyrd. Finally, I wish to acknowledge the anonymous referees of *Cinema Journal* for their careful readings and constructive advice.

1. Jean-Louis Baudry, "Ideological Effects of the Basic Cinematographic Apparatus," trans. Alan Williams in Philip Rosen, ed., *Narrative Apparatus Ideology: A Film Theory Reader* (New York: Columbia University Press, 1986), 286–298. The argument that Baudry and certain other contemporary film theorists make about illusion is more complex than this summary implies. The illusion that is said to be produced by the cinema is nothing less than the illusion of the unity or coherence of a transcendental ego whose unity is guaranteed by the fact that the transcendental ego appears to have direct, unmediated perception of the referent. In reality, according to these theorists, both the referent and the transcendental ego are a product or function of signification. Baudry's argument receives a further complex elaboration in Stephen Heath's essays collected in *Questions of Cinema* (Bloomington: Indiana University Press, 1981). For extended discussion and criticism of this argument, see my "Representation, Meaning and Experience in the Cinema: A Critical Study of Contemporary Film Theory" (Ph.D. diss., University of California, Los Angeles, 1989), 50–218.

2. See Noël Carroll, *Mystifying Movies: Fad and Fallacies in Contemporary Film Theory* (New York: Columbia University Press, 1988), 90–106. An earlier version of this argument is contained in "Address to the Heathen," *October* 23 (Winter 1982): 103–109. For Heath's response to this issue, see "Le Père Noël," *October* 26 (Fall 1983): 91–99, and for further comments from Carroll, see "A Reply to Heath," *October* 27 (Winter 1983): 93–97.

3. Richard Wollheim, "Seeing-as, Seeing-in, and Pictorial Representation," *Art and Its Objects*, 2nd ed. (Cambridge: Cambridge University Press, 1980), 205–226; and *Painting as an Art* (Princeton: Princeton University Press, 1987), 43–77.

4. Wollheim, *Painting as an Art*, 46.

5. Kendall L. Walton, "Transparent Pictures: On the Nature of Photographic Realism," *Critical Inquiry* 11:2 (1984): 252.

6. Ibid., 264.

7. Wollheim, *Painting as an Art*, 62.

8. I thank Ben Singer for drawing my attention to the photo-realist trompe l'oeil.

9. Roland Barthes, "Rhetoric of the Image," in *Image, Music, Text*, trans. Stephen Heath (New York: Hill and Wang, 1977), 44.

10. I thank Ben Singer for pointing out these examples of photographs that contradict Barthes's suggestion.

11. I thank Antonia Lant for telling me about the photogravure.

12. Historians are particularly sensitive to reproductive illusion in film. See William Hughes, "The Evaluation of Film as Evidence," in Paul Smith, ed., *The Historian and Film* (Cambridge: Cambridge University Press, 1976), 49–79.

13. Noël Carroll, "From Real to Reel: Entangled in Nonfiction Film," *Philosophic Exchange* 14 (1983): 30.

14. Ibid. For further discussion of the distinction between "nominal" and "physical" portrayal see Noël Carroll, *Philosophical Problems of Classical Film Theory* (Princeton: Princeton University Press, 1988), 149–152.

15. Linda Williams, *Hardcore: Power, Pleasure and the "Frenzy of the Visible"* (Berkeley: University of California Press, 1989), 201.

16. Carroll, *Mystifying Movies*, 95.

17. Ibid., 96.

18. The claim that the Müller-Lyer illusion is always compelling must be qualified: it is only compelling to someone who has learned to see a two-dimensional configuration of lines as a three-dimensional representation.

19. Ludwig Wittgenstein, *Philosophical Investigations*, 3rd ed. (New York: Macmillan, 1953), II, xi.

20. For a comprehensive discussion of these issues, see Malcolm Budd, "Wittgenstein on Seeing Aspects," *Mind* 96:381 (1987): 1–17.

21. Roger Scruton, "Photography and Representation," In *The Aesthetic Understanding: Essays in the Philosophy of Art and Culture* (London: Methuen, 1983), 112. The example that follows is adapted from Scruton.

22. My focus here is on the cinema. However, both the projected image and certain kinds of projected moving images predate both photography and cinema. Cinema inherited the aura of magical illusionism that had been associated with these prephotographic forms of projected images since ancient times. From this historical perspective the addition of photographic likeness and cinematic movement (and then sound) to the projected image simply renders the illusion more palpable. For an outstanding historical discussion of precinematic forms of screen practice and their relationship to cinematic illusionism, see Charles Musser, *The Emergence of Cinema* (New York: Scribner, 1990), 15–40. The television image also is a kind of projected moving image lacking a surface and an edge, and other things being equal, the argument developed in this section is also applicable to our experience of the television image. The quality and size of the television image may diminish the propensity to projective illusion, although high definition, projected television can produce an image whose clarity and size are equal to those of the cinema.

23. Christian Metz, "On The Impression of Reality in the Cinema," In *Film Language: A Semiotics of the Cinema*, trans. Michael Taylor (New York: Oxford University Press, 1974), 3–15.

24. This myth and its legacy are challenged effectively by Tom Gunning in "An Aesthetic of Astonishment: Early Film and the (In)credulous Spectator," *Art & Text* 34 (1989): 34–45. Gunning proposes that, contrary to myth, early film spectators entered in and out of the experience of illusion in precisely the way I try to rationalize here.

25. John Ellis, *Visible Fictions* (London: Routledge, 1982), 58. This contention is also criticized by Noël Carroll in *Mystifying Movies*, 119–127.

26. Noël Burch, "Narrative/Diegesis—Thresholds, Limits," *Screen* 23:2 (July–August 1982): 16–33.

27. Christian Metz, *The Imaginary Signifier: Psychoanalysis and Cinema*, trans. Ben Brewster (Bloomington: Indiana University Press, 1982), 49.

Bibliography

Abel, Richard. *French Film Theory and Criticism: A History/Anthology, 1907–1939*. Princeton: Princeton University Press, 1988.

———. "On The Threshold of French Film Theory and Criticism, 1915–1919." *Cinema Journal* 25, no.1 (Fall 1995): 12–29.

Aitken, Ian. *Alberto Cavalcanti: Realism, Surrealism and National Cinemas*. London: Flicks, 2000.

———. "Distraction and Redemption: Kracauer, Surrealism and Phenomenology." *Screen* 39, no. 2 (Summer 1998).

———. *European Film Theory and Cinema: A Critical Introduction*. Edinburgh: Edinburgh University Press, 2001.

Alekan, Henri. *Des lumières et des ombres*. Paris: Le Sycamore, 1984.

Allen, Richard. *Projecting Illusion: Film Spectatorship and the Impression of Reality*. Cambridge: Cambridge University Press, 1995.

Alpers, Svetlana. *The Art of Describing: Dutch Art in the Seventeenth Century*. Chicago: University of Chicago Press, 1983.

Alpers, Svetlana, and Paul Alpers. "Ut Pictura Noesis? Criticism in Literary Studies and Art History." *New Literary History* 3 (Spring 1972): 437–458.

Andrew, Dudley. *André Bazin*. Foreword by François Truffaut. New York: Oxford University Press, 1978.

———. "Cognitivism: Quests and Questionings." *Iris: A Journal of Theory on Image and Sound*, no. 9 (Spring 1989).

———. *Film in the Aura of Art*. Princeton: Princeton University Press, 1984.

———. *The Major Film Theories: An Introduction*. London: Oxford University Press, 1976.

Andrew, Dudley, with Sally Shafto, eds. *The Image in Dispute: Art and Cinema in the Age of Photography*. Austin: The University of Texas Press, 1997.

Arnheim, Rudolf. *Art and Visual Perception*. Berkeley: University of California Press, 1954.

———. "The Center Surviving Mondrian." *Journal of Aesthetics and Art Criticism* 44, no. 3 (Spring 1986): 292–293.

———. "The Completeness of Physical and Artistic Form." *British Journal of Aesthetics* 32, no. 2 (April 1994): 109–114.

———. "Composites of Media: The History of an Idea." *Michigan Quarterly Review* 38, no. 4 (Fall 1999): 558–563.

———. *Entropy and Art: An Essay on Disorder and Order*. Berkeley: University of California Press, 1971.

———. *Film as Art*. Berkeley: University of California Press, 1957.

———. *Film Essays and Criticism*. Translated by Brenda Benthien. Madison: University of Wisconsin Press, 1997.

———. *The Genesis of a Painting: Picasso's* Guernica. Berkeley: University of California Press, 1962.

———. *The Power of the Center: A Study of Composition in the Visual Arts*. Berkeley: University of California Press, 1982.

————. *The Split and the Structure: Twenty-Eight Essays.* Berkeley: University of California Press, 1994.

————. *To the Rescue of Art: Twenty-Six Essays.* Berkeley: University of California Press, 1992.

————. *Visual Thinking.* Berkeley: University of California Press, 1969.

"Art and Film." *Art & Design:* Profile No. 49. London: Academy Editions, 1996.

Ash, Mitchell G. *Gestalt Psychology in German Culture, 1890–1967: Holism and the Quest for Objectivity.* Cambridge: Cambridge University Press, 1995.

Astruc, Alexandre. "The Birth of a New Avant-Garde: La Caméra-Stylo." In *The New Wave,* edited by Peter Graham, 17–23. Garden City, N.Y.: Doubleday, 1968.

Aubenas, Jacqueline, ed. *Le Film sur l'art en Belgique, 1927–1991.* Brussels: Centre du Film sur L'Art, 1992.

Aumont, Jacques. *La Couleur en cinéma.* Milan and Paris, 1995.

————. *Du visage au cinéma.* Paris: Editions de L'Etoile, 1992.

————. *The Image.* London: British Film Institute, 1997.

————. "The Importance of the Text in Rohmer, Eric, *L'Ami de mon amie."* *Avant-Scène de Cinéma* 366 (December 1987): 3–12.

————. *Introduction à la couleur: Des discours aux images.* Paris: Armand Colin, 1994.

————. *Montage Eisenstein.* London: British Film Institute and Indiana University Press, 1979.

————. *L'Oeil interminable: cinéma et peinture.* Paris: Séguier, 1989.

————, ed. *L'Invention de la figure humaine: le cinéma, l'humain et l'inhumain.* Conférences du Collège d'histoire de l'art cinématographique, no. 8. Paris: Cinémathèque française, Musée du cinéma, 1995.

Aumont, Jacques, Alain Bergala, Michel Marie, and Marc Vernet, eds. *Aesthetics of Film.* Translated by Richard Neupert. Austin: University of Texas Press, 1992.

Balázs, Béla. *Schriften zum Film,* 1. [Includes *Der sichtbare Mensch* and a generous selection of articles from 1922 to 1926.] Munich: Carl Hanser Verlag, 1982.

————. *Theory of the Film: Character and Growth of a New Art.* Translated by Edith Bone. New York: Roy, 1953.

Bann, Stephen. *The True Vine: On Visual Representation and the Western Tradition.* Cambridge and New York: Cambridge University Press, 1989.

Barlow, John. *German Expressionist Film.* Boston, Mass.: Twayne, 1982.

Barna, Yon. *Eisenstein.* London: Secker & Warburg, 1973.

Barr, Alfred H. "The Researches of Eisenstein." *Drawing and Design* 4, no. 24 (June 1928): 155–156.

————. "S. M. Eisenstein." *The Arts* 14, no. 6 (December 1928): 316–321.

Bataille, Georges. *Visions of Excess: Selected Writings, 1927–1939.* Translated by Allan Stoekl. Minneapolis: University of Minnesota Press, 1985.

Batchelor, David. *Chromophobia.* London: Reaktion, 2000.

Bazin, André. *Bazin at Work: Major Essays and Reviews from the Forties and the Fifties.* Translated by Alain Piette and Bert Cardullo. New York: Routledge, 1997.

————. *What Is Cinema?* Vol. 1. Foreword by Jean Renoir. Essays selected and translated by Hugh Gray. Berkeley: University of California Press, 1967.

————. *What Is Cinema?* Vol. 2. Foreword by François Truffaut. Essays selected and translated by Hugh Gray. Berkeley: University of California Press, 1971.

Bellour, Raymond. *L'Entre-images: Photos, cinéma, video.* Paris: La Différence, 1990.

————. "I Am an Image." Translated by S. Suleiman. *Camera Obscura,* nos. 8–10 (Fall 1982): 117–123.

————, ed. *Cinéma et peinture: Approches.* Écritures et arts contemporains. Paris: Presses Universitaires de France, 1990.

———— with Mary Lea Bandy, eds. *Jean-Luc Godard: Son-Image 1974–1991.* New York: Museum of Modern Art; distributed by Harry N. Abrams, 1992.

————, et al., eds. *Passages de l'image.* Translated into Catalan, English, and Spanish from the original French. Barcelona: Centre Culturel de la Fundació Caixa de Pensions, 1990.

Belting, Hans. *The End of Art History.* Translated by Christopher S. Wood. Chicago: University of Chicago Press, 1987.

————. *Likeness and Presence: A History of the Image before the Era of Art.* Chicago: University of Chicago Press, 1994.

Benjamin, Walter. "Eduard Fuchs: Collector and Historian." In *The Essential Frankfurt School Reader,* edited by A. Arato and Eike Gebhardt, 225–253. New York: Urizen Books, 1978.

————. *Illuminations.* Edited and with an introduction by Hannah Arendt; translated by Harry Zohn. New York: Schocken, 1968.

————. *Reflections: Essays, Aphorisms, Autobiographical Writing.* 1978. New York: Schocken, 1986.

————. "A Small History of Photography" (1931). In *One-Way Street and Other Writings,* trans by Edmund Jephcott and Kingsley Shorter. London and New York: Verso, 1979, pp. 240–257.

Berger, John. *Ways of Seeing.* London: Penguin, 1983.

Bettini, Maurizio. *The Portrait of the Lover.* Translated from the Italian by Laura Gibbs. Berkeley and Los Angeles: University of California Press, 1999.

Bois, Yves-Alain, and Rosalind Krauss, eds. *Formless: A User's Guide.* New York: Zone, 1997.

Bolter, Jay David, and Richard Grusin. *Remediations: Understanding New Media.* Cambridge, Mass.: MIT Press, 2000.

Bonitzer, Pascal. *Décadrages: Peinture et cinéma.* Paris: Cahiers du Cinéma: Éditions de L'Étoile, 1985.

Borchardt, Edith. "Eric Rohmer's *Marquise of O* and the Theory of the German Novella." *Literature/Film Quarterly* 12, no. 2 (1984): 129–135.

Bordwell, David. *The Cinema of Eisenstein.* Cambridge, Mass.: Harvard University Press, 1993.

————. *Film Art: An Introduction.* New York: McGraw-Hill, 1997.

————. *French Impressionist Cinema: Film Culture, Film Theory and Film Style.* New York: Arno, 1980.

————. *On the History of Film Style.* Cambridge, Mass.: Harvard University Press, 1997.

Boschi, Alberto. *Teorie del cinema: Il periodo classico 1915–1945.* Rome: Carocci, 1998.

Bourget, J.-L. "En relisant Panofsky." *Positif* 259 (September 1982): 38–43.

Braudy, Leo, and Marshall Cohen. *Film Theory and Criticism: Introductory Readings.* 5th ed. New York: Oxford University Press, 1999.

Bredekamp, Horst. *The Lure of Antiquity and the Cult of the Machine: The Kunstkammer and the Evolution of Nature, Art and Technology.* Princeton: Markus Wiener, 1995.

Brender, Richard. "Functions of Film: Léger's Cinema on Paper and on Cellulose, 1913–1925." *Cinema Journal* 24, no. 1 (Fall 1984): 41–64.

Brennan, Teresa, and Martin Jay, eds. *Vision in Context: Historical and Contemporary Perspectives on Sight.* New York: Routledge, 1996.

Bresson, Robert. *Notes sur le cinématographe.* Paris: Gallimard, 1975.

Breteau, Gisèle. *Abécédaire des films sur l'art moderne et contemporain, 1905–1984.* Paris: Centre national des arts plastiques, Centre Georges Pompidou, 1985.

Brougher, Kerry. *Hall of Mirrors: Art and Film since 1945.* Exhibition catalogue. With essays by Jonathan Crary, et al. Los Angeles, Calif.: Museum of Contemporary Art, 1996.

Brubaker, David. "André Bazin on Automatically Made Images." *Journal of Aesthetics and Art Criticism* 51, no. 1 (Summer 1993): 59–67.

Bruno, Giuliana. *Atlas of Emotions: Journeys through Film, Art, and Architecture.* New York: Verso, 2002.

Bryson, Norman. "Intertextuality and Visual Poetics." *Style* 22, no. 2 (Summer 1988): 183–193.

Bryson, Norman, Michael Ann Holly, and Keith Moxey, eds. *Visual Theory: Painting and Interpretation.* New York: HarperCollins, 1991.

Buchloh, Benjamin H. D. "Filmographie: Filme von Kunstlern 1960–1974/Filmography: Films by Artists 1960–1974." *Interfunktionen,* no. 12 (1975): 85–95.

Budd, Mike, ed. *The Cabinet of Dr. Caligari: Texts, Contexts, Histories.* New Brunswick, N.J.: Rutgers University Press, 1990.

Burch, Noël. *Life to Those Shadows.* Translated and edited by Ben Brewster. Berkeley: University of California Press, 1990.

Bürger, Peter. *Theory of the Avant-Garde.* Translated by Michael Shaw. Minneapolis: University of Minnesota Press, 1984.

Buscombe, Edward. "Painting the Legend: Frederic Remington and the Western." *Cinema Journal* 23, no. 4 (Summer 1984): 12–27.

Campari, Roberto. *Il Fantasma del bello: Iconologia del cinema italiano.* Venice: Marsilio, 1994.

Canudo, Ricciotto. "Chronique du septième art: Films en couleurs." *Paris-Midi,* no. 4131 (13 August 1923).

————. *L'Officina delle immagini.* Rome: Edizioni di Bianco e Nero, 1966.

Carroll, Joseph. *The Cultural Theory of Matthew Arnold.* Berkeley: University of California Press, 1982.

Carroll, Noël. "Film/Mind Analogies: The Case of Hugo Münsterberg." *Journal of Aesthetics and Art Criticism* 66, no. 4 (Summer 1998): 489–499.

———. *Philosophical Problems of Classical Film Theory.* Princeton: Princeton University Press, 1988.

———. *Theorizing the Moving Image.* New York: Cambridge University Press, 1996.

———, ed. *Theories of Art Today.* Madison: University of Wisconsin Press, 2000.

"Cartoon: Caricature: Animation." Special issue. *Art History* 18, no. 1 (March 1995).

Cassirer, Ernst. *The Philosophy of Symbolic Forms.* 3 vols. New Haven, Conn.: Yale University Press, 1972.

Cavell, Stanley. *The World Viewed: Reflections on the Ontology of Film.* New York: Viking, 1971.

Charney, Leo, and Vanessa Schwarz, eds. *Cinema and the Invention of Modern Life.* Berkeley: University of California Press, 1995.

Christie, Ian, and Philip Dodd, eds. *Spellbound: Art and Film.* London: British Film Institute/Hayward Gallery, 1996.

"Cinema and Cognitive Psychology." Special issue. *Iris: A Journal of Theory on Image and Sound,* no. 9 (Spring 1989).

"Il Cinema e le altre arti." *Cinergie.* Udine: Editrice Universitaria Udine, 1999.

Clark, T. J. "J.-L. David with the Swollen Cheek: An Essay on Self-Portraiture." In *Rediscovering History: Culture, Politics, and the Psyche,* edited by Michael S. Roth. Stanford, Calif.: Stanford University Press, 1994.

Coelho, René. Introduction to *Imago, Fin-de-siècle in Dutch Contemporary Art.* Amsterdam: Rijksdienst Beeldende Kunst/Mediamatic, n.d.

Cogéval, Guy, and Dominique Païni. *Hitchcock and Art: Fatal Coincidences.* Montreal: The Montreal Museum of Fine Arts/Milan: Mazzotta, 2001.

Cohen, Ralph, ed. *Studies in 18th Century British Art and Aesthetics.* Berkeley: University of California Press, 1985.

Conley, Tom. "Portrayals of Painting: Translations of *Vivre sa Vie.*" *Film Reader* 3 (1978): 169–179.

Costa, Antonio. *Cinema e pittura.* Torino: Loescher, 1991.

———, ed. *Carlo L. Ragghianti: I Critofilm d'arte.* Udine: Campanotto Editore, 1995.

Covert, Nadine, Vivian Wick, and Elizabeth Scheines, eds. *Art on Screen: A Directory of Films and Videos about the Visual Arts.* Boston: G. K. Hall, 1992; distributed by Gale Group.

Crafton, Donald. *Emil Cohl, Caricature and Film.* Princeton: Princeton University Press, 1990.

Crary, Jonathan. *Techniques of the Observer: On Vision and Modernity in the Nineteenth Century.* Cambridge, Mass.: MIT Press, 1990.

———. *Suspensions of Perception: Attention, Spectacle, and Modern Culture.* Cambridge, Mass.: MIT Press, 2002.

Crawford, Larry. "Looking, Film, Painting: The Trickster's in Site/In Sight/Insight/Incite." *Wide Angle* 5, no. 3 (1983): 64–69.

Crow, Thomas E. *Modern Art in the Common Culture.* New Haven, Conn.: Yale University Press, 1996.

Dagrada, Elena. "Cinema and the Other Arts." *Bibliographie internationale du cinéma des premiers temps/International Bibliography of Early Cinema,* 69–72. 2nd ed. Quebec: Domitor, 1995.

Dalle Vacche, Angela. *Cinema and Painting: How Art Is Used in Film.* Austin: University of Texas Press, 1996.

Damisch, Hubert. "Cinema and Painting." *Cahiers du Cinema* 386 (July–August 1986): 26–32.

———. *Théorie du nuage: Pour une histoire de la peinture.* Paris: Editions du Seuil, 1972.

Debord, Guy. *Society of the Spectacle.* New York: Zone, 1994.

Debray, Régis. *Vie et mort de l'image: Une histoire du regard en Occident.* Paris: Gallimard, 1992.

De Gaetano, Roberto. *Il Cinema secondo Deleuze.* Rome: Bulzoni, 1996.

———, ed. *Pensare il cinema.* Rome: Bulzoni, 1993.

De Haas, Patrick. *Cinéma intégral: De la peinture au cinéma dans les années vingt.* Paris: Transéditions, 1985.

de Lauretis, Teresa, and Stephen Heath, eds. *The Cinematic Apparatus.* London: Macmillan, 1980.

Deleuze, Gilles. *Cinema.* Vol. 1: *The Movement-Image.* Translated by Hugh Tomlinson and Barbara Habberjam. Minneapolis: University of Minnesota Press, 1986.

————. *Cinema.* Vol 2: *The Time-Image.* Translated by Hugh Tomlinson and Barbara Habber-
jam. Minneapolis: University of Minnesota Press, 1989.

————. *The Deleuze Reader.* Edited and with an introduction by Constantin V. Boundas. New
York: Columbia University Press, 1993: "Nomad Art: Space," 165–172; "Cinema and Space:
The Frame," 173–179; "Cinema and Time," 180–186; "Painting and Sensation," 187–192;
"The Diagram," 195–200.

————. *The Fold: Leibniz and the Baroque.* Foreword and translation by Tom Conley. Minne-
apolis: University of Minnesota Press, 1993.

————. *Francis Bacon: Logique de la Sensation.* Paris: Éditions de la Différence, 1981.

Deleuze, Gilles, and Félix Guattari. *Mille Plateaux.* Paris: Edition de Minuit, 1978.

Delluc, Louis. *Le Cinéma au quotidien.* Edited by Pierre Lherminier. Paris: Editions de l'Etoile/
Cahiers du Cinéma, 1990.

————. *Cinéma et compagnie.* Écrits cinématographique II. Paris: Cinémathèque Française, 1986.

De Man, Paul. *Blindness and Insight: Essays in the Rhetoric of Contemporary Criticism.* New
York: Oxford University Press, 1971; Minneapolis: University of Minnesota Press, 1983.

Derrida, Jacques. *Memoirs of the Blind: The Self-Portrait and Other Ruins.* Translated by Pascale-
Anne Brault and Michael Naas. Chicago and London: University of Chicago Press, 1993.

De Santi, Pier Marco. *Cinema e pittura.* Art Dossier, no. 16. Florence: Giunti, 1987.

————, ed. *I disegni di Eisenstein.* Grandi Opere. Rome/Bari: Laterza, 1981.

————. "Pasolini fra cinema e pittura." *Bianco e Nero* 46, no. 3 (July–September 1985): 6–23.

Deutelbaum, Marshall. "The Birth of Venus" and "The Death of Romantic Love" in *Out of the
Past. Literature and Film Quarterly* 15, no. 3 (1987).

Diderot, Denis. *Diderot on Art.* Translated by John Goodman; introduction by Thomas Crow.
New Haven, Conn.: Yale University Press, 1995.

Didi-Huberman, Georges. *Devant l'image: Question posée aux fins de l'histoire de l'art.* Paris:
Éditions de Minuit, 1990.

Dilly, Heinrich. *Ging Cézanne ins Kino?* Ostfildern: Edition Tertium, 1996.

"Distractions: A Dossier on Weimar Culture." Special issue. *Qui Parle* 5, no. 2 (Spring–Summer
1992).

Doss, Erika L. "Edward Hopper, Nighthawks, and Film Noir." *Post-Script: Essays in Film and
the Humanities* 2, no. 2 (Winter 1983): 14–36.

Dulac, Germaine. "Les procédés expressifs du cinématographe." *Ciné-magazine,* 11 July 1924.

Duro, Paul, ed. *The Rhetoric of the Frame: Essays on the Boundaries of the Artwork.* Cambridge:
Cambridge University Press, 1996.

Edgerton, Gary R. *Film and the Arts in Symbiosis: A Resource Guide.* New York: Greenwood,
1988.

Ehrenzweig, Anton. *The Psycho-analysis of Artistic Vision and Hearing.* London: Routledge, 1999.

Ehrlich, Linda C. "Interior Gardens: Victor Erice's *Dream of Light* and the Bodegón Tradition."
Cinema Journal 34, no. 2 (Winter 1995): 22–36.

Ehrlich, Linda C., and David Desser, eds. *Cinematic Landscapes: Observations on the Visual
Arts and Cinema of China and Japan.* Austin: University of Texas Press, 1994.

Ehrlich, Victor. *Russian Formalism: History, Doctrine.* London: Mouton, 1965.

Eidsvik, Charles. *Cineliteracy: Film among the Arts.* New York: Horizon, 1978.

Eisenstein, Sergei M. *Beyond the Stars: The Memoirs of Sergei Eisenstein.* Translated by Richard
Taylor. Calcutta: Seagull, 1995. French edition: *Mémoires,* 3, tr. fr. UGA, coll. 10/18, 1985.

————. *Film Form.* Translated and edited by Jay Leyda. New York: Harcourt Brace, 1977.

————. *The Film Sense.* Translated and edited by Jay Leyda. New York: Harcourt Brace, 1975.

————. *Nonindifferent Nature: Film and the Structure of Things.* Translated by Herbert Mar-
shall. Cambridge and New York: Cambridge University Press, 1987.

————. *Notes of a Film Director.* New York: Dover, 1970.

————. "Rodin et Rilke: Le problème de l'espace dans les arts représentatifs" [1945]. In *Ciné-
matisme: Peinture et cinéma,* 249–282. Brussels: Éditions Complexes, 1980.

Eisner, Lotte H. *The Haunted Screen.* Berkeley and Los Angeles: The University of California
Press, 1977.

Eitner, Lorenz. "The Open Window and the Storm-Tossed Boat: An Essay in the Iconography of
Romanticism." *Art Bulletin* 37 (December 1995): 281–290.

Elkins, James. *The Object Stares Back: On the Nature of Vision.* New York: Simon and Schus-
ter, 1996.

————. *Why Are Our Pictures Puzzles?* New York: Routledge, 1999.

Elliott, David. *New Worlds: Russian Art and Society 1900–1937.* New York: Rizzoli, 1986.

———, introd. *The Director's Eye: Drawings and Photographs by European Filmmakers.* Oxford, England: Museum of Modern Art, n.d.

Elsaesser, Thomas. "Peter Greenaway." In *Spellbound: Art and Film,* edited by Ian Christie and Philip Dodd. London: British Film Institute/Hayward Gallery, 1996.

———. "Le Portrait peint au cinéma: Mirror, Muse, Medusa." *Iris* 14–15 (1992): 147–160.

———. "Rivette and the End of Cinema." *Sight and Sound* (April 1992): 20–23.

Epstein, Jean. *Bonjour Cinéma.* Translated by Chiara Mezzaluna. Rome: Edizioni Fahrenheit 451, 2000.

———. *Écrits sur le cinéma, 1921–1953.* 2 vols. Paris: Séghers, 1974–1975.

Fagioli, Marco. "Akira Kurosawa e la tradizione della pittura giapponese." In "Akira Kurosawa: Premio Fiesole: Maestri del cinema 1986: Convegno di studi: "Akira Kurosawa, le radici e i ponti"; Villa la Torraccia, S. Domenico di Fiesole, 7–8 June 1986. Fiesole, 1988.

Farber, Manny. *Manny Farber.* [Exhibition at the Museum of Contemporary Art, Los Angeles.] Los Angeles: Museum of Contemporary Art, 1985.

Faure, Elie. *Fonction du cinéma: De la cinéplastique à son destin social (1921–1937).* Preface by Charles Chaplin.1953. Reprint, Paris: Gonthier, 1963.

Felleman, Susan. *Botticelli in Hollywood.* New York: Twayne, 1997.

Ferguson, George. *Signs and Symbols in Christian Art.* London: Oxford University Press, 1989.

Ferretti, S. *Cassirer, Panofsky and Warburg: Symbol, Art and History.* Translated by Richard Pierce. New Haven, Conn.: Yale University Press, 1989.

Flint, R.W., ed. *Marinetti: Selected Writings.* New York: Farrar, Straus, and Giroux, 1972.

Flitterman-Lewis, Sandy. "Magic and Wisdom in Two Portraits by Agnès Varda: *Kung Fu Master* and *Jane B. by Agnes V.*" *Screen* 34, no. 4 (Winter 1993): 302–320.

Foster, Hal, ed. *Discussions in Contemporary Culture.* New York: Dia Art Foundation, 1987.

Foucault, Michel. "Las Meninas." In *The Order of Things: An Archeology of the Human Sciences,* 3–16. 1971. Reprint, New York: Vintage, 1994.

Frabotta, Maria Adelaide, Nadia Fusini, and Anne-Marie Boetti, eds. *Cinema, letteratura ed arti visive.* Milan: Gulliver, 1979.

Frascina, Francis, ed. *Pollock and After: The Critical Debate.* New York: Harper and Row, 1985.

Freud, Sigmund. *Psychopathology of Everyday Life.* Authorized English edition, with introduction by A. A. Brill. New York: New American Library, 1951.

Fried, Michael. *Absorption and Theatricality: Painting and Beholder in the Age of Diderot.* Berkeley: University of California Press, 1980.

———. *Art and Objecthood: Essays and Reviews.* Chicago: University of Chicago Press, 1998.

Furniss, Maureen. *Art in Motion: Animation Aesthetics.* Sidney: John Libbey, 1998.

Gallagher. Steve, ed. *Picture This: Films Chosen by Artists.* Buffalo: Hallwalls, 1987.

Gardner, Paul. "Light, Canvas, Action! When Artists Go to the Movies!" *ARTnews* 93, no. 10 (December 1994): 124–129.

Ghali Noureddine. *L'Avant-garde cinématographique en France dans les années vingt.* Paris: Editions Paris Experimental, 1995.

Godard, Jean-Luc. *Histoire(s) du cinéma.* Paris: Gallimard, 1998; Gaumont, 1998 imprimé en Italie.

Gombrich, Ernst H. *Art and Illusion: A Study in the Psychology of Pictorial Representation.* Bollingen series 35, 5. 1961. Millennium edition. Princeton: Princeton University Press, 2000.

———. *The Image and the Eye: Further Studies in the Psychology of Pictorial Representation.* Ithaca, N.Y.: Cornell University Press, 1982.

———. "Psychoanalysis and the History of Art." *Journal of Psychoanalysis* 35 (1954): 1–11.

Graebner, William. *The Age of Doubt: American Thought and Culture in the 1940's.* Boston: Twayne, 1991.

Greenberg, Clement. *Art and Culture: Critical Essays.* Boston: Beacon, 1989.

Grierson, John. "Flaherty, Naturalism and the Problem of the English Cinema." *Artwork* (Autumn 1931).

Hake, Sabine, ed. *The Cinema's Third Machine: Writing on Film in Germany 1907–1933.* Lincoln: University of Nebraska Press, 1993.

Hall, James. *Dictionary of Subjects and Symbols in Art.* New York: Harper and Row/Icon Editions, 1979.

Harms, Rudolf. *Philosophie des films.* 1926. Reprint, Zurich: Hans Rohr, 1970.

Harrison, Charles, and Paul Wood, with Jason Gaiger. *Art in Theory: 1815–1900: An Anthology of Changing Ideas.* Oxford, England: Blackwell, 1998.

Hart, Joan. "Heinrich Wölfflin: An Intellectual Biography." Ph.D. diss., University of California at Berkeley, 1981.

———. "Reinterpreting Wölfflin: Neo-Kantianism and Hermeneutics." *Art Journal* 42, no. 4 (Winter 1982): 292.

Hartman, George W. *Gestalt Psychology: A Survey of Facts and Principles.* New York: Ronald, 1935.

Hauptman, Jodi. *Joseph Cornell: Stargazing in the Cinema.* New Haven, Conn.: Yale University Press., 1999.

Hauser, Arnold. *The Social History of Art.* 3rd ed. Vol. 4, *Naturalism, Impressionism, The Film Age.* London and New York: Routledge, 1999.

———. *The Social History of Art.* 3rd ed. Vol. 3, *Rococo, Classicism and Romanticism.* London and New York: Routledge, 1999.

Hayward, Philip, ed. *Picture This: Media Representations of Visual Arts and Artists.* 2nd rev. ed. Luton, Bedfordshire: University of Luton Press; London: Arts Council of England, 1998.

Hedges, Inez. *Breaking the Frame: Film Language and the Experience of Limits.* Bloomington: Indiana University Press, 1991.

Heinich, Nathalie. "Tableaux filmés." *Cahiers du Cinéma,* no. 308 (February 1980): 35–40.

Hollander, Anne. *Feeding the Eye.* Berkeley: University of California Press, 2001.

———. *Moving Pictures.* New York: Knopf, 1989.

Howze, William Clell. "The Influence of Western Painting and Genre Painting on the Films of John Ford." Ph.D. diss., University of Texas, Austin, 1986. Abstract in *Dissertation Abstracts International* 48 (10) (1988): 2475A.

Iles, Chrissie. *Scream and Scream Again: Film in Art.* Oxford, England: Museum of Modern Art, 1996.

Iversen, Margaret. *Alois Riegl: Art History and Theory.* Cambridge, Mass.: MIT Press, 1993.

———. "Politics and the Historiography of Art History: Wölfflin's Classic Art." *Oxford Art Journal* (July 1981): 31–34.

———. "Style as Structure: Alois Riegl's Historiography." *Art History* 2, no. 1 (March 1979): 62–71.

Jarman, Derek. *Derek Jarman: A Portrait.* Introduction by Roger Wollen, with various contributions. London: Thames and Hudson, 1996.

Jay, Martin. *Downcast Eyes: The Denigration of Vision in Twentieth-Century French Thought.* Berkeley: University of California Press, 1993.

———. *Permanent Exiles: Essays on Intellectual Migration from Germany to America.* New York: Columbia University Press, 1985.

Kaes, Anton, Martin Jay, and Edward Dimendberg, eds. *The Weimar Republic Sourcebook.* Berkeley: University of California Press, 1994.

Kemp, Wolfgang. "Death at Work: A Case Study of Constitutive Blanks in Nineteenth-Century Painting." *Representations* 10 (Spring 1985): 102–123.

Kirby, Lynne. "Fassbinder's Debt to Poussin." *Camera Obscura* 13–14 (Spring–Summer 1985): 5–27.

———. "Painting and Cinema: The Frames of Discourse." [Review of Pascal Bonitzer's *Décadrages: Peinture et cinéma*]. *Camera Obscura* 18 (1988): 95–106.

Kittler, Friedrich. *Literature, Media, Information Systems.* Edited by John Johnston. Amsterdam: G+B Arts International, 1997.

Kleinman, Kent, and Leslie Van Duzer, eds. *Rudolf Arnheim: Revealing Vision.* Ann Arbor: University of Michigan Press, 1997.

Koch, Gertrud. "Béla Balázs: The Physiognomy of Things." *New German Critique,* no. 40 (1987).

———. *Siegfried Kracauer: An Introduction.* Translated by Jeremy Gaines. Princeton: Princeton University Press, 2000.

Koerner, Joseph Leo. *Caspar David Friedrich and the Subject of Landscape.* New Haven, Conn.: Yale University Press, 1990.

Koffka, Kurt. *Principles of Gestalt Psychology.* New York: Harcourt, Brace, 1935.

Köhler, Wolfgang. *Gestalt Psychology: An Introduction to New Concepts in Modern Psychology.* New York: Liveright, 1947.

Körner, Stephan. *Kant.* London: Penguin, 1964.

Kracauer, Siegfried. *From Caligari to Hitler: A Psychological History of the German Film.* Princeton: Princeton University Press, 1974.

————. *Theory of Film: The Redemption of Physical Reality.* London, Oxford, and New York: Oxford University Press, 1978.

Kral, Petr. "De l'image au regard: Les peintres de l'imaginaire et ses cinéastes." *Positif,* nos. 353–354 (July–August 1990): 68–77.

Krauss, Rosalind. "'. . . And then turn away?': An Essay on James Coleman (Coleman's film still projects and the specificity of mediums in post-conceptual art)." *October* 81 (Summer 1997): 5–33.

————. *The Optical Unconscious.* Cambridge, Mass.: MIT Press, 1993.

————. *The Originality of the Avant-Garde and Other Modernist Myths.* 1985. Cambridge, Mass.: MIT Press, 1997.

————. *"A Voyage on the North Sea": Art in the Age of the Post-Medium Condition.* London: Thames and Hudson, 2000.

Kuenzli, Rudolph E., ed. *Dada and Surrealist Film.* New York: Willis, Locker & Owens, 1987; Cambridge, Mass.: MIT Press, 1996.

Kultermann, Udo. *The History of Art History.* New York: Abaris, 1993.

Lant, Antonia. "Haptical Cinema." *October* 74 (Fall 1995): 45–73.

Larrabee, Harold A., ed. *Selections from Bergson.* New York: Appleton-Century-Crofts, 1949.

Lavin, Maud, Annette Michelson, Christopher Phillips, Sally Stein, Matthew Teitelbaum, and Margarita Tupitsyn. *Montage and Modern Life 1919–1942.* Boston: MIT Press and ICA, 1992.

Lawder, Standish. *Cubist Cinema.* New York: New York University Press, 1975.

Lawton, Anna, ed. *The Red Screen: Politics, Society, Art in Soviet Cinema.* London and New York: Routledge, 1992.

Legrand, Gerard. "De l'espace du tableau à l'espace filmique: Formes symbolique et mouvement du regard." *Positif,* nos. 353–354 (July–August 1990): 60–67.

Lemaitre, Henri. *Beaux-arts et cinéma.* Paris: Les Editions du Cerf, 1956.

Leppert, Richard. *Art and the Committed Eye: The Cultural Functions of Imagery.* Boulder, Colo.: Westview, 1996.

Lessing, Gotthold Ephraim. *Laocoön: An Essay on the Limits of Painting and Poetry.* Translated with an introduction and notes by Edward Allen McCormick. Baltimore: Johns Hopkins University Press, 1984.

Leutrat, Jean-Louis. "The Declension." In *Jean-Luc Godard Son-Image 1974–1991,* edited by Raymond Bellour, 24–34. New York: Museum of Modern Art; distributed by Harry N. Abrams, 1992.

————. *Kaleidoscope: Analyses des films.* Lyon: Presses Universitaires de Lyon, 1988.

————. "Traces That Resemble Us: Godard's Passion," *Sub-Stance,* no. 51 (1986): 36–51.

Leutrat, Jean-Louis, and M. Bouvier. *Nosferatu.* Paris: Gallimard, 1981.

Levin, David Michael. *Modernity and the Hegemony of Vision.* Berkeley: University of California Press, 1993.

————, ed. *Sites of Vision: The Discursive Construction of Site in the History of Philosophy.* Cambridge, Mass.: MIT Press, 1997.

Levin, Thomas Y., trans., ed., and introd. *The Mass Ornament: Weimar Essays: Siegfried Kracauer.* Princeton: Princeton University Press, 1995.

————. "Walter Benjamin and the Theory of Art History: An Introduction to 'Rigorous Study of Art.'" *October* 47 (Winter 1988): 77–83.

Levine, Steven Z. "Monet, Lumière, and Cinematic Time." *Journal of Aesthetics and Art Criticism* 36, no. 4 (Summer 1978): 441–447.

Lewis, Brian. *Jean Mitry and the Aesthetics of Cinema.* Ann Arbor: UMI Research Press, 1984.

L'Herbier, Marcel. "Idées d'un peintre sur le cinéma." *L'Intelligence du cinématograph.* Paris: Éditions Corréa, 1946.

Lindsay, Vachel. *The Art of the Moving Picture.* New York: Macmillan, 1915; New York: Liveright, 1970.

Luciani, Sebastiano Arturo. *Il cinema e le arti.* Taranto: Barbieri, 2001.

Lyons, Deborah. *Edward Hopper and the American Imagination.* New York: Whitney Museum of American Art; in association with W. W. Norton, 1995.

Malraux, André. *Esquisse d'une psychologie du cinéma.* Paris: Gallimard, 1946.

————. *Le Musée imaginaire de la sculpture mondiale.* 3 vols. Paris: Gallimard, 1952–1954.

————. *A Museum without Walls.* London: Secker & Wazburg, 1967.

Manovich, Lev. *The Language of New Media.* Cambridge, Mass.: MIT Press, 2000.

Marin, Louis. *To Destroy Painting*. Translated by Mette Hjort. Chicago: University of Chicago Press, 1995.

———. "Towards a Theory of Reading the Visual Arts: Poussin's *The Arcadian Shepherds*." In *Calligram: Essays in the New History of Art from France*, edited by Norman Bryson. Cambridge, Cambridgeshire, and New York: Cambridge University Press, 1988.

Marks, Laura. *The Skin of the Film: Intercultural Cinema, Embodiment, and the Senses*. Durham: Duke University Press, 2000.

Masson, Alain. "Le geste, en peinture et sur l'écran." *Positif*, nos. 353–354 (July–August 1990): 56–59.

Merleau-Ponty, Maurice. *Sense and Non-Sense*. Translated and with a preface by Hubert L. Dreyfus and Patricia Allen Dreyfus. Evanston, Ill.: Northwestern University Press, 1964.

Metz, Christian. *The Imaginary Signifier: Psychoanalysis and Cinema*. Bloomington: Indiana University Press, 1982.

Micheli, Sergio. *Lo Sguardo smaliziato: Cinema e arte figurativa: il movimento*. Rome: Bulzoni, 1994.

Michelson, Annette. *Drawing into Film: Directors' Drawings*. Exhibition catalogue. New York: Pace Gallery, 1993.

Michelson, Annette, Patrick Loughney, and Douglas Gomery. *The Art of Moving Shadows*. Exhibition catalogue. Washington, D.C.: National Gallery of Art, 1989.

Milani, Raffaele. *Il Cinema tra le arti: Teorie e poetiche*. Vols. 1 and 2. Modena: Mucchi, 1985.

Minturn, Kent. "Digitally Enhanced Evidence: MoMA's Reconfiguration of Namuth's *Pollock*." *Visual Resources* 17 (2001): 127–145.

———. "Peinture Noire: Abstract Expressionism and Film Noir." In *Film Reader*, 2nd ed., by Alain Silver and James Ursini, 271–309. New York: Limelight, 1999.

Mitchell, W. J. T. *Iconology: Image, Text, Ideology*. Chicago: University of Chicago Press, 1986.

———. *Picture Theory: Essays on Verbal and Visual Representation*. Chicago: University of Chicago Press, 1994.

———. *The Reconfigured Eye: Visual Truth in the Post-Photographic Era*. Cambridge, Mass.: MIT Press, 1992.

Moneti, Guglielmo. *Luciano Emmer*. Il Castoro cinema, 155. Florence: La Nuova Italia, 1991.

Montani, Pietro. *Fuori campo: Studi sul cinema e l'estetica*. Urbino: QuattroVenti, 1993.

———. *L'Immaginazione narrativa: Il Racconto nel cinema oltre i confini dello spazio letterario*. Milan: Guerin, 1999.

———, ed. *Sergei M. Eisenstein: La Natura non-indifferente*. Venice: Marsilio, 1988.

Moore, Rachel O. *Savage Theory: Cinema as Modern Magic*. Durham: Duke University Press, 2000.

Morin, Edgar. *Le cinéma ou l'homme imaginaire*. Paris: Éditions de Minuit, 1958.

Munro, Thomas. *The Arts and Their Interrelations*. New York: The Liberal Press, 1949.

Münsterberg, Hugo. *The Film: A Psychological Study*. 1916. New York: Dover, 1970.

Murray, David J. *Gestalt Psychology and the Cognitive Revolution*. New York: Harvester Wheatsheaf, 1995.

Murray, Timothy. *Like a Film: Ideological Fantasy on Screen, Camera, and Canvas*. London and New York: Routledge, 1993.

Natali, Maurizia. *L'Image-paysage: Iconologie et cinéma*. Paris: Presses Universitaires de Vincennes, 1996.

Ndalianis, Angela. "Traversing the Boundaries: Neo-Baroque Aesthetics and Contemporary Entertainment Media." Ph.D diss., The University of Melbourne, Cinema Studies Program, School of Fine Arts, Classical Studies and Archeology, 1998.

Nemerov, Alexander. "Projecting the Future: Film and Race in the Art of Charles Russell." *American Art* (Winter 1994): 70–89.

Niesluchowski, Warren. *Postcards from Alphaville: Jean-Luc Godard in Contemporary Art, 1963–1992*. Long Island City, N.Y.: P.S.1 Institute of Contemporary Art, 1992.

Nilsen, Vladimir. *The Cinema as Graphic Art*. With an appreciation by S. M. Eisenstein; translated by Stephen Garry, with editorial advice from Ivor Montagu. London: Newnes Ltd., 1937.

O'Brian, John, ed. *Clement Greenberg: The Collected Essays and Criticism*. Chicago: University of Chicago Press, 1986.

Olin, Margaret Rose. *Forms of Representation in Alois Riegl's Theory of Art*. University Park: Pennsylvania State University Press, 1992.

———. "Forms of Respect: Alois Riegl's Concept of Attentiveness." *Art Bulletin* 71, no. 2 (June 1989): 285–299.

———. "Gaze." In *Critical Terms for Art History*, 208–219. Chicago and London: University of Chicago Press, 1996.

———. "Validation by Touch in Kandinsky's Early Abstract Art." *Critical Inquiry* 16, no. 1 (Autumn 1989): 144–172.

Païni, Dominique. "A propos d'un colloque et d'un livre: Le Cinéma et la peinture, le cinéma hait la peinture. Entretien avec Jacques Aumont." *Cahiers du Cinéma*, no. 421 (June 1989): 60–62.

"The Painted Portrait in Film." Special issue. *Iris*, nos. 14–15 (Autumn 1992).

Panofsky, Dora, and Erwin Panofsky. *Pandora's Box*. New York: Pantheon, 1956.

Panofsky, Erwin. *Perspective as Symbolic Form*. Translated and edited by Christopher Wood. New York: Zone, 1991.

———. *Three Essays on Style*. Edited by Irving Lavin, with a memoir by William S. Heckscher. Cambridge, Mass.: MIT Press, 1995.

Parmesani, Loredana. *Art of the Twentieth Century: Movements, Theories, Schools and Tendencies 1900–2000*. Translated by Rhoda Billingsley. Milan: Skira/Giò Marconi, 2000.

Pasolini, Pier Paolo. *Drawings and Paintings*. Compiled and edited by Johannes Reiter and Giuseppe Zigaina. Berkeley/San Francisco: University Art Museum, University of California; Italian Cultural Institute, 1984.

La Persistance des images: Catalogue des restaurations. Paris: Cinémathèque Française, 1996.

Petro, Patrice. *Fugitive Images: From Photography to Video*. Bloomington: Indiana University Press, 1995.

Peucker, Brigitte. *Incorporating Images: Film and the Rival Arts*. Princeton: Princeton University Press, 1995.

"Philosophy and the Histories of Art." Special issue. *Journal of Aesthetics and Art Criticism* 51, no. 3 (Summer 1993).

Pilard, P., and Peter Greenaway. "Peinture et cinéma/Notes de travail pour les livres de Prospero." *Positif*, no. 363 (May 1991): 23–33.

Podro, Michael. *The Critical Historians of Art*. New Haven, Conn.: Yale University Press, 1983.

———. *The Manifold in Perception: Theories of Art from Kant to Hildebrand*. Oxford, England: Clarendon, 1972.

Poggi, Stefano. *Gestalt Psychology: Its Origins, Foundations, and Influence: An International Workshop*. Florence Center for the History and Philosophy of Science, 1989. Florence, Italy: L. S. Olschki, 1994.

Pollock, Griselda. "Artists, Mythologies and Media—Genius, Madness and Art History." *Screen* 21, no. 3 (September–October 1982): 57–96.

———. *Vision and Difference: Femininity, Feminism and Histories of Art*. London and New York: Routledge, 1988.

Preziosi, Donald. *Rethinking Art History: Meditations on a Coy Science*. New Haven, Conn.: Yale University Press, 1989.

———. "Alois Riegl: Leading Characteristics of the Late Roman Kunstwollen" (1893). In *The Art of Art History: A Critical Anthology*, 169–176. New York: Oxford University Press, 1998.

Quaresima, Leonardo, and Laura Vichi, eds. "La decima musa: Il cinema e le altre arti/The Tenth Muse: Cinema and the Other Arts." VI Domitor Conference/VII International Film Studies Conference Proceedings. Udine/Gemona del Friuli, 21–25 March 2000, Dipartimento di Storia e Tutela dei Beni Culturali, Università di Udine. Udine: Forum, 2001.

Ragghianti, Carlo. *Le film sur l'art: Répertoire général international des films sur les arts*. Rome: Edizioni dell'Ateneo, 1953.

Read, Herbert, and Nikos Stangos, eds. *The Thames and Hudson Dictionary of Art and Artists*. Rev. ed. London: Thames and Hudson, 1994.

Rice-Sayre, Laura, and Henry M. Sayre. "Autonomy and Affinity: Toward a Theory for Comparative Arts." In *Bucknell Review: The Arts and Their Interrelations*. Lewisburg: Bucknell University Press; London: Associated University Press, 1979.

Richard, Lionel. "Encyclopédie de l'expressionisme." *Phaidon Encyclopedia of Expressionism: Painting and the Graphic Arts, Sculpture, Architecture, Literature, Drama, the Expressionist Stage, Cinema, Music*. Translated from the French by Stephen Tint. Oxford, England: Phaidon, 1978.

Riegl, Alois. *The Group Portraiture of Holland.* Introduction by Wolfgang Kemp; translations by Evelyn M. Kain and David Britt. Los Angeles, Calif.: Getty Research Center, 1999.

———. *Late Roman Art Industry.* Translated from the original Viennese edition with a foreword and annotations by Rolf Winckes. Rome: G. Bretschneider, 1985.

———. *Problems of Style: Foundations for a History of Ornament.* Translated by Evelyn Kain; annotations, glossary, and introduction by David Castriota; preface by Henri Zerner. Princeton: Princeton University Press, 1992.

Robergé, Gaston. *Eisenstein's Ivan the Terrible: An Analysis.* Calcutta: Chitrabani, 1980.

Robinson, Henry Peach. "Idealism, Realism, Expressionism." In *Classic Essays on Photography,* edited by Alan Trachtenberg. New Haven, Conn.: Leete's Island, 1980.

Rodowick, D. N. *Gilles Deleuze's Time Machine.* Durham: Duke University Press, 1997.

Rodriguez, Hector. "Questions of Chinese Aesthetics: Film Form and Narrative Space in the Cinema of King Hu." *Cinema Journal* 38, no.1 (Fall 1998): 73–97.

Rohdie, Sam. *Antonioni.* London: British Film Institute, 1990.

Rohmer, Eric. *L'Organisation de l'espace dans le "Faust" de Murnau.* Paris: Union Générale d'Éditions, 1977.

———. *The Taste for Beauty.* Translated by Carol Volk. Cambridge, England: Cambridge University Press, 1989.

Rondolino, Gianni. "Painters and Men of the Cinema: Man Ray and Moholy-Nagy." *D'Ars* (Italy) 14, no. 65 (July 1973): 1–21.

———. "Painters and Men of the Cinema: Francis Picabia and Fernand Léger." *D'Ars* (Italy) 14, nos. 66–67 (November–December 1973): 68–81.

Ruiz, Raúl. *Poetics of Cinema.* 3 vols. Translated by Brian Holmes. Paris: Éditions Dis Voir, 1995.

Rush, Michael. *New Media in Late Twentieth-Century Art.* London: Thames and Hudson, 1999.

Scarrocchia, S. *Studi su Alois Riegl.* Bologna: Nuova Alfa, 1986.

Schaeffer, Jean-Marie, et al. *Think Art: Theory and Practice in the Art of Today.* Symposium under the direction of J.-M. Schaeffer. Rotterdam: Witte de With, 1998.

Schiff, Gert, ed. *German Essays on Art History.* Translated by Peter Wortsman. New York: Continuum, 1988.

Schneider Adams, Laurie. *The Methodologies of Art.* New York: HarperCollins, 1996.

Schorske, Carl E. *Fin-de-Siècle Vienna: Politics and Culture.* New York: Vintage, 1981.

Schrader, Paul. *Transcendental Style in Film: Ozu, Bresson, Dreyer.* New York: Da Capo, 1988.

Schwartz, Allen K. "The Impressionism of Elvira Madigan." *Cinema Journal* 8 (Spring 1969): 25–31.

Shafto, Sally. "The Strange Adventure of Jean-Luc Godard: *Ut Pictura Cinema.*" In *First Light,* edited by Robert Haller. New York: Anthology Film Archives, 1998.

Shatskikh, Alexandra. *Kazimir Malevich.* Moscow: Slovo/Slovo, 1996.

———. "Malevich and Film." In *Kazimir Malevich: zhivopis, teoriia,* edited by Dmitrii Vladimirovich Sarabianov. Moscow: Iskusstvo, 1993.

Silver, Alain. "The Fragments of the Mirror: The Use of Landscape in Hitchcock." *Wide Angle* 1, no. 3 (1976): 53–61.

Silverman, Hugh J. *Postmodernism: Philosophy and the Other Arts.* New York: Routledge, 1990.

Simmel, Georg. "La signification esthétique du visage." 1901. French translation in *La Tragédie de la culture,* 137–144. Paris: Rivages, 1988. English edition: *The Conflict in Modern Culture, and Other Essays.* New York: Teachers College, 1968.

Smithson, Robert. *Robert Smithson: The Collected Writings.* Berkeley: University of California Press, 1996.

Sobchack, Vivian. *The Address of the Eye: A Phenomenology of Film Experience.* Princeton: Princeton University Press, 1992.

Souriau, Etienne. *La Correspondence des arts.* Paris: Flammarion, 1947.

Sparshott, Francis. *The Theory of the Arts.* Princeton: Princeton University Press, 1982.

Stafford, Barbara Maria. *Good Looking: Essays on the Virtue of Images.* Cambridge, Mass.: MIT Press, 1996.

———. *Visual Analogy: Consciousness as the Art of Connecting.* Cambridge, Mass.: MIT Press, 1999.

Staller, Natasha. "Méliès' Fantastic Cinema and the Origins of Cubism." *Art History* 12, no. 2 (June 1989): 202–232.

Stauffacher, Frank. "Art in Cinema: A Symposium on the Avantgarde Film Together with Program

Notes and References for Series One of Art in Cinema." San Francisco: Art in Cinema Society, San Francisco Museum of Art, 1947.

Steffen, James. "Paradjanov's Playful Poetics on the 'Director's Cut' of *The Color of Pomegranates.*" *Journal of Film and Video* 47, no. 4 (Winter 1995–1996): 17–32.

Steimatsky, Noa. "Pasolini on *Terra Sancta*: Towards a Theology of Film." *Yale Journal of Criticism* 11, no. 1 (Spring 1998): 239–258.

Steinmetz, Leon. *The World of Peter Greenaway.* Boston: Journey Editions, 1995.

Stindt, Georg-Otto. *Das Lichtspiel als Kunstform.* Bremerhaven: Atlantis Verlag, 1924.

Storr, Robert. "No Stage, No Actors, But It's Theatre (and Art)." *New York Times*, 28 November 1999.

Talbot, Daniel. *Film: An Anthology.* Berkeley: University of California Press, 1966.

Tarkovskii, Andreii. *Sculpting in Time: Reflections on the Cinema.* Translated from the Russian by Kitty Hunter-Blair. London: Bodley Head, 1986; New York: Alfred A. Knopf, 1987.

Tashiro, Charles Shiro. *Pretty Pictures: Production Design and the History Film.* Austin: University of Texas Press, 1998.

Tatar, Maria. *Lustmord: Sexual Murder in Weimar Germany.* Princeton: Princeton University Press, 1995.

Taylor, Richard. *The Film Factory: Russian and Soviet Cinema in Documents 1896–1939.* London and New York: Routledge, 1988.

———, ed. *The Eisenstein Reader.* London: British Film Institute, 1998.

Taylor, Richard, and Ian Christie, eds. *Eisenstein Rediscovered.* London and New York: Routledge, 1993.

Thuillier, Jacques, Roland Recht, Joan Hart, and Martin Warnke. *Relire Wölfflin: Principes et théories de l'histoire de l'art.* Paris: Musée du Louvre and École Nationale Supérieure des Beaux-Arts, 1995.

Touati, Jean-Pierre, and Santiago Amigorena. "Peinture et cinéma: L'épée devant les yeux. Entretien avec Hubert Damisch." *Cahiers du Cinéma*, no. 386 (July–August 1986): 26–32.

Turim, Maureen Cheryn. *Abstraction in Avant-Garde Films.* Ann Arbor: UMI Research, 1985.

Varnedoe, Kirk. *Vienna 1900: Art, Architecture & Design.* New York: Museum of Modern Art; Boston: Distributed by New York Graphic Society Books/Little, Brown, 1986.

Vergo, Peter. *Art in Vienna 1898–1918.* 3rd ed. London: Phaidon, 1993.

Vescovo, Marisa, ed. *Arte e Cinema: Torino 1930–1945.* Milan: Electa, 1997.

Viani, Simone. "Il Concetto di pittorico e lo svolgimento degli stili: Burckhardt, Wölfflin, Riegl." *Critica d'Arte*, no. 1 (1990): 34–38.

———. "Kunstwollen, Aura, Kunstwerk." *Critica d'arte* 53, no. 17 (Summer 1988): 42–47.

Viatte, Germain. *Peinture, cinéma, peinture.* Paris and Marseilles: Éditions Hazan, 1989.

Vieth, Hermann. *Der Film: Ein Versuch.* Euskirchen: Wilhelm Zimmerman Kommissions-Verlag, 1926.

Virilio, Paul. *The Aesthetics of Disappearance.* Translated by Philip Beitchman. New York: Semiotexte, 1991.

"Visual Thinking: On Rudolf Arnheim." Special issue. *Salmagundi*, nos. 78–79 (Spring–Summer 1992).

Walker, John A. *Art and Artists on Screen.* Manchester: Manchester University Press, 1993.

Warnke, Martin. "On Heinrich Wölfflin." *Representations* 27 (Summer 1987): 172–187.

Welchman, John C. *Modernism Relocated: Towards a Cultural Studies of Visual Modernity.* Sydney: Allen & Unwin, 1995.

Wilson, Sarah. "Postmodern Romantics." In *The Assassination of Experience by Painting—[Jacques] Monory*, by Jean-François Lyotard. London: Black Dog, 1998.

Wind, Edgar. "The Revolution of History Painting." *Journal of the Warburg and Courtauld Institutes* 10 (1947): 159–162.

Wölfflin, Heinrich. *Principles of Art History: The Problem of the Development of Style in Later Art.* Translated by M. D. Hottinger. New York: Dover, 1950.

———. *Renaissance and Baroque.* Translated by Kathrin Simon, with an introduction by Peter Murray. Ithaca, N.Y.: Cornell University Press, 1966.

Wollen, Peter. *Signs and Meaning in the Cinema.* Bloomington: Indiana University Press, 1972.

Wood, Christopher S. *Vienna School Reader: Politics and Art Historical Method in the 1930s.* New York: Zone, 2000.

Woodfield, Richard, et al. *Framing Formalism: Riegl's Work.* Amsterdam: G+B Arts International, 2001.

Worringer, Wilhelm. *Abstraction and Empathy: A Contribution to the Psychology of Style.* Translated by M. Bullock. New York: International Universities Press, 1953; Chicago: Ivan R. Dee, 1997.

Worth, Sol. *Studying Visual Comunication.* Edited by Larry Gross. Philadelphia: University of Pennsylvania Press, 1981.

Zerner, Henri. "Alois Riegl: Art, Value and Historicism." *Daedalus* 105, no. 1 (Winter 1976): 177–188.

Zimiles, Murray. "The Influence of Photography and Cinema on Contemporary Painting." Master's thesis, Cornell University, 1965.

Contributors

RICHARD ALLEN is associate professor of cinema studies at New York University. He is author of *Projecting Illusion: Film Spectatorship and the Impression of Reality* and co-editor of *Film Theory and Philosophy, Hitchcock: Centenary Essays,* and *Wittgenstein, Theory and the Arts.*

RUDOLF ARNHEIM (1904–) is author of *Film as Art, Art and Visual Perception, Visual Thinking, The Power of the Center, Toward a Psychology of Art, Entropy and Art,* and *The Dynamics of Architectural Form.* He is professor emeritus in the College of Literature, Science, and the Arts at the University of Michigan. After moving to the United States in 1940, he also held professorships at Sarah Lawrence College, the New School for Social Research, and Harvard University.

JACQUES AUMONT is professor of film studies and aesthetics at the University of Paris–Sorbonne Nouvelle. He is the author of a dozen books on various topics related to film analysis and aesthetics, of which two have been translated into English, *Montage Eisenstein* and *The Image.*

BÉLA BALÁZS (1884–1949) was a Hungarian film theorist. He collected all his essays in *Theory of Film* (1945), after publishing *Der Sichtbare Mensch oder Die Kultur des Films* (1924) and *Der Geist des Films* (1930). Besides establishing himself as an influential film theorist, he was a scenario writer for Leni Riefenstahl, for *Narkose* (1929) by Abel, and for *Dreigroschenoper* (1931) by Pabst. Balázs also worked as a librettist for Bela Bartok, and he proved he could be a film director in his own right. Finally, Balázs taught with Eisenstein at the Soviet film school in Moscow.

ANDRÉ BAZIN (1918–1958) was the mentor of the young critics and filmmakers of the postwar French Nouvelle Vague in the 1950s and 1960s. Through a growing network of cine-clubs and cine-philes in Paris, Bazin revolutionized film criticism thanks to his detailed discussions of how editing, camerawork, and deep-space-staging offered expressive possibilities to the filmmaker. By assuming the filmmaker to be a sort of novelist-on-film, the Bazinian critic could examine even a popular film as the vehicle of a personal vision. There arose the so-called *auteur theory,* which celebrated the achievements of many Hollywood filmmakers despite the pressures of the studio system.

From the pages of *Cahiers du cinéma* (co-founded by Bazin in 1951), Bazin and others began to ponder the possibility that cinema might radically differ from all the traditional arts. They argued that the filmic medium has as its basic purpose to record

and reveal the concrete world in which we find ourselves. This line of thought treated cinema as a "phenomenological" art, one suited to capture the reality of everyday perception. Many of Bazin's essays are collected in *What Is Cinema?* (2 vols.), published by the University of California Press.

WALTER BENJAMIN (1892–1940), German Jewish man of letters, was known to the discerning few as one of the most original critical and analytical minds of his time. His work consisted of literary essays, general reflection, aphorisms, and probings into cultural phenomena. He achieved posthumous fame when a collected edition of his writings appeared in Germany in 1955.

DONALD CRAFTON is a professor in the Department of Film, Television, and Theatre at the University of Notre Dame. He is the author of *Before Mickey: The Animated Film, 1898–1928* (MIT, 1982; Chicago, 1993), *Emile Cohl, Caricature, and Film* (Princeton, 1990), and *The Talkies: American Cinema's Transition to Sound, 1926–1931* (Scribner's, 1997; California, 1999). Crafton was also named Academy Scholar by the Academy of Motion Pictures Arts and Sciences.

ANGELA DALLE VACCHE is the author of *The Body in the Mirror: Shapes of History in Italian Cinema* (Princeton, 1992) and *Cinema and Painting: How Art Is Used in Film* (University of Texas Press, 1996). She is currently working on *The Silent Sex: The Italian Diva in Early Cinema (1900–1920)*, forthcoming from the University of Texas Press. Dalle Vacche teaches film studies at the Georgia Institute of Technology.

GILLES DELEUZE (1925–1995) was professor of philosophy at the University of Paris–Vincennes. His many books include *Kant's Critical Philosophy*, *Foucault*, and (with Felix Guattari) *Anti-Oedipus*, *A Thousand Plateaus*, and *Kafka*.

SERGEI EISENSTEIN (1898–1948), Soviet film theorist and filmmaker, was author of *The Film Sense* (1942), *The Film Form* (1948) and *The Non-Indifferent Nature* (19??). Throughout his career Eisenstein was interested in the relation between film and the arts. He was fascinated with Japanese hieroglyphic writing, kabuki and No theater, the circus, Vsevolod Meyerhold's theories of acting, the Italian commedia dell'arte, and Bertolt Brecht's and Wagner's aesthetics. Among his major films were *The Battleship Potemkin* (1925), *October* (1928), *Que Viva Mexico* (1931–32), and *Alexander Nevsky* (1938). Eisenstein saw film editing, or montage, as a process that operated according to the Hegelian-Marxist dialectic of thesis, antithesis, synthesis. He distinguished among five different kinds of montage: metric, rhythmic, tonal, overtonal, and intellectual or ideological.

THOMAS Y. LEVIN is associate professor in the German Department at Princeton University, where he teaches media theory, cultural criticism, and intellectual history. His most recent publication is *Rhetorics of Surveillance from Bentham to Big Brother* (MIT Press, 2002), the catalogue of a major exhibition that he curated at the ZKM in Karlsruhe, Germany. Levin also translated, edited, and introduced the collection of Weimar essays by Siegfried Kracauer entitled *The Mass Ornament* (Harvard University Press, 1995).

ARA H. MERJIAN is a doctoral candidate in the department of the History of Art at the University of California, Berkeley, and an editor for *qui parle: literature, philosophy, visual arts, history*.

PIETRO MONTANI is professor of aesthetics at the University of Roma "La Sapienza." He has published many studies on film theory (*Fuori campo*, *L'immaginazione narra-*

tiva) and he is the editor of the Italian translation of S. M. Eisenstein's *Selected Writings* (7 vols.).

ERWIN PANOFSKY (1892–1968) was a German art historian, active in the United States. He wrote primarily on late medieval and Renaissance art in Northern Europe and Italy, mostly, by no means exclusively, on painting. He sought consistently to place individual works of art in relation to what he took to be an underlying aspect of the human situation, the reciprocity between 'objectivity,' our receptive relation to the external, and 'subjectivity,' the constructive activity of our thought.

PATRICE ROLLET is a professor at the Ecole Nationale Supérieure d'Art de Paris-Cergy and is co-publisher of the journal *Trafic*. He is the author of *Passages à vide: Ellipses, éclipses, exils du cinéma*, and co-editor of *Paris vu par le cinéma d'avant-garde (1923–1983)* and of *John Ford*.

HEINRICH WÖLFFLIN (1864–1945) was a Swiss art historian. Starting as a student of philosophy he turned to art history under the influence of Jacob Burckhardt's teaching at Basle. He was interested in discovering general principles for interpreting the visual character of works. He wrote almost exclusively on Renaissance and baroque art. In 1915 Wölfflin published *Principles of Art History: The Problem of the Development of Style in Later Art*.

Index